THE SLOW BREATH
OF STONE

ALSO BY PAMELA PETRO

Travels in an Old Tongue:
Touring the World Speaking Welsh

Sitting Up With the Dead:
A Storied Journey through the American South

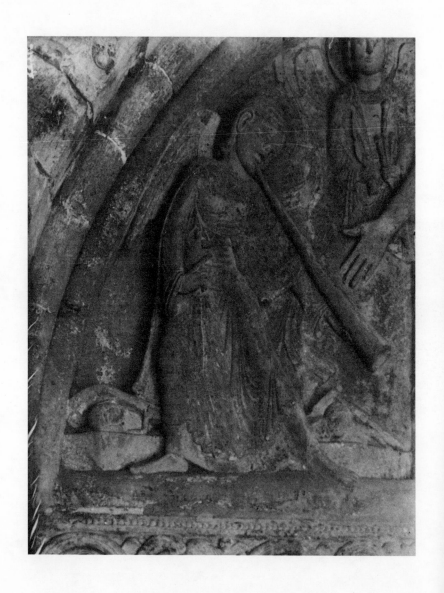

THE SLOW BREATH
OF STONE

A Romanesque Love Story

PAMELA PETRO

FOURTH ESTATE · *London* and *New York*

First published in Great Britain in 2005 by
Fourth Estate
A Division of HarperCollins*Publishers*
77–85 Fulham Palace Road
London W6 8JB
www.4thestate.com

1

A catalogue record for this book
is available from the British Library

ISBN 0-00-257147-1

Lines from 'In Praise of Limestone' by W. H. Auden;
'Stone' by Charles Simic; 'Sandstone Keepsake',
'Seeing Things' and 'The Stone Verdict' by Seamus Heaney
appear courtesy of Faber & Faber Ltd.

Lines from 'Inside' and 'Ninetieth Birthday', from
Collected Poems by R. S. Thomas, appear courtesy of
J. M. Dent, a division of The Orion Publishing Group.

Material from the papers of Arthur Kingsley Porter
courtesy of the Harvard University Archives.

Maps by John Gilkes

Set in PostScript Linotype Galliard by
Rowland Phototypesetting Ltd, Bury St Edmunds, Suffolk
Printed and bound in Great Britain by
Clays Ltd, St Ives plc

For Mary Diaz and Tom Ferguson
and for Richard Newman

Contents

List of Illustrations

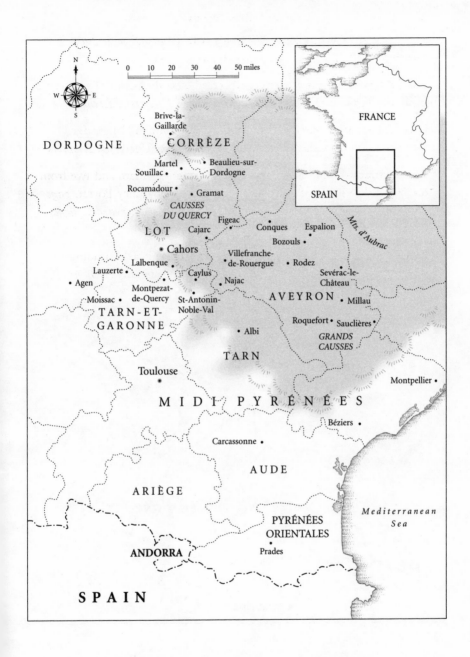

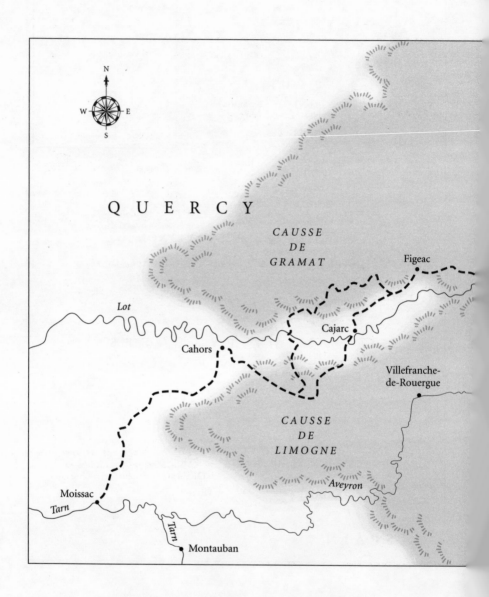

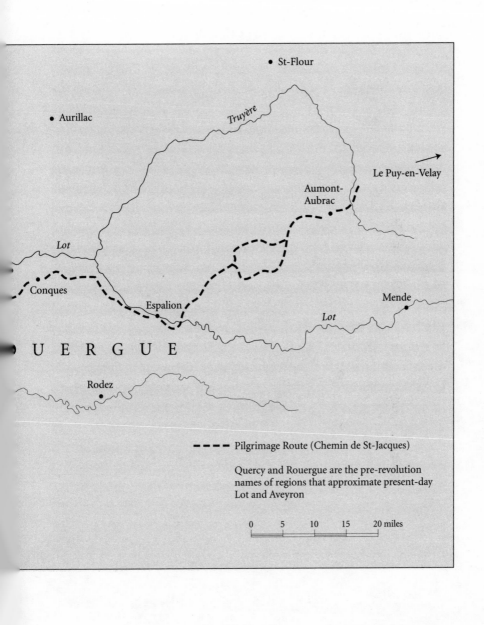

● St-Flour

● Aurillac

Truyère

Le Puy-en-Velay

Aumont-
Aubrac

Lot

Conques

Espalion

Mende

Lot

U E R G U E

Rodez

- - - - Pilgrimage Route (Chemin de St-Jacques)

Quercy and Rouergue are the pre-revolution
names of regions that approximate present-day
Lot and Aveyron

0 5 10 15 20 miles

1

DISCOVERY

Lend me the stones of the past, and I will lend you the wings
of the future.
 Robinson Jeffers

Lucy Porter awoke in a meadow outside the town of Espalion. She
was unaccustomed to lying in meadows, but the summer of 1920
had been kind to the grass in southwest France, and it was as thick
and inviting as any mattress. She propped herself up on an elbow.
Perhaps Anfossi, her chauffeur, had jacked up the Fiat to check the
patch on their latest puncture. But he was still asleep at a discreet
distance in the next field. No matter, she was awake now. Lucy picked
up her pen and rolled onto her side, pulling her journal closer. Its
filled pages looked like an artist's rendering of a hedgerow.

'In the evening,' she wrote of last night's after-dinner stroll, 'to
walk by the River Lot. The willows grew in an exact Corot way – a
boat with a touch of red in it, would have completed the Metropolitan
Museum picture.'

The composition in which she lay was equally satisfying, perhaps
more so thanks to the addition of her own small body, her pale dress
like a white erasure against the green meadow. In front of her, its soli-
tary bulk dwarfing the town and surrounding river valley, was a great
cone of basalt, a volcanic orphan of the Mesozoic Era about eighty

million years old, capped by the erratic profile of a ruined château. Behind Lucy lay a more recent, more imaginable past: a cemetery of granite crypts, many topped with vases holding fresh flowers, and, behind the graves, a worn, red church of the eleventh century.

Lucy sat up and looked back at the church of Perse, adjusting the bun at the nape of her neck. Her hair was dark but beginning to grey in weedy strands. She didn't like it – grey hair reminded her that Kingsley was so much younger – but what did she expect? She was forty-four years old. The church was greying, too. White blotches – what the French called *la maladie blanche*, secretions of lime oozing from the red sandstone – had broken out over its façade, under the eaves, across the faces of sculpted apostles.

An image in Lucy's mind, an image framed only a few hours earlier on the focusing plate of her view camera, superimposed itself across the bare western profile of the church. At the time the image had been upside down, but her mind's eye righted it for her. She'd been dutifully recording the tympanum, the half-moon formed by the lintel of the church's entrance and the rounded arch above, but then had become taken with one of the angels that framed it.

Her angel, Raphael, had more to do with architecture than art. It was his image that now lodged behind her eyes. He had been carved out of the wedge-shaped, fitted stones that formed an outer arch around the tympanum, cut in two at the waist, his upper body hewn from one stone, his legs and feet from another. More utilitarian than aloft, she'd thought – his wings were really little more than scratches – but she had made him fly. She had focused her camera on Raphael; the *maladie blanche* lightened him, and lifted him away from the stone. Then she had cropped the image severely, leaving only the angel and the curve of the arch to which he was bound, which suddenly, to her surprise, became transformed into a vertiginous arc of flight. Looking at him on the focusing plate, her head draped under the camera's black cloth, she had thought he would propel himself right out of her frame. From the frozen

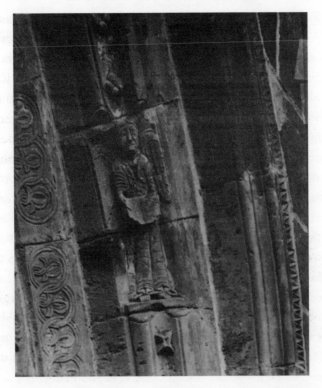

gasp on his thin, wide-eyed face, he seemed to have thought so too.

The memory of Raphael's flight was interrupted by a sound. At first it had been one note amidst the persistent birdsong, but now her ears sifted out the familiarity of her husband Kingsley's whistle. Lucy smiled, turned around, and quickly grabbed her journal to record the moment.

'In about two hours I heard his whistle and saw him coming in the softness of the August afternoon, the castle, the pastures and ripe blackberries setting off exactly his dear, sensible face. So tall and fair and mine!'

Later that day, before dinner, Lucy added a line. 'Again, almost fearful because of our great happiness.'

* * *

Ste Foy, or St Hilarion, de Perse – it is known by both names – is
not one of the great Romanesque churches of southern France. Its
situation alone gives it a measure of rural dignity. It is possible to
drive to the field-locked church, but not past it; only a footpath
accomplishes this, passing beneath its northern profile and forcing
walkers to crane their necks to take in the sizeable pile of red sand-
stone upon its hillock. A human body on its own tired feet ensures
the church relative majesty by comparison. So does the fact that one's
feet are treading the Chemin de St Jacques, the famous medieval
pilgrimage road to Santiago de Compostela, eight hundred miles
away on the Spanish coast.

I first saw the church of Perse on a mild spring day in 2002. Its
porous stones were the colour of a human tongue, some lighter,
some darker, but all of the same hue. The interior was as cold as a cave
deprived of geothermal heat. Awkward Gothic chapels meandered off
the northern transept, and last year's leaves collected beneath an
ancient wooden door that once opened onto the grand south portal.
It was locked now. Visitors used a smaller entrance fitted with an
electronic buzzer.

The church was dank and forlorn inside – no nave was meant to
be raked – so I went back out to see the temporal world meet its end
on Perse's façade. The earth was the same shade of tongue-red as the
church; a breeze whipped up a pink whirlpool and I breathed the
soot of France's millennia into my lungs.

No one who has written about the tympanum of the church of
Perse has avoided the word 'rustic'. 'Clumsy', 'anarchic', and 'inept'
are other adjectives that crop up. Most of these remarks pertain to
the lower portion of the space, wherein we are to understand that
Christ has come again, freeing humankind from the heartbreaking
dictates of time. In the centre a corpse pokes his head out of a coffin,
alert but addled with the sleep of centuries. For want of space, his
head serves as the fulcrum for a set of scales, upon which angels and
a cat-faced devil weigh souls. To the right, Jesus and the evangelists

jumble crookedly into paradise; to the left, Satan and his devils feed the damned into a scaly, saw-toothed mouth of Hell, whose low-browed head erupts in a thatch of spikes.

For me, a 42-year-old American woman drawn to France by my long-time love of Romanesque sculpture, this was a paradox as familiar as my own reflection: eternity in a state of decay. A thousand years of weather had made a crumbled mess of Satan's face; Christ's features were worn almost smooth. The everlasting angels were victims of the *maladie blanche*. The whole composition had lost the crisp admonition incised into it with a sharp chisel. Like a nursemaid, nature had said 'There, there' to our nightmare – for it was the rare man who was saved – and brought serenity to the Apocalypse. Ferreting in my bag I pulled out a small portfolio of fox-edged photographs and held up a dutiful shot of the tympanum, and then an inspired one of the angel Raphael, one of the figures that surrounds it. Most of the weathering had occurred before 1920, when the photographs had been made.

I moved into the surrounding cemetery and sat propped against one of the headstones, shivering like a reptile from its sudden warmth. Even though my side was in shadow the three-inch sandstone slab radiated heat. I calculated that the sun must have been shining on the facing side for at least three hours. Stone absorbs solar heat slowly, photon by photon, an inch an hour.

The photographs I held were from Volume IV of Kingsley Porter's ten-volume masterpiece, *Romanesque Sculpture of the Pilgrimage Roads* (one volume of text, nine of images). His wife Lucy – by far the better photographer – had shot the Espalion pictures and then taken a nap in the neighbouring field while he'd strode off to visit another church nearby.

There hadn't been an ounce of sacrifice in Lucy's nap. She'd loved the life that had led her to Espalion, in the old region of the Rouergue. She'd loved dashing through France, Italy, and Spain in the open Fiat; photographing Kingsley's beloved Romanesque

churches; enduring cold baths in provincial hotels, the two of them eating and sleeping like young soldiers. F. Scott Fitzgerald said that we all have a favourite, heroic period in our lives, and this had been theirs.

The field where she'd lain may have even seemed like a featherbed to Lucy after the conditions she had endured the previous spring. The war had just ended and Kingsley had been keen to visit and photograph Romanesque churches in the eastern environs of Paris. Lucy identified her journal from this time as, simply, '1919: Devastated Regions'.

The churches were often in ruins. 'Climbed up fallen debris to height of capital to take photo,' wrote Lucy without fanfare, or 'Church had been blown up. Took heap of ruins, apse a circle against the sky.' In another village she wrote, 'Nothing standing and no people. Took a pile of stones to show what had been the church.'

Sometimes the churchyards had been shelled as well, so that the Porters were forced to navigate open graves and walkways strewn with body parts. 'We had to pick our way carefully,' recorded Lucy in April, 'because of shells and hand grenades.' Decaying horses littered the countryside. Lucy took in the horror and loss and legitimately feared for locals' safety – 'they mark [the buried shells] this year and not have them explode, but how about next year?' – but she couldn't keep her mind entirely off food ('The Croix d'Or still sets a good table . . .') nor her happiness discretely between the lines of her journal.

> After our hot but poor coffee and tea we were off on the day's work we both love so well.
> . . . took interior, piers of nave distinctive. Despite the cold the birds, the flowering forsythia, and the ploughing oxen and horses announced spring. How happy I am!

Lucy may well have been content in her pasture, but I shifted restlessly against my tombstone. It was hard for me to sit still within eyeshot

of the great pilgrimage way to Compostela. The road tugged at my peace, not so much that of my feet as of my mind. The Chemin de St Jacques implies a passage through time as well as countryside. In its promise of great distances lies the inescapable reckoning of passing seasons and years, and in my mind the Porters' lives tumbled messily over the dam of 1920, down the decades of the twentieth century.

The thought nagged at me: why had Lucy been fearful of her and Kingsley's great happiness? The phrase weighed down her journal like clumsy foreshadow. There amidst Perse's dead I knew what she, in 1920, did not – that eventually Lucy had every reason to be fearful. That the Porters outlived the joy of that summer I knew from reading Lucy's subsequent journals, discovered amongst her husband's papers in a Harvard library. But that did not explain why a shadow had crossed her thoughts in Espalion. Was it a premonition? And did she recall that old, inexplicable dread a decade later when the high tide of her happiness had turned?

By then – the early 1930s – Kingsley and Lucy had forsaken the abundance of southwest France for the thin resources of the north of Ireland. On that warm, ripe afternoon, curled up against a rosy stone that smelled complete and holy, of everything that had ever lived and died, I couldn't help thinking that in abandoning this place, this art, the Porters had left behind a source of salvation. These old French regions where my travels overlapped theirs – rural hinterlands once officially, but since the Revolution only affectionately, called Quercy and the Rouergue – are richly accommodating of body and soul. They burst at the seams with stone. Not the dense granite of Donegal, but fertile lime and sandstones central to the ecology, sculpture, and spirit of the great geological basin just south of the Massif Central.

In the Rouergue, which more or less corresponds to the modern *département* of the Aveyron, valleys of plum-coloured sandstone give root to the sloping vineyards of Marcillac. Quercy, a territorial ghost

haunting today's *département* of the Lot, is striated in bands of pale limestone plateaux called the *causses* – tablelands where the exposed bedrock is so plentiful you can smell it in the air. Its sheer abundance accounts for a culture of stony offspring varying greatly in age but retaining familial resemblance: dolmens and standing stones, erected thousands of years before Romanesque churches, and dry-stone walls, farmhouses, and conical shepherds' huts – at once cheerful and ancient, like Stone-Age gazebos – erected centuries after. The bed-rock from which they've all sprung, weathered into rich, calcareous soil, coaxes grapevines and walnut trees, melons and black winter truffles into abundance under the Quercynois sun.

This stone is both material and mortar. It not only builds art and shelter, it binds produce and architecture, sculpture and fungi, together as kin. The 'black' wine of Cahors is cousin to the angel Raphael, whom Lucy's photograph freed from nine centuries' bond-age to the church of Perse.

To my mind Raphael and his Romanesque brethren are as generous to humankind, in their way, as the landscape. Their physical decline – Perse's paradox of a sculpted vision of eternity fallen to ruin – is at heart a romantic paradox, begging us to imaginatively reanimate the life of an idea just as it asks our eyes to fill gaps in crumbled stone. These sculpted fragments and their pleas to be made whole again drew me, as nearly a century earlier they had drawn Lucy and Kings-ley, generously and irresistibly into the sculpture. For the greatest romance of all is that of the self in love with the shadows it throws onto the external world. Romanesque art in its thousand-year-old decrepitude begs us to cast shadows. It insists we become part of what we view. And if we are unable to reinvent and reanimate? Then we are left with the dark pleasures of tragedy.

Lucy and Kingsley Porter were New Englanders, but they had meridi-onal hearts: they loved Italy and found joy in what Lucy called 'the choppy country' of the Rouergue. And yet they exchanged the ready

fecundity of southwest France for the dense granite and busy skies of County Donegal, in Ireland. Eventually I followed them there, too, to a saw-edged ridge of pink cliffs on Inishbofin, a tiny island barely clinging to the rim of Europe. Crouched there on the granite, I wondered if Lucy had remembered, as I was remembering, the tongue-red church of Perse, and that it was precisely the same colour as the headlands. The tumult of waves had worn them smooth just as rain and wind had erased the features of Christ's face from the tympanum. Lucy must have wondered how she had come to travel so far from that sanctuary.

The autumn day I visited Inishbofin was unusually warm and I'd tarried on the little island, letting my imagination repopulate the past. I saw Lucy and Kingsley and their new young companion, Alan Campbell. Each in my mind's eye poised in his or her turn on the cliff edge, a look of surprise not unlike that worn by Raphael on their faces. It was about Alan that I wondered the most. Alan, the inveterate dreamer, who would have been as likely as I – I'm easily his match in the sport of daydreaming, as was Kingsley – to fill the latent romance of the scene with characters and melodrama. By then, however, in midsummer 1933, he would have known that he'd wandered into a story beyond his own conjuring.

Alan was 21 years old at the time. I had been the same age when I discovered Romanesque art. Both of us were in dire need of a good hard slap from the backhand of maturity. And both of us got it, though I dare say mine stung a good deal less.

*　　*　　*

Shortly after I graduated from university, on the heels of my twenty-second birthday, I moved to Washington, DC to work at the Smithsonian Institution. Washington was then, and still is, overrun by ambitious young people who intern by day and party by night. My friends grazed on free appetizers put out as bait at slick bars and danced in clubs. Sometimes I did, too, but more often I stayed

home drinking cheap wine and listening to the radio while I slowly, painstakingly filled a pencil drawing I'd made with tiny black dots of Indian ink.

My drawing was copied from a photograph of the tympanum of Ste Madeline of Vézelay, a twelfth-century Romanesque abbey in Burgundy. The picture tightly focused on a man and woman who held hands as he bowed to her. They were rapturously elegant, with rows of neatly braided hair and garments blown by unseen air currents into cascades of folds. Each partner bore the snout of a pig.

These were the 'Pig-Snouted Ethiopians', members of the heathen damned carved onto the great abbey of Vézelay at a time when tympana mapped a geography of Christianity's fertile imagination. Night by night, my face inches from the paper and the desk lamp inches from my head – so close I could smell my scalp cooking – I lovingly translated their big hands and heads, their slim, pointy feet and voluminous drapery from photographed stone into ink. I was in love with Romanesque sculpture.

I'd discovered this strange art, the eccentric, embarrassing forebear of Gothic sophistication, just months earlier during my final semester at Brown University, in Providence, Rhode Island. In my medieval art seminar I'd learned that the word 'Romanesque' had been coined in the nineteenth century with derogatory intent. It referred to the heavy, earnestly sturdy abbeys and basilicas that had begun to crop up in Europe around the turn of the first millennium, in the muddy, nameless years between the classicism of Rome and the spun stone of Gothic cathedrals.

These buildings of the eleventh and twelfth centuries had 'Romanesque' features – columns, capitals, arcades – but their decoration was radically unclassical. Hand in hand with the renaissance in architecture, the remembered skills of sculptors and masons had rushed back into currency as well. But instead of sculpting well-proportioned narratives of gods, these artisans freely – sometimes giddily – cut, scored, drilled, and chiselled the façades and column capitals of

Europe's Romanesque stonescape with stories from the Bible and detritus from their nightmares.

Out of the willing stone emerged hares in Hell, roasting poachers on a spit; rams playing harps and devils eating men's brains; a female centaur pulling a mermaid's hair; women suckling snakes at their breasts; tiny Peeping Toms. There were acrobats displaying their private parts; a man yanking out his own tooth; two warriors sharing a single penis; and in the Pyrenees, a marble dog stretching out his tongue, eternally unable to touch his water dish carved just out of reach.

Relatively little Western art before or after, excepting that of Hieronymus Bosch and the Surrealists, has been so feverishly inventive. From the beginning it was this very strangeness that was wondrous to me, this stony certitude that there was more to the world than sunlight illuminated for our eyes. Don't misunderstand: I wasn't looking for fairies and angels, rather confirmation that at one point in time, at least, images of the mind's eye bore equal value to those fixed on the retina. Romanesque art stirred in me a deep, visceral joy, an inchoate thrill of imaginative validation, all the more extraordinary for spanning so many centuries.

Perhaps its appeal also betrayed the innate curiosity of a born traveller who had not yet travelled. In one of his brilliant essays on the Romanesque, Meyer Schapiro cited St Bernard's furious twelfth-century letter condemning the then-new decoration of Clunaic abbeys. 'What profit is there', thundered the saint, 'in those ridiculous monsters, in that marvellous and deformed beauty, in that beautiful deformity?' Schapiro pointed out that Bernard sensed in those monsters an attitude that would eventually compete with Christian doctrine –'an attitude of spontaneous enjoyment and curiosity about the world'. A traveller's attitude.

At the time I didn't question too vigorously what fuelled my schoolgirl crush on the Romanesque. I just admired its easygoing, latent democracy. It was the first art of the Western tradition to place

scenes of daily life – a peasant drying his socks by the fire – side by side with those of didactic importance, such as Abraham sacrificing Isaac. I felt an instinctive sympathy for its carved figures with over-sized heads and eyes. Their bodies performed stunts possible only in a world unacquainted with linear perspective. Boats sailed on top of the sea, and Jesus and the Apostles evidently consumed the Last Supper in a room without gravity, where the tabletop floated before them and nothing fell off. Shoulders faced forward and knees turned to the side. After the Renaissance elevated the human eye and the illusions that please it above the soul and the cautionary tales that might save it, Romanesque art *looked* ridiculous. It became vulnerable; how could its ideas be taken seriously if it looked so naive?

It should come as no surprise that I did not choose the Roman-esque as my field of study. I didn't want my personal attachments supplanted by extraneous knowledge. So I left it at that, and did something else for twenty years. Then I attended the end of the world.

* * *

'Before and After the End of Time: Architecture and the Year 1000', read my friend Marguerite from the arts page of the newspaper, repeating the name of an exhibition so I could make a note of it. She thought it was something I might enjoy.

The show had been mounted in the second half of 2000 at the Fogg Art Museum at Harvard to commemorate the more-or-less millennial birthday of Romanesque architecture. While a copy of the Pig-Snouted Ethiopians drawing hangs in my stairwell – regrettably, I sold the original for pub money when I was a poor postgraduate at the University of Wales – I have tended not to think much about things Romanesque over the years, but I made a point of seeing the exhibition. 'The idea of the millennium enables us to contrast what might have happened in the year 1000 – the descent of the Heavenly Jerusalem – with what did happen, the Romanesque revival of archi-

tecture,' wrote Christine Smith, an art history professor at Harvard who curated the show. 'We juxtapose the City of God with the City of Man, the eternal with the temporal, and the divine with the human architect.'

To give viewers something to look at as she pursued these heady divisions, Smith pulled a couple of nearly hundred-year-old black-and-white photographs from Harvard's Fine Arts Archive. 'Old pictures of older buildings, what could be duller?' asked my friend Dick, who'd worked at Harvard at the time. I thought much could be duller. The black-and-white prints revealed a reverence for the tactile surface of stone. Every crack, every crumbling rough edge or rash of lichen was fixed with absolute clarity and modulation of light. These were not simple documentary photographs. They were scrupulously unsentimental, but they betrayed a sense of humour and a devotion to texture; a clear-eyed acknowledgement of great age; a sense of grace; susceptibility to valuing the overlooked. Whatever the source, there was passion in these pictures.

I checked a label for the photographer's name: Arthur Kingsley Porter. Months passed before I discovered that his wife Lucy, or 'Queensley', as she was called, had actually taken most of the pictures in the show. By then I was planning my own tour around southwest France to see what she and Kingsley had seen almost a hundred years earlier, and to find out why her photographs quickened my heart. I had no idea then that their Romanesque love story would lead me to Ireland as well.

Twenty years ago, when I was at university, I pondered the body of Romanesque sculpture but not its soul – nor did I give much thought to my own, for that matter. For argument's sake, let us say that if carved stone has a soul, perhaps it looks like a photograph. In the course of writing this book I came back time and again to a working proposition I'd first articulated to myself at the Harvard exhibition: that stone carving is to the body what photography is to the soul. One describes the solid, three-dimensional art of occupying

space and being at rest; the other, a chimera of light and water, the art of being in motion, of being in two places at once – of travelling.

I needed both to learn about the paradox of the Romanesque and to understand the reasons why I loved it so much. I needed to look back to the beginning of the twentieth century in order to really see the sculpture of the eleventh and twelfth, as it crystallized on Lucy Porter's focusing plate. As I travelled and read and learned over the course of three years her face began to appear there as well, a shadowy overlay that grew ever stronger. Often Kingsley's reflection flickered next to hers, and together their images foxed the present with intimations of their beleaguered, but always graceful, love story. Finally, once or twice, I glimpsed my own image beside them.

2

PREPARATIONS

The Yukaghir people of northeastern Siberia, seeing a camera
for the first time, called it 'the three-legged device that draws a
man's shadow to stone.' The three legs were the tripod, and
the shadow drawn to stone was the image inscribed onto the
glass-plate negative.
Drawing Shadows to Stone, Laurel Kendall

Room Five in the two-star Hôtel Quercy struck the visual equivalent
of perfect pitch. The walls were white; so were the gauze curtains
and quilted cotton bedspread. A chestnut armoire, in which I knew
I would find two square pillows cased in starched linen, sat on Empire
legs in the corner, a full-length mirror dividing its two doors. Simple
wooden tables flanked both sides of the bed, and a third, set with
two chairs and a flowered cloth, was placed beneath the full-length,
open window. The bathroom had all the appropriate fixtures includ-
ing a white marble baptismal font of a sink, and a small wooden table
for toiletries.

Two stars release hotel rooms from the need for incidentals, and
that was fine: sensibility, simplicity, and forethought were on view
without distraction. There was no telephone or television, nothing
betrayed a date. It could have been any decade of the twentieth or
twenty-first centuries, or even the nineteenth.

Several months earlier I had woken in a similar room after arriving

in France and driving from the airport, and not known if I'd slept for
an hour – if it was 8:20 p.m. – or if I'd slept off my jetlag for thirteen
hours and it was 8:20 a.m. Thick yellow sunlight had slanted through
the curtains: marginal sunlight, but I had no clue from which margin
of the day, morning or evening, it shone. For two or three minutes I
had been helpless, acutely baffled, until I'd turned on the television
and found the evening news.

A time traveller might have the same problem in Room Five of the
Hôtel Quercy. It was one of the best places in France, in addition to
Romanesque churches, in which to conjure Lucy and Kingsley Porter.

> Called at 8. We strolled about town, having leisurely put on
> pressed [and clean] clothes . . . Natalina makes this hurried travel-
> ling almost luxurious.

Without Lucy's journal I probably would not have envisioned
Natalina, her Italian maid, ironing their summer linens. Despite hav-
ing to make do with provincial hotels ('the hotels . . . are abominable',
wrote Kingsley to Bernard Berenson, 'but the sculptures are worth
putting up with anything'), the Porters travelled in style. Berenson's
biographer describes them in Paris at the end of the First World War:
'a well-to-do, well-educated couple of no particular idiosyncrasies
apart from their obsession for some curious sculpture.' In appearance
they were opposites. Kingsley had the tall, slim, slightly awkward
frame of a runner who doesn't run – he was in fact an intrepid walker
and swimmer – matched by gentle, blond good looks. Lucy was
short and a little stocky, her face broad and candid, with high cheek-
bones and a square jaw; her husband's, by contrast, was long and
thin, an oval of smooth, sloping angles. In photographs she looked
directly into the camera. He tilted his head and sought the horizon,
always slouching apologetically for his height.

Both were from wealthy families that split their time between
Connecticut and New York City. As affluent young men do in
Connecticut, Kingsley had gone to Yale University; as affluent young

women do, Lucy had attended Miss Porter's School for Girls. After graduation, Kingsley wasted no time in becoming an academic wunderkind, publishing his first book on medieval architecture in 1909, at the age of 25. It immediately seized his peers by both the imagination and intellect – a twin reaction he'd inspire for the rest of his life. Kingsley was an art historian who thought of himself as an archaeologist. When other scholars went to the library he went into the field, took comparative photographs, sought out primary documents, and drew his dates accordingly, rejecting prevailing notions about architectural development. His work was consequently perceived as both rigorous and romantic. First at Yale, where he was an assistant professor, then especially at Harvard, he was surrounded by admirers who considered him 'a valued exotic'. As one former student wrote: 'His scholarship offered a paradoxical blend of solidity with a penchant for living dangerously.'

How much Kingsley believed and perpetuated his own myth is uncertain; it's doubtful he considered being chauffeured around the

back roads of southwestern France with his wife and her maid a hazardous undertaking. Yet in some ways he did see his fieldwork as a scholarly extension of the big-game hunting he'd pursued in Newfoundland as a teenager. Early in 1920 he wrote to Berenson about his great project, photographing and comparing Romanesque sculpture on the pilgrimage roads of France and Spain, in hopes of discovering a relational lineage of development. 'I am delighted with some of the things that have turned up from the Burgundian photographs we made last summer. There are so many things I want to find out about that the excitement of the chase perhaps lends an interest not purely aesthetic . . .'

Fuelled by adventure, romance, and a kind of moral pragmatism in equal parts – a scrupulous, verging on puritanical, need to set eyes on his subjects before he wrote about them – scholarship, for Kingsley, could never be a strictly indoor pursuit. After Yale and a two-year stint at the Columbia University School of Architecture in New York, he moved to Europe to study on his own. It wasn't what was meant to have happened; his mother, one of the first students to study at Vassar, had intended him to join his brother Louis' law firm. But in the summer of 1904 Kingsley visited Coutances, in Normandy, and beheld the cathedral that had recently captured the attention of Henry Adams, another gentleman-scholar from New England. Of the cathedral Adams had written in his book on Romanesque and Gothic architecture, *Mont Saint Michel and Chartres*, which would be published the following year: 'Nothing about it is stereotyped or conventional, – not even the conventionality.' The same might be said of Kingsley.

Adams thought that the Coutances cathedral epitomized the Normans' masculine, martial culture. 'The meaning of the central tower cannot be mistaken,' he wrote; 'it is as military as the "Chanson de Roland"; it is the man-at arms himself . . . the mere seat of the central tower astride of the church, so firm, so fixed, so serious, so defiant, is Norman . . .' For Kingsley it became the place where the present

cracked open and he glimpsed his future. He'd been standing in front
of the cathedral when suddenly, he recalled, 'shined a light round
him', and it was as if he'd fallen into a trance. When he awoke, he
later told Lucy, he knew he would never be a lawyer.

Like his rival, the Frenchman Émile Mâle, Kingsley felt he had
been called to the study of medieval art – a vocation announced by
epiphany rather than mere choice or happy accident. 'Only romantic
personalities,' wrote Janice Mann in a study of their rivalry, 'would
imagine themselves so singled out by fate.' It was the passion of this
conviction that made Kingsley a memorable teacher. Students who
later in life couldn't tell a cornice from a corbel could not forget the
intensity of his love for the subject, which lay like bedrock under his
surface shyness and affability. They remained a little star-struck, even
years later. 'His intransigent idealism, his extreme sensitiveness, his
incorruptible magnanimity and high-mindedness, even his prodigious
capacity for work, have something Shelleyan about them,' wrote one.
Others were moved to even loftier comparisons:

> It was . . . in the manner in which he transmitted to others the
> results of his own studies and of his perfectly rounded character,
> making an indissoluble unit of his research, his instruction, and his
> friendship, that he attained an Hellenic integration of all aspects of
> his personality.

One of the reasons for Kingsley's immense popularity was that Lucy
channelled his generosity into a weekly schedule. Both Porters
became famous at Harvard for their 'Sunday Afternoons at Home',
when they would open their house to students who flocked there to
converse, look at photographs, and be fed. One undergraduate later
wrote of Kingsley and his Sundays: 'I value the memory of hours
spent with him in his study and photography collection from 1925
to 1930 beyond any other recollection of the university.' Lucy had
hit upon the idea of Sunday parties to protect her husband, who
otherwise would have had students round every night. She was, one

of them later recalled, the unflagging guardian of Kingsley's 'never robust health'.

That Kingsley felt the same way about his students as they did about him is evident from the dedication he made in his 1931 study, *Crosses and Culture of Ireland*. 'To My Teachers', wrote Kingsley, '– My Harvard Students'.

* * *

On 1 June 1912, Kingsley married Lucy Bryant Wallace in her parents' home in New York City, when he was 29 and she 35. During their courtship, initiated by his loan to her of some photographs of Italian architecture, he portrayed himself to her as precisely the reserved romantic his peers made him out to be. Shortly after their engagement he'd made the mistake of perching himself on the arm of another woman's chair at a tea given by Lucy's family. By the time he reached home he was eaten up with guilt, and immediately wrote her to apologize. 'I am afraid you have in hand a wild and wayward nature that has so seldom thought of conventions and forms that it never considers until afterwards that one's thoughts are judged by purely external actions.' In the same letter he reminded her, 'as you know darling social tact is the one thing more than any other that I haven't'.

Despite his protestations to the contrary, Kingsley's was a waywardness strictly controlled (so strictly it was perhaps only apparent to himself, though he tried hard in his letters to impress this 'wild side' upon Lucy). When she complained that a visit from his relatives had been 'the most formal kind of call' he explained to her: 'My family are all so mannered and stiff; the only way to treat them is to rather break through the ice wall with which they surround themselves. I know because I am just like them.' Later in life he expanded on the theme to Berenson. Kingsley wrote that it was a part of his 'Puritanism' never to show his feelings, a characteristic he loathed, and tried hard to rectify in letters. In many ways, art history – his

brand of it, practised in the field – offered a means by which to reconcile his self-perceived 'wildness' with his inherited propriety. Roving about the European countryside on his own terms (universities and publishers gave him so much free reign he felt guilty) was never anything less than a respectable vocation. Yet it simultaneously renounced the 'very formal, very quiet, very refined, in perfect taste, and deadly dull' world of tennis and dinner parties in which he had grown up.

Kingsley's second fortuitous discovery was Lucy Wallace: a wealthy, respectable woman with whom he could have a comfortable and respectable marriage and yet, from the first, share his inner nature. While propriety laid its claims on her as well, Lucy's natural spontaneity reduced the distance between her public and private selves, just as Kingsley's habit of reflection increased the space between his. The letters they exchanged during the six months of their engagement, beginning on 12 December 1911, are revelatory. Kingsley's were neat, even-lined, long and analytical; Lucy's dashed at top speed in impossible scrawl on tiny blue note cards (when she ran out of space she borrowed the old technique of turning the cards on their sides and writing on the perpendicular, between her previous lines). She made no bones about how she felt: 'Just the tiniest note in the world to carry the biggest amount of love to the finest and most loveable man.'

When Kingsley went to a conference in Pittsburgh shortly after their engagement, she chafed under her sister Ruth's watchful eye and literally counted the hours until he returned to New York, unembarrassed that she was 35 and carrying on like a teenager. 'Sweet adorable Kingsley (I just can't be proper anymore) are you never coming back to me?' Further down she added, 'I must wait forty-four hours before you can hold me in your arms again. That would or should solicit tears from a stone (Lucky Ruth does not censure this note!).' The day before, she promised him that she was getting fat and rosy and lonesome in his absence. This she later amended,

insisting 'I'm not getting fat and rosy. I'm only getting lonesomer
and lonesomer and LONESOMER.'

For Lucy, such declarations must have been the equivalent of going
out on an emotional limb, for until she met Kingsley she practised a
degree of independence unusual for women of her time and, especi-
ally, class. She worked as a schoolteacher – by choice, certainly not
financial necessity – teaching elementary students at a private school
in New York City. In one of her letters she tried to tease Kingsley
into coming along to help her hunt for subjects and predicates during
a grammar lesson. That she continued teaching, possibly against her
parents' wishes, certainly against her friends' – one was scandalized
that she kept it up after her engagement – suggests that Lucy, too,
chafed against the world into which she was born. 'I never leaned so
willingly on anything', she wrote to Kingsley before their wedding,
'as I did on your protective care. And can it be I am to have that
always, Kingsley, dear?'

After their marriage and honeymoon at Lake George, in New York
State – snapshots show Lucy looking uncharacteristically demure,
holding a parasol, and Kingsley surprisingly jaunty – the Porters were
inseparable, moving always as a pair. When, in 1918, Kingsley was

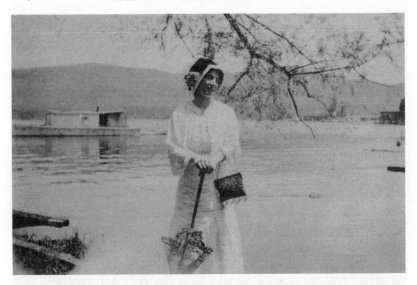

appointed by the French Ministry of Fine Arts to a panel of experts charged with assessing war-damaged medieval monuments (the only foreigner so honoured), Lucy went along and took photographs and made notes. The Porters were based in Paris, where they would remain until the autumn of 1919. It infuriated Lucy to be attending luncheons in the same city where Woodrow Wilson, David Lloyd George, and Georges Clemenceau were simultaneously redrawing the world map for the Treaty of Versailles and to be without adequate news sources.

'I stumble in my groping ignorance,' she wrote in frustration. 'I can't feel it is fair for the "Little Powers" to have only 5 representatives together against two for each of the 5 powers.' Paris at the time was still very much a city in recovery. Even for the very wealthy a lukewarm bath was reason for celebration; mail delivery was sporadic at best. And Lucy's French was still a work-in-progress. In February 1919 she wrote of attending a lunch party with one of Kingsley's colleagues and his family: kind people who were none the less not of the same social class as the Porters. It was the first time Lucy had

been able to speak French with abandon in Paris, a feat for which she later berated herself in her journal. 'I was ashamed', she wrote, 'that my fluency came from a superior feeling socially.'

Curt reflection was a trademark of Lucy's journal writing, no matter what the subject. She recorded and commented; she didn't dwell. A rare theme – Lucy was too eclectic to be repetitive – was that of her and Kingsley's desire for privacy in an unrelentingly social environment. 'I suppose a tea once in awhile brushes up one's manners,' she conceded.

About Paris Lucy avoided generalizations, preferring the sharp, focused observations of a photographer. 'A thin whiteness over the city'; or, on walking past Notre-Dame in mid February: 'It was closed but I studied the south portal. The frozen spray of ice from the mouth of each gargoyle showed which way the wind had blown on the first cold day. On my return home a warm shower of family letters.'

In March 1919 the Porters gratefully exchanged city for country-side ('Glad to leave Paris,' commented Lucy) so that Kingsley could begin researching *Romanesque Sculpture of the Pilgrimage Roads* in earnest. They would remain travelling, despite a few hiatuses, until Kingsley took up his post at Harvard in the autumn of 1921.

'How many young dead we meet,' wrote Lucy as they struck out east of the capital, ' – always they are before us.'

<p style="text-align:center">* * *</p>

I was equally glad to trade the congestion of Toulouse for the small towns of the Rouergue. The city's wealth of sun-faded brick, with its southern promises of warmth, long naps, and lingering meals, was compromised by the edgy graphics of its thriving shops, not to mention its labyrinthine system of one-way streets. I was drawn to the shops, but my heart belonged to the brick's promises, which no urban hub could ever keep. When I'm in the city I always long for the country; in the country the city never enters my mind.

Upon arrival in Toulouse I'd risen from the Capitale Métro station straight into a 200,000-strong student demonstration protesting against recent successes of the French far Right. Like a piece of foreign flotsam I'd been swept into the human tide, whereupon I immediately began marching, dragging my wheelie suitcase in an erratic path behind me. I was pleased to make a show against encroaching fascism, but the deep-throated chant of the crowd touched a nerve. That noise, like thunder, suggested a latent storm and made me fearful. Although the marchers remained calm – many leashed dogs participated – I'd been almost teary with relief to glimpse my hotel on a quiet side street.

I'd had a similar experience while visiting Toulouse's great basilica, St Sernin (short for Saturninus), the largest Romanesque church in Europe, consecrated in 1096. The interior had been peaceful enough. Visiting in the 1880s, Henry James remarked: 'What makes it so extraordinary is the seriousness of the interior . . . As a general thing, I favor little the fashion of attributing moral qualities to buildings; I shirk from talking about tender cornices and sincere campanili, but one feels that one can scarce get on without imputing some sort of morality to St. Sernin.'

He was right – James usually was – although the painted plaster walls that he, as well as Lucy and Kingsley, had seen have since been stripped down to masonry and pale brick. To my mind the dependability he attributed to the basilica (I felt it too) came from the fact that here brick and stone kept their promises of tranquillity and peace, as they could not in the surrounding streets. The long rhythms of the eleven-bay nave, barrel arched above, repeated the assurance of serenity.

In the time I'd slipped into St Sernin, however, early on a Saturday morning, and returned again to daylight, a massive 'antiques' market had gathered around the church, pressing in on it the way hungry children surround a tourist. The pilgrimage church's quintet of radiating chapels, blooming in semi-circles at its eastern end, now

radiated a makeshift architecture of their own: folding tables strewn with disorganized cast-offs, two aisles deep. This wide flounce of price-tagged junk actually extended all the way around the church.

'Watch for pickpockets,' shouted an elderly British tourist, inches from her husband's ear. I took my rucksack off my back and wore it on my chest.

No one so much as glanced up at St Sernin; we were all hypnotized by the pretty rubbish of the century just passed. Mass-produced African sculptures; broken Portuguese pottery; detective paperbacks in French and English; used cassette tapes; a collection of doorknobs. There was even a white cast-iron kitchen sink. I had a friend who used to joke whenever he bought some bauble or other that he was part bower bird, a species inclined to build its nest out of glittery, shiny scraps. This was a bower bird's dream-come-true.

I tried, but even with binoculars I couldn't get close enough to the south portal to make out a capital of Adam and Eve's expulsion; had I not carried Lucy's photograph, I would never have glimpsed the pair's rather proud demeanour – curious in the circumstances – caught in Lucy's sunlit image, or their giant hands haughtily covering private parts.

After an African gentleman tried to buy my binoculars I gave up on the church and attempted to strike a bargain with one of the antique dealers over a copper kettle. From her journal I knew that Lucy had set off on a restorative walk in a city not too far from here, but instead had been lured into a shop selling copper utensils ('ended by buying 21 articles for the kitchen'), so I was hoping for a nice convergence. But the woman wouldn't budge.

The Musée Joseph Vaylet in Espalion, in the Rouergue, is St Sernin's Saturday market enclosed, dusted, hushed, and (loosely) curated. I preferred it by far. It costs next to nothing to enter and is staffed by an elderly couple who take advantage of the time on their hands by shelling peas. Joseph Vaylet was a Rouergat worthy who fought in

the First World War and lived until 1982. In the course of his long life he amassed a staggering collection of objects: a military horn used in the French army until 1840, the trumpet of which is shaped like a toothed serpent; a grape-picker's basket designed to be worn on the head; a glass baby bottle with a glass nipple; gas masks from the Second World War, both military and civilian; a seventeenth-century gourd used for holding spirits; a photo from the *Fête des Druides*, 1937; a red sandstone sink; a bone from a plesiosaurus – the accompanying drawing shows a long-necked reptile like a brontosaurus, with fins – who lived on the *causses* for five million years, when they formed the bottom of the sea. None of these objects are for sale, of course, but it doesn't take a great leap of the imagination to see a fine Saturday market in the making.

Based on sheer numbers, the museum shines in its assortment of ceramic holy-water vessels, but its chief prize is singular: an anthropomorphic menhir about waist-high, found locally and erected sometime between 3500–2200 BC. Statue-menhirs, which are essentially standing stones carved with human attributes, are rare, though the greatest concentration in Europe is in the Rouergue. Some sport schematic arms and legs, beards and breasts, even tattoos incised onto large, tooth-shaped stones; this one, however, was more enigmatic. Two deep eyeholes and a long, half-open mouth seemed to fix the viewer from a place far older than the Bronze Age. I couldn't shake the feeling that it was an ancestral totem, a sire of all creatures with eyes and mouths before we differentiated into separate species. It was an eerie sight, like looking deeply into everything and nothing in particular at once.

When I visited the Musée Joseph Vaylet I had the place entirely to myself; the handful of other museum-goers in Espalion were all next door at the Musée du Scaphandre – the Diving Suit Museum. The unusual fact that a land-locked town like Espalion has a museum of the diving suit, advertised by a statue of a bronze diver in antediluvian gear standing in the middle of the River Lot and an orange diving

bell on the pavement, is imperfectly explained by the fact that two
local men were diving pioneers in the mid nineteenth century. I never
made it there; I was too busy pondering M. Vaylet's exhibits, the
only common attribute of which seems to be their irrelevance to the
present day.

The sixteenth-century building that holds his collection, the former
church of St Jean, is irrelevant itself, having been made redundant in
the late nineteenth century by the construction of a new parish church
across the street. The older structure is an urbane building, compact
and narrow but lofty – the in-town edifice of a rising middle class
grown wealthy on the tanning trade. The only thing it shares with *its*
predecessor, the field-locked church of Perse, is building material of
local red sandstone. There must have been a town meeting at which
the masons, tailors, tanners, and stone-cutters of Espalion decided
that an eleventh-century church in a meadow outside the town was
no longer fitting to their stature, so they decided to commission a
new one.

It was in this former church, now a repository of the extinct and
obsolete, itself the very agent that had thrust irrelevance on the
church of Perse five hundred years earlier, that I momentarily lost
faith in my adventure. Here at the beginning of my journey was every
reason to abandon it. If a nineteenth-century antelope-headed mallet
was no longer useful to the residents of Espalion, how could eleventh-
century Romanesque sculpture be relevant to me? It rendered an
increasingly discredited theology of judgement and damnation in
thoroughly discredited artistic shorthand: what could be more irrel-
evant than that? St Bernard's question – 'What profit is there in this
art?' – had got inside my head. What did I want of it, not to mention
the Porters and Lucy's photographs?

The facts I'd gathered about their lives were as so many exhibits in
these cloudy glass cases. Lucy liked to garden; Kingsley was driven to
distraction by the unruly clanging of church bells in French villages;
they were both bothered by flying insects in the night. Knowing

these things didn't begin to answer why I was so drawn to them.

Instead they rendered the Porters in a kind of Romanesque perspective. Lucy and Kingsley moved about in my imagination, but they did so within the constricted, one-dimensional space of the past. They were like photographs shot by my mind's eye – as yet a camera without a depth-perceiving lens, restricting its subjects to the surface plane. My mental images of them reminded me of the sculpted tympanum figures on the church of Perse. Although the Perse sculptures were shaped in the round, they had been conceived to inhabit a flat universe. Christ is depicted sitting, but because he sits in one dimension, his knees occupy the same plane as his torso. Writing about Romanesque sculpture, Meyer Schapiro tried to explain how three-dimensional carvings could be rendered in one dimension: 'They are', he wrote, 'like shadows cast on a wall' – the antithesis, in other words, of real photographs, which are themselves flat but depict depth.

At this point in my journey I felt like that eleventh-century sculptor who had shaped the awkward little figures at Perse. Perhaps, over time, Lucy's photographs and their stony subjects, abetted by her journal and Kingsley's letters, even the French countryside itself, might begin to lend the couple shading and spatial depth. Perhaps my own younger self would flesh up a bit, too, and speak to me of the real reasons she'd felt such an affinity for this strange art; at the moment she was little more than a shadow cast behind the present Pamela. It seemed odd to be looking for answers – for personalities, even – in stone. But then I thought of Lucy's words about winter in Paris; how she'd seen frozen sprays of ice issuing from the mouths of gargoyles, and how they'd revealed the way the wind had been blowing on the first cold day.

I, too, wanted to know which way the wind had been blowing; I wanted to catch secrets on the breath of stone. Lucy had found traces of the wind's restless passage in ice; perhaps I would be lucky enough to find answers – or at least clues – in sculpture.

I chatted again with the pea-shellers, who directed me to an

excellent greengrocer. I was feeling better about things. For good or
ill – for now, anyway – let the Porters be a pair of Romanesque
photographs cast on the wall of my mind's eye. About the old sculp-
tures Schapiro had also written: 'Although they represent incidents
. . . drawn from a real world, it is another logic of space and movement
that governs them.' His words gave me a way to think about Lucy
and Kingsley that honoured them for what they were at present: not
a living, breathing couple who had stood outside the church of Perse
eighty years earlier, perhaps chatting with Joseph Vaylet, their three-
legged view cameras at the ready, but guides reshaped on the focus-
ing-plate of my imagination by the logic of my journey. The questions
that propelled my travels governed my acquaintance with them. I was
not so much their biographer as their fellow traveller, in the same
place but another time, and their own painstakingly constructed,
black-and-white photographs would be my maps.

<p style="text-align:center">* * *</p>

There are 1,527 photographs in *Romanesque Sculpture of the Pilgrim-
age Roads*, and only three, to my count, have people in them. In one,
a priest poses in front of St Michel de Cuxa near the Spanish border;
in another, three children line up before the entrance to a church in
Western France; the third, labelled 'Baptism of Christ; Shepherds;
Magi', is the most curious. Lucy shot the other figures, but Kingsley
took this picture, and as a documentary photograph of column capi-
tals it is an abject failure. The capitals are barely legible – the carvings
look like webs secreted by a clumsy, stone-spinning spider – but
below them, in sharper focus, stand two young peasant children, a
boy with a hat pulled low over his eyes and a girl whom Kingsley
half-cropped out of the picture.

It wasn't unusual for the Porters to take pictures of the children
who gathered to watch them work, but it was a rare portrait that
Kingsley allowed into print. Lucy noted in her 'Devastated Regions'
journal that, 'I let the Le Duc brothers – aged 11, 9, and 5 – stand

in my picture. They were clad in cast-off soldiers uniforms.' That photograph was not included in *Romanesque Sculpture of the Pilgrimage Roads.*

Everything about Kingsley's picture is curious. The capitals and the children are pushed to the extreme left side of the image; the right simply shows a blank, masonry wall. Had he been fully concentrating on the sculpture he could have got much closer to it, as he did with a different set of capitals in the next photograph. That he didn't suggests he was taking a portrait of the children, and yet the little girl is half missing. It is either a rare display of sentiment, if not quite sentimentality – both children look solemnly obstinate – or a display of wry humour. From their dress and the rural setting of the church, it's a good bet the children are shepherds. The fact that they stand directly beneath their carved, biblical colleagues suggests that Kingsley was making a visual pun and a subtle reference to the rural pastureland in which he and Lucy, the church, and the children found themselves.

This photograph is from Volume IV, somewhat misleadingly called 'The Aquitaine', of his multi-volume work. In *Romanesque Sculpture*

of the Pilgrimage Roads Kingsley set himself an exhausting mission: to examine the sculpture of Romanesque churches along the great medieval pilgrimage ways that led to Santiago de Compostela, in Spain (the route flows like a straight river across northern Iberia, fed by tributaries that branch out into France, Italy, and northern Europe). He and Lucy took photographs in northern Italy and Spain and throughout France; then, using comparative analysis, he determined his thesis. Kingsley rejected the idea of national schools of medieval art, suggesting instead that Romanesque forms and iconographies, like the *chansons de gestes*, had grown up along the roads, flowing freely across linguistic and political boundaries. The French art historian Émile Mâle also postulated that there was an 'Art of the Road'. Mâle, however, believed that the Romanesque flowered first in Toulouse and spread from there to Spain. Kingsley countered with the notion that pilgrims and masons carried the new art in both directions, though he thought it might have originated on the Iberian Peninsula. His nine volumes of photographs – totalling 21 pounds on their own, 23 with the volume of text – were the ammunition in his battle (most art historians today have left the battlefield, preferring instead to study Romanesque form rather than date it).

Kingsley amassed six volumes of principally French photographs; one of Italian; and two of Spanish. I chose to concentrate on 'The Aquitaine', which includes not only the area around Bordeaux, but almost all of southwest France from the Mediterranean to the Atlantic, stretching as far north as the lower Limousin. I picked this volume for two practical reasons. One, I can get by in French, but speak not a word of Spanish or Italian; and two, as opposed to other volumes, which are liberally sprinkled with photographs taken by the Porters' assistants or purchased from photographic services, almost all of the plates in 'The Aquitaine' were shot by either Lucy or Kingsley. Pride betrays this last fact, as each of the 1,527 plates in all nine volumes is attributed to the photographer who made it. The image of the shepherd children is labelled 'A.K.P. phot.', and the Espalion pictures

'L.W.P. phot.' – a rare practice in a scholarly text, but a fair clue as to how much both Porters valued their work.

There was a third, personal, reason I chose Volume IV as my map to Romanesque France. Nestling within the central portion of its geography, in the corrugated landscape of Quercy and the Rouergue, lie three of the churches I have wanted to see since I was an under-graduate: the great abbeys of St Pierre in Moissac, Ste Foy in Conques, and Ste Marie in Souillac. This litany of names, for me, summoned up the accessible majesty of Romanesque sculpture that, for some intuitive reason, had offered a steady source of serene con-tentment ever since I'd first heard of them twenty years earlier.

Before I could march off to France, however, I needed a copy of the book. A little hunting turned up three editions: the original of 1923, in 10 volumes and limited to 500 copies, and two later editions of 1966 and 1985, both compressed into three volumes. I descended into the art storage lair of Smith College and looked at all three. The plates in the 1923 books – many of which were missing, having been removed by Smith undergraduates over the years – were bathed in tones of grey, both luminous and grainy, like the pocked surface of a full moon. When the librarian brought out the newer editions I literally rubbed my eyes, thinking my contacts had clouded over. The beautiful plates were blurred and hazy, as if they'd been wound in plastic wrap. I later discovered that the reproductions had not only been taken from prints, rather than the original negatives, they had also been shot *through* slips of tissue paper that protected the plates.

I bought an original Volume IV and a plane ticket to France, and made up in metaphor what I lost in convenience. So much for obscur-ing the past.

3

STONES

Go inside a stone
That would be my way . . .
I have seen sparks fly out
When two stones are rubbed,
So perhaps it is not dark inside after all;
Perhaps there is a moon shining
From somewhere, as though behind a hill –
Just enough light to make out
The strange writings, the star-charts
On the inner walls.

'Stone', Charles Simic

I was lost and trapped behind a truck. Not just any truck, an *Auto École* truck – a big, lumbering learner's vehicle that inched along and came to a painstakingly diligent stop at each intersection. Instead of overtaking it and risking a fiery death, I decided to hang back and try to get a bearing on where I might be.

It was late afternoon and the sun flared in my windscreen. This seemed impossible: according to my map I'd been heading east. But prolonged squinting proved I was driving west, and the map was old. So I pulled over, irked at lost time but thankful to be rid of the truck, swung the car around, and headed the other way, in the direction of the Rouergue – one of the few places in France, wrote Fernand Braudel, not yet entirely transformed by the modern world.

Quickly the ravishing but mild, carefully tended farmland of north-east Quercy, where the region meets the Dordogne, became a pleasant memory. As I drove east the vegetable colours faded and the soil grew pinker. Towns and farms became scarce and the wavy earth fell almost flat, like a sea with long, rolling swells from a distant storm. Only here the swells were covered in pale moors or forests of stumpy scrub-oak: low trees with thick, gnarly branches whiskered in lichen that made them an alternately venerable or menacing presence, depending on whether they were in sun or shadow.

I did not know it at the time, but later discovered that I was crossing the Causse de Gramat, one of Quercy's 'Petits Causses', so named to differentiate them from the Grands Causses farther to the east. Despite the aged look of the trees they gradually came to seem newborn, a kind of piny stubble, once it became clear that the land was assaulting me with a dose of deep, geological time. Exposed bedrock was everywhere; the *causse* crawled with it, and the roadside shoulders were bleached white with its dust. Outcrops shared the moors with occasional sheep and goats. Dry-stone walls, thickly over-grown with moss and lichen, wine-tipped with tiny flowers, textured either side of the smooth macadam like mountains on a topographical map. The road itself was relatively new and its construction had left gashes in the earth that hadn't yet scarred over in the weathered grey of the walls.

Out of these roadcuts tumbled the colours of crustacea, coral, and seashells: white and light grey, cream, tan, pink, and peach. The whitish stone had been tinted by iron oxide, but the marine allusion was on the mark. These were the same colours I would find in the cool interiors of Romanesque churches. This was the same smell I would smell there: a salt-and-chalk scent I remembered from child-hood, from holding conch shells to my nose and taking a great sniff. It was the smell, I'd learn, of Conques Abbey. In that sanctuary and others I'd remember the Causse de Gramat and feel the tug of an ancestral memory-tide ebbing back to ancient seas. For that rock and

this – everything within eyeshot, all of the stone tumbling from the roadcuts – was limestone.

Limestone is essentially calcium carbonate – it's called *calcaire* in French – brought into being by the joint agencies of weight, time, and the sea. As sedimentary rock, limestone is made up from layer upon layer of compressed sea-bottom graveyards, rich with lime secreted from the dead things that collect there: algae, coral, the shells of marine invertebrates, the drowned. As building stone it's wonderfully abundant, and for humid regions like Europe there has never been a material more receptive to man's need for shelter, or his drive to express his imagination. The earth gives it up with relative ease and, unlike marble, limestone blocks hold firm against one another – marble skids – which is why Romanesque arches and Gothic vaults literally got off the ground. Most limestone is also mercifully soft and easy to carve (only soapstone and alabaster are easier, but they're too delicate to be practical building materials). Although its rogue fossils occasionally deflect a chisel, it takes and keeps any detail a stonecarver's imagination wishes upon it.

Like all sedimentary rock, limestone is a process as much as a substance. At the earliest stage it's just latent ooze, still in the midst of precipitating out of seawater and collecting in beds on the ocean floor. There is limestone-to-be forming right this minute. The hard, chalky rock of the Causse de Gramat was at this stage during the Jurassic Period, the middle phase of the Mesozoic Era, which lasted from between 208 to 145 million years ago. At that time the *causses* formed the seabeds of shallow, prehistoric oceans: it was here that M. Vaylet's plesiosaurus would have swum.

The Mesozoic was a 185-million-year bull market for the species then occupying the globe, especially the reptiles, whose evolutionary stock proliferated as their bodies swelled to stupendous size. The dinosaurs developed during the Jurassic, which was named for tremendous outcrops of limestone in the Jura Mountains, in Switzerland. The Jurassic has been called 'the noblest of geological time'.

Life was good then. The dinosaurs enjoyed the kind of environment we see today only on expensive vacations. Large, warm seas were hiked into shallows by chains of coral reefs. There were underwater gardens of sea lilies and acres of oyster beds. Dunes and shell banks piled the shores. The dinosaurs came of age in this period and then had their time in the sun all throughout the Cretaceous, as geologists call the following 80 million years. It was during this last period that a massive volcano erupted in what is known now as Espalion, about thirty miles to the east, covering its flanks in lava that, as it cooled and hardened, became the basalt mound Lucy Porter noted in her journal.

About 65 million years ago the dinosaurs vanished abruptly and the Mesozoic seas began to dry up, bringing the era to a close. As they evaporated they left behind limestone outcrops, where masons quarried only a thousand years ago for stone with which to build and sculpt Romanesque churches. Not quite a hundred years ago the Porters drove across these limestone plateaux in their 1920 Fiat, in search of the masons' handiwork; today I was doing the same in my rented Renault. Had any of us been a few million years earlier, we would have needed a boat.

As I approached the crossroads village of Livernon – that is all it was, literally, a crossroads – I came upon a pile of bones left over from this fathomless, geological past: an acre, maybe, of loose, palm-sized rocks, pure white, for all the world like an archetypal joke, a caveman's trash heap in a cartoon. I slammed on the brakes and got out and took one as a souvenir. It smelled of both seashells and sanctity; it smelled of church. There was latent sculpture underfoot, sanctuaries, farmhouses, walls, and villas. This was where Romanesque sculpture had come from and what had made it possible in the first place – this landscape, this stone, this history that so dwarfed my imagination. Samuel Taylor Coleridge, climbing a mountain in Germany, once defined the sublime by saying that it resided in a suspension of the powers of comparison. On that afternoon the *causse*

achieved sublimity, as geological time struck my associative memory stone cold mute.

So I retracted back into the sphere of my kind, projecting human aspirations on the obliging rock. So much potential all around, and what did I find but the simplest, perhaps the first, stone structure of all: a dolmen, the evolutionary ancestor of all European building.

Just outside Livernon I saw a sign for the Dolmen de la Pierre-Martine. For the same reason that Quercy and the Rouergue boast an abundance of old churches they also, not surprisingly, have the market cornered on Stone-Age structures. There is a greater concentration of dolmens, or cromlechs as they're also known, in this part of southern France than anywhere else in Europe. Quercy has eight hundred dolmens on record; the Rouergue has a thousand, most of them about 4,500 to 3,500 years old. The pursuit of this particular one led me down a farm track of such beauty that my throat ached. The grey, dry-stone walls had fallen into lavender shadow, behind which branches of scrub oak, roughly interlaced, made shard-patterns of the sky. Bells sounded as ponies bent down to graze.

The dolmen wasn't much to look at; two of its supporting slabs had been reinforced with concrete to render its massive capstone perfectly flat. A dog's leash lay on top, domesticating the tomb by association. It looked more like a picnic table than the skeleton of a prehistoric gravesite once filled with human bones (the horizontal and vertical megaliths originally would have been covered with earth, forming a tumulus). I taped my bit of limestone on it and tried to recall when I'd first begun to think about stone. My name, Petro, means 'stone' in Greek, and my father has collected gems and minerals since I was a child. But it was only when I was about forty that I began to suspect that my lithic adventures in life – dolmen hunting in a beat-up Renault in Portugal, toting dinosaur footprints to school as a child, a yen to build dry-stone walls – might add up to more than casual appreciation.

Shortly after my fortieth birthday I'd found myself crouching in a

cave in Tuscany, inspecting an Etruscan relief carving of a faceless woman, her legs impossibly splayed outward like wings. A leaflet told me that she was a 'mermaid with two tails'. I recognized her as a fertility goddess. I touched her shin, entranced. The other visitors wandered off, but an elderly Italian guide lingered behind. 'You love this,' he said in halting English, taking my hand and pressing it against the stone.

Over the next months it occurred to me that he was right. I didn't just love Romanesque sculpture, I loved stone itself. Dogs may be our best friends, but stone is our most steadfast companion. It accepts whatever we find significant – our scratchings and carvings, our borings and borrowings – and remembers them far longer than we do until, like this dolmen, they become secrets. I trusted the mute companionship of stones, their testament to ancient lives and even older weather, and, especially, their humbling perspective. Compared to us, stones are immortal.

The only hotel in Livernon, a shifty-looking place, was closed, so I drove on to the much larger town of Figeac, not far from the Rouergue border. Venerable, mottled sycamore trees and neon advertisements lined streets crammed with rush-hour traffic. I could see a string of old hotels with lovely terraces on the far embankment overlooking the River Lot. In the forty-five minutes it took to travel three blocks to a bridge and cross the river, not a single parking space was left to be had. I bolted out of town in desperation, as fast as the Friday evening crush would permit, and fled south.

The ample croplands of the Lot Valley didn't last long. Soon I was climbing, switch-backing up atop a high ridge, which gave onto the open, scrubby moors of the Causse de Limogne, another limestone plateau just south of that of Gramat. I bellowed out of the car window into the greying emptiness, noisy with relief. It was refreshing to find feral lands in France, where the trees aren't pruned or planted in neat rows – an antidote to Gallic cultivation, in every sense of the word.

The next town I came to was called Cajarc, an old market village around an open square, which had been strung with coloured lights. I found a parking space in front of a café that also proved to be a hotel; inside, the owner-chef and his family were eating dinner before customers arrived. His wife jumped up when I walked in, letting the ladle she'd been gripping fall with a plop, handle first, into a big white tureen. There was a long moment in which no one seemed to move, or breathe, the air still as art. In the time it took to swallow, the impression vanished. The woman retrieved her spoon with a good-natured shrug, wiped the soup off her hand, and showed me to a room at the back.

A stairway led to seven second-storey rooms opening off an exterior corridor. She presented one and left me with a key, and I went back to the car to retrieve my suitcase. When I returned I'd forgotten which of the identical, numberless doors was mine. The fourth one, I thought, so I tried the key; it fitted, and I walked in. I had a moment's deep dread – the rucksack I'd left was gone – before I decided, calmly, that this was simply the wrong room. I tried the fifth door, which also opened to my key but which was also empty; then the sixth, with the same result. With growing concern of several kinds I marched back to the third door, certain my key would work, and threw it open: inside a startled man in a wide-brimmed hat was placing a large bamboo staff against the wall. A different rucksack entirely, bound with a large scallop shell attached to a cord, sat on the bed. I apologized in embarrassment-addled French, and tried the second door, certain it couldn't possibly be mine. It was.

* * *

All night long – a fluorescent light had glared directly outside the frosted glass door to my room, preventing measurable sleep – I amused myself with game-show scenarios presented by my skeleton key. Behind door number one lay this! Behind door number two lay that! Behind door number three stood – a pilgrim!

We met again at breakfast. '*Bonjour, Madame,*' he greeted me. '*Je suis un pèlerin.*' So you are, I thought.

He'd been driven to conversation with me because the locals – a fearsome pack of middle-aged men drinking strong coffee and beer at the bar, grunting to one another from their gullets – had confiscated the newspaper he had been reading while he'd gone to pick up his staff, which had fallen with a clatter. In between bites of local peach jam spread on a baguette, he told me he was walking the entire pilgrimage route to Santiago de Compostela. My eyes widened in honour. 'In pieces, Madame,' he specified. 'I shall get no medal for speed. Last fall I walked from Le Puy en Velay to Conques in ten days. Now, this spring, I am walking from Conques to Moissac. I give my feet a rest in summer and winter. There are whole peach-halves in this *confiture*,' he concluded, fishing one out of the pot with a spoon.

I wished him well. I had guessed he was a pilgrim on account of his outfit – a wide-brimmed hat and staff have been pilgrimage accoutrements since the Middle Ages – and because Cajarc lies on one of the branches of the great pilgrimage way. There are four principal routes of spiritual drainage across France, all of which converge in the Pyrenees. One route begins in Paris and travels through Tours and Bordeaux; another starts at Vézelay in Burgundy – home of my Pig-Snouted Ethiopians – and continues through Limoges and Périgueux; a third takes the southernmost route, starting in Arles and winding through Montpellier and Toulouse; and the last one, called the Via Podiensis, sets out where my friend began, at Le Puy en Velay in the Massif Central, and passes through Espalion, Conques, Figeac, Cajarc, Cahors and Moissac. The Via Podiensis is also known as the GR 65, 'GR' standing for *Grande Randonnée,* one of France's meticulously well-marked, long-distance hiking paths, a map of which the Cajarc pilgrim had spread on his breakfast table in lieu of the missing newspaper.

So many well-trodden routes converging on one place suggest a

very great destination at the end, and so Compostela was, and is yet. The allure began when the Apostle James, or in Spanish, Santiago, appeared to Charlemagne in a dream in which he revealed the location of his body, inconveniently buried in infidel-occupied Spain. Charlemagne tried to beat back the Moors, but failed; after Galicia was freed nearly two centuries later, pilgrims began flocking to James's tomb in Compostela. There were other pilgrimage options for medieval travellers as well, Jerusalem being the holiest, but also the farthest; Rome was next in line of importance, with the bodies of two saints, Peter and Paul; after that, Compostela was the only other site in Europe to boast an entire Apostle (other churches had bits and pieces in reliquaries, but they didn't match the glamour of an intact corpse whose owner had actually walked with Christ).

The Compostela pilgrimage was enthusiastically promoted by French abbots, who welcomed the revenue and prestige brought by masses of pilgrims travelling through French territory, not to mention the opportunity to shift attention from Rome. Its popularity also drew upon proto-tourist attractions along the route: the new Romanesque churches going up in southern France, with their beautiful, terrifying, bizarre sculpture – some abbeys also had powerful relics of their own – and the battlefield of Roncevalles in the Pyrenees, where Charlemagne's nephew, the folk-hero Roland, had died in battle. By the 1130s the pilgrimage was established enough to have its own 'guidebook', which offered opinionated advice on just about everything.

'The Navarese bark like dogs', complained the anonymous, Francophile author. Kingsley Porter wrote that from *The Pilgrim's Guide*, which is actually a portion of a manuscript called the Callistine Codex, 'We learn the characteristics of various nations – which peoples were kindly, which treacherous, which dirty; where the wine was good, and where the food was bad; where rivers could be forded; and where inns or hospices afforded shelter for the night.'

For most Western Europeans the pilgrimage took a year to undertake. Set out at the end of winter, travel in spring, arrive in summer,

retrace your steps in autumn, return with the first snow. If, of course, you returned at all (if you didn't show up within one year, the compulsory will made out for you by your parish priest was promptly acted upon). The pilgrimage was attractive to all social classes – rich people eventually paid others to walk for them – but for the most part Compostela pilgrims were poor peasants and serfs, usually elderly and therefore expendable to their lords. These people walked an average of fifteen miles a day, often in hopes of curing pre-existing ailments. They were endemically cheated by toll-takers and money-changers, beset by bandits, and at the mercy of river ferrymen who sometimes purposely sank boats in order to loot their drowned customers. They suffered from heat stroke on unshaded Spanish roads (French roads were purposely lined with trees on one side, to provide comfort). And they were trapped in late spring blizzards crossing the Pyrenees – an event I knew a thing or two about, having crept in my car from France to Andorra through the Pas de la Casa in April. The two-lane road had writhed in an agony of curves as snow slicked the surface and low clouds clamped visibility down to about ten feet. It was perhaps more treacherous in a car than on foot – accidents littered the shoulders – but unlike foot-travellers, at least I could turn up the heat.

Despite the litany of hazards, pilgrims went to Compostela. They went in droves, ushering in a boom in the medieval shoemaker's trade, their only protection a deterrent that sprang from the same fountainhead as their own incentive: fear of eternal damnation. It was a grievous sin to harm one of St James's faithful, who were identified by costume and an insignia – the scallop shell – which has been the symbol of the Compostela pilgrimage since the eleventh century.

The pilgrimage to Santiago, to the home of St James, was above all an expression of optimism. In a world that recognized no causality other than God's or the Devil's constant meddling – illness was the work of the latter, good luck of the former – one's future in both

life and death depended on the beneficence of otherworldly forces. St James had the power to intercede on a supplicant's behalf, especially that of a pilgrim who had given a year of his life and crossed the better part of a continent to honour the saint in his resting place. James was powerful; he had been Christ's disciple; he was a reminder that all was not lost. Through his bones shone a chink of light within the theological shadow of near-certain damnation. The pilgrimage ultimately attested to the tenacity of human hope.

The path of the GR 65 ruts the emotional landscape of the Rouergue and Quercy. It's not on my Michelin map, but the *chemin* falls like a latitude line across people's lives. It has been a constant for over a thousand years, and thus a directional anchor. 'Oh, you're looking for the dolmen? Go to the pilgrimage road, and turn left.' Or, 'You can buy tweezers in the Pharmacie de l'Europe. It's the one near the bridge, on the Road.'

The Chemin de St Jacques is also an attitude line; it is impossible not to perceive its presence – the westbound direction laden with spiritual urgency, the eastbound with equal measures of relief and disappointment – as a yardstick for one's own journeys. Everyone who travels in the territory must at some point wonder how a pilgrimage differs from a mere journey. Must one be travelling on the soul's business, to address God, or can a pilgrimage be more prosaic? Does spiritual business necessarily involve God?

I was rather unproductively pondering these questions as I approached the village of Conques, in the Rouergue; specifically, I had been mulling over the idea of an incomplete pilgrimage, which is how I fancied my travels. I was setting out to visit Romanesque sites on a branch of the pilgrimage road in southwest France, but defying the historical and spiritual tug of its destination, in Spain. Few roads lead nowhere, and this one had one of the most famous endpoints in European history. Even the stars of the Rouergat sky formed directional arrows, reproaching me for my stillness (it is said that the Milky

Way leads to Compostela, the 'Starry Field' in the west). What did it mean to be more concerned with a segment of the *chemin* than its conclusion? A wilful choice of body over soul?

* * *

I put my hand to the south door of the abbey and it drew me in more than opened to applied pressure. I lost my balance and stumbled inside, into the bear hug of a large priest who was on his way out into the night. His white cassock glowed against the black space beyond. We both spoke in wine-scented whispers. Yes, I was welcome to come in, the abbey was open. But *attention!* The paving stones were uneven.

I stepped inside: the great building was dissolving into echoes of darkness. At first greys, masonry greys, hovered at eye level. As they rose upwards they grew less substantial, optical memories more than illuminated stones, until the visual echoes faded entirely and the majestic barrel vault of Conques Abbey ceased to be, and for me, not knowing if the stars were out yet or not, became heaven itself. Soon the foundations of the massive pillars and the exterior walls disappeared too. I was inside an idea of a Romanesque church, nothing more concrete than that, but that idea was strong, and it was enough. I felt the muscle of architecture flex around me, repeating in pleats of rounded arches down the side aisles – and there was a quiet undertone of pleading in that repetition, too – the twelfth-century message of God's tough love.

I sat down on one of the curiously tiny, rush-back chairs that filled the nave. The night-time had brought singularity back to the abbey. I could smell the church far better than I could see it – it smelled like the rock in my pocket, only damper – and that limy scent defined its space as unique, something different from the green smell of spring drifting on the night-mists outside. By contrast, daylight had revealed not only Conques Abbey itself, but its endless repetition throughout the village. Despite being a 'Grand Site de France' – advertised as

such by banners on nearby *auto-routes* – Conques village has remained wondrously small and self-contained, coiled into deep, wooded countryside halfway down the steep declivity that separates the Causse de Comtal from the Dourdou Valley. There is not a modern bone in the village's medieval body, and yet one of the first things that struck me upon leaving my car and walking into town was wave upon wave of photographic reproduction. I've rarely seen such a plural place.

So many images of a single spot! Granted the almost shocking magnetism of the abbey – imagine Big Ben, or the Empire State Building, surrounded by a rural hamlet – and yet still the proliferation of postcards overwhelms. There are old ones, new ones, black-and-white and in colour; postcards in matte finish, shiny finish, printed on textured paper. Postcards of parts of the abbey that are off-limits to visitors, like the one I'd bought of a mermaid clasping her forked tail in each hand, carved onto a capital in the upper gallery. To purchase for 35 centimes an image never intended to be seen from the ground seemed, somehow, a violation of the abbey's privacy. But then photography heedlessly violates the privacy of time past as well as space delimited, for I had approached the great western façade of Conques, surrounded by its little apron of a cobbled *place*, with a fixed, black-and-white moment from the morning of 18 August 1920 clasped in my hand.

Unlike Lucy's, my moment – afternoon, 20 April 2002 – came with distracting colour and sound. An announcer commented on a women's gymnastics championship on a television set in the Salon de Thé opposite the abbey. 'I am just ringing to say I am standing in front of the church,' repeated a blond woman, loudly and carefully, into her mobile. Beside her an Irish setter was hopelessly knotted up in her leash in a patch of shade. Above us all rose the massive, no-nonsense towers of the abbey, braided 'round above and below by the shimmering roofs of the village' (Conques is so steep that windows of two-storey houses one block from the church overlook its nave). Hannah Green, in her memoir *Little Saint*, likened the roofs to

dragonfly wings. The standard comparison is fish scales. The traditional Rouergat *lauzes*, thin, round roof-tiles, here cut from silvery schist and overlapped very much like gills – reminded me of braided leather, arresting my eye again and again with intricate fugues of texture.

I thought of Lucy and Kingsley in Vézelay in 1919, the summer before they had visited Conques. They had fallen in love with the village that clustered around the great Burgundian abbey just as I was becoming smitten with Conques. Lucy had written in her journal that their travelling companion, Bernard Berenson, had fallen asleep in the car on the way back to Paris, and she and Kingsley had been free to fantasize. They'd decided that if their taxes kept going up at home they would return to Vézelay to live in one of the little houses that framed the abbey, and have a garden in front and a view at the back.

I smiled at the familiar daydream, and began to commence on one of my own. But there was the setter to untangle, and a photo to be taken of three Brazilians from Belo Horizonte. After that, my moment in Conques merged with Lucy's, and I forgot everything but the great, scarcely weathered tympanum before me, to which traces of coloured paint still cling. A Conquois friend of Hannah Green's called the tympanum 'one of the four wonders of the world' (she neglected to name the other three). Just a glance reveals its importance. The early twelfth-century abbey is predominantly built of buttery yellow limestone (salted butter, to be exact; the interior is the paler shade of whipped sweet butter), with rosy mortar and mottled grey schist in-fill. The tympanum, however, and the *pierres de tailles* – the fitted stones – of the surrounding portal are pure, creamy, ochre-coloured sandstone. The very best stuff the quarry had to offer.

The eye notes this and marks it; only when you move in closer do you realize that the golden stones were set there as a lure, to lead you to one of the most magnificent spectacles of Romanesque art. And it *is* a spectacle, like a parade or a circus, with a multitude of

incidents, intimate and grand, frightening and beatific, some grimly
funny, mushrooming throughout every inch of the sculpted half-
moon. The theme is the Last Judgement. At the church of Perse in
Espalion the great reckoning was compactly and clumsily depicted in
shorthand – just a reference to ignite whatever associations already
existed in the viewer's mind. Here the theme has become art, supplying
visual images of its own, supplanting others. Imagine that a director
of greatness, of real vision and inspiration, working with a troupe of
earnest amateurs, has set out to perform skits from the Second
Coming of Christ – not to convey the *idea* of judgement, but to
narrate it. The result is the tympanum of Conques.

Back at university my professor had thought that the little sculpted
actors, the saints and the saved, the devils and damned, had a 'folk-art
quality'; my guidebook found them 'endearingly anecdotal'. What I
think they both meant is that the carvings are not types, representing
ideas, but individuals acting out very particular rewards and punish-
ments. This is an impolitic thing to say, but then travel books permit
the occasional lapse into sentimentality: they are heart-achingly sweet.
Even the devils look like nice guys in masks, trying to be mean. An
abbot takes the hand of Charlemagne, depicted as an old, stooped,
shuffling king, and kindly leads him into heaven. And it was a com-
passionate heart that imagined the justice of the damned – nowhere
else but the tympanum of Conques would a rabbit be given the oppor-
tunity to roast the man who had hunted him, on a spit, eternally,
in Hell.

Ste Foy, to whom Conques Abbey is dedicated, kneels under a
miniature eave on the left-hand side of the composition, blessed quite
literally by the hand of God. Foy, the 'little saint' of Hannah Green's
book, was beaten, broiled, and decapitated at the age of twelve, in
the year 303, for refusing to pay lip service to the Roman pantheon.
She was canonized a century later. Her remains lay at Agen, near
Toulouse, for over four hundred years, until she was either stolen,
lent, or borrowed (the facts are unclear) and brought to Conques,

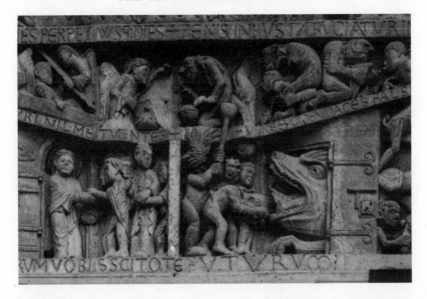

where a piece of her skull was set into a portable reliquary statue around the year 900. Foy had already been working miracles, but she seemed to like the reliquary, with its golden face – probably originally that of a Celtic god – and feverishly granted prayers as fast as they came in, rendering the abbey not only a stop on the Via Podiensis, but a pilgrimage destination in itself.

Of all the incidents on the busy tympanum, Lucy typically found and focused on the moment of greatest tension. It is a tension her black-and-white photograph enhances, making the weary graininess of the thousand-year-old carvings into a kind of elemental cognate to the fraught scene (more appropriate to its mood than the cosy sunlight that pampered the stone when I saw it). On the lowest tier of the tympanum, right in the centre, just beneath an angel and devil tensely weighing souls, is a divide; on one side angels lead little souls into what looks like a coat closet, but is actually the door of heaven. On the other, devils cast the damned into the mouth of hell – here depicted as a kind of toothy fish – which emerges from another, grimmer, door. The angel and devil closest to the centre glare at each other across

the gulf that separates good and evil. The devil, with sumo-wrestler proportions, punk-spiked hair, and an enormous bludgeon, is the only character on the tympanum blatantly to overwhelm his allotted niche. The others, encased in their cartoon-strip boxes, tell *their* stories; this devil, however, poses an active threat, as if at any moment he may free himself from the stone and add *your* story to his.

The angel at whom he stares grabs a little soul by the hand and pulls him out of no-man's-land – the grey area between good and evil, from which we only see him partially emerging – it's that close a save – before the devil can get his claws on him. The angel's eyes hold a dare: just try it, he says to the bludgeon-wielding devil. And yet he hurries the little soul onward toward heaven, just to be safe.

This is it, Romanesque art at its most anxiously appealing. This moment is acted on what Hannah Green calls 'the rim of time'. The everlasting is about to begin; mortality is about to end. Yet it is a quintessentially human moment, full of fear of the awful arbitrariness of fate. Far from ceasing to be, time plays a role – the angel snatched that soul from the void just in the nick of it – and so does luck.

Most art makes a statement. Romanesque sculpture poses a question: will we be saved? The only answer it musters is a shrug. Maybe. Probably not. There is uncertainty and death, hard work and hunger in this life, and judgement in the next. No wonder its quiet, secular moments, the corbels of clasping couples, fiddlers, dancers, and domestic beasts, all found their places on religious buildings. Each is a touching bid to secure a chip of immortality – the cheap kind found in stone – for the otherwise brief pleasures of life. Despite its fixation with the everlasting, the Romanesque point of view ultimately hails from the conundrum of the human condition. This is one of the reasons I love it so much: it dares to reveal not the nobility, but the vulnerability of life in the face of death.

Lights came on without warning, like a shock of lightning. I had slipped into an over-fed daze sitting in the stony darkness of the nave.

Before entering the abbey I'd found a very pink garret room in the Auberge St Jacques, just steps away, and had eaten dinner there too in the over-lit dining room. The young waiter had inquired if I wanted a *salade aux gésiers.* I'd asked what it was.

'*Une salade avec pommes et poulet, Madame,*' is what I heard.

A salad *avec pommes* de *poulets* is what came. Not a salad with apples and chicken at all, but a salad with apples *of* the chicken – fried gizzards, in other words. Ah, I'd thought, undone by a crafty French preposition. Not the first time, nor the last. What I'd actually ordered was a *Salade Caussenarde,* a speciality of the region, made up of mixed greens, local walnuts, and either crumbled feta or Roquefort cheese. Mine came with Roquefort – an appropriate choice, considering the caves where the cheese is aged used to belong to the monks of Conques. I willed myself to forget what I was eating. After the duck, crusty crème brulée, and half-bottle of Gaillac that followed, and then the soft abbey darkness, I had almost fallen asleep. But the abrupt lights in the upper gallery banished any easygoing rapprochement between wakefulness and sleep, night and day, light and dark. My grey-black heaven was gone, replaced by definitive black shadows cutting at odd angles across brilliantly revivified white stone: a sight unbeheld for more than nine hundred of Conques' thousand years, until the twentieth century wired the abbey for electricity.

An organist had come to practise for tomorrow's mass. Far above me he struck the keys and vibrations filled every cavity, the barrel vault and my chest alike, making heavy, solemn music inside my body and out. I was thankful the nave itself was still fairly dark, and the side aisles, too. They beckoned me away from the electric intrusion like conduits to an alternate state of mind, much as the road outside my window had at night, when I was a child. A nearby streetlight had thrown leaf patterns into a small puddle of illumination, casting the road beyond into even greater darkness. I knew where it led – down to Grove Avenue, my school, the football field – but I would pretend it could take me anywhere.

Surely the drive to *go*, to be surprised, to leave the unrelenting known for whatever lay beyond, has always lurked somewhere beneath the pilgrim's piety. In his book on pilgrimage, Peter Sumption suggests that upon taking to the road the pilgrim left behind the chief quality of medieval life – 'monotonous regularity and the rule of overpowering conventions'. He cites a fifteenth-century writer who bluntly identified the wanderlust factor: a pilgrim's principal motivation, he wrote, was 'curiosity to see new places and experience new things, an impatience of the servant with his master, of children with their parents, or wives with their husbands'.

Not surprisingly, Kingsley put his finger on the same chord. 'Into the psychology of the pilgrimage there must have entered love of wandering for its own sweet sake,' he wrote in *Romanesque Sculpture of the Pilgrimage Roads*. 'The same restlessness that creates the modern tourist spurred on the men of the Middle Ages to roam.'

'For its own sweet sake'. Again and again, Lucy notes in her journal their arrival at a hotel and her keen desire to bathe and nap, while Kingsley goes 'out to investigate the village', or 'takes a walk', or 'visits the church'. The man was perpetually restless. During the early stages of their courtship it nearly killed him to spend the summer of 1911 at home reading Rabelais (counting the pages was 'an indication, doubtless, that I am not properly enjoying it'), while Lucy travelled on the West Coast. He made a show of being enthusiastic about her adventures, but envy got the better of him. 'One day I was dragged out yachting, which fairly made my hair curl with excitement.' In another letter he was 'stale from lack of travel'. When Lucy wrote of her climb up Mount Hood, in Oregon, he replied: 'I thoroughly envy you the experience. I hate hard climbs while I am doing them – always get as scared as a kitten and never fail to vow to myself that if I get down safely I shall never no never try a mountain again – and yet one always does.' By the time he finished writing, his blood was 'on fire' to climb anything.

Janice Mann, who wrote comparatively of Kingsley and Émile

Mâle, believed Kingsley's wanderlust to be typical of his nationality and generation. 'For Porter,' she wrote, 'the process of art history was one of travel – physical and figurative – to the frontier. His sense of art historical accomplishment was satisfied by moving from familiar areas of the discipline into the unknown, just as progress in the European settlement of America involved moving repeatedly from civilisation into the wilderness. He was drawn to the open road both literally and metaphorically.'

It was true: as more scholars moved into the study of Romanesque art in the late 1920s, Kingsley shifted his focus to Ireland, where he and Lucy acquired a castle in Donegal as a base for his pioneering work on early Christian crosses. But even more intriguing than his need to roam was the nature of the unknown that Kingsley sought. For him, as well as for other American writers from Henry Adams to Henry James, the 'wilderness' of which Mann speaks was nothing other than the European past: a wilderness in time rather than place. In Kingsley's case, he was not travelling to discover a new, empirical reality – a continent that could be sampled, measured, drawn, and detailed – but rather overlooked evidence that would substantiate a dream of the Middle Ages that he already held in his head. Like Conques Abbey in darkness, invisible but present, Kingsley imagined a world that could be sensed but no longer be seen, built upon remnants and old stone foundations that he and Lucy sought by day, of a society he valued far more than his own. Like me, he was a romantic, rebuilding the ruined eternity of the Romanesque in his mind, spellbound by his own reinventions.

His friends, notably the Irish poet George Russell, known by his epithet 'Æ', teased him about his disregard for modern life. Imagining Kingsley's horror of air travel, Russell wrote with delight, 'I suppose that would be an adhesion to the mechanical age which would seem to you almost as bad as Bolshevism. I fancy you sigh for travels with a donkey like Stevenson's.' He goes on to muse upon Lucy's feelings for donkeys, then adds in clear-headed fashion, 'I am

sure with all your yearning for a simpler age without mechanics you could not endure it. You really ought to thank Heaven that you being born in a comfortable age can investigate uncomfortable ages without their dirt, smells, bad cooking, lack of sanitation, etc.'

Russell hit a nerve; Mann, too, feels that Kingsley regarded the medieval world as an insular, golden time in painful contrast to the whirring gears of an increasingly mass produced, mechanized America. It was this yearning of his, more than anything else, that provided a private, portable milieu within which he carried on his work as a scholar, and which suggests that the Porters' travels amounted to a kind of pilgrimage in their own right – a pilgrimage back in time to satisfy a need of the imagination. An archaeologist's search for relics upon which to build an imagined, better place is perhaps not so very different from a medieval pilgrim's prayer to Ste Foy, or St James, to one day be admitted to the collective dream of heaven. That Kingsley linked his own road with the great pilgrimage route to Compostela is apparent, more than anywhere else, in the rapture of his prose. Of the Chemin de St Jacques he wrote:

> One feels, as nowhere else, wrapped about by the beauty of the Middle Age. One is, as perhaps never before, emotionally and intellectually stimulated. Shards of the memory, long unused, are set vibrating. The actuality of the pilgrimage, like a cosmic phenomenon, overwhelms with the sense of its force, its inevitability. It seduces one, irresistibly . . .

Neither Lucy nor Kingsley was particularly religious; the endemic Protestantism of their youths seems to have manifested itself as a horror of idleness rather than a spirituality-driven habit of traditional churchgoing. Ironically, for a Luddite like Kingsley, it was their very American reliance on mechanical innovation – not just the Fiat, but the camera, especially – that most set their own journey apart from the spirit of the medieval pilgrimage in which he had so longed to invest himself.

The linchpin of pilgrimage, or relic-worship in general, is that the

sacred item, be it a saint's finger, whole carcass, or lock of holy hair, not only heals and answers prayers; it also confers sacredness on its environment. As William Melczer writes in his introduction to *The Pilgrim's Guide*, 'Pilgrim and relic are two sides of the same coin. The one is conditioned by the other. The essential mobility of the pilgrimage is a function of the essential immobility of the relic.' Compostela, Conques, and all the other destinations of sacred medieval travel were mountains that would never, ever go to Muhammad.

 Yet Lucy's three-legged view camera broke the bond between place and pilgrimage. Her photographs rendered the hallowed stone fortresses to which penitents had trudged in a westward direction for almost a millennium as light and slim and portable as the paper on which their images were printed. Relics – or rather their encircling architecture – were no longer essentially immobile. Photographs took a print of their souls and rendered them relational commodities, open to comparison and historical analysis, able to be scrambled and studied; they were no longer absolutes wedded to a particular plot of earth by the sacred weight of a pile of stones. The ebbing of faith, of course, is responsible for the erosion of belief in traditional pilgrimage, but photography released the process of it, the procession of it, from the steady, seasonal gravitation of its course even for nonbelievers. Lucy and Kingsley did the Chemin de St Jacques backwards, in a car.

The abbey's everlasting dampness had been inching through layers of skin, muscle, fat, and blood vessels until it finally reached the marrow of my bones, chilling me to my soul. I got up to leave and go to bed – the organ was still sending crashing breakers of Bach through my chest – and when I did, I noticed something unusual. The abbey's white windows had taken on colour. Conques' windows probably peeve traditionalists, but to me they are sublimely simple, pure and organic, a modern response to the craving for 'stained' glass. They were designed by the artist Pierre Soulages and installed

in 1993: opaque white panes broken by black trim. By day they define whiteness, rendering the pale limestone interior creamy-grey by comparison. By night they pick up, alternately, the blues and amethysts of twilight and the pinks and oranges of the sodium vapour lamps outside, staining the glass with the modern colours of night.

I was seeing these shades for the first time, and I smiled to myself to think how similar they were to those of the limestone rocks spilling from roadcuts on the Causse de Gramat. Outside in the dark *place*, I put my nose to the window of a rock shop just opposite the abbey. Samples of barite, pyrite, agate, and ammonite fossils, all from the Rouergue, gleamed in the dim light. I bent down to look at a piece of limestone carved in the shape of an animal – I couldn't see what kind – but the moonlight made the window a mirror, and instead all I saw was my own reflection. As I stood up a realization shot across the sleepy night sky of my mind. It wasn't quite the experience Kingsley had in front of the Coutances cathedral, but it startled me into wakefulness.

'I look up at the giant stones absorbing the summer sunlight into their age-old might and order, and I think of the massive size and grace of this Romanesque church – the *stones*, the *stones*, the skill that went into cutting these stones exactly to measure, each one . . . the work, the labor of transporting them such a distance across difficult terrain, the skill of the masons . . . who built with these stones, fitting them precisely, the strength required, the patience.'

Hannah Green's ode to the abbey's limestone rang in my ears. My pilgrimage, if it could be called that – and in this instant I thought perhaps it could – needn't be incomplete. I had been looking at the wrong end of things. My starting point was the Romanesque, and the Porters were showing it to me; but lingering in Quercy and the Rouergue, ignoring Compostela, did not mean I had to be stationary. Kingsley had pursued a pilgrimage that delved into time; why could I not pursue one that delved into place – this place, and the art and architecture to which its environment, its very geology, had given

rise? I would follow the sculpture I loved back to the quarries that had given it up a thousand years ago. Let others pursue questions of judgement and salvation; I would go backwards instead of forwards, plumb vertically rather than tread horizontally. It was indeed a body I was seeking: the body of the earth.

My heart pounded out the rightness of the idea. My square pillow, again found hidden in my room's armoire – log-style French pillows prop my head up too high – would have to wait. Following the newly risen moon I followed some stairs near the south transept down into what remained of the abbey's medieval refectory. A fountain splashed in the middle and columns salvaged from a former cloister made a dark gallery along one side of the square. In the strong moonlight it wasn't hard to find the capital I was seeking. In the very best lime-stone of all, pale grey, denser and harder even than the smooth, tawny sandstone of the tympanum, were carved eight tiny stonemasons, peering out over the wall of the cloister that they were in the process of building. It was as close as I'd ever come to a snapshot from the early twelfth century.

I loved it: self-made memorial and in-joke, all in one compact composition. The masons' wide faces had deep-bored eyes and seri-ous expressions; one was blowing a horn, the others gripped a variety of tools of their trade. In the moonlight, glimmering with a hint of sodium-vapour orange, they looked to have been carved from opal. I told them about my pilgrimage and promised I would be back.

* * *

'Quarries?' wrote my friend Annie. 'You are the oddest person. It's that stone thing again, isn't it?'

Annie Garthwaite, originally of Hartlepool, lately of Shropshire, met in Wales, had agreed to fly into Toulouse to join me for a long weekend's hike. I sprang the quarry idea on her at the last minute; she had thought we were doing the pilgrimage route, but said the itinerary really didn't matter as long as there was plenty of red wine

at the end. I picked her up on a Friday afternoon, and we drove three hours straight to Conques on a highway posted with signs warning of wild boars. I was returning to the little masons, as promised, after a three-month absence. We passed toast-coloured stone barns propped with angled buttresses, textured like errant tweeds, and tiny villages where the roofs winked, turning up ever so slightly at the ends in the French proposition that, even in rural hinterlands, form should follow beauty, then function.

Back at the Auberge St Jacques we climbed four flights of stairs to our room, laden with plastic bags chattering with the weight of wine bottles, bread, cheese, chocolate, and grapes. Annie is a shrewd businesswoman with a hair-trigger appreciation of things ridiculous and absurd, quick wit, and a fanatical devotion to Richard III, whom she believes history has wantonly maligned. She has a practical streak that she takes care to keep well hidden.

'Pam,' she asked, pouring herself some wine and raising one eyebrow – a talent of hers – 'just curious: where are these quarries? Do you have a map?'

I waved a 1:25,000 blue series production of the Institut Géographique National at her. 'But come with me, I'll show you our real map.'

I led her to the abbey. The oldest portions in the apse and south transept, including the Chapel of Ste Foy, which date from around 1040, are built of *rougier*, plum-red sandstone from the Dourdou Valley and the southwestern Rouergue. It's soft stuff: a millennium of smoke, incense, and a miasma of congregational sweat have eroded even the interior capitals past recognition. Around the turn of the twelfth century limestone was discovered and began to be quarried in the nearby village of Lunel, southwest of Conques on the Causse de Comtal. The ochre-coloured limestone was sturdier, tougher, more reliable than *rougier*; masons used it for the towers, western façade, north wall, and most of the cloister capitals. Locally it's called *rousset*, a word that derives from Occitan and means 'dark yellow', although

underground, before the stone has been deepened and darkened by sunlight, it is the creamy-pale shade of the abbey's interior, like the underside of my forearm.

There is plenty of pewtery schist in the abbey, too: local stone, still harvested from the neighbouring town of St Cyprien-sur-Dourdou, abundant but hard to quarry. Its metamorphic crystals give it a dull sheen like the iridescent film on dead fish.

Schist is everywhere in Conques; it fills the non-load-bearing walls of the abbey and makes up the walls, streets, and roofs of the village, knitting the place together top to bottom. Finally there are the special materials: dense, golden sandstone from Nauviale, a village just down the valley from St Cyprien, reserved for the tympanum and surrounding *pierres de tailles*, and the magnificent, pale grey limestone of the masons' own cloister capital. Narrative sources claim that the masons' limestone is from 'the *Causse*', though none takes care to name which *causse*. A few other capitals, along with the noble old fountain in the centre of the former refectory, are carved from black-green serpentine, brought in from the Massif Central.

'Here's your map,' I said to Annie. Following the sweep of my hand her eyes tripped down the nave. The abbey may have been erected to please heaven, but it still sings of the earth. Stone is stone, raised in architecture or lying quietly underground. More than other structures, the great, glorified cave in front of us – that's what Romanesque churches really are, barrel-vaulted, above-ground caves – affirmed the bond between nature and the works of man. Deep inside the Last Judgement are memories of the valley, the Dourdou and its fish, vineyards planted by the monks of Conques (vineyards that today yield the Rouergue's only *Appellation d'origine contrôlée* wine, the reds and sophisticated roses of Marcillac). The façade and its towers remember ponies, sheep, a big sky; wind hurling across the open pastures of the Causse de Comtal. A thousand years ago masons united the topography of the central Rouergue in a religion of stone.

Trying to find a balance between geology and human history, Vidal de la Blache proposed, 'One should start from the idea that a country is a storehouse of dormant energies whose seeds have been planted by nature, but whose use depends on man.' It was those dormant energies that interested me now.

'We, my friend,' I said to Annie, in what I hoped was a grand manner, 'are going to follow the *rousset*, everything you see around you – the limestone – back to its home on the *causse*. Tomorrow we're hiking to Lunel.'

By morning, Annie, who had been studying the blue series map, had formulated a plan of her own. 'Pam,' she mused, dragging the 'a' in my name until it became two syllables, 'instead of going back and forth to Lunel on the same route, why don't we make it a triangle: south to St Cyprien, east to Lunel, northwest back to Conques?'

Her triangle seemed logical enough – I wondered why I hadn't thought of it. We set off in a shower of church bells, not at the crack of dawn, but at a civilized mid-morning hour after an open-air breakfast attended by flies. I'd vouched for the coffee, but Annie had insisted on having tea.

Our route descended along a narrow, writhing lane from the car park outside the village, where all non-local cars must be stabled, to the main road to St Cyprien alongside the Dourdou. Healthy corn-stalks rustled in the wind like conspirators. Annie, the inveterate gardener, identified flora: yellow evening primrose, coral-coloured campsis vines, which grew amidst sandstone outcrops the shade of old wine stains. I pocketed a piece of schist I'd been kicking along. We were too early for *dégustation* of the local Marcillac in St Cyprien, an incurious little town in the flatbed of the river valley, where residents were going about their morning business along the solitary shopping street. Here we turned east through a two-block suburbia until the houses were overtaken by cornfields.

Above us loomed the *causse*. 'Ah, we've a climb ahead,' said Annie

lustily, shaking off a passing shower and striding uphill in her hiking boots. I, in my trainers, eyed the rising ground with trepidation. It's an established fact of our friendship that Annie is hearty; I am less so. The ground rose with a vengeance. About halfway up to the *causse*, St Cyprien now pocket-sized below us, we came upon a sandstone farmhouse and its outbuildings, all topped with fanciful pavilion roofs covered in schist *lauzes*. Geraniums and roses outlined the courtyard.

I couldn't believe the name: La Carrière. 'It means "The Quarry",' I translated to Annie, who can't speak a word of French and doesn't see this as a defect in the least. Glorious confirmation, it was, to find a thousand-year-old memory ringing in a name. Better yet, just opposite, on the rising hillside, was a geological event that took my breath away.

'Stand there, stand there!' I gasped to Annie, pulling out my camera. She finger-combed her blonde hair and smiled. 'No, no, not you.' She frowned. 'Point to the rock and make sure you don't get in the way.'

Annie pointed and I took a photograph of Ste Foy's abbey in the rough, before it had become an idea shaped by man. Here on the road to Lunel, like two big animals lying together for warmth, the red sandstone of the lowland met the yellow limestone of the *causse*. Together their limy run-off turned hydrangea flowers pink rather than blue in the valley below. We could easily see the frontier between the two kinds of bedrock; the line was perpendicular to the ground but tilted precipitously on its axis. It made me shudder. What kind of tectonic chaos, how many millions of years of upheaval, erosion, unimaginable pressure, and more upheaval, had it taken to thrust primeval sea bed and board into this position? Like the masons' achievement at Conques, this was another union of stone, telling a not-dissimilar story of genesis, death, and rebirth. It was a cycle that had been repeated over and over throughout the 4.55 billion years of pre-history; a cycle still in progress; a cycle given human form and

a name in the silent stories of the abbey's New Testament sculptures.

My compatriot, Henry David Thoreau, said that the Christian notion of looking for God in heaven, literally above our heads, prevents us from understanding that heaven is really here on earth, in the rock beneath our feet. For Thoreau, spirituality lay in the wonders of nature. But I felt its sudden, nascent spark in an interstice, in the tug of kinship between this cliff face and the Abbey of Ste Foy, and that kinship both thrilled and comforted me. Perhaps the two weren't so different after all.

'It's called an angular unconformity,' I announced.

'And this,' said Annie, pointing at a lacy, lavender flower, 'is called scabious. And that is purple heather. It's like you – it loves limestone.'

We continued climbing. Handkerchief vineyards clung to the upslope, walnut groves to the down. Without warning Annie became frighteningly high-minded and began quoting from George Herbert's poem 'The Pulley'. First she set the stage.

'God, you see, makes man and then pours out for him a cupful of riches, all but contentment, which he leaves sloshing around in the bottom. Here's the bit I can remember:

> When almost all was out, God made a stay,
> Perceiving that alone, of all his treasure,
> Rest in the bottome lay.
>
> For if I should (said he)
> Bestow this jewell also on my creature,
> He would adore my gifts in stead of me,
> And rest in Nature, not the God of Nature:
> So both should losers be.
> Yet let him keep the rest,
> But keep them with repining restlessnesse . . .

She launched that eyebrow at me. I'd thought she hadn't been paying attention, and now she was reducing the ambiguities of my pilgrimage – and the fount of Kingsley's wanderlust – to ten lines. Thankfully

we'd reached the final, banked curve of the climb and stood at last on the *causse*. A metallic-tasting wind tossed away our sweat.

'Where is it?'

I had promised Annie a dolmen. Ahead of us stretched a bumpy blanket of pastures and wheat fields, neatly separated by dark windbreaks. Lunel lay a mile or two down the road. I pointed in that direction.

It was cold now, and we walked with our heads bowed to avoid the wind. Our lunch by the roadside was a brief and chilly affair: an apple and a squashed nectarine, Quaker oatmeal bars I'd brought from home, and two thick slabs of Laguiole cheese from the Aubrac – rough, Rouergat highlands to the east. The cheese tasted like the rind of a fresh Camembert, a young, new taste, but with a supple texture; we ate it atop pilfered slices of baguette from breakfast. Shortly after lunch we came upon the great prehistoric hunks of granite. The dolmen sat next to the macadam encircled by a little gravel drive, giving the impression of a caged beast in a zoo. Annie prowled around it.

'It's a wonder to behold.'

'Don't make fun of the dolmen.'

'Perhaps it was made by quite short people.'

At 5 foot 9, she was a good foot taller than the capstone. I had to admit it did look like a very large, mottled mushroom. Hannah Green, however, had been enamoured. She reported its Occitan name, La Peira-Levada, the Raised Stone, and said that a ring of menhirs had once stood nearby. She also wrote that the Celts believed dolmens to be meeting places where the living conferred with the dead, and that they became sites of pilgrimage. The fact that I can't confirm this is what makes dolmens so wonderful – no one knows much about them, least of all their original or, in the Celts' case, even secondary significance. Dolmens aren't ruins; unlike weathered Romanesque carvings, it is their stories, not their shapes, that have eroded away.

And that's fine. We need to forget in order to invent. Dolmens, too, offer a handshake to the human imagination.

'Looks like a beached whale,' remarked Annie. 'By the by, dare I ask about this quarry of yours?'

I had been anticipating this moment. 'Well, you see, there is no quarry per se, at least not any more.' Up went the eyebrow. 'It was filled in ages ago. But the exact site doesn't really matter. We're in Lunel; we know there *was* a quarry somewhere nearby. This is the place the abbey stone called home. Ancestors of those stone-hatches you just identified for me probably knew it as neighbours.'

Annie snorted good-naturedly as fast clouds patterned the fields with moving shadows. The little village of Lunel was entirely built of *rousset* – it looked like Conques' little sister. Kind-eyed cattle the colour of dark caramel, Aubrac cattle, populated the adjacent fields. Here we turned around; the next day we would follow the same route in my car, taking twenty minutes to do what today had taken hours. We retraced our steps for about half a mile before heading off on a new track – the GR 62, a southern tributary of the Chemin de St Jacques – back toward Conques. A wrought-iron cross stood at the turning; pilgrims had come this way. There was also a signpost that put the distance to the abbey at 11 kilometres. I was aghast and immediately began to calculate.

'Do you realize we've already hiked 15 kilometres? Dear God, that will make 26 altogether.'

'Ooh, that sounds impressive.'

'Impressive? It's insane. That's over 16 miles! No wonder my feet hurt.' It now dawned on me, belatedly, why I hadn't come up with Annie's triangular itinerary on my own. It's always been dangerous to let her plan hikes and parties: I lacked her fabled stamina in both realms. A farmer working sheep with a rambunctious Border collie – the lambs had tails like pipe cleaners – warned us it was a long way to Conques. 'Downhill, though,' he added cheerfully. Blossoms that Annie had just identified as evening-blue cornflowers were startled at

our approach and flew off together, revealing themselves (we caught our breath) as butterflies. Wild thyme scented our footfalls.

It was a Rouergat paradise, but even so, once I'd worked out how far we'd walked I began to whine: my arches ached, my hips' ball-and-socket joints felt like those of an old German Shepherd. Annie, however, marched on relentlessly. For a while the route held to the top of a high ridge, the south face of which fell away dramatically, culminating in the valley below in a perpendicular fan of woolly-wooded, peaked fissures. Patches of oxblood earth showed between gaps in the forest. Finally we began to descend. This is how the stone had come, too, atop wagons hitched to twenty-six pairs of oxen. We were following its tracks. It had been a tradition with medieval pilgrims walking to Compostela to carry stones as a penance (a variation on walking barefoot, or in chains). Sometimes monks put this practice to use, encouraging pilgrims to transport not just any old rocks, but to carry cut stones from quarries to ecclesiastical construction sites. I fingered the piece of schist in my pocket and trudged on.

Some time later Annie broke the silence by asking if I'd rather run a marathon or take heroin.

'Right now?'

'Yes, you have to do one or the other right now.'

'Take heroin.'

'Thought you'd say that.'

As we neared Conques we came upon a sign pointing toward a detour to a *Point de Vue*, overlooking the great *concha* of the Dourdou (Hannah Green translates *concha* as 'valley'; others argue that it is the shell-shaped enclave on which Conques is built that lends the village its name). 'Shall we?' asked Annie in ready tones.

A look from me sufficed. 'Ah, well, you get out there and find it's only an opinion anyway.'

'How dare you have the strength to be funny,' I growled. Ancient apple and plum trees, woven with mistletoe, guided us back to the village: we'd been gone for seven hours. That night Annie treated

me to a dinner of sea bass with chanterelles – the lacy mushrooms the French call *girolles*, along with *groseilles* (red currants), they're a staple of summer markets – which we downed with a bottle of Gaillac, rounded off with Cognac, at the three-star Hôtel Ste Foy. It had become increasingly difficult for me to speak French in her profoundly English company, and I'm afraid our waiter suffered the consequences. Lucy and Kingsley had lunched in the same place; 'a heavy meal, of much meat'. Later that night we went to a concert of 'Chasticovitch', Mozart, and Schubert, held in the abbey.

The clarity of sound in the big, white, clean space of the church was pure and true. Wayward lines of melody explored the nave, climbed its pillars, ribboned down the arches, while harmony felt its way along the dark side aisles with my eyes, or perhaps ears, in tow. Music and stone were old partners here, still searching together for common ground, joined tonight by the cries of house martins swooping in through the open door and whirling around the nave. Later I asked Annie if she'd picked them out amidst the Schubert.

'Ah yes,' she said, 'They balanced it out. A fairly pleasant disharmony, didn't you think?'

4
—————

KINGSLEY AND QUEENSLEY

My idea of paradise is a perfect automobile going 30 mph on
a smooth road to a 12th century cathedral.

Henry Adams, 1902

On 22 July 1920 Lucy and Kingsley Porter found their friend Bull
Durham waiting for them at the Spanish border. They had com-
missioned Bull to drive their new Fiat over from Italy, and together
the three made their way into France along with Anfossi, the Porter's
chauffeur, and Lucy's maid Natalina. The Porters had just spent two
months in Spain photographing churches, eating too much, dressing
in what they considered rags, and enjoying the good, earned weari-
ness that comes from spending active days in fresh air. 'We sleep in
one stretch,' Lucy wrote, 'like a baby.' As she did every night of their
trip, she meticulously noted in her journal how much they paid for
their hotel room and midday and evening meals, always taking care
to add whether or not the wine was included, and how much extra
they spent on Natalina, who ate alone.

Compostela had pleased them. Lucy was satisfied to find St James
on the altar instead of Jesus: 'It seems right Christ should take second
place here.' She thought the sculpture fine: 'The South passage-
way interests me the most. The devils are exquisite ... the nude
figure (soul) held by the leg, head forward, is perhaps the loveliest of

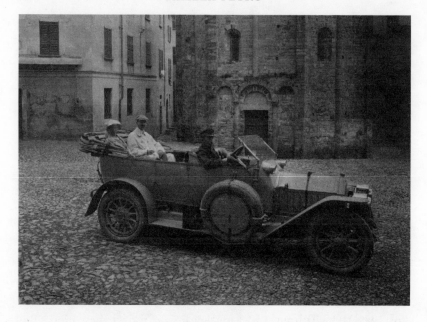

everything. I feel here how polytheistic the Catholic religion is! . . .
It is a much more rational explanation of the existing universe than
monotheism.'

By the time they reached France they were worn out. 'The Spanish
trip has left us in a condition of physical and mental exhaustion,'
wrote Kingsley to Bernard Berenson and his wife in Italy. Still they
purposefully ploughed ahead, making their first stop in France at the
Romanesque abbey of St Michel de Cuxa, just outside the town
of Prades. From here it would take them nearly a month to reach
Conques.

Travelling slowly, only laxly following their route, experiencing no
punctures nor lengthy respites for camera repair, it would take me
two days. (Lucy, I believe, secretly enjoyed the punctures; it provided
an opportunity for exercise – she fretted about the effects of over-
eating – and to walk ahead alone with Kingsley in the 'glorious air'
of the French countryside.) By contrast I endured only one hindrance
en route to the Rouergue from a side-trip to the Pyrenees, at a

roundabout coiled between gnarled vineyards just outside Castelnau-
dary. The police were stopping all northbound cars in a breathalyser
sting. I hadn't tried the local sparkling white, called Blanquette de
Limoux, which had been much praised at lunch, but was nervous
none the less. The *gendarme* had to demonstrate how to breathe into
the tube, which I then tried to do as he presented it to me.

'*Non, alors!*' he snapped. 'You take it!'

This I did, blew, and was pronounced sober. Distracted by my inep-
titude, he hadn't taken in my accent, leaving my identity as a foreigner
to become apparent upon the presentation of my Massachusetts
licence.

'*Voila une Américaine!*' He called his partner to the car and my
heart sank. I wondered which French law I had openly flouted. The
partner took my licence and addressed me gravely. 'Have you,
madame, yet tasted the *cassoulet* of the region?' I shook my head.
'Ah, well then. You must try it!' As drivers fumed in an ever-growing
line of cars behind me, the policemen first debated, then concurred
upon, the best place to experience the wonderfully adaptable white
bean stew of southern France, and gave me directions. We parted
with a question about Boston baked beans: they are rumoured to be
sweet – can this really be so? (Yes.) The gendarmes shook their heads
in disbelief.

My nerves, it occurred to me, were a residue of the day's drive. I
had spent hours following the River Aude northward on a crumbling,
thirties-era highway through a desolate park in the Pyrénées-
Orientales. No cars trailed behind me, nor could I see any ahead.
Clinging ferns and mosses and the dense over-storey above brewed
the air into a shade and scent much like that of green tea. The
bedrock muscled its way into my lane and would have forced me into
oncoming traffic, had there been any. Farmhouses were rare, and
empty; old resort hotels, advertising geothermal baths, had been
long abandoned. I willed the foothills to fall to their knees but they
complied only by eroding into individual, towering formations, left

behind from another epoch. The geological drama reached a cres-
cendo at the 'Gorges de Georges', a cubist collage of giant rocks like
the bombed remains of cathedral towers, from which a natural crevice
had been expanded to make room for the road.

Here was a very different relationship between humankind and
rock – the brutal disagreement between the immovable object of
immemorial age and human impatience to proceed in a straight line
– and it was a fierce one. The narrow passageway was something
nightmarish that Escher might have dreamt up had he been a sculptor:
knife-sharp, angular thrusts of rock lunging at the car from every
conceivable direction, and so dark I had to put on the lights. After I
emerged, the land abruptly relaxed and grew agricultural, hills rolled,
and a pretty haze formed from the exhalations of asparagus.

Many hundreds of hours earlier, it seemed, I'd begun the day in
Prades, with a visit to the abbey of St Michel de Cuxa. Lucy's journal
hardly recommended it: 'Once a famous Benedictine monastery,
now served by a handful of Cistercian monks. Little left of its past
grandeur.' She added, 'They talk with interest of . . . restoring church
and cloisters (but out of what?). An old abbot (almost blind) and
several dirty monks came and talked with us while we photographed
the portal of the abbey.'

What Lucy didn't say is that the monks had only taken charge a
year earlier, in 1919; before that the abbey had been empty since the
French Revolution, when the previous order was kicked out and
the place sacked to a state of desolation. Today it is again run by
Benedictines; in fact, a time traveller from the twelfth century would
be more likely to recognize St Michael de Cuxa now, thanks to
nearly a century of renovations, than would either of the Porters.
Nonetheless, an older continuity than Christianity – the sun in this
luxuriant enclave beneath the snow-capped Pic de Canigou, the
orchards here, the lilacs, wildflowers and rosemary, the scent of
cypress, the quietude broken by cuckoos' cries, above all an inkling
of Mediterranean ease while yet in sight of the great, cold mountains

– created a kind of sacred serenity beyond the abbey walls that Lucy and Kingsley had surely experienced. Despite the discontinuity in architectural time, I felt very close to them in this secret place.

In 1920 there had been no crypt to visit; it was only resurrected in 1937. At its heart I found a domed room called the Chapel of Our Lady of the Crib (Christ's crib, of which the abbey had reputedly owned a shard), supported by a single massive central pillar. At its peak the ceiling just permitted me to stand my full height (5 foot 5). The floor was earthen. Imagine a stone fountain spouting forth a circular jet of stones; imagine a perfect half-sphere of a cave with one magnificent stalactite growing in the centre from ceiling to floor; imagine if Buckminster Fuller had been born in the twelfth century and built his geodesic dome of mushroom-coloured stones mortared with lime.

The chapel was a diplomatic accord between man and nature. It was the perfect Romanesque cave. Henry Adams called Norman architecture of the same period 'naïve', intending the original sense of the word, which meant 'natural'. The chapel made his etymology clear. I would see its pedigreed offspring at Roquefort, filled with wheels of cheese. I had seen its distant ancestors in the nearby Grottes de Niaux, natural caves filled with images of horses, bison, deer and ibex, painted on the walls in sure, fluid streaks – all the beasts ran in an imagined wind – 13,000 years ago. It was there I had first learned of *la maladie blanche*, which oozed from the crib chapel as well. All were places of reverence; this one simply consolidated the revered under one name.

If the crypt at St Michel de Cuxa was a cave, the church was a barn. A huge, stone barn built *before* the Romanesque period, from 956 to 974, which makes one wonder: if the builders really believed the world was going to end in a few years, why create a stone church to last the ages? The arches between nave and side aisles recalled the East – keyhole-shaped openings that were a legacy of the Visigoths, and what they'd remembered of the Byzantine Empire as they plundered their way westward and eventually settled down.

The early twelfth-century cloister reached even farther across Europe, past Byzantium to Asia, all the way to China, perhaps, for inspiration. It certainly wasn't what I expected to find in the foothills of French Catalonia.

'Looks like – How do you say? – corned beef?' commented a sweaty German, eager to speak a Teutonic tongue, even if it weren't his own.

I agreed. The delicate arcades, columns, and capitals were all carved from local, dark pink marble veined with white streaks that really did call to mind a variety of lunchmeats. The capitals were stylishly carved in deep relief and were fantastic in every sense of the word. They were unconcernedly irreligious: smiling lions with Assyrian-style braided manes and far-sighted eyes; bearded kings and smooth-faced warriors; laughing beasts meticulously pointing out their private orifices; body-less creatures whose claw-footed legs issued straight from their necks. The brochure called these carvings 'scenes from Asian myth-ology', and suggested they'd been borrowed from eastern manu-scripts then resident in the abbey library. I loved them for the confidence of their craftsmanship and the witty, worldly, vanished community their presence recalled, rendering the present strange and provincial by comparison. They were wedged between rough, reconstructed arcades and column shafts like exquisitely crafted gemstones forced into crude settings.

The German apologized for his rather healthy-smelling sweat. 'I am on holiday with my bicycle, surfboard, and snowboard,' he told me with overt enthusiasm. We'd been sharing my brochure. 'Listen to this!' he said, reading aloud about the cloister. 'It was destroyed and totally plundered in 1789 and afterwards. Ultimately, 32 columns and capitals . . . ended up in the Cloisters Museum in New York.' I sighed in national apology.

'Don't take it too hard,' he said, giving me a pat on the back. 'We have the Greeks in Berlin.'

There was no cloister when Lucy and Kingsley came to Cuxa. Now

– smooth, polished, warm to the touch in the April sun – twenty-seven original capitals had been restored to the completely rebuilt arcades. I winced at the overactive German and did not say that the husband and wife who had led me to this place were dear friends of the cloister thief – a man whose idea of pilgrimage precisely meant bringing mountains to scores of New World Muhammads. Lucy reminds herself in her journal, as if to differentiate this ruined abbey from hundreds of others, 'Bernard bought the capitals for his cloister from here. Tried to obtain others which had been removed to a bathing establishment at Prades, but they were seized by the French government.'

'Bernard' was Bernard Berenson, originally Bernhard Berenson, the Lithuanian-born American art historian and connoisseur who had dominated the international art world from his Italian villa, I Tatti, near Florence. Berenson was eighteen years older than Kingsley, and very much the celebrated authority on Italian Renaissance art, as well as arbiter of taste to *le beau monde,* by the time they struck up a correspondence in 1917. After Berenson wrote praising Kingsley's early work on medieval art, Kingsley, then 34 and an assistant professor at Yale, responded with barely suppressed excitement. 'Your letter gave me more delight than anything which has happened to me in a long while. I have read and re-read and admired your works so intensely, that an autograph from you carries with it the romance of a relic.' He continued breathlessly: 'You have proved to me two important facts – first that an American could be thorough, and secondly that at least one man has been at the same time brilliant and sound.' Within two years both Kingsley and Lucy would be addressing their letters 'Dearest B.B.'.

While Berenson's work, especially attributions made in his capacity as an adviser to dealers and collectors – work that made him a wealthy man – has been increasingly questioned since his death in 1959, in 1920 he was at the top of his game. I Tatti was a gathering place for artists and intellectuals, and Berenson's private collection rivalled those of the great museums. Kingsley had hoped that he and his

wife, Mary, would join him and Lucy for portions of their reverse Compostela pilgrimage, as Berenson had done the previous year when Lucy and Kingsley were photographing churches in Burgundy. One of Kingsley's students at Harvard who knew both couples recalled that 'Berenson couldn't understand why he liked these old churches. To Berenson there was only Greece and the High Renaissance and everything in between was artistically debased. So he would join them on their trips to find out what it was all about.'

The Berensons never made it to southern France, although 'B.B.'s' biographer portrayed the earlier outing in Burgundy as a cosy one.

> They picked up Berenson at the Ritz in Paris on a fine, clear August morning and headed for Burgundy. Like Berenson, the two Porters were tireless in pursuit of choice specimens. There would be just enough time in the mornings to pack and buy food for the afternoon tea basket and they would be off, in their chauffeur-driven limousine ... They stopped at seven or eight small villages a day and, while B.B. and Lucy lunched at a small inn, Porter, to save time, would be huddled in a church taking notes and photos and would eat his lunch in the back seat on their way to the next.

For her part, Lucy had reserved her most enthusiastic journal commentary for the basket. 'Had tea (how I love my tea-basket!) under pine trees near an ancient cross while Anfossi blew up another tire.' It was also on this trip that she learned the valuable lesson that potatoes and macaroni together make a tasty dish.

What Berenson's biographer neglected to mention was that Lucy also assumed her position behind the camera, so that sometimes it was Kingsley and Berenson who went off exploring. She didn't seem to mind, but what is apparent from her journal is that Berenson's presence not only slowed the breakneck pace of their work, but broke the unspoken rules of their travelling sanctuary: casual clothes, hard work, early nights. Her irritation is apparent in a string of unusually sharp comments.

THE SLOW BREATH OF STONE

BB was interested in carved wooden altar pieces of the 16th century. Strangely childish things.

How I hurried to buy K. a lunch to eat in car and to pack trunk before I ate . . . BB announced production amounted to nothing in life. The only goal was to become.

BB pronounced the sculpture horribly dull – as bad as modern work.

Yet despite her annoyance, Lucy found time to take pleasure in the small details of travel. 'Nice bathroom. Wore Natalina's blue dress and good black hat for dinner.'

Berenson's relationship with Kingsley seems to have reminded the older man of his friendship with Henry Adams, who had died in 1918. Adams' own work on medieval architecture – *Mont Saint Michel and Chartres* – had memorably described the cathedral of Coutances before which a young Kingsley had semi-mystically glimpsed his future. That book had also begun the process of cultivating in Berenson an appreciation of medieval art; Kingsley's enthusiasm for Romanesque sculpture pushed it further. What Berenson had formerly considered 'degraded' he now called his 'last great love'.

In a later letter to his brother Louis, Kingsley recalled an incident from their Burgundy trip in which he, Lucy, and Berenson had stayed in a small provincial hotel. The proprietress had treated them like royalty, then charged very little. 'Lucy and I were embarrassed as to how to express our appreciation . . . We did it in the American way of rather raving, and produced very little effect.' Berenson had quietly complimented the woman as they were leaving, equating her hotel with Parisian counterparts. 'Of course,' wrote Kingsley, 'a light tap square on the head of a nail is infinitely more availing than a heavy blow from the side.'

Beset by self-doubt in the best of situations, Kingsley's sense of inferiority was on view in his relationship to Berenson as it was in no other, running through his letters like a dark seam in country rock (excepting of course in his marriage; Kingsley hid nothing from Lucy, including his insecurities; he considered her and Berenson to possess a vitality that he lacked). When he was trying to decide whether or not to take the Harvard job or remain in Europe, preferably at a villa near Berenson's – a subject on which he wavered for months – Kingsley imagined sitting at the older man's feet, where his Olympian influence might succeed in 'transmuting a base metal'. He then conjured up the horror of being without a job *and* without Berenson. 'Should I have the strength to stand on my own two legs, sans label and sans you?'

Kingsley never did find out if he had that strength, for he took the job at Harvard, which he – doubtless alone in the cosmos – forever after viewed as a failure of courage. He wrote to 'B.B.': 'As I grow older I seem to see quite clearly that my chief problem in life is time. Where you, for example, are brilliant and intuitive, I am dull and plodding (and how I dislike the characteristics!) – If I am ever to have a peek at the farther shore even through a telescope I have no hours to waste.'

Despite having decided not to live in Europe full time, following their summer of research in 1920 Kingsley and Lucy agreed to spend five months looking after I Tatti while the Berensons were in the States. Both Porters, however, had private qualms. Kingsley fretted to his brother Louis that it was too big and expensive for them to run, though 'the library is without equal for art' (it was in that library that he would begin *Romanesque Sculpture of the Pilgrimage Roads*). Lucy, uncertain of what was expected of her as mistress of a famous villa, wrote nervously to Mary Berenson, 'I might as well confess that I am a much better photographer than housekeeper.'

She needn't have worried – she herself fell victim to the only incident of their stay. On Christmas Eve 1920, as she was writing at Mary's desk,

a mouse ran down the back of her dress. 'She jumped into the bath tub and shook it out,' wrote Kingsley, 'then turned on the water and drowned it. Finis one mouse.' The irony that such an incident happened at I Tatti rather than on their travels was doubtless not lost on her. In her journal Lucy took precise care to note when the hotels they stayed in were clean and when they were not, though most were passable. They generally fared better at meals. One of her typically concise entries from northern Quercy sums up the tenor of their days:

> Returned . . . to pick up Natalina and bags about 6:30. K. studied church while I paid bill and bought postals. We thought of dining at 'Terminus' but too unpromising. A puncture on the road. I was horribly tired but walked ahead. Ate dinner at a little hamlet . . . our meal served out under the grapevines. Such a delectable meal with good wine . . . 10 francs for us 7 for Natalina. The cold run in the moonlight past Martel very beautiful. Had comfortable quarters at Hôtel de la Source, arriving about 10:30 p.m. – but again (or still) no hot water!!

Lucy often mentioned her weariness and the occasional tender intestine, but Kingsley proved the more delicate traveller, often succumbing to headaches as she noted in the Auvergne:

> Houses are high with slate roofs – the stables and older ones are often thatched. No curtains at the windows, no children but plenty of majestic geese. K felt headachey and ate no lunch . . . I ate dinner alone. K had malted milk and biscuit. Waiter, in rundown, badly managed hotel took me for *ma femme de chambre.* Afterwards couldn't be obsequious enough. A bottle of Graves (10 frs.) made a poor meal possible.

Now and then she played truant – 'I was very lazy this lovely morning and dressed slowly not joining K. at the cath. until ten' – but more often than not they photographed together or split up to do errands, such as picking up their mail. ('K got the mail,' Lucy noted on one occasion, tartly adding, 'a man's mail is not delivered to a woman'.)

The process of photographing sculpture was not an easy one. They

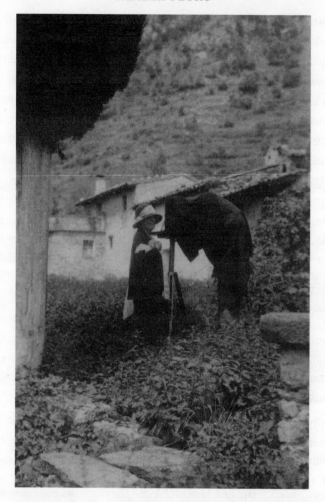

had to work in the heat of the day, or wait hours for the sun – or shadows – to be in the right place. Often there was a to-do about finding a key to open a church. Lucy wrote on 30 July 1920, 'K was so sweet when he returned. I was cross, ostensibly that he had to walk in hot sun, really, I fear, that I had been bored by waiting.'

Every evening they had to change the plates that held film for their view cameras – a time-consuming operation that could only be accomplished in the dark (and over which they occasionally fussed at

one another, each wanting to spare the other the trouble of doing it). In one location Kingsley wished to photograph some sculptures that hadn't yet been installed in a new museum; Lucy wrote that he was 'stealthily photographing jamb figures with a small camera after climbing over an iron gate'. While he skulked she kept lookout for two hours, absorbed in watching chickens trying to peck at grapes growing on an arbour above their heads.

Yet despite such difficulties, as Lucy's journal attested, the vaga-bonding life suited them. Rare snapshots bear out their happiness. The two of them in the back of their open Fiat, Anfossi at the wheel. Lucy in a big sun hat on a hillside, smiling and standing next to Kingsley, who is bent double, his upper half draped beneath the black cloth of his view camera. On the back Lucy quipped in her sprawling, spiky hand, 'A good picture of Kingsley, isn't it?'

* * *

I moved heaven and earth to reach the tiny spa town of Moltig-les-Bains, not far *on the map* from Prades, and occupied a threadbare room in a hotel the two best features of which were its sign – one side bore the front end of an elephant, the other the back – and its proprietors. The owner greeted me apologetically, wiping wet hands on her apron in the universal way of friendly cooks, in order to shake mine while explaining that the only other occupant was 'taking the cure' at the spa across the way. When we met at breakfast he cryptically referred to having 'problems of the skin'.

I'd made an effort to find Moltig because Lucy had raved about the meal they'd had there; she and Bull Durham had also enjoyed sulphur baths. Unfortunately, the dinner being prepared at my hotel was not for me. 'The only public restaurant is next door,' explained the cook's husband, genuinely regretful that I would have to leave the premises to eat. 'They are kind there.'

And so they were, although the level of cuisine in Moltig has fallen since the 1920s. I believe I was served the only inedible baguette in

France, along with a plain omelette and a pitcher of dark, aggressively alcoholic table wine. By far the best thing about the meal was the bunch of grapes that arrived for dessert, big, sensual spheres with nearly black skin that glowed purple when held to the light.

I had brought copies of some of Lucy's photographs with me to occupy my eyes as I ate. I was taken with a lovely profile portrait she'd made of two stone saints, the rear one shadowed nearly into silhouette, the other, in the foreground, marbled like Italian paper with beaded outcrops of lichen. But it was another photo that arrested my fork: a close-up of an angel on a tympanum, her body and one wing gently bent to echo the half-moon curve. Christ's hand – only his right hand – intruded into the image, forming a V with the long, straight horn that the angel held to her lips.

Delicate grey tones picked out the shallow folds of her gown, the deep incision of her jaw line. Lucy had made something new here. Christ's large hand seemed to be that of a showman, introducing the angel who swayed centre stage as if transported by her own sweet music. And I, too, in the poorly lit, smoky restaurant, my head gently spinning from the wine, absently caressing my magnificent grapes, made of it something newer yet, something fine and vaguely pagan, dionysiac. The angel kept becoming, in contexts unthinkable to the sculptor who had made her; travelling – thanks to her reincarnation in light and photo-chemicals – to geographies far beyond her home in Martel, in the Dordogne valley of northern Quercy. Where I longed to go that very moment.

My thoughts were interrupted by a commotion. My only companions in the restaurant, a large family that had dined on soup (loudly slurped) and rabbit stew, were leaving. Each one, the children too, nodded to me on the way out in the gracious French acknowledgement that those who have eaten together have formed a bond that must be honoured, however short-lived and tenuous it may be.

In the morning I followed Lucy to St Martin de Canigou, another Romanesque monastery near Prades but in the highlands, rather

than the low. A sign in the car park at the beginning of a footpath announced a 40–45 minute climb to the abbey. It did not add, 'straight up'. The trail was fantastically steep with vertical drops all around. Out of the encircling abyss rose individual, jagged peaks that could have been – perhaps were – knives thrown in anger by Stone-Age gods. Their pinnacles were broken, some snow-covered, all beautiful and terrifying. I remembered Kingsley on mountain climbing ('I always get scared as a kitten') and made myself small and low. When I reached the top, gasping, who was there but the sweaty German, beaming and dripping. He had come from the direction of St Michael de Cuxa through a pass in the mountains, on his bicycle. 'I held the tow-rope with one hand, it was steep, yes? And in the other I held my handlebars. Now, after the tour, I walk back' – a look of horror from me – 'no, only a mile or so, not bad. I want to take the photograph I missed.'

The eleventh-century abbey had already been completely rebuilt in Lucy's day. 'Bull and I were tired due largely to sulphur bath in a.m.,' she wrote, 'but pushed along. A hard, picturesque climb of about an hour. Church has been entirely restored by the Bishop', whom she went on to describe in detail. 'His refined, thin face made an unforgettable picture set off by his purple robe (trimmed with red) . . . The purple veins on his forehead were the same exquisite colour as his vestments. He had just come out of his retreat and an odour of saintliness still hung about him.'

The abbey was wonderfully situated and in use; those who took the tour also accepted a temporary vow of silence. There I found more pink capitals like those of Cuxa – the marble quarry in nearby Villefranche-de-Conflent had only closed in 1941 – and an assembly of mortared stones set in arches and passageways like the silent, solid equivalent of hundreds of voices locked in chant. I scribbled in my journal, 'A rougher place than Cuxa, less refined, more urgent.'

More so than the abbey I was taken with the Pic de Canigou – a hulk of Pyrenean rock 2,784 metres high that Catalans climb in

midsummer, lighting a bonfire on the summit to celebrate their extra-national solidarity. Like many other nations without geo-political borders, Catalonia is an idea in which the Mediterranean people of southern France, their neighbours in northeast Spain, and the inhabitants of Andorra, believe. Even in France, one hears these beliefs expressed in the Catalan language. I learned the hard way on a side trip to Andorra that while it is rational on a global scale for guidebooks and encyclopedias to call it a bilingual country, in which residents speak the tongues of the two European powers surrounding them, that is less the truth than an urge for logic imposed upon fact. In *fact*, everyone speaks Catalan, and often nothing else (the French I heard in Andorra was thick-skinned and bristly, as if it lived outside all its life). In Andorra, Catalan made sense: global languages seemed out of scale in such a small country.

The vernacular language accompanied a vernacular architecture. In addition to tax-free shopping – the capital, Andorra la Vella, is essentially a duty-free mall with scenery – Andorra is blessed with the highest density of Romanesque churches in the world. There are only seven, and they are tiny, perhaps the size of a large entryway, but in a country of just 179 square miles, much of it impossibly mountainous, seven is a lot. I thought of them as changeling offspring of Sts Michael and Martin of Cuxa and Canigou. The first one I found, Sant Serni de Nagol, built in 1055, barely clung to a hairpin turn on a road pressed by mountains so close and massive that their beauty was undercut by the careless brutality of height. I felt about to pitch into the three-sided chasm until I realized that the nave floor was sturdy, living rock. Sant Serni grew out of the mountain, its walls, miniature apse, and roof tenuously bound together in architecture, but not so very far removed from an empty cairn. It wasn't completely tame.

My guide said the church was made of *matériel du pays* – local stone (she and I met linguistically in a no-woman's-land of imperfectly learned French). Never were truer words uttered. It was every-

where, a whole country built of ash-and-tabby coloured rock, from ancient chapels to hundred-year-old farmhouses to the palatial new homes that crept up the mountainsides. Such stony continuity gave whole villages, and especially individual churches, the speckled look of sparrows' eggs, perfectly camouflaged against the rocky hillsides from which they had emerged. The only exceptions were ugly, hastily made, reinforced concrete blocks that afflicted all the bigger towns in Andorra.

Like its Romanesque brethren, Sant Serni de Nagol was decorated with thousand-year-old frescoes: four wide-eyed archangels floating in perpetuity around a Romanesque arch, one of whom inexplicably had four arms and another a third, ghostly foot poking from beneath his gown. Santa Coloma, another rough and holy place, bore fragments of bright, flower-coloured frescoes by the Master of Santa Coloma, whose work is identified all over Andorra by his figures' big ears.

Paradoxically, stone gives warmth to Romanesque art; it forced the eleventh-century artist's urge to map the human body – his desire to flatten and schematize individual parts rather than suggest the whole – to compromise with the mass of its unyielding matter. With a paintbrush in hand, however, the artist was free to isolate and intellectualize every last component, down to rendering the blush on an angel's cheeks as little red circles. That is what I found on the walls of Santa Coloma. No surprise there; what took me aback was that I was looking at reproductions. Scattered around the church, so cold inside that I could see my breath, were mildewed posters of black-and-white photographs shot between the wars that showed the original frescoes intact. Sometime during the Second World War they'd been chipped off, all but for one small corner hidden by a Baroque altarpiece. Bits circulated for a while until they landed in Berlin and the USA, though the lion's share from this and other Romanesque churches belongs to the National Art Museum of Catalonia, in Barcelona.

A few days later as I was leaving Andorra, near the border, I caught sight of something that brought the frescoes back to mind: a line of black dots and dashes, the kind of symbol you see marking international boundaries on maps, but this one was moving and laid down against a real hillside. It turned out to be a network of chair lifts at a ski resort, but from a distance, against the snow, it really did look like a kind of twitchy frontier. The aptness struck me. Most Andorrans I'd spoken to identified themselves as Catalans, and acknowledged Barcelona – 'a great city, an international city!' said one old man with pride – as their larger capital. In Lilliputian Andorra, being Catalan is a way of not being provincial. And yet Andorra's borders (which date back to the thirteenth century) *do* have meaning for the people who live inside them. Until recently the little country was a protectorate of France and Spain: half the year it was administered by the Bishop of Urgell, the other half by the President of France. In 1993 Andorra cast off its twin yoke and became independent. But in the last national election more than half its residents did not vote because they could not – they weren't Andorran. 'The Portuguese, Spanish, Dutch,' explained the young woman who'd showed me Sant Serni de Nagol, 'they come to live here because we have no tax. There are more of them than of us.'

These days Andorra's perforated borders let people in and art work out. That's okay, say most Andorrans; Barcelona is home-away-from-home, even though it's in another country. Home, on the other hand, is where foreigners live. In which home do Andorran frescoes belong? My young guide didn't think they ought to be in Barcelona, though she conceded they were more accessible there. Then she checked herself. 'I told you Andorra wasn't on the pilgrimage route to Compostela,' she said to me, 'but aren't our churches relics in their own right? Why shouldn't people have to come here to see our frescoes?'

She had said '*reliques*', and the word sang with resonance. Once you invest identity – or, more potent yet, belief – into an object or

image conflicts are bound to arise over interpretation. Andorra is struggling over a conflict of interest between the ancient integrity of the relic and its bond to *place* – a strong tie, particularly when it comes to those feral little churches, unweaned from their mountains yet the closest thing Andorra has to an artistic heritage – and nationality, especially of the amalgamated kind, recognized in the contemporary world. To which do the souls and the bodies of those Romanesque frescoes belong?

It was a question I longed to ask the Porters. For me, Romanesque sculpture was fast becoming a route into the particularity of place, a way to tunnel deep down into southwest France. My journey paid homage to the body of the earth, to which sculpted stones, even if they were absconded with by the Bernard Berensons of the world, remained irreducibly bound. Their smell of old seasons, their heft and rough touch to the fingers, their warmth by day and chill at night, profoundly express the art of immobility and constancy, a wagon to which human artists have ever hitched their dreams of immortality (covering their bets, perhaps, lest priests' promises let them down after death – which is why stones, even Christian ones, will never lose their pagan allure). I was growing older and learning that these things were important to me. Ever a traveller, I was finally being lured by the art of standing still.

Lucy and Kingsley had different priorities. It is impractical to carry column capitals around in a Fiat, so instead of taking the art and leaving the photos – as fresco-hunters did in Andorra – they left the stones where they'd found them, and carried away their pictures. Far more harmless, and much lighter. Either way, photography or theft, the idea was to make art portable. Neither option paid the least heed to my obsession with home stone or the bonds of relics. *Should* art be moved? Well, that's a knotty question. Some would say yes, sometimes, when in service to purposes greater than its own. In the case of the Andorran frescoes, the purpose was political: they were one of the visual components of consolidated Catalonian identity, of

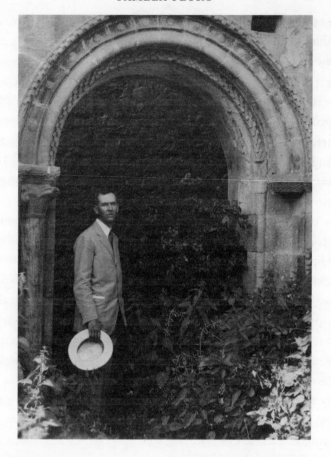

which Kingsley had witnessed the first stirrings (and of which he approved) in the 1920s.

For his own purposes, the wings Lucy's photographs fixed to sculpture erased the old adage that you can only be in one place at one time. A fixed moment from July in Spain could be placed next to another from August in France so that the art works revealed by the camera at those two instances might be compared. And through comparison Kingsley was able to tease out humanity's patterns of migration and tutelage, economics, politics, and chronology. He was above all other things an historian. Photography allowed him to look

into art and seek man – or rather the medieval dead, with whom he had always wanted to speak. What its comparative potential cost him in terms of experiencing the procession of pilgrimage it provided in the perception of a vanished world. He also, more perilously, looked into art and found relativity. When stone carving, or any place-bound art, is made mobile it becomes comparative, and once one thing is compared to another, thinking about those things becomes qualitative. Kingsley, so used to comparing himself to others, wound up spending a lot of energy worrying about which tympanum was better than the next.

Lucy, meanwhile, chose to remake Romanesque sculpture with her eyes. Huddled under her dark cloth, peering through the lens of the view camera, her job was to provide evidence for Kingsley's great project. But through her choices of where to focus and what to crop, she gave the angel at Martel a new identity – a second soul born in a dark room and held in a photograph. The image and the stone were and were not the same thing; photography, the art of travelling, split the atom of the older, sedentary art and let it roam to two places, two identities, at once.

Both Porters were engaged in releasing beautiful old art works from their thousand-year bondage. Now here I was, coming along and trying to pin them back to the earth – to draw Lucy's shadows back to their stones. Were our journeys leading us in irrevocably separate directions? It seemed that way. I wanted the frescoes returned to Andorra. I wasn't sure either Porter would much care.

*　　*　　*

From French Catalonia they wound their way northward to Carcassonne. The mountains were behind them, the river valleys of the Lot and Aveyron lay ahead. Bull and Anfossi had left for Paris with the damaged camera; Natalina was aboard a train, innocently barrelling in a direction they'd been headed but were no longer going; and for a brief time, Lucy and Kingsley were alone. Marooned.

The photographs of Sts Michael de Cuxa and Martin of Canigou had been developed and were disappointing. Kingsley had held the camera – their best one – up to the sun and discovered leak after leak in the bellows. He'd tried to fix them with adhesive plaster, but it was hopeless. Since Bull was leaving for Paris anyway, he took the camera with him to be fixed. Natalina would have to be telegraphed to wait for them. There was nothing to do but cool their heels in the walled city.

They were staying at the Hôtel de la Cité. As comfortable as any home, and as expensive, Lucy thought wryly, making a mental note to put that in her journal. At first she had felt almost guilty – they hadn't been on their own together in so long that the effects were startling. 'A hot bath, and I fear being alone, seemed to rest us,' she wrote, tentatively trying out the pleasant sensation of having a selfish wish granted. She was so used to being in motion, to living in a split-frame in which the present moment is perpetually shared with plans for a string of future moments, beginning with the next hour, leading to the next year, the rest of their lives, that coming to a sudden standstill in mind and body induced a kind of torpor. 'I wrote in the garden, lifeless, as I have been since our arrival. Tried to pick up Americans unsuccessfully! Decided they were bride and groom.'

Despite a lingering cold, his manuscript, and the ever-present allure of old stones, she was pleased that Kingsley, too, was turning his eye on people for a change. It was he who had made them stay and watch the celebration after a village wedding of two local youths – the young man with a cap of horns on his head, being led through the cobbled streets on a mule. He, too, who had surprised her by declaring the American pair to be a schoolteacher and his pupil. 'And neither married,' he'd added with glee. She wouldn't have imagined he'd given them a second thought.

The August heat, of course, was rendering them both into over-cooked vegetables. She fancied the dark walls of Carcassonne a kind of gigantic *pot au feu*, the tourists inside, still pale in their northern

skins, so many beans bubbling in a *cassoulet*. Kingsley was fond of the place, though he would never admit it. To Bernard he'd written of the 'disgusting vulgarity' of the restored fortifications, which had curiously stung Lucy's feelings. She preferred what he'd said to his brother Louis, about Carcassonne being melodramatic. What was it? 'One has the feeling of living in a play of Victor Hugo.'

Lucy had read her Henry James, too, and had a better memory. On his *Little Tour in France* in 1882 James had found Carcassonne at night to be 'ghostly enough on its neighbouring hill. Even by day,' he continued, 'it has the air of a vignette by Gustave Doré, a couplet of Victor Hugo. It is almost too perfect . . .'

Lucy sighed fondly. The fact that James's words had taken root in Kingsley's imagination didn't disturb her – rather it gave her pleasure. Their sensibilities were so alike. James had written that Carcassonne forced the visitor to make his mind up on the matter of restoration. 'For myself I have no hesitation,' wrote the Master. 'I prefer in every case the ruined, however ruined, to the reconstructed, however splendid.'

Kingsley too, she well knew, didn't like his medieval architecture too obvious or too well preserved. He preferred it not to state its aim so clearly that everyone could repossess it. In truth, he actually seemed more taken with the wind than the stones. 'The place is . . . on the water-shed between the Atlantic and the Mediterranean,' he'd told Louis, 'and a wind sucks through from sea to sea that almost blows you off the cliffs. They say that this wind never lulls at Carcassonne, and is in fact the great curse of the place. In winter I should think that it would almost drive one insane, quite literally.'

Lucy had been surprised he was so sensitive to the wind – she'd hardly noticed it. But then of course there was his cold; she mustn't fuss over him, though she'd been sorely tempted. He loathed couples who 'mollycoddled' one another, as he put it, and heaven knew she wasn't his mother. It helped that she'd been preoccupied for the past few days thinking back to the fall of 1918, almost two years ago. The

only time they had ever been separated, when Kingsley had to go off
to Rome to check on some monuments, and she'd stayed behind in
Paris. How they'd longed for one another! He had called her his
'Bobby' and she had memorized his letters. 'My Bobby – If you knew
how long and heavy the moments are on this our first (and may it be
the last – until that final one comes) separation.' And her favourite:
'I love you, Bobby, and wish, oh how I wish, you were here with me
. . . I love you more than the seven worlds or the nine heavens. I only
live because of you and when I am beside you. Every moment when
I am separated from you is a moment of living lost from my life.'

She had intended to join him, but it was so difficult to travel back
then, with the frontiers just reopening, and all the papers one needed.
Then she'd lost his introduction to the Italian authorities from the
ambassador – or rather he'd thought she'd lost it, when she had done
nothing of the kind. How upset he'd been, calling her a 'thoughtless
little girl', and then in the same sentence saying he loved her. That
was Kingsley: coming undone without her (that part she rather liked),
angry with her, yet unable to say so outright. She marvelled that this
tall, handsome, brilliant man – really, it must be said, he was brilliant
– believed he was so unworthy of holding onto her love that one
harsh word would turn her away.

He had always been like that, not just with her, but with everyone.
Before they were married, when he'd believed her sister was trying
to separate him from his chums (Lucy had never been able to decide
who to be cross with on that score), he'd confessed how hard it was
for him to make friends. She had been astonished. 'Real friendship
has always seemed to me the thing perhaps most worthwhile in life
until I found something better in love,' he'd written to her. 'But
because I have such difficulty in breaking through and winning friend-
ship, I have been passionately attached to the few people I have
known intimately.'

Ruth *was* a bit possessive of her, she had to admit. But Kingsley . . .
Lucy sat up with a start. Ruth! Dear Rufus, sister of sisters, she

needed to finish that letter. Lucy looked from side to side to see if anyone had witnessed her initiative, but the courtyard was empty. 'Dear Rufus,' she repeated out loud, 'I have to finish that letter.' No, it was hopeless. She fell back against the chaise longue. Two weeks ago she would have had pen in hand by now, but here in Carcassonne her will ignored the call-to-arms. Still, she really did need to write. Without Ruth and Louis their future would be in shambles by now. Here they were lolling about in Europe, while Louis was busy renting a house for them in Cambridge, now that Kingsley had finally decided to take the job at Harvard. Louis had assured her it was a magnificent place. It had been James Russell Lowell's house – a perfect place for his brother the poet, he'd joked. A big, tall, box of a Georgian mansion with a lovely balustrade around the roof. Built in 17 – what had he said, 67? Yes, that was it, 1767.

The house was called 'Elmwood'. Lucy tried hard to picture it, but she could summon no American clapboards to her mind's eye, saturated as it was with sun-baked stone. Ruth was presiding over the details of moving them there. Guilt began to stir at the back of her brain, but anticipation got the better of it. It seemed a brave, daring thing to do – to take on a job and a house in Cambridge, sight unseen. To plan a future so very different from the present.

Later that night, revived a little by the evening breeze (she had managed to finish the letter after all), Lucy and Kingsley walked together arm-in-arm in the blue-edged starlight, a circuit of the walls that had become their pattern. A few days later Anfossi returned with their camera, which Kingsley immediately tested. 'No befogging!' he announced in triumph. They had all cheered. That evening he and Lucy took their last stroll together in Carcassonne; tomorrow they were due to leave for the Rouergue.

'The glow worm on the town,' she wrote in her journal 'had gone out.'

* * *

Writing in December 1904, Henry Adams opened his great book on Romanesque and Gothic architecture with an Elizabethan fragment: 'Who reads me, when I am ashes,/Is my son in wishes'. Then he cast a cool eye on sons, and decided they were an untrustworthy lot; next in line came nephews, who 'as a social class, no longer read at all'. So he decided to address his book to a niece – a niece who is about to accompany him on an imaginative journey through France, and who is likely to 'carry a Kodak and take interest in it, since she has nothing else, except her uncle, to interest her'. If at times she grows a bit bored, so be it: 'One cannot assume, even in a niece, too emotional a nature, but one may assume a Kodak.'

Lucy had a bit more knowledge of things Romanesque than Adams' niece-in-wishes, and she carried a view camera rather than a Kodak, but it must be said that she really was more interested in photography – and photographs – than in her stony subjects. When she and Kingsley visited Moissac Abbey later on their trip, widely considered the premier Romanesque monument in France, she admitted in her journal that she only warmed to the beauty of the carvings after meeting a French artist ('a delightful talker') who was sketching there, and whose work she admired. Lucy was a photographer; her husband, for whom photographs were a means to an end, invested them in his dream of the Middle Ages. Creating images, says Peter Osborne in *Travelling Light*, helps 'draw the dreamer or traveller towards a world that might be repossessed'.

Repossession of the Middle Ages – ever Kingsley's shadow-goal on the pilgrimage roads – was an investment in which Henry Adams also had a share. Adams' life, almost more so than his work, was a template for any serious, sensitive young American seeking a rapprochement between New World restlessness and Old World anchorage. Born in 1838, Adams was two generations older than the Porters, but of similar, if even more blue-blooded, New England stock. His great-grandfather John had been the second President of the United States; his grandfather, John Quincy, had been the sixth. His father, for

whom he occasionally acted as private secretary, was Lincoln's minister to Great Britain.

After graduating from Harvard, Adams spent most of his twenties in Europe, as Kingsley did several decades later; but unlike the younger man, Adams maintained a lively engagement with American politics and found an outlet for it in journalism. He had a critical eye and despite being a quintessential insider – in addition to family members, Adams' friends, men like John Hay and Teddy Roosevelt, essentially shepherded the USA into the twentieth century – he maintained few personal or party allegiances in his writings. Money and family lifted him above the need for patronage; by temperament, especially, he was an outsider with a conscience and the far-sighted perspective of an historian (Adams also taught history at Harvard for seven years).

In 1870, with no prospects in sight, he wrote on the subject of marriage, 'my heart is as immovable as a stone'. But as his friend Bernard Berenson well knew, stones *can* be moved. By 1874 he had married the daughter of a prominent Boston doctor, Marian Clover Hooper, known to friends as Clover. Like the Porters, the Adamses had no children. Kingsley's worries that he and Lucy were becoming a 'mollycoddling' couple echoed Adams' own – without children, he feared he and Marian had become overly, if agreeably, dependent on one another. In time he would discover his fears were grounded. If the best place to live were inside the emotional entanglement of marriage, it was also the most perilous. In December 1885 Marian killed herself by swallowing photo chemicals, unable to revive from depression brought on by her father's death.

'I have had happiness enough to carry me over some years of misery,' wrote Adams shortly after Marian's death, sounding a bit like a Yankee farmer, 'and even in my worst prostration I have found myself strengthened by two thoughts. One was that life could have no other experience so crushing. The other was that at least I got out of life all the pleasure it had to give. I admit that fate at last has

smashed the life out of me, but for 12 years I had everything I most
wanted on earth.'

Adams spent the next thirty-three years, until his own death in
1918, in near-constant motion. He grew attached to one of Marian's
good friends, Elizabeth Cameron, with whom he had a close but,
despite his best efforts, unrequited relationship. Beginning in 1895,
while he compulsively pursued points in space, travelling non-stop
throughout Europe, Asia, and the Americas, he began a project that
required him to reel through time as well, and which succeeded in
anchoring him in the eleventh and twelfth centuries for the next
decade, culminating with the private publication of *Mont Saint Michel
and Chartres* in 1905. (Adams issued another private, slightly revised,
edition in 1912; a year later the public printing broke sales records
at Houghton Mifflin.)

While working on the book in Paris, disgusted with what he viewed
as the political atrocities of the day, from the Dreyfus Case to the
Boer War ('Our interests require that the Boers must be brought into
our system, so we will kill them until they come'), Adams found the
eleventh century peaceful by distant comparison. Paris, he wrote to
a friend, 'approaches closely to my idea of retirement from the world,
if not of devotion to God and the saints . . . I always drift back to the
11th and 12th centuries by a kind of instinct which must be terribly
strong. Cowardice I think! . . . The modern world artistically begins
with Michael Angelo and I don't like it. There is not peace or protec-
tion or repose about it. They won't even let me be damned and
quiet.'

In *Romanesque Sculpture of the Pilgrimage Roads* Kingsley never
leaves his intellectual perch in the twentieth century; it is precisely
the distance between himself and his subject that allows him to see
patterns and trends in Romanesque sculpture. *Mont Saint Michel and
Chartres* attempted something strikingly different. Adams sought to
understand Romanesque and Gothic architecture – and the brief
moment of unity between them – on their own terms. To do this, as

he put it, 'we have got to become pilgrims again.' And that was not easy. 'One needs to be eight centuries old to know what this mass of encrusted architecture meant to its builders,' he wrote of the Norman abbey of Mont St Michel, built amidst the quicksands of the English Channel, 'and even then one must still learn to feel it. The man who wanders into the 12th century is lost, unless he can grow prematurely young.'

Writing about his method, J.C. Levenson neatly sketched out how Adams leads his readers back into youth. Adams begins with a tale of actual travel – his and his niece's journey from Normandy to Chartres Cathedral, in the Île-de-France; he then strikes out on an imaginative journey atop the physical one, using historical fact and observation to build a bridge back to the Middle Ages. Adams admits this second step requires imagination – it cannot be achieved by scholarship alone – and it leads to his third, most intimate journey: a spiritual pilgrimage of the heart without which, he believes, the 'miracle' of Chartres' beauty and grace is inaccessible.

Adams' route is complicated, underlain by what he perceived as a movement in medieval society from the martial, masculine culture of the eleventh-century Normans through the feminizing influences of the following centuries (particularly in poetry), to a sweet moment of balance at Chartres, before what he considered as a tragic return to *machismo*. Each of these social moments has counterpoints in architecture, culminating for Adams in the perfect beauty of Chartres cathedral, which can only truly touch the soul of the pilgrim who *believes* it was built by the perfect woman, the Virgin Mary. Adams the author, the uncle, does not present the virgin as a metaphor; he presents her as *real*. Without a profound and firm belief – a knowledge, even – that Mary was watching and was pleased, he believed that twelfth-century masons, artisans, and architects could not have been inspired to achieve the rose window ('a jewel so gorgeous that no earthly majesty could bear comparison with it'), the pointed arches, the soaring stone. We now, centuries later, *must* take their

achievement as proof of the same, or else we will be shorn of their inspiration.

> One sees her personal presence on every side. Any one can feel it who will only consent to feel like a child. Sitting here on any Sunday afternoon . . . your mind held in the grasp of the strong lines and shadows of the architecture; your eyes flooded with the autumn tones of the glass; your ears drowned with the purity of the voices; one sense reacting upon another until sensation reaches the limit of its range – you, or any other lost soul, could, if you cared to look and listen, feel a sense beyond the human ready to reveal a sense divine that would make the world once more intelligible, and would bring the Virgin to life again . . . but what is still more convincing, [you] could, at will, in an instant, shatter the whole art by calling into it a single motive of [your] own.

Agree with it or not, Adams' travel narrative – for it is that, a delicious *mille-feuille* of physical and spiritual travels – is a sublime synthesis of historical scholarship (he shunned what he thought of as the fuzzy medieval nostalgia of his old Harvard professor, James Russell Lowell, the former owner of Elmwood) and instinctive, personal feeling. Although his imagination also rode a medieval surge-tide, Kingsley rejected Adams' integrated method. If *Mont Saint Michel and Chartres* was historically sound literature that sought the spirit, *Romanesque Sculpture of the Pilgrimage Roads* was art-historical analysis based on dispassionate observation. Catching the tenor of the new century, it was 'scientific' and cool-headed; apart from crediting the value judgements of a trained eye (one carving was 'debased' compared to another), emotions were now reserved for literature alone. A comment in the *New York Times* made an overt comparison: 'In [Porter's] endeavour to make the past come alive, he was akin to Henry Adams, but more erudite.' The territorial stakes of twentieth-century arrogance had already split the two-chambered heart of art and science.

This is not to say that Kingsley didn't seek an outlet for his emo-

tional response to the Middle Ages – he did, on the other side of the divide. In 1929, quite apart from his work as an 'archaeologist', he quietly published *The Virgin and the Clerk*, a play set in the eleventh century. Kingsley took the story of Theophilis, a monk who sells his soul to the Devil, and made of it a treatise on the double-edged values of friendship and art. The story is simple. Theophilis is proposed to succeed a bishop who has just died. He refuses the honour so as to continue writing his hymn to the Virgin Mary – 'In every line must be what I have dreamed and what I have thought and what I have learned for years.'

Another (bad) monk is elected instead, and he proceeds to make life miserable for Theophilis and his friend the archivist. ('A man has the right to sacrifice himself, but has he the right to sacrifice others?' asks Theophilis. 'If the other really be his friend,' responds the archivist. 'You prove there is still generosity in the world.' 'Not generosity,' says the archivist, 'friendship.') Greatly embittered, Theophilis seeks revenge and enlists the Devil's aid in a series of cheap gains that boost his ego and power. When the old Pope dies, the Devil offers the job to Theophilis, who comes to his senses and turns it down. The bond between them is broken, and the Virgin makes a personal appearance to reassure him that everyone falters, and that in art it is the striving, not the achievement, that pleases her.

What is memorable about *The Virgin and the Clerk* is not the message, which was hardly news to an eleventh-century audience, much less a twentieth-century one, nor the characters: Theophilis' about-face, from unworldly artist to snubbed functionary, willing to sell his soul because he wasn't invited to a dinner party, is hardly credible. It is the bitterness that lingers with one. After having been snubbed by the new bishop, now his enemy, Theophilis comments to the archivist, 'The purpose of entertaining is not to give pleasure to those who are invited, but pain to those who are not.' He expands: 'Those who treat you well in this world are not the people who love you, but the people who are afraid of you.'

Kingsley tries to offset Theophilis' rage through his exchanges with the archivist, but he invests the latter with so little intellect that bitterness again overwhelms. Discussing their adversity in the coded language to which they seem to have been addicted, the archivist comments, 'Two standing together have double strength.' Theophilis retorts, 'But present a double surface to the wind.' The archivist concludes, simplistically, 'What matters when there be friendship?'

Their conversation, in the play presented in stereo, is really the sound of one man arguing exhaustedly against himself when he has already, deep down, made up his mind. 'A man has the right to sacrifice himself, but has he the right to sacrifice others?' To Kingsley in the coming decade, this would become the question.

It is a pleasant daydream of mine that the young Kingsley and elderly Henry Adams had been acquaintances, converging now and then on I Tatti to jointly wear down Berenson's resistance to medieval art. It wasn't unlikely, but neither recorded such an instance. Of Adams' investment in the Middle Ages it has been written: 'We must respect the deep impulse which was behind it all and realise that Adams had, after his own fashion, really found a refuge in which his soul could stand.' Setting aside the question of their meeting in fact, perhaps Kingsley and Henry Adams did rendezvous somewhere in the cool, romantic shade of their medieval reinventions.

Actually, while the two men had much in common, no brotherhood amongst the ruins was essentially possible. Adams' remarkable study served, after a fashion, as his soul's sanctuary. His need for distance may have been so profound that he sought it in time as well as space, the book being a corollary to his constant travel as far away from Washington (where he'd lived with Marian), as he could get. It also came close to the illusion of repossessing the past. Kingsley's play, on the other hand, gave public expression to an inner dilemma, and dressed it in medieval garb. Writing in the last moments in which it was possible to be a 'professional' historian and lyric poet in the

same text, Adams took an empirical approach to Romanesque and Gothic architecture. Yet he recorded responses to facts and artefacts not of his intellect but of his *soul*, in a mighty effort to understand something external to him, a 'pile of stones' from another time and place. You might say he had the courage to give to Chartres the same intensity of self he had once given Marian. Adams may have had psychological demons driving his work (there's a large, queasy body of literature about his relationship with women and the Virgin Mary), but on a conscious level he used his emotions as tools for understanding art, not vice versa, and in turn art gave him refuge. As he realized himself, it could all be shattered 'by a single motive' of his own.

The Virgin and the Clerk – the flip side to Kingsley's ten volumes of documentation – was virtually all motive. If the earlier work drew little or hardly at all on his emotions, the play drew upon them exclusively, but not in response to external allures of art or history (he had already considered those things 'scientifically', as an archaeologist). Had that been the case, Kingsley might have found the simple solace, the companionable pleasure and, indeed, sanctuary of being buoyed in contemplation of something other than the self on the universal plane of art, religion, or science, where mind meets mind. But the play was another animal altogether. It was an aspect of that old dream of the Middle Ages that he already held in his head, which his learning gave trappings of tone and substance, rendered almost palpable (or indeed very palpable; it was staged once at the Carnegie Institute of Technology in Pittsburgh in 1930).

There is no dishonour in working from the inside out, nor does it inspire lesser art. It does not, however, give sufficient substance to the ruined past that Kingsley so wanted to rebuild – not enough, anyway, to offer shade from the blinding sun of the self.

5

MAPS AND QUARRIES

It is a kind of chalky russet
solidified gourd, sedimentary . . .
A stone from Phlegethon,
bloodied on the bed of hell's hot river?

'Sandstone Keepsake', Seamus Heaney

The miracle had a long, twisted tail of asphalt edged in ferns. Up it
I climbed, up higher, side-winding up a silent hillside early enough
in the morning for shadows to be long and blue. The river Lot lay
below, down amongst the sunlit pastures of the valley; above, over
the rise, somewhere to the south, wound the Aveyron. All was dense
greenery, freckled sunspots, and shadows. And then the miracle. I
left the car and stood in the middle of the track, hands on hips,
open-mouthed.

It was as if a giant from another time had stood on the hilltop and
poured his giant's pitcher of chocolate milk all the way down the
slope. A wide stream of it, mauve-brown and thick, a quarter-mile
long, and it had washed away all the trees and ferns and shrubs in its
path. Then, without absorbing into the earth, it had solidified, petri-
fied, and cracked. And it was still there today, chocolate-coloured and
broken and rock, but a *stream* of rock none the less. Or I should say
of rocks: a stream of hundreds, no millions, of rocks, each one a little
bigger than a football.

The road cut the stream in half. The top slope was in sunlight, fringed with trees on the hillcrest. The down slope was in shadow. The miracle was the Coulée de Lave, what the people of nearby Espalion called the Lava Flow. A brochure that I'd been given at my hotel was quick to correct the name; it wasn't a flow, it was a landslide. About seven million years ago there had been an eruption and the lava had cooled and hardened into a towering ledge that dominated the valley. The ledge had taken the shape of giant columns of jointed, basalt prisms (think of 'crystals' too irregular to fit seamlessly together), which had weakened with erosion and eventually collapsed into the valley, breaking into millions of reddish-chocolate-coloured pieces as they fell. It was a singular event.

What's strange – what held and hypnotized me – is that it could have happened yesterday. Nothing green grew where the giant basalt formations had fallen seven million years earlier. The only indicators, and sly they were, that any time had passed at all were pale patches of lichen discreetly spotting the rocks.

> You go up the long track
> That will take a car, but is
> best walked
> On slow foot, noting the lichen
> That writes history on the page
> Of the grey rock.

The Welsh poet R.S. Thomas wrote that, and very aptly indeed, although in this case lichen told the story that came before ours. Lichen told the tale, lichen gave it away every time.

I was back in the Rouergue, back in Espalion at my favourite hotel, the Moderne, seeking something at once much older *and* younger than the Coulée de Lave. I hadn't been able to get the church of Perse out of my mind. I wanted to know where its red sandstone came from, where the ancient sedimentary stuff – it was probably hundreds of millions of years older than the basalt – had been quarried

a thousand years ago. I needed to know its provenance. Once, before the red stone had been shaped into blocks and angels, before it became a corbel of a two-tailed mermaid just above the main entrance, with long tresses, two bare little breasts, and scales on her fishy bottom (a reminder about the pretty perils of lust), it had lain somewhere nearby, quietly underground. It had known tree roots and rainwater and more warmth from the earth's furnace than Perse's interior ever provided. Back then, when the church was just a pre-monition of this stone, as another Welsh poet, Gillian Clarke, would have it, where did it do its dreaming? Was it a hill waiting to be levelled? A seam in the valley waiting to be opened? Did it know the river or the rises? The answers were part of the church and I loved the church, so I wanted to know these things too.

Not that it would be easy. A few days earlier I'd been driving just south of town near the village of Biounac and had come upon a pair of farmers, husband and wife, calling their sheep at the end of the day. The sheep had just been sheared – they were honey-golden in late sunlight – and were running hell-for-leather toward the farmers, heads down, single-minded, knobby-kneed, the effort and glee of it all forcing their tongues out of the sides of their mouths. They were the very picture of heedless obsessives, and over the course of my time in Espalion, hurrying about, asking questions, seeking quarries, I came to see myself as one of the flock.

The problem was that unlike the stones of Conques Abbey, the source of Perse's building material was undocumented. Where did one begin to look for a medieval quarry, doubtless filled in centuries ago, that had supplied a little parish church? Besides, Espalion was nothing if not red. The fifteenth-century church of St Jean, now the Musée Vaylet: red sandstone. A river-serpent of a bridge over the Lot, graceful, triple-arched in profile like the Loch Ness monster, built around the same time as Perse: red sandstone. The tall medieval tanners' houses lining the riverbank, their foundations sunk deep below water level: red sandstone hidden under coats of plaster

(occasionally the stuff went out of fashion). The new post office, built in the late 1970s or 80s (no one remembered for sure): red sandstone. Only the parish church that replaced St Jean in 1883, a building trapped without a soul in commonplace nineteenth-century dignity, was actually built of limestone and hidden beneath a thin *crépis* of red (all but the façade and buttresses, which were real). At the time, sandstone had been temporarily too expensive. Otherwise it was simply *matériel du pays* – local stone.

I went to inquire at the Musée Vaylet. 'Come back tomorrow,' said the same old couple at the door, 'the man who works here tomorrow will know where the stone is from.' I went to the tourism office. 'Go to Bozouls, the next town over; there's a geology exhibit there. Someone should know about a quarry.' I stopped at the greengrocer's where I'd bought cheese months before. He remembered me, gave me a handful of cherries, and said something to the effect that my search was heroic but futile. I went to the library. Despite my halting explanation in French, the concave-chested librarian took up my quest with alarming gusto – I think all librarians hunt buried treasure in their daydreams – and brought me every book she had on Perse, including an unpublished thesis. When I escaped hours later, having exhausted the resources to her satisfaction (mine had been met at least an hour earlier), I knew that Perse's monastery, now vanished, had been standing as late as 1664, and that there are currently 6,806 registered quarries in France. But nothing about the source of Perse's stone.

Head swimming from an unholy combination of French texts and fluorescent lights, I sought shelter back at the Moderne on the eastern side of the Lot. The Hôtel Moderne is *not* built of red sandstone; it's a half-timbered, rambling behemoth that wraps around a corner at the town's busiest intersection in a confusing triptych of façades. Two of its faces poke up in gables above a mansard roof sheathed in fish-scale *lauzes* (here made from slate rather than schist). A little turret capped by a rooster weathervane separates the gables.

The effect, intensified by a second-storey, façade-wide box of red geraniums, is oddly alpine.

Inside there's a reception area with a quasi-public bar (guests rarely dare approach) and a genteel sitting room with old sofas and good rugs laid across a leathery, hardwood floor. Most people tend to shun the tiny elevator in favour of two ancient and twisting flights of stairs. The breakfast area extends off an elegant dining room beneath a low stone arch. The latter is called L'Eau Vive – literally, Living Water, its speciality being river fish – and it has a sure, light touch in its handling of both food and customers.

The Moderne is run by a mother and son, both in their prime, complemented by a stylish, good-natured staff that remembers how guests like their morning coffee. I had been to the hotel many months before, and hadn't really expected to return. When I'd walked into the lobby on this visit, bleary and dishevelled from a long journey, the pretty, doe-eyed young woman at the desk had exclaimed – there is always a table of friends and family members at the Moderne, tucked semi-privately behind the desk, to exclaim to – 'La petite journaliste est revenu!' I'd been surprised she'd remembered me, more so when the owner had risen, instinctively smoothing her skirt, to greet me personally. Once again I'd been struck by her air of serenity, which seemed at one with her beautiful posture – striking in a tall, older woman – and dark silver hair, which she wore pulled back in an immaculate bun. She'd taken both my hands in hers and greeted me with warmth, and, seeing the state of me, discreet brevity.

Now I sat in the dining room, gripping a pen between my thumb and forefinger and a glass of wine in the remaining three. It felt comfortable and right. A young waiter arrived with my starter, a Rouergat salad, which was large and satisfying but barely dented my hunger. Of its lettuce, potatoes, ham, and hard-boiled eggs, it was the potatoes, introduced to the Rouergue in the 1860s and now a huge favourite, that earned it the adjective 'Rouergat'. The last time I had eaten in the Moderne I had unintentionally driven my

shy young waitress past the limit of her duties into heroic humili-
ation. Although the restaurant specializes in fish, that night I'd pre-
ferred meat; *pas de problème*, said the waitress, who was confident
I'd want the special. I'd asked what it was; she told me. I'd
asked again, listening carefully; she repeated. Then she said, '*Peeg.*' I
shook my head. 'But I say in English,' she cried. '*Peeg!*' Still I didn't
comprehend.

'*Mais vous savez!*' – But you know! – she protested in frustration.
Try as I would, and I ached for her, I was being magnificently stupid.
Then she drew herself up, took a breath, held it a millisecond, and
snorted. It was a thunderous, meaty snort that echoed throughout
the dining room and established its goal of instant comprehension.
Everyone stopped eating to stare at us, and she and I – after a second's
deep shock on both our parts – collapsed into hilarity. After that I'd
eaten excellent pork and she'd stayed far away from me.

That waitress, I realized with both relief and unease, was nowhere
in sight. After the salad I returned to my journal. 'Last night dreamt
that the knuckle-shaped door-knockers at the hotel were real hands
that grabbed me and wouldn't let me go. Decided it was another
emblem of obsession, like the sheep.' Dinner – steak with haricots
verts, roasted potatoes, and a mousse of pale cheese and herbs that
melted over the edge of the meat like a low, broad waterfall – came
and went. I'd saved a few mouthfuls of Marcillac for the cheese board,
from which I selected a wedge of Bleu de Causse and Laguiole.
Unlike Roquefort, which is made from goats' milk, this blue is pro-
duced from the milk of cows; by the time I finished eating it, I felt
very much like one.

Quick footsteps came up behind me and stopped at my table; a
shiver poised for an instant between dread and gluttony, then shook
itself loose down my back. The owner believed I needed dessert. I
declined. But one must never end a meal with cheese! Cheese is a
transition, not a conclusion!

I started to argue, then simply mimed panic. She took pity and

disappeared, returning moments later with a perfect sphere of black-currant sorbet, a lovely shade of deep, sunburnt maroon, sent as a gift by the kind-hearted chef. 'It is,' she said gently, 'precisely the colour of the earth.'

* * *

Morning brought hope and frustration. A large brown envelope had arrived for me – 'Mlle. Pamela Petro, Hôtel Moderne, Espalion' – from a French geologist named Annie Blanc. In it was a colourful diagram of the south porch of Beaulieu Abbey in northern Quercy, confusing and promising in equal measure. I set it aside to make sense of later. The frustration came at the Musée Vaylet. The old couple had led me astray. Their co-worker knew nothing about medieval quarries. The stone is, well, it is *partout* – everywhere, he said, making a very French noise like a cushion being sat upon (Boof!), that admits frustration but seals hope with finality.

That left Bozouls, what Lucy had called in her journal 'a curiously-built town', on the edge of the Causse de Lanhac. It turned out I'd misunderstood her, thinking I would find something odd about its pink-and-yellow houses of rough-cut limestone. But there was nothing curious about them whatsoever, apart from the landscapes that hung in their windows. One set of curtains depicted a barnyard with chicks, hens, and roosters, a hill rising beyond; on another horses galloped across a turfy meadow. It was as if all the windows in Bozouls were mirrors that reflected the Rouergat countryside in white lace – arresting, but not odd. What was truly strange about Bozouls wasn't how its houses were built but where. Here in the centre of France, without the benefit of Atlantic or Mediterranean, was a narrow head-land that fell away into a deep *trou* – a hole – on three sides. The oldest part of town crowded on top of it.

The hole was the work of the little River Dourdou, the ancient rage of which had also sculpted the shell-shaped enclave of Conques. Some time in prehistory, relatively not too long ago, the river on its

way to Conques had come upon a circular deposit of soft, Jurassic limestone where Bozouls sits today. Over time its waters sculpted what would have been a perfect circle out of the soluble stone, had not an arm of much harder rock protruded into it, forcing the river in a fury around the headland, driving the water deeper and deeper into the buttery limestone. The result is today's peninsula, one street wide, teetering atop sheer cliffs far above the tops of trees growing in the *trou* below. The church of Ste Fauste, pink and Romanesque but closed, clings to the narrow tip. From it I could see striated limestone cliffs, yellow and grey, ringing me in a perfect, 270-degree fan. It was, as the French say, *un site géologique curieux*. They advertised it – Trou de Bozouls! – on the local highway.

I thought it must have required a sense of humour to build a town on a tiny finger of land several hundred feet high, surrounded by a giant hole. For that I liked Bozouls and forgave the little rivulets of tar that oozed down its main street in the ungodly heat, pulling my sandals from my feet.

It wasn't hard to find the geological display in a swanky exhibition centre in the newer part of town, on the 'mainland' edge of the *trou*. Bored school children crested here and there in sporadic waves of attention, listening to the Tour de France on radio headsets. It wasn't a high-budget display, but I knew at once I was in the right place. A geological survey map was tacked to one wall, and labelled stone specimens sat in piles of their own mineral dust on folding tables. The children left and I had the place to myself.

'May I help you?'

'*Non, merci, Madame.*' I wanted to be left alone with the stones. I peered hard at the map.

Three, maybe four beats of silence, then heavy breathing over my left shoulder and the smell of old flowers and older fried fish. 'It is a map of the *sous-terre*' – literally, the under-ground – '*oui?*' Yes, I said, thinking 'hell' in more ways than one. 'This interests you?'

Yes, I said, it interests me, regretfully turning around. She was a

very elderly woman, big-boned and tall, wearing a hearing aid and a smart, sky-blue summer woollen suit, crusted with food stains. She twirled her thick white hair around a finger and said she looked after the exhibitions. Her face was tanned, but the skin around her red-rimmed eyes was very white and fine, a souvenir of ancient girlhood. She looked like my mother's Aunt Elsie. We chatted, she simplifying her French for me, I simplifying my geography (I came from Massachusetts – No? – Boston – No? – New York, then) for her. Finally she was called away and I was left alone with my rocks.

And what splendid rocks they were. There were specimens of *calcaire* – limestone – from Lunel; a blob of frozen yellow ooze studded with fossils (more limestone) from the Causse de Larzac; a shiny piece of schist from St Cyprien sur Dourdou. I felt as if I were amongst old friends. There was also a piece of pale grey limestone, sliced open to reveal a consistency like suede, 'remarkably fine', said the label, from the 'Quarry of Monsieur Alla, Commune de Sauclières'. My God, I thought, it was the masons' stone from Conques! This was the same glorious stuff they had used for their memorial capital, cryptically noted to have come from 'the *causse*'. I was elated. M. Alla's quarry wasn't a thousand years old, of course, but it might offer an insight into the source of Conques' finest stone.

I had come to Bozouls trying to find a home for a red mermaid, and lo! Here was a clue to the grey masons instead. It was a fantastically lucky break.

'*Madamoiselle?*' Oh no. My heart sank. 'Look!' The old woman was shuffling towards me carrying a phone book that she could barely read even with her thick, magnifying eyeglasses. She stood close to me and again I was engulfed in old fried flowers. 'Here is the name of the man who organized the exhibition, a retired professor of geology, and his phone number. He lives near Bozouls. I called him for you but I am afraid his daughter said he was on holiday. This is the time of summer *vacances*, you know. But perhaps you could reach him later?'

My shame was visceral – it made me sweat with discomfort. She had also located a working quarry for me just north of Espalion, but was dismayed to report it only produced gravel. I gave up (slightly reluctantly) on the rocks and sat with her in a connecting room filled with puddley abstract paintings. We talked about chanterelle mushrooms and when the French begin to eat soup again after summer (1 October, no matter the weather). I asked if she knew of Sauclières. No, she said, she'd never heard of it.

I buzzed open the door and a draught of winter rushed over me, instantly harvesting little pearls of perspiration on my forearms. A light clicked on automatically. Someone had cleaned up last autumn's leaves, but it was still bone-chillingly cold inside the church of Perse, and doubly dark where the electric lights didn't shine. I was afraid of being locked in.

I traced thousand-year-old chisel marks with my fingers on the big, tongue-coloured sandstone blocks of the nave; the slanting incisions looked like children's pictures of rain. Above them were two carved capitals, one of plump birds drinking from a fountain, the other of two men fighting, one with a club, the other a sword, both gripping shields like those in the Bayeux Tapestry. And they, too, were dried-blood red.

In Seamus Heaney's poem 'Sandstone Keepsake', the poet finds a piece of red sandstone underwater in a coastal inlet. He thinks it looks bloodied, as if it were from Phlegethon, one of the rivers in Hades that runs with liquid fire, eternally burning its victims without consuming them. Heaney picks up the rock and it steams in the cool air:

> Evening and frost and the salt water
>
> made my hand smoke, as if I'd plucked the heart
> that damned Guy de Montfort to the boiling flood . . .

Guy was the son of Simon de Montfort. The father, an Englishman of Norman heritage, was a famous scourge in Quercy and the Rouergue in the thirteenth century, burning Cathars – religious heretics – for the King of France. He is remembered for commanding, when asked whether or not to put a church filled with Cathars to the flame, 'Burn them all; God will recognize his own.' Much later Guy avenged his father's death by stabbing his killer's unarmed son in church during mass, and cutting out his heart to display on London Bridge.

The poem shuddered between old violence and modern quietude, just like the cold red church where I sat. I'd realized I would never find the location in space from which Perse's stones had been quarried – that was lost for good – but in Bozouls I had found their location in time. Some pilgrimages, I was learning, require different per-ceptual co-ordinates, and some quarries demand to be dug in other dimensions.

The geological survey map in the Bozouls exhibition had colour-coded the bedrock of Espalion and its environs by type and era. The limestone of the Causse de Lanhac was burnt-orange; the metamor-phic schist of the Aubrac highlands was green. Stretching between them, south of the Lot and including the town of Espalion, was an irregular swath of pewter-grey that corresponded to the *rougier*, the red sandstone, of the Permian Period, 290 to 250 million years old.

The Rouergue is underlain by vast deposits of *rougier*. It crops out nearly purplish-plum-red in the nearby valley town of Marcillac, where the south-facing slopes of the Causse de Comtal make ideal roosts for the vineyards. It crops out further south in St Affrique, near Roquefort, where Conques' red sandstone was quarried. All of it formed during the 40 million years of the Permian Period, possibly one of the most horrifying times the earth has ever known. Permian stone is awash in fossils that all but disappear in the younger rock directly above it. Geologists haven't discovered the reason, but the record shows that during Permian time death rolled over the earth and took between 50 to 96 per cent of all living things with it. 'It

was an extinction of a magnitude,' writes John McPhee in *Annals of the Former World*, 'that would be approached only once in subsequent history, or – to express that more gravely – only once before the present day.'

In this church I loved, embedded in the mermaid, the cut stone blocks, the angel Raphael, in the Devil and Christ himself, was the suffering and death of creatures whose lives and bodies I couldn't begin to imagine, on a scale impossible for my mind to grasp; violence so wrenching and thorough it would shock Cain, not to mention Guy de Montfort. Like the Christian God to whom the church was dedicated, the Permian Extinction was there inside it, invisible, a matter of belief. Permian time, the cataclysm and misery of it, occurred so long ago that to acknowledge it as an actual, prehistoric moment requires a leap of faith not dissimilar to a belief in God. The church of Perse asks us to believe in both, and it's not an outlandish request.

Like metamorphic rock, converted by heat, pressure, and time from one material to another, so, perhaps, the cycles of prehistory passed through the vice of our collective imagination to emerge as metaphor, as the compact, crystalline notion we express as God. I have read that R.S. Thomas, the poet of lichen and the basalt miracle, himself a clergyman, despised red sandstone. I don't know why; perhaps he didn't wish to see a premonition of God's footprints in the fossil record.

The narrow shopping streets of Espalion buzzed. It wasn't a big town, only 4,600 people; Rodez, just to the south, could more aptly be called a city. But towards evening Espalion summoned a palpable energy. Delivery vans, lights flashing, tried to inch through swarms of pedestrians; behind counters, otherwise open to the hubbub, butchers expertly wrapped fist-sized packages in brown paper; a few tourists spun postcard racks and images of Conques whizzed past; the green and blue neon cross of the Pharmacie de l'Europe quietly

hummed. There was activity but not much noise. A good sense of calm, ancient habitation and modern well-being had hold of the place. Above town, atop its ancient volcano, the ruins of the Château de Calmont d'Olt caught brass-coloured sunlight. Driving in from the south, over the *causse*, I'd looked down into the river valley and it had been like a child's Monopoly board of rural France: the town, the fields, the silver river, the detached hill with its castle, another hill behind it recently ploughed and bright red, all rendered in simple visual epigrams. It was so striking I'd half-expected a giant hand to emerge from the cloud-cover – it being God's turn, I guess – and move the château to another hilltop.

I asked my friend the greengrocer if he knew of Sauclières. No, he'd never heard of it, but he did have fresh goat cheese for sale. I bought some for dinner. In the Lot, fish the colour of tarnish struggled against the current so as not to be swept down a little weir.

Now pull away from all this, far back, farther than the Monopoly view from the *causse*. From this far-distant perspective everything I had seen, smelled, and touched today was man-spun lichen, writing our story on the bedrock – so very momentous to us, and on the geological scale just another temporary way of marking time. Of course someday, incomprehensibly far in the future, we might just *be* the bedrock.

We ask who loves us and who doesn't, and if there is justice. We ask why there is suffering or, as Romanesque art compactly puts it, if we are saved. And we consider these the ultimate questions. But there are questions beyond these – they may be of more concern to our organic matter than our moral awareness (never mind about where 'us' resides), but they exist, none the less. Will we, packed into our hard, shallow beds with our lovers and enemies, our houses, pets, cities and lichen, our century and others we've never known, remain sedimentary or become metamorphic? Will some apocalyptic violence toss us into the air – will we become great mountain chains – or will we lie low in tropical basins? Will we bear fossils, and what will they

be? An old Boeing 747? A shoe? A bear? Or perhaps some of us will become fossils ourselves, claimed one day and pressed like leaves in the soot of an unknown sea.

I recalled a long-ago afternoon on the beach. Someone had shouted, 'Look, there's a dog in the water', and everyone had stood up to see. A man with binoculars corrected him, saying no, it was a fawn, swimming fifty feet or so offshore, confused and heading out to sea. Someone suggested it had been driven off the cliffs by wild dogs. The lifeguards had fetched their surfboards and paddled out to save it, but the fawn went under before they got there. It had been seeking safety in the wrong direction; they never found its body. That happened almost ten years ago. The fawn is already on its many-million-year journey to becoming limestone.

To my surprise the memory brought quick, hot tears to my eyes, and I absently kneaded my hands against the side of the old Romanesque bridge over the Lot, where I'd been standing watching the fishermen. Red grit came off on my fingers and to my relief time began to leap exponentially in my mind. Decades quickly skidded into centuries into millennia into epochs. Suffering was brief. The thought that living creatures became rock that became art – a small red mermaid on a sandstone church – and its corollary, that we mermaid-carvers ourselves may one day become rock that may become art, was compelling and oddly calming. From this perspective, the weathered eternities of Romanesque sculpture, coming undone after just a thousand years of wind, sun, and rain, again partook of life everlasting, albeit a more communal kind. They, too, were part of the eternal process of ruination and recycle. A Celtiberian site I'd once seen in Portugal – the round hole of a crematory excavated out of living rock, explicitly chiselled to resemble the human birth canal – came to mind out of nowhere, and for the briefest instant life and death, creator and created, linked arms. The man next to me reeled in his line, pointed to an empty bucket, shrugged, and left. A swan chased a Golden Retriever out of the water.

I returned to my room at the Moderne and threw open the tall windows, then buttoned back the shutters behind them, letting in a gusty, foreboding wind that blew up every evening at this time but rarely, in the end, summoned a storm. My view included a row of dormers, the nearest of which was close enough for me to touch its fish-scale tiles, so like the mermaid's tail. I threw my packages and notebooks on the bed and opened a bottle of Estaing, a *Vin délimité de qualité supérieur* (VDQS) wine from a nearby town of the same name, a pretty place with a castle, also on the banks of the Lot. A 'superior quality' wine ranks one notch below France's top-drawer 'AOC' designation, *Appellation d'origine controlée*. The Estaing, made from grapes grown on schisty slopes, reminded me of a Gamay Beaujolais. It was unchallenging and pleasant and contained alcohol – three fine things in a wine – whereas the Marcillac of the previous evening had required more attention, conjuring up complicated memories of blackcurrants and blueberries.

Most evenings when I travel I dine the way I was preparing to dine now. Place tomatoes, cheese, and bread on separate notebooks; open my lucky Swiss Army knife and cut sizeable chunks of each without too deeply gouging the covers; wash and slice an apple; pour wine into whatever glass has been supplied for the bathroom. Tonight's featured cheeses from the greengrocer's were *cabecous* – round pats of goat cheese, specialities of Quercy and the Rouergue, that are allowed to remain idle and uneaten long enough to grow soft, downy skins. Brought to room temperature, their insides have the consistency of molasses and a taste like a warm, farm afternoon.

The last time I'd stayed at the Hôtel Moderne I'd prepared another memorable bed picnic. That one had consisted of a Nestlé's crunch bar; stolen breakfast baguette; a farmer's cheese made of cow's milk from the Aubrac so mild as to have had almost no taste (a fact that changed dramatically over time), and a texture between chalk and cream cheese; green olives I'd bought in Andorra; the last of the glorious Moltig grapes; and a bottle of Entraygues, another VDQS

wine of the Rouergue that had tasted strangely of bacon. Then I'd
watched a Women's Weightlifting Championship on Eurosport TV;
now I tuned in to Synchronized Diving.

As I was eating, one of the shutters came loose and the wind
banged it against my window. The *cabecous* were running faster than
I could eat them, so on my way back from securing the shutter I
grabbed a piece of hotel stationery to help staunch the flow. Months
later I would find it pasted into my notebook, glued fast with old
cheese – the latter-day mate of a similar piece of stationery I'd found
amongst Kingsley's letters at Havard. On 16 August 1920 he'd writ-
ten to his brother Louis on notepaper stamped with the following
heading:

> Grand Hôtel Moderne
> K. Berthier
> Espalion, Aveyron
> Chambres T.-C.-F.
> Chauffage Central
> Salle de Bains
> Telephone No. 11

The notepaper has been updated, but the address is still the same
(though the proud possession of central heating makes somewhat less
of an impact today). Our routes were crossing now without my
anticipation. Kingsley's letter to Louis had been about their setback
in Carcassonne; after that he'd gone on to expand about the French
character. 'It seems to me [that] laziness seems to be a vice unknown
in France. What sometimes appears to be such, I think, is a sort
of constitutional dislike for a botchy job. People who are perfectly
competent will refuse to do all sorts of things for you, but I think it
generally comes down to fear that they won't do it just right.'

Plenty of people did things for me at the Moderne – photocopies
thought to be useful were produced on my behalf, telephone books
were fetched and interpreted. Of course none of these things required
particular skill. Had I wanted them to extract a tooth or teach me

how to juggle, I doubt they would've tried to help. I wondered on what scores Kingsley had been refused. He thought that in comparison to the French, 'other peoples', of whom he singled out the Spanish, Italians, and Americans, were rather crude.

Despite that, Kingsley longed to live in Italy; Paris would do at a pinch. He didn't much like the States, yet in Europe he was prone to sloth, which was something his Yankee nature could not condone. In the spring of 1920 he'd written to his brother from Italy: 'The golden minutes are flying by too quickly. And yet I have an idea that I do not do as good work when I am having so congenial a time. Perhaps after all Cambridge [Massachusetts] with prohibition and American prices and poor food and the general absence of all things that make life sweet may prove to be very wholesome.'

Whereas Lucy seems to have thrown herself into planning their long-distance move to Cambridge, where Kingsley would take up his duties at Harvard in the fall of 1921 – her letters to Ruth are full of vigorous preparations for the occupation of Elmwood – Kingsley is almost silent on the subject. In fact, while they were villa-sitting at I Tatti for the Berensons in the winter of the same year, he was still dreaming about living part-time in Cambridge, and part-time in Florence. 'The thing Lucy and I both long for,' he told Berenson, 'is a definitive home.' But according to him, the location of that home differed.

'Lucy although she will not admit it, I think secretly fears a little living in a foreign country,' he continued. 'She thinks we should feel hostile towards the Italians and remit to American type. But I wonder whether this might not be rather a good thing. The promiscuous cordiality of New Yorkers seems to me much more dangerous.'

Kingsley's eagerness to remain in Europe while circumstance – or rather his own acceptance of security at Harvard – inexorably tugged him home, seems to have made Lucy into a scapegoat. It's difficult to see how he could rationalize that a woman who had just spent almost three years living cheerfully in hotels and friends' houses all

over Europe could 'fear a little living in a foreign country'. The only time the Porters actually spent at home in New York between 1918 and 1921 was a brief interlude from October 1919 to February 1920, when Lucy had an operation in New York to remove an ovarian cyst. Even then, Kingsley was chomping at the bit to return to the Continent. He booked an impossibly early date for their crossing, and then had to postpone it when Lucy, not surprisingly, hadn't sufficiently recovered. When they did leave some weeks later it was only with her doctor's reluctant release.

Lucy rarely kept a journal when she was in the States, but she did write several pages about her operation, beginning with the offhand quip, 'suddenly we remembered we hadn't had Arthur overhaul me'. Even in so personal a record as her journal, Lucy maintained a tone of cool, almost jovial detachment about herself and her health – as if being a Good Sport were the supreme goal in life.

'It was done on December 19 at St Luke's . . . For me the entry into the hospital meant my own hard times were over. K stayed that night in a different room . . . Never can I appreciate his exquisite solicitude and fortitude. I remember the last thing on the operating table seeing his face with pain in it and feeling he must be spared this – that he wasn't used to such things and shouldn't have to stand it. Then – came the return to life in my room – the welcome pain told me I was still alive . . .'

Following her surgery Lucy and Kingsley received what turned out to be the false report that Lucy was pregnant. Here her journal is more cryptic.

> We had the scare of my being pregnant. Again K. was so wonderful and kept assuring me we'd find a way out which wouldn't mean death to me. I fear[ed] he would mean killing the child (which wasn't there in embryo after all [here Lucy drew a smiley face]) . . . as well as my bidding adieu to the sunlight . . . We read much – of Shelley's and Keat's deaths – the end of full life seemed to fascinate us . . .

It is impossible to know what factors made Lucy's having a child an unthinkable prospect. Whatever they were, the palpable relief she records in *not* being pregnant after all is striking. One thing is clear: emerging from the private shorthand of Lucy's journal is the sense of a woman not only eager to live, but to live on her own (and/or her husband's) terms.

Soon after Lucy's release from hospital the Porters were preparing, with apparent happiness on both their parts, to return to Europe. By March 1920 they were again contentedly ensconced in Italy, about to commence photographing Volume III of *Romanesque Sculpture of the Pilgrimage Roads*.

Lucy's readiness to return to Italy, especially after having been ill, refutes Kingsley's later charge to Berenson that she felt hostility toward Italians on account of the First World War. Not only are her own letters full of enthusiasm for Italy, she later became so attached to her Italian servants that she arranged for a cook, a waitress, a laundress, and a chambermaid, along with Anfossi and Natalina, to return with her and Kingsley to the States. (If your lot in life was to be a servant in the 1920s, the Porters' house was the place to work. Lucy's date-books are filled with planned outings for the help: 'Maids to theatre', 'Maids to country', 'Maids to Boston'.)

The issue clearly wasn't Lucy; it was Kingsley's desire for security and respectability in conflict with the freedom he felt living abroad. He opted for the former, and conveniently handed the responsibility for their return to America to Lucy. Like so many Americans, Kingsley found more breathing room in historical time – and in my case, prehistorical time – than in the open spaces of the New World that attracted so many Europeans. At home he had to live in the present, and for Kingsley, that was one temporal dimension too few.

* * *

I was crushed. The staff at the Moderne hadn't wanted to tell me, but they could no longer keep silent: my room was booked for the

night, and the hotel full up – yes, yes, it had been booked months ago. Ah, well, boof! I'd made no reservation! – and I would have to leave. Yes, that morning. They were so sorry.

I regretfully packed my bags and paid the bill. One last question, I said: did they know of Sauclières? No. Friends were found and asked. No, no one had ever heard of it. The doe-eyed young woman had a brainwave and looked it up in a phone book, and discovered that there *was* a Sauclières in the Rouergue, and gave me the mayor's telephone number. The owner came out from behind the desk and kissed me on both cheeks. I hated to leave.

One reason I was loath to go was that I didn't know *where* to go. The very idea of speaking French on the telephone to someone I didn't know – calling the mayor's office, no less, and asking about a quarry – filled me with dread. In addition, the goats' cheese had had an ill effect upon my digestive system and I was feeling a little fragile, so I felt myself entitled to a day's procrastination.

The land around Espalion was rural without being wild. As I drove somewhat aimlessly I was aware of intense cultivation, of pastures, cabbage plots and cornfields, marine-blue windbreaks, all intricately embroidered into the soil. The hilliness reminded me of Wales but with a generous, wide-open horizon, a huge bowl of ridges and free-standing mounds. Farms offered pattern, texture, and silhouette – tweedy fieldstone walls, roofs like rough seas, with wave upon wave of slate *lauzes*, curling up pavilion-style at the ends – but very little fuss or incidental colour. At one point I turned down a farm track and straight into a herd of horned, Aubrac cattle. They calmly broke around me like seawater around a jetty as their drover, an old woman more or less dressed for church, whacked one of them on the rump and shouted in exasperation, '*Bêtes impossibles!*'

The little track led to a bigger one that led to the road to Marcillac, home of the Rouergue's only AOC wine. Marcillac's vineyards luxuriate in the unique embrace of lowland sandstone and highland *calcaire* that Annie and I had witnessed on our gruelling hike from

Conques to Lunel. It's a unique *terroir* of protected, sunny slopes and calcareous soil, a product of Permian death and Jurassic seas.

I arrived in Marcillac and all but gasped: the entire town was built of Permian *rougier*. It was so saturated in sunburnt stone – red, red, red everywhere – that Espalion looked pale by comparison. A friend had passed through several years before and thought Marcillac a backwater – full of slightly lunatic, leering youths, was what he'd said, though he'd praised the wine. I liked the place. Through serendipitous good fortune I found the last parking spot in town; I pulled in, sat back and rubbed my eyes. When I opened them I was looking at a simple hotel; moments later I was installed in a room with lace curtains embroidered with ducks. Across the way was a terraced hillside with grapevines braided like cornrows; gashes in the topsoil cut through to blood-red bedrock beneath. Bob Dylan sang 'Tangled up in Blue' through an open window. In littering the bed with the day's notes and receipts, I noticed that my bill from the Moderne didn't add up. I pulled out my calculator and realized they hadn't charged me for my numerous phone calls, my wine, or my breakfasts – a sweet generosity discovered too late for thanks.

Outside, in the earthen alley between Marcillac's shops and its parking area, men finished a game of *pétanque* and women in work smocks swept the day into twilight. The place was a jumbled red chequerboard of shifting tonalities. Rusty-red stone blocks with grey mortar; maroon ones with pink; oxblood blocks with white mortar (the eye hops and skips); terracotta pink ones with mortar of the same shade (the eye skims and rests); stone the colour of certain summer plums. The colour scheme was Paleozoic, in memory of a time around 260 million years earlier, when this very green corner of France was a hard, dry, red desert, much like Arizona today.

I was just in time for a quick *dégustation* of the local rosé, a crisp, cool sunset of a wine, before dinner. My hotel was having a special called 'The Aubrac' for 9 euros, and I didn't want to miss it. In fact everyone in the dining room ordered 'The Aubrac', which consisted

of one glass of wine, two sausages, a salad, crème caramel, and the *pièce de résistance*, *aligot*.

Aligot is the best-known dish of the Aubrac highlands, in the eastern Rouergue. It's made of cheese, potatoes, butter, and crème fraîche, puréed together into a smoothly yielding, molten mass the colour of creamy scrambled eggs, and though rarely served outside the region must be declared France's answer to macaroni-and-cheese. It's wonderful comfort food – in fact, it was originally made by monks (with soft breadcrumbs instead of potatoes), and served to medieval pilgrims on the Chemin de St Jacques as they made their difficult way across the Aubrac from Le Puy en Velay to Espalion, and on to Conques. The name comes from the fact that the cheese was melted – *l'aliquide* – which eventually tumbled, linguistically, into *l'aligot*.

Maps like to invoke the phrase Monts d'Aubrac, the Mountains of the Aubrac, but experience proves the place to be more of a high plateau, like a *causse*, laid atop bedrock of dark grey basalt schist. The Aubrac marks the southernmost expanse of the Massif Central, and carries with it, almost into the lap of Espalion in its snug river valley, a whiff of ancient, unfettered highlands known better to sheep and cows than settled men. Shepherds guide their herds up into its empty spaces each spring, and to this day cows march through main streets in late May wearing garlands of flowers, to celebrate their triumphant return to summer pastures.

The Aubrac is a place of few trees – those that manage to grow are arthritically bent before the wind – and turf a colour between young moss and dried tea roses. It's famous (relatively so: nothing in the Rouergue is much known outside southwest France) for its rare wildflowers, a strange bunch that includes viscous orchids shaped like bees and spiders; a bloodthirsty carnivorous plant that thrives in peat bogs; tall shoots with delicate but horribly toxic red bells called *Digitale pourpre*; and a prehistoric plant known as *Ligulaire*, also found in Siberia. Its villages are small, huddled, heroic, and dark.

I was not where I would be headed in the morning. Not at all.

* * *

'Ever hear of Sauclières?' I asked the hotel proprietor as he served my coffee and baguette. I explained that I was looking for a limestone quarry and began to mumble something about a column capital at Conques . . .

'*Non.*' I was abruptly advised to see Conques, and then accused of pronouncing 'Sauclières' wrong, which explained his ignorance.

This rankled. By now I was fed up with hearing '*non*' and called the mayor's office. The conversation with the receptionist was so easy and cordial that my knee-jerk eagerness to get off the phone made no sense. I explained that I had seen a sample of limestone from the quarry of M. Alla, and wondered if it were operating? *Bien sûr!* It is just outside the village. Anyone would be happy to point the way. And where is Sauclières? She waited while I pulled out my map. Near La Cavalerie. Where is that? Near Roquefort. Yes, in the Rouergue. How far from Marcillac? Sorry, I don't know Marcillac . . .

I marched back into the hotel and imparted this news to anyone who would listen. The assembled minds at the bar put La Cavalerie at a three-hour drive, which presented a conundrum. After looking over Annie Blanc's map of Beaulieu Abbey – and getting fidgety with excitement about what I saw – I'd made a reservation in Beaulieu for the following evening, which was about a three hours' drive north-west of Marcillac. La Cavalerie lay southeast, in exactly the opposite direction. I hemmed and hawed. The little masons glowed with Conques' night-time opalescence in my head, beckoning, beckoning. I hesitated. I bought water. Then, in a flash, I logically took note of the foolishness of what I was about to do, and roared away south.

Through Rodez' infuriating Olympics insignia of roundabouts (all roads in the Rouergue lead to Rodez), then east toward Sévérac-le-Château. This was dolmen country. On my last visit to Espalion I'd crested the ridge separating the Lot river valley from that of the

Aveyron, which runs lazily parallel further south, and spent a day hunting tombs. I'd had a map indicating seventeen dolmens within an area of about ten square miles; I'd sought eleven, found six. It had been a spring day of intense solitude and wind. There had been no one about, not a soul; most of the humanity that clung to the man-made little outcrops had weathered away, too. On my hands and knees, head stuck inside the Dolmen de Galitorte near Buziens – a perfect, open-ended cave – I'd listened to the sound of distant cowbells echoing off the walls, and been lonely.

Today I had no time to pity myself. I sped through the valley, taking only one image with me: a man building a *cabane* by the roadside, struggling up from a squat with arms burdened, just about to put the capstone in place. *Cabane, gariotte, cazelle, chazelle.* Different areas of the Rouergue and Quercy have different names for what is essentially the same thing: a small, circular, dry-stone shepherd's hut, usually built of grey or lion-coloured limestone. Slightly bigger and longer ones, called *burons* and shaped like Quonset huts, were once used on the Aubrac for making Laguiole cheese. Most *cabanes* are abandoned now. Earlier I'd found one on the Causse de Comtal, rounded on top – it looked exactly like a warm-weather igloo – which seemed to have found a new use as a toilet.

Naturally I was drawn to the little huts. They were lovely. Intricate (every dry-stone structure is a kind of thought-fossil, a record of selection and choice), and scrupulously simple. They're really hollow cairns, literally gutted of symbolic importance, making room to shelter the living rather then remember the dead.

> Let it be like the judgement of Hermes,
> God of the stone heap, where the stones were verdicts
> Cast solidly at his feet . . .

Heaney again. Yet the *cabanes* were judgements against the sentimental old god, guardian of boundaries and roads whose name means 'a heap of stones'. The immemorial practice of making cairns came

about to mark a boundary or memorial; everyone who passed added his or her own stone to the pile. These empty cairns of the *causses* reproached Hermes. Their message was different: our shelter is temporary, keep moving, there are sheep to look after. Or maybe, in his traveller's aspect – when he wasn't 'waist-deep in the cairn of his own absolution', as Heaney sees him, when he hit the road in his winged bootees, bearing messages – Hermes might have appreciated a *cabane* himself. A god of travel *and* of standing stone still: I smiled into the windscreen, and asked for his protection.

Near the loo-*cabane* on the Causse de Comtal a worker at a stone supply yard had been busy breaking big pieces of limestone into little ones with a sledgehammer. '*Calcaire?*' I'd asked eagerly. Don't know, he'd said, just stone.

By the time I reached Millau the fish-scale *lauzes* had disappeared, replaced by red-clay roof tiles. Houses were clad in white stucco. Not far from Sauclières now. Protesters dressed as Native Americans with tom-toms (I never discovered their complaint) held up traffic at an intersection, and after that the road pitched skyward, snaking up a colossal, naked wall of limestone. At the top I expected it to peak and then coast downhill, but the land tabled onto an immense plain of wheat fields. The cultivation alternated with bone-dry pastures of scrub-juniper pocked with grey outcrops: home to half a million sheep. The intimate, handcrafted look of the central Rouergue was gone utterly. I was on the Grands Causses, specifically, the Causse de Larzac.

My mind crackled with comprehension. These were *the causses*, the vast limestone tablelands against which the Petits Causses of Quercy and the central Rouergue – Gramat, Comtal, Cajarc, Limogne, and others – defined themselves by comparison. The aridity, the colours, the bleached greys, whites, corals, and pinks were the same, but the scale was monumental.

Now that I had nearly reached my destination I was seized by a

sudden, perverse desire to stall. Fearing that Sauclières might prove an anticlimax, I decided to make a brief side-trip to Roquefort to see the *caves* in which the town's famous cheese is aged. Give a flavour, literally, to the taste of anticipation on my tongue.

Roquefort looked as if it had been pushed off the edge of the Causse de Larzac. I could see its red-tile roofs, crumpled and corrugated, in a jumble at the base of an escarpment near the southwest corner of the plateau. To get there I slalomed down a reverse Jacob's Ladder of well-banked switchbacks – the D999 – that French engineers had hacked out of orange and violet bedrock. Above me, on the plateau I'd left behind, fortified farmhouses interrupted the horizon at irregular intervals and wheat fields, red with Flanders poppies, fell away to the east – the direction of Sauclières. Roquefort lay in shadow below.

Soon I was standing with a tour group beneath one of the roofs I'd just glimpsed from the *causse*. Our guide switched off a light and we all waited politely in darkness. Ahead of us purplish lights flashed and flickered in a spectacle we all understood to mean 'primeval', or more specifically, 'about a million years ago in what is now southwest France'.

A spotlight was switched on and a diorama appeared of an empty, mountainous upland. When we'd taken that in, the lights went out again and there was more lightning, now accompanied by eerie animal cries. The spotlight reappeared. A corner of the plateau had collapsed – a feat mechanically accomplished by wires on a creaky pulley which hoisted a chunk off the top of the diorama, in a neat illustration of the ascension of the earth's soul – leaving a new lowland at the base of a vertical cliff. Here was the provenance of the D999.

As a geological event, the diorama was rickety and under-funded, but it did help explain why the town of Roquefort makes the best blue-veined cheese in France. The collapsed highland not only created the cliff face I had just descended, it also exposed a series of limestone

caves that riddle the *causse*. It is in these caves that the cheese matures and ripens, the air, algae and stone unique to each cave lending a subtly different character and texture to the cheese stored within. The diorama also enacted, quite unintentionally, a pretty fair pantomime of the end of the world.

Of course it wasn't the end, merely the bottom falling out of the world as it had been, but that was close enough. It reminded me of the masons' best work at Conques, their narrative of time's end depicted in the great tympanum, and I knew I'd tarried with cheese long enough.

I took a deep breath: back across the Causse de Larzac and on through La Cavalerie and empty, eerie military land (the following morning, having inadvertently stayed at a hotel opposite the base, I was shocked awake at 6 a.m. when reveille was blasted over a loudspeaker). Past signs stumping for the far-right party of Jean-Marie Le Pen that I had protested in Toulouse. Writhing down into Nant – *cité médieval* – in its green basin. Up again through a darkness of ferns and forests to the grail itself: a sign that read '0.5 k Sauclières – Village du Causse'. The journey, not counting my detour, had taken nearly four hours.

Sauclières offered neither epiphany nor disappointment. It turned out to be an impacted little place of narrow, cramped alleys curled snail-fashion around an ugly church. Wisteria and flowers added summer prettiness. In winter it would be grim. It was too small to allow me to savour my victory through exploration, so I sat down at the Café L'Agora, where the very young local priest in full cassock was dining on multiple courses, and ordered a sandwich. The waitress wore striking Egyptian eye make-up and, as predicted, gave me exact directions to the quarry of M. Alla. It was a stirring drive. The horizon – a line of low blue mounds – was very far away. Pine forests grew close; the roadsides were studded with poppies and cornflowers; broom grew straggly and tall as trees. The car bounced and thundered over loosely packed, salmon-coloured stones, making a noise like a

team of horses. Then at a Y in the road a handmade sign pointed left
to the *carrière*.

So this is what the little masons had wanted me to see. They wanted
me to know that they were, literally, from big open spaces that smelled
of pine – from a southern place. I rounded a bend and came to an
abrupt halt. A barrier crossed the road next to a sign that read,
Interdit au Publique. Damnation! I beat the steering wheel. Then I
burst out laughing till I wept.

I don't know what I'd been hoping to find at the quarry; I already
knew it produced fine limestone for building. (This fact was later
confirmed by a thoroughly French-speaking friend's phone inquiry;
she also discovered that when I'd visited, the quarry had been closed
for summer *vacances*. I guess I could've rung.) I also knew that
the dense grey specimen I'd seen at Bozouls had been harvested
somewhere just around the next bend, in M. Alla's quarry. That
specimen had been so like the mason's capital at Conques, with its
finely incised brick walls and little peering men, their tiny lips, nostrils,
and knuckles, neatly combed hair and clipped beards, even the
fiddleheads of their ears, still fresh and crisp after so many centuries.
The marvellous stone that had accepted those attributes for a thou-
sand years' safe keeping had been quarried *here*, where heat leached
the smell of turpentine from bubbling pine sap. Not from this quarry,
but probably from this plateau. And if not, then from another nearby.
Certainly from this environment, this geology, that made up the
Grands Causses.

I felt privy to a secret of that great Rouergat abbey to the north.
The stones of Conques had introduced Annie and me to its neigh-
bouring highland and the Dourdou valley, and now they'd led me
on this unsuspected journey, far from the rippling grey roofs and
schist houses, far from the fertile river valleys, farther south to lands
touched by a Mediterranean sensibility, an awareness that the sea
isn't so very far away. And this meant that back in the abbey, too,
there resided fallow memories of sun-baked juniper and cypress, the

lightheartedness of red clay, and the immense skies of the Grands
Causses. The masons had sent me here to witness these things that
were as much part of the Rouergue as Ste Foy and *aligot*. I got out of
the car and gathered up eight or ten rough shards of tawny-coloured
limestone from the road, and made a little heap under a pine tree.
Then I went back to the café and toasted the masons with lemonade.
The young priest had not yet eaten his dessert.

* * *

Beaulieu means 'beautiful place', an apt description of Beaulieu-sur-
Dordogne in northern Quercy, called Haute Quercy by the people
who live there. It wasn't so very far from the Grands Causses of the
southern Rouergue, perhaps five hours' northwesterly driving. My
pupils barely had time to widen – they'd been pinpricks in the raging
luminosity of the south – to do justice to the deep, gentle greens of
the Dordogne valley, its restful fields, its well-tended walnut groves
and fruit orchards. Such is the dislocation, or perceptual whiplash,
brought on by contemporary transportation.

All travel experiences, fast or slow, optional or compulsory, raise
issues of perception and belonging. Do I or don't I fit? Exiles, refu-
gees, immigrants, pilgrims, even to some extent pleasure travellers,
must situate their identities, constructed in another place on another
map, within the new locations in which they find themselves. This
process is always a matter of negotiation, of finding an ever-shifting
balance between challenge and comfort, alienation and assimilation,
shock and recognition, leaving the wanderers – and to some extent
the hosts too – with a muddy, multi-layered sense of who they are,
were, and who they may yet become.

Throughout the twentieth century, as wars disrupted geo-ethnic
boundaries, as colonial empires collapsed, as immigrants followed
wealth around the globe, writers chased these experiences in context
after context, making the permeability of identity a nearly compuls-
ory vein of literary exploration. But these contexts have always

been contingent on spatial dislocation, travellers or migrants moving from one *place* to another, encountering welcome and resentment in ambiguous proportions. In Beaulieu Abbey I encountered a different kind of rupture, one in which time was the dislocating factor rather than space. The abbey hasn't budged since it was built in the 1100s, but unlike that of Conques, its identity is not fixed like the North Star. It is very much a tentative constellation, full of black spaces on which so many different designs have been imposed throughout the centuries that no clear picture emerges. The abbey is something of an exile in its own home – a traveller that has always stood still.

I first found the abbey of St Peter in the medieval quarter of Beaulieu during the last dregs of twilight. It was locked and unlit. Forming two sides of the abbey square were rows of medieval townhouses, noble old buildings of two and three storeys, resting atop stone columns and massive wooden beams the width of my waist. A group of young people, maybe ten or so, had gathered at the abbey's eastern end, where a young man was showing a home-made video on a white sheet he'd tacked between two of its radiating chapels. Bluish images of him and his friends the same shade as the sky flickered uncertainly, weaving like ghosts as wind gusts played with the sheet.

Morning brought flying ants and a puzzle. Beaulieu couldn't have been better situated: the Dordogne flowed like dark honey alongside the town, which announced itself as the strawberry capital of France. Market tables stood in the square, ready to be heaped with vegetables and fruits, *confits* and pâtés, cheeses, fish, and sunflowers. Cafés spilled onto sidewalks. But in sunlight I realized that the townhouses I'd seen the night before were empty and crumbling; advertisements in an estate agent's window put their prices at a song. The nest of ancient streets around the abbey, smelling of decay, damp plaster and worse, gave a good idea why Napoleon III had let Baron Haussmann knock down so much of medieval Paris. The riverfront was pretty

but hardly a focal point of recreation. Anything that could bring visitors to town, the abbey most of all, was in a state of middling neglect. I thought this might be a conscious policy – keep the headache of tourism at bay – but no one I spoke to had given much thought to tourism at all; in fact, people didn't appear to dream by day or night. Everyone was frazzled, seemed sleep-deprived. Whereas Espalion exuded ease and well-being, Beaulieu, its back streets throbbing each afternoon with amplified pop music, projected unexamined restlessness.

I swept the ants aside as best I could, and lay Annie Blanc's map of the south portal of Beaulieu Abbey on the cobblestone *place* in front of it. A chocolate Labrador puppy ran up and tried to shred it but I snatched it away just in time, and let her gnaw on my fingers instead. Annie Blanc is a geologist who works with the Limestone Sculpture Provenance Project, a brainchild of the Cloisters Museum in New York (the recipient of Bernard Berenson's scavenging of St Michel de Cuxa). Its goal is to determine the origin of medieval sculptures that have been plucked from their sites or salvaged from razed buildings – orphaned art – through the use of Neutron Activation Analysis.

Geologists take a small sample of stone from the sculpture and bombard it in a nuclear reactor. The constitutional elements of the stone – potassium, cobalt, whatever may be present – break down into unique radioactive isotopes, which can be measured and plotted on a graph. The result is a 'fingerprint' of each piece of sculpture, which is then stored in a database and matched with fingerprints of other displaced or exiled carvings, as well as those of churches, abbeys, and cathedrals, and the few medieval quarries that have been discovered. In this way many transient pieces have been traced back to their rightful homes; a Gothic head in the Art Institute of Chicago, long thought to have come from Sens Cathedral, was actually found to belong to Notre-Dame, in Paris.

Most of the monuments so far sampled are located in the Île-de-

France. Of the Romanesque pilgrimage churches in Quercy-Rouergue, Annie Blanc has only sampled stone from the south portal of Beaulieu Abbey, and discovered that masons had not used lime-stone (as many thought), but four different types of creamy-yellow, local sandstone, the colour of Conques' interior. Based on her find-ings she made a beautiful, schematic map of the doorway and sculp-tures of its surrounding porch, colour-coding each segment by the type of stone from which it had been carved. The masons' use of different sandstones turns out to have been so varied and piecemeal that her map virtually vibrates with colour and pattern (she also indicated, by means of horizontal and vertical coloured lines, whether masons cut the stone on its grain or against it).

Apart from the tympanum and central pillar on which it rests, called a trumeau, which are carved exclusively from pale 'yellow sandstone' (map key: blue; the quotation marks refer to Mme Blanc's description of the stone), the surrounding figures and blocks inhabit a middle-ground between hodgepodge and pattern. The masons clearly contracted stone from different quarries and used whatever was at hand. Many corresponding sculptural elements – jamb figures flanking the portal, narrative scenes from the left and right sides of the porch – are of the same material, but there are scores of excep-tions. Looking up from the busy mosaic of the map to the silent, sedentary stone before me, and back again, the map won; it contra-dicted the quietude of long-finished labour, and for an instant brought back the chaotic intensity of the construction site. Masons haranguing quarry workers; carvers sending chips flying; sculptors calling for more stone; apprentices trying to eat their lunch in peace. Traces of ancient hubbub, like Mme Blanc's radioactive isotopes, throbbed in the tumult of her map.

The sculptures themselves, by contrast, were peaceful. 'They are horrible, really horrible, you will see,' warned a waitress at a nearby café, wagging a finger at me. I was intrigued.

The theme of the tympanum is that 12th-century favourite, the

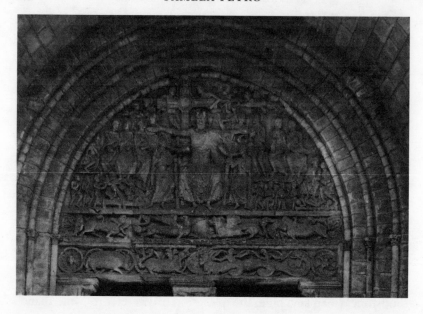

Last Judgement. It is utterly unlike that of Conques. At Conques
there is a détente between material – stone – and the artist's corporeal,
earth-bound imagination; his Last Judgement is enacted by a huge
cast of solid beings doing specific things. But here the artist used
sandstone, another supremely earthy substance, to depict a realm
apart – heaven, or perhaps a mental or spiritual state of mind. It is
this unbreachable disjunction that at Beaulieu gives Romanesque
sculpture its heartbreaking tension, its unresolveable striving. It's
a consequence of art and representation, whereas at Conques the
representation is taken for granted, and the heart-tug emanates from
an unrequited yearning for salvation. You see the difference immedi-
ately. Gone are the stout little beings with their feet firmly on the
ground in their individual niches. Instead slim, long-legged apostles
and angels, the immortal and resurrected, flutter in elegant restless-
ness in the rarefied atmosphere around Christ (who, with his skeletal
arms and legs and bare chest, seems fresh from his own resurrection).

Below the Judgement are two rows of fantastic beasts, some

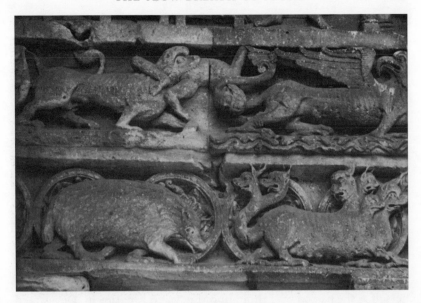

vaguely boar-like, others sprouting viscous little heads from multiple tails, still others gnawing in unsavoury fashion upon the damned. Their legs, tails, tongues, and wings writhe and curl in interlaced patterns, just as many of the figures above twist in contraposto, knees in one direction, arms in the other, shoulders stiffly facing forward. At Beaulieu, again unlike Conques, beauty has broken free of narrative and stands next to the message as an end in itself, nursing its treasured offspring, rhythm, style, and ornament.

Lucy wrote in her journal, 'Sculptures are very lovely. Tympanum with Christ and angels, cross placed off axis; column in center, caryatid figures on three sides appealed to me most.'

Lucy's caryatids are trapped in the trumeau: a bearded prophet, a youth and a young man, all of whom appear to hold up the tympanum. They're a languid species. Their bodies seem to have been poured into a columnar mould, as if they were more akin to the slow-flowing Dordogne than to cold, hard, sculpted stone. The central figure especially seems too frail and slight to hoist the enormous

half-moon above him. It's coming down on him, forcing his head sideways onto his shoulder (his serene smile belies this anatomically impossible agony), even as his slender fingers curl around the stone pediment above. His much shorter partner, the youth, stands on the shoulders of the bearded elder while also elegantly upholding his load. Lucy made an exquisite portrait of him. Her camera caught his arrest ing juxtaposition better than my eye – both the miraculous fluidity and constitutional graininess of the stone – in addition to a network of ghostly spider webs, which seem to be all that weaves him to the abbey.

None of this was horrible in the least, but then it was all sculpted from the same honourable and well-protected sandstone. By contrast, the carvings on either side of the porch had the look of open graves. As I stood sketching them a woman came out of the church and crossed herself as she passed by. I thought of Lucy and Kingsley in 'Devastated Regions' shortly after the war, stepping over corpses to reach a church. These sculptures weren't horrible, but they did elicit chills. They walked that perilous line between the beautiful and grotesque; they were fodder for nightmares. Annie Blanc told me that she didn't know the quarry sources for Beaulieu's stones, but as soon as I saw the ravaged figure of Luxuria (Unchastity), and her companion the Miser, it was a moot point. The abbey itself was a quarry, and time was slowly removing its stone for unfathomable purposes of its own.

The stone hadn't worn well. It was fading, eroding, flaking away; it reminded me of roadcuts I'd snaked through following the Dordogne, where weather and spring water had eaten the face of the bedrock. But the fascinating thing was that the four different types of sandstone were weathering in different ways. A jamb figure of St Peter framing the left side of the entrance, carved from 'fine yellowish sandstone' (map key: green), appeared to have melted. Compared to the still-distinct trumeau trio, his body was pocked and porous, almost webbed as if it had been burrowed out by termites. A millennium had rendered the stone soft and indistinct, and oddly beautiful.

The narrative carvings on either side of the porch were far more gruesome. A scene to the right showed Christ being tempted by a pair of howling demons, whose looks time had done nothing to improve. Christ's body and the demons (in their entirety) were carved from stone that Annie Blanc's map coded blue – the same yellow sandstone of the tympanum. But here it was far less protected, more open to the ruination of wind, sun, and rain. All three bodies were both deeply pitted and riddled with raised lumps like tumours, the demons' faces only a suggestion made by eye sockets and gaping mouths. The effect was topographical; it was also riveting and macabre, a very public display of decomposition. Because Christ was taller than the devils, his head poked into a different band of the relief, the uppermost level, which had been carved – possibly by a master mason, who did the heads himself and was supplied by a different quarry – of 'grey sandstone' (map key: black). Actually, Christ's head was missing. This mauve-coloured stone, by far the least durable of the lot, hadn't eroded so much as flaked away in sedimentary leaves. What was left looked like a puddle drying in the sun after a storm.

Annie Blanc hadn't mapped the figures of Unchastity and the Miser, which had been affixed to the south wall of the abbey, but my guess was that they were of the same kind of stone as St Peter, coloured green on Madame Blanc's map. Unchastity, also known as Luxuria or *La Femme aux Serpents*, tears at her hair while snakes wind around her legs and bite her exposed breasts; a lizard devours her private parts. Not the prettiest image in the best state of repair – the Benedictines who commissioned this sculpture were fixated on creative sins of the flesh, as corbels of exhibitionists, coital couples, giant phalluses, and a man locked in passion with a goat, suggest – but erosion had enhanced the message. Her stony flesh is now indistinct and scaly, as if the poor sinner were becoming one with the snakes who torment her. It's a rare case of deterioration revealing, rather than obscuring, the impulse of art.

The interior of the abbey was cavernous and dark; the sooty-grey

stone wept *la maladie blanche* by the bucketful. An exposed, fitted-
stone barrel vault above the nave was unplastered and reminded me
of a Rouergat roof, the art of fish-scaling on a grand scale. A huge
dome above the crossing had been plastered and painted, but was
peeling in large, dirty flaps. It was brutally cold inside. I followed the
ambulatory around the choir and found its cluster of radiating chapels
a curious lot. In one, fresh flowers had been placed in front of a
fantastically ornate altar; its neighbour was choked with fallen plaster
and debris and stank of pigeon droppings. A carved wooden angel at
the rear of the high altar turned her back to the ambulatory and
showed herself to be caked with dust. Spiders had woven what looked
like fishing nets between her wings.

It was the house of God, but it seemed more like the House of
Usher. The evidence was unmistakable: Beaulieu Abbey has been
exiled from the hearts of its townspeople. The faceless figures on the
exterior, the worn-away features, were just shorthand for the abbey's
wholesale loss of identity. The contrast with Conques was powerful,
and devastating. That abbey was a well-loved neighbour. Towns-
people and tourists congregated in the little *place* in front of it;
organists practised by night; musicians made music in summer; people
prayed there daily. But in Beaulieu, residents had turned their backs
on their own beautiful abbey. It was still used for services, but was
carelessly treated. Postcard racks held precious few images of it. On
summer nights only video ghosts stalked its walls, pouring photons
into chinks that need to be filled with mortar.

Beaulieu Abbey was founded in the ninth century. By the eleventh,
when it came under the protection of the powerful Clunaic monks
of Burgundy, it was already sandwiched between two branches of the
Compostela highway and possessed miracle-working relics of its own.
The Clunaic Benedictines rebuilt the abbey as a pilgrimage church –
the ambulatory with its projecting chapels is a Romanesque solution
to the problem of traffic flow – and in so doing put Beaulieu on the
map. Town and church shared an identity, as Conques and its abbey

still do. But in travelling through nine ensuing centuries the two split apart, leaving the abbey to negotiate a new identity with the town of Beaulieu-sur-Dordogne: Burden, Tax Break, Provider of Shelter and Shade, Site of Weddings and Funerals.

The town had chosen to live in the present moment while the abbey had no choice but to stick with the past and the *plus*-past of its ancient stone. Because no one else appeared to love it, I loved it all the more. It was closer kin to the Coulée de Lave than to Conques. That primeval landslide was the matching verb to the abbey's neglected noun, its lost identity. The Coulée de Lave was a fixed constellation of basalt fallen from on high into a heap of earthly stars, a memorial to nothing but its own destruction. The abbey's identity had likewise tumbled out of its fixed image into a puzzle of black holes, screens onto which townspeople could project images of themselves or literally anything they chose.

I don't know why Beaulieu Abbey was forsaken, though I believe the vulnerability of its stone has something to do with it. No one wants to think of stone as mortal; no one wants to see it decay. As it erodes it drains our handmarks from the future and turns our secret pagan dreams to dust. Beaulieu's stone committed this sin, and for it the abbey was emotionally exiled from the town, left to become time's own quarry. And yet there is a feature of quarries it always pays to remember. While they can be sites of devastation, they also reveal what lies below the surface. The paradoxical corruption of the abbey's saints, devils, and their eternal brethren may be what poked black holes in the structure's identity, but those holes are the very mirrors into which we now peer. This is the Romanesque paradox again, the impossibility of eternity in ruins, on a civic scale. The abbey is begging the townspeople of Beaulieu to reanimate and reinvent its stone and its idea, to make it whole again in their hearts and fill it with music, like Conques; to bend their imaginations to its presence; to love it. The abbey is demanding that they join it or share in its tragedy, and one day soon they will have to choose.

As for me, the abbey's invitation was irresistible and I walked through its pores like radiation through sculpture, straight into the sunlit countryside of my dreams. I found myself in a little town called Collogne la Rouge – *Un des plus Beaux Villages de France*, one of the most beautiful villages of France (an official designation; the area is full of them). It was redder than Marcillac; it was redder than the Michelin Guide. It was too red for a town, its lovely sandstone buildings were impossibly, ravishingly rose and garnet red. I saw a white whippet in Collogne standing backlit in the sun, his hind legs glowing with the blood pulsing inside. It was that red.

I found the mermaid's sister carved on a Romanesque house. Flowers cascaded through the streets and at lunchtime meals glistened with the mellow lubricant of walnut oil. The local liqueur called Quercy Noix – a walnut aperitif – tasted sweet and fertile. In the guest book of the red church I read an inscription in English: 'You are children of paradise.' Above the entrance was a white limestone tympanum sculpted in the twelfth century, rediscovered in the nineteenth. Two angels lunged athletically and pointed at Christ. Beneath, on the steps in shade, a young witch in a black hat and Nike trainers consulted her watch. In the market enclosure opposite a bagpiper from Lincolnshire finished his ice cream cone and played medieval French airs on an old set of English pipes.

I followed a road into the countryside: past a holy well, apple orchards, and walnut groves where the red earth was studded with yellow flecks of limestone chips clustered at the base of each young tree. My knee balked. Bamboo grew by the roadside and when I turned to limp back, the red city glowed on a distant hilltop like the whippet's blood.

I returned with my car and went further, into a blond bowl of wheat fields, each one hyphenated by dark rows of walnut trees planted in the midst of the pale grain. Inside the bowl was a tiny village called Saillac, houses hovering around a simple Romanesque church. Times had been hard. The church was hidden behind a heavily fortified

porch, built in Gothic years. Inside the porch was a sweet secret. A
humble tympanum of the 1100s, its colours still bright with paint.
In the silence of the rural mid-afternoon, inside the coolness of stone,
alone with strangeness, I felt as if I were at the doorway to a different
world.

On the tympanum three Magi gripped each other's shoulders and
surged forward toward baby Jesus, who sat on Mary's lap. Three
little donkeys lowered their heads to meet the downslope of the
curve. Below them a white-robed figure in a halo – the resurrected
Christ? – tugged on the tongue of a serpent-tailed beast with wings
and a curly beard. Next to them a rampant griffin, painted white with
golden Dalmatian spots, consumed a tiny soul whose legs stuck out
of his mouth.

In the middle of the doorway an elegant trumeau twisted like a
barber's pole in alternating bands of decoration and winding figures.
Dogs corkscrewed after deer who twisted upward towards out-
stretched hunters who wound ever up and up towards heaven. All
became a chain on which it was impossible to tell who was stalking
whom.

The trumeau was a stone maypole, simple and slim, known to
generations of village hands that followed its contours by heart. I
twisted around it too, starting at a crouch and following its ribboning
band up in circles, higher and higher until I ran out of stone and
flung myself into vineyards where the trunks of grapevines were also
sheltered under little cairns of limestone shards. The grapes became
a local table wine called *Mille et Une Pierres*: a Thousand and One
Stones. The label said it was produced '*en terrain truffier*', in a land
of truffles. It too was red, dark red, and tasted of pilgrimage.

I put some in an empty Vittel bottle and returned to the open
pores of the abbey to stand alone at the day's dusk before the south
portal, where I drank the blood of the countryside to the health of
the abbey's thousand crumbling stones.

In Lucy's honour I thought to take a souvenir snapshot of her

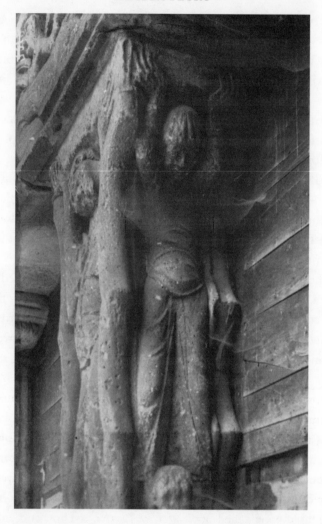

aesthete friend, the caryatid. Holding her photograph in one hand and the camera in the other, I looked back and forth from the print to the viewfinder, thinking I saw the impossible – mirror images. I checked again, and sure enough: Kingsley had peered into his wife's negative of the little figure shouldering his impossible burden, and had printed it backwards.

6

SCULPTURE

For do I now persuade men, or God? or do I seek to please
men? for if I yet pleased men I should not be the servant of
Christ.

Epistle of Paul to the Galatians, 1: 10, as copied by Lucy Porter

Who would budge, God or Kingsley? Who was more open to persuasion? One had to be right and the other wrong, or Lucy would
not have found herself caught in the cleft between them. Believing
the word of both was impossible, it was madness, it was immoral; it
was exactly what she did. Perhaps, she thought, with some coaxing
one of them might change his mind, and then she would have room
again to breathe. She still seemed to remember what it was like to
breathe. Lucy set about trying to change God's mind.

For her own comfort she copied chapter 1, verse 10 of Paul's
Letter to the Galatians onto the inside cover of her journal for the
first half of 1928, taking care to make a parenthetical note that
Galatians were 'Celts in Asia Minor'. It helped to know that someone
else had been similarly trapped, that her predicament was not unique
in the history of humankind. Yet instead of feeling better, a tentative
anger rose in her, a sentiment with which she was unfamiliar. Lucy put
down her pen and took up a pencil, underscoring the final sentence of
Paul's conundrum to record this sudden protest against the unfairness

of life, but she pressed lightly, ashamed of so primary, so solitary, an emotion.

Souillac Abbey in Haute Quercy is famous for its Romanesque sculpture. One figure, Isaiah, is amongst the most beautiful carvings ever made. He is not simply whole; his body is the offspring of contrapuntal parts mated together by the restless genius of the twelfth century – he is the very apex of incestuous line and elegance. Other carvings are very different, all interlaced violence and tumult, barely suppressed in the quietude of stone. Such art cannot be approached quickly or casually; I needed time to acclimatize my anticipation to its age-old presence, and so walked past the abbey into, of all things, the Automaton Museum next door.

I might as well have fallen asleep in Beaulieu or Conques and had a nightmare that the sculptures had dislodged and dressed themselves as acrobats and snake charmers. Hundreds of mannequins – life-size men, women, children, and animals with hidden gears and widgets that moved their eyes and limbs – congregated behind glass cases where they played pianos and trumpets and waited for the Métro, rocked cradles, rode tricycles, did magic tricks. Most were from the 1920s, though some had been made as early as the 1870s, others as late as the 1980s. One case depicted an enchanted winterscape. Two seals in formal wear waltzed while a polar bear crashed a pair of cymbals, and a white fox in a frock coat played the violin. Two birds in a bonnet and bowler hat looked on.

Some of the automatons were still; others had been switched on and were doing their tricks. A busload of elderly pensioners wandered amongst them, finding much to giggle at. I stopped in front of one case and was just about to move away when a whirring noise started up and the figures began to twitch. Inside the case a photographer bent over and peered under the dark cloth of his view camera, mechanically raising his head every thirty seconds to look directly at me, rakishly raising his eyebrows. His subject posed in front of the

camera's bellows: a clown, who every now and then lifted a mask in the shape of a pig's head to cover his face.

I don't like clowns, but that wasn't why I quickly, sinkingly, began to feel haunted. I had looked through Lucy's eyes for so long, their gaze having been caught in the beautiful photographs I carried with me, that I knew without doubt she would shut them in front of this scene. And then she would leave the museum.

I sat panting in the coolness of Souillac Abbey in a state of mild confusion. As I often did, I had the sensation that Lucy was at my side; the confusion came in her being at my other side, too. As I learned more and more about the Porters, and the depth of our acquaintance grew before and beyond 1920, the past became a multiple place. Lucy had visited Souillac with Kingsley during that chalk-and gin-scented summer they had raced over the *causses* of Quercy in their open Fiat. But I had brought an older Lucy into the church with me as well, the woman who had copied Paul's epistle into her date-book – the same woman who couldn't bear to look at the automaton photographer and his masked clown. The poet Anne Carson says of Giotto's paintings that 'he slips you sideways into time'. I was doing the same with Lucy. I needed to know what that older woman made of these sculptures that her younger self had photographed so beautifully, even if I knew it would have made her weep.

The Souillac Isaiah – a work, wrote Kingsley, that 'haunts every memory' – became the subject of one of the best photographs he ever made for *Romanesque Sculpture of the Pilgrimage Roads* (Kingsley's pictures, unlike Lucy's, are usually blurry, distant, or slightly over-exposed). His image is a detail of Isaiah's head and shoulders, taken from an angle slightly beneath the prophet, so that we look directly into his eyes – a position that fully draws us into the prophet's yearning wistfulness. Abandoning solemnity himself, Kingsley wrote,

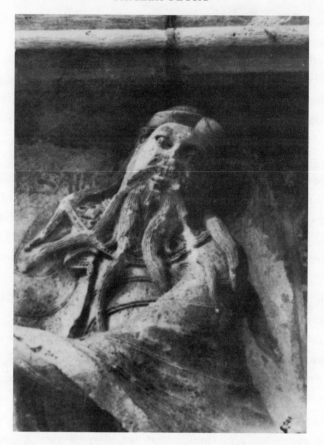

There is . . . in this figure a certain something which leads one to
understand why solemn archaeologists, not withstanding his
clearly engraved name and ample beard, have set him down as a
'foolish virgin,' but the movement of the figure is so stimulating,
the swirl of the draperies so intoxicating, the lines of the scroll so
decorative, that the severest critic must capitulate.

Capitulate? Isaiah is no foolish virgin, but Kingsley has a point: he's
almost too beautiful to be a man. He poses like a runway model in
contraposto, his robe swinging and clinging to his long, slender legs.
Even damage to his nose and mouth doesn't mar the sweet dreami-

ness of his face, framed by coils of long, wavy hair and beard. In her journal Lucy called him, succinctly, 'a high water mark'.

Directly in front of this ethereal beauty is Souillac's trumeau, which, like Isaiah and his damaged partner, Joseph, is a fragment from a sculptural programme that no longer exists. The trumeau was once part of a vanished exterior porch, but like the prophet and saint, and a monumental relief depicting the Theophilis story, it now resides inside the abbey, just within the western entrance.

It is a masterpiece of interlaced agony. Meyer Schapiro, the art historian and presiding spirit of the Souillac sculptures, described it as a 'frantic confusion of struggling, devouring, intertwining figures'. From a distance it looks like a petrified nest of snakes. A closer view reveals birds, monsters, and humans all locked in a stone food chain in which they eternally feed on one another, beak to buttock, teeth to skull, bound and braided together by insatiable hunger, or perhaps retribution. At first it seems just a confusion of topsy-turvy body parts – wings, heads, legs, tails – but it is actually a tightly structured design composed of repeated pairs of crossed birds and animals who devour common prey. After some time I noticed that the bird motif was repeated on column capitals through the church; the sculptor either loved or hated them. One capital in particular, of two large owls decoratively pecked by two sets of pigeons, was both beautiful and disturbing in equal measure.

Set into the western wall above Isaiah and Joseph is a very large and curious relief, neither fluid like Isaiah nor decoratively chaotic, like the trumeau. It tells in three episodes the story of Theophilis, the Devil (here an emaciated, beaked savage in a skirted loin cloth), and the Virgin Mary, with the bearded figure of Theophilis appearing in each scene. Whereas Kingsley chimed to the subject matter of the monk's tale, and in it found a parable of love and friendship – 'A man has the right to sacrifice himself, but has he the right to sacrifice others?' – Meyer Schapiro looked hard at the relief and pondered its formal structure. He skipped the message and examined

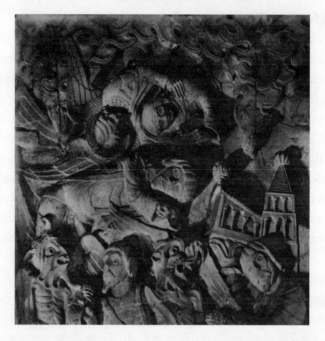

the composition, and read in it the underlying principles of
Romanesque art.

Like Bernard Berenson, Schapiro was a Lithuanian Jew who came
to the United States at a young age. As an art historian his range was
encyclopaedic, and as an artist himself he experimented with media
ranging from pastels to sculpture. Schapiro spent his entire pro-
fessional life at Columbia University in New York City, entering at
16 as an undergraduate in 1920, and leaving only on his death at 91,
in 1995. When he died colleagues remembered him as a 'poet among
scholars' and a teacher who 'delighted in knowing and sharing what
he knew'. Unlike Kingsley, whose peers also found him 'poetic',
Schapiro was as fully engaged with the art of his own time – especially
abstract expressionism – as he was with that of the Middle Ages.
While Lucy was meditating on Paul and the Galatians in the late
Twenties, Schapiro was writing his doctoral thesis on the Roman-
esque sculptures of Moissac Abbey. Ten years later he turned his

infrared gaze on Souillac. (David Finn, the photographer who illus-
trated a late edition of Schapiro's Moissac study, reported that every
art historian he's worked with has expressed pleasure at discovering
new details in his photographs, with the exception of Schapiro. He
had, said Finn, 'seen everything that could be seen' with his own
eyes; the photographs were for others.)

The Theophilis relief seems so jumbled that some writers have
called it an inept reconstruction of a lost original. The Virgin Mary
is upside down, leaning out of heaven to snatch Theophilis' soul; the
architectural frame around it is lopsided; instead of one monumental
figure occupying the centre ground with action occurring around
him – think of the tympana of Conques and Beaulieu – two large
saints occupy either side, with the middle ground a messy hive of
activity. Schapiro, however, masterfully disputed charges of both inep-
titude and reconstruction, claiming that while the relief might look
accidental, it was really a deeply coherent design.

He called it a 'discordant composition'. By that he meant a group-
ing in which corresponding shapes and masses are prevented from
achieving visual cohesion by sets of contrary forms that regularly
disrupt the harmony. It's discordant, but it's a *balanced* dis-
co-ordination, intentional and painstakingly planned, an artistic sol-
ution to an age of gnawing uncertainty. There was no symmetry in
the twelfth century between life and death – being a good person
bore no relation to one's chances of getting into heaven – so it made
little sense for art, the mirror of life on earth, to be symmetrically
composed. The inequitable balance between heaven (under-
populated) and hell (overcrowded) was in fact this art's great obses-
sion, its energy that of unease rather than harmony.

Just about the time Meyer Schapiro was writing his doctoral thesis
on Romanesque sculpture – around 1928 – Kingsley, now in his
mid-forties, woke to the realization that, like Souillac's beautiful
sculptures, fragments of a once-integrated whole, his life with Lucy,

his research and teaching, his many friendships, were only fragments of a larger self. The difference was that, unlike the abbey, Kingsley had never been complete. Uniting the disparate parts, the hidden self with the public persona, would mean either severing his marriage or severing himself and Lucy from the rest of the world; but by the late Twenties he felt he no longer had a choice. He told Lucy that he loved her still, but could no longer deny his homosexuality. It was a courageous admission at a time when homosexuals were no more acceptable than lepers. Although Harvard had a long, covert history as the Ivy League's homosexual bastion, the university's president during Kingsley's tenure, A. Lawrence Lowell, was a dedicated homophobe. When he learned of another professor's 'deviancy', Lowell demanded his resignation and advised the man that if he were in his place he would 'get a gun and destroy myself'. Opinions hadn't changed much from the Middle Ages, when, as Kingsley well knew, sodomy was considered the most serious of crimes, punished even more severely than murder.

'Comical, isn't it,' he later wrote to the well-known British sociologist Havelock Ellis, to whom he had turned for advice, 'that I who was so proud of my perspicacity, failed to discover the one fact it was essential I should know, although it was written in letters of fire across the sky.'

Kingsley's revelation before Coutances Cathedral, in Normandy, had taken on a new meaning – one that would eventually supplant even his love of the Romanesque.

Kingsley's fears of severing his marriage were unfounded, as Lucy responded with characteristic sympathy. From the first their concern seems to have been for each other. Of his wife Kingsley commented to Ellis, 'However faltering my courage may be, hers never flinches.' And yet uncertainty had entered their marriage and their lives; they had become vulnerable to scandal, to blackmail, to the censure of friends and family, the loss of position and income, the pressures of leading a double life. Like the carved façades of Romanesque abbeys,

their lives became a response to the endemic unease of those seeking salvation in a perilous world. Beginning in the late Twenties and increasingly in the early Thirties, the Porters' marriage grew 'discordant' in a way that uncannily echoed the discordance of Souillac's masterpiece, the relief depicting Kingsley's alter ego, Theophilis. Their great achievement was to seek, and through remarkable openness, mutual care and understanding, and innovative – certainly unconventional – creativity, for a time sustain, a precarious balance within the imbalance of their marriage. If eleventh- and twelfth-century sculpture, ever obsessed with the afterlife, posed the question, 'Will we be saved?' Lucy and Kingsley asked, 'Will our humanity ensure that we emerge intact from this sea change in our lives?'

It was a brave query but a moot one. Kingsley's life had never been intact to begin with. His sexuality was fragmented from the start, suppressed when he channelled loving friendship into marriage. If the face he presented to Lucy – and for years to himself – was not quite a clown's mask, it was not complete either. He held another one in his hand all along, which the world derided as being no better than that of a swine.

As I sat in Souillac Abbey, trying to follow the Porters through the tumult of the late Twenties, staring at Isaiah and the trumeau (it had become too dark to see much of the relief), trying to keep warm, my personal fascination with Romanesque art gradually grew into something crucial, something huge and important. From the outset I've been drawn by what I called the romance of its physical decline. But there are all kinds of ruins; it is specifically Romanesque sculpture, trying so hard to create an eternity in the midst of doubt, to which I respond so powerfully. The fragments of Souillac, the weather-wrecked figures at Perse and Beaulieu, demand temporal reparations not only from our intellects – where would the porch have been, what would Christ's or the devil's face have looked like intact? – but from our souls. To make this art complete we must believe in eternity again, in our own way, which for me has meant turning to the bedrock

of the earth (a surprise to myself and all who know me), just as Henry
Adams turned to his vivid, blazing image of the Virgin Mary.

What Romanesque sculpture asks of us is no more than what we
ask of each other. This is what makes it so essential, so *familiar*, and
despite its age and oddity, so supremely humane. Kingsley is hardly
unique in possessing a fragmented self. We're all aggregates, finding,
recognizing, offering to others different strata of ourselves at different
times in our lives. I was no longer the young student who had thrilled
to the strangeness of the Romanesque, or perhaps, as I was beginning
to think, who had pursued the Romanesque as a diversion from the
strangeness within. Our quest, our mortal mission, is to use our
creativity to repair the rents that open in ourselves and between us
and those we love as we move through time and change. The human
challenge is the same as the Romanesque paradox: we all want to be
made whole, a feat rarely, if ever, accomplished alone. As thousand-
year-old sculpture in its decrepitude draws us to it and begs our
imaginations to cast healing shadows, so do we need the will,
strength, and soul of others to repair the weathering within. This
is why Lucy and Kingsley Porter's marriage was a *chef d'oeuvre* of
Romanesque art: despite physical and sexual incompatibility, they
never stopped trying to restore each other's ruins.

And if they, and we, are unable to reinvent and reanimate the
spaces between us and within ourselves? Then we are left with tragedy,
minus art's dark pleasures.

Lucy had stopped crying some time ago. She sat alone at Elmwood
with plates from Volume IV of Kingsley's Romanesque sculpture
book scattered around her, portraits of an easier time. She vividly
remembered taking the Souillac pictures; it had been so hot outside
the abbey, and like a keeping cellar within. They had pushed hard to
get the exposures finished before dusk, and she'd been exhausted.
Then afterwards they'd driven through the early evening to Brive.
Lucy closed her eyes. She could still feel the cool wind on her face,

smell the night coming on, could see the stubble of young trees against the bluing horizon. Tenderly, she remembered writing that phrase – that sad, innocent phrase – in her journal.

She shook the vision away. The Souillac photographs disturbed her now. How she'd delighted back then in the frozen commotion of the trumeau; only now did she make out the figures of Abraham and Isaac hidden amongst the birds and beasts. Abraham held the boy by the hair with one hand and raised the other, ready to strike. He hadn't been allowed to sacrifice his son. She doubted God would intervene to prevent Kingsley from sacrificing her happiness to his troubles, but she feared that he himself would not allow it to go on for long. Guilt was already badgering him, so much so that he'd recorded their discussions in his play. 'Two standing together have double strength.' She'd said something very like that, though it had been far less poetic. Kingsley was the poet, she'd always been the accountant, the photographer. Just then it occurred to her. Of course! What is a keeper of books and recorder of images after all, but an archivist? She shook her head at his relentless cleverness, irritated that Kingsley had made the archivist so dull-witted – surely that's not how he saw her? – and given himself the last word. Two, he'd argued back, present a double surface to the wind.

Lucy's hands fretted the pictures without guidance, churning the souls of the sculptures. After some time it dawned on her that she was looking for Isaiah. To her eyes he was all decorative flourish, a dancing ripple on a wave of stone, nothing more. As she frowned down at him she slowly became distracted by a memory. A cold January in Paris – 1919? – shortly after the war. A silly young woman reading aloud in French, of whom she'd been grandly dismissive. Lucy even recalled her own phrase – 'The poverty of her taste and the wealth of French literature was pathetically contrasted.' Not a single poem, she'd later complained to Kingsley, had touched *life* – the only beauty had been in the rhythm. He hadn't said a word.

Perhaps – Lucy's thought rose from a cold place inside her – Kingsley

had enjoyed the rhythm, the release from thought. She took one last
look at Isaiah. If only he could have remained content with stone.

<p style="text-align:center">* * *</p>

Just east of Souillac, where the corn fields and walnut groves of Haute
Quercy meet the most northerly of central Quercy's limestone moors
– the *causses* – lies the calm town of Martel. I had a social call to pay
there, dinner with wonderful cooks and conversationalists, a friend's
brother and his wife, in their ancient château overlooking the Causse
de Martel. We ate guinea fowl cooked in cabbage and duck fat. A
friend of theirs, a carpenter, told me he was making a Louis XIIIth
bed out of walnut for someone in New York City. The wood had to
remain outside for two or three years, airing, between the time it
bore fruit and could be crafted into furniture.

Legend has it that Martel was named either by or for Charles
Martel, founder of the Carolingian dynasty and known, rather omin-
ously, as 'The Hammer'. I was in his town to see an angel. Lucy's
angel, perhaps my favourite of all her photographs. It was the image
that had mesmerized me at dinner in Moltig-les-Bains, the only thing,
along with my perfect grapes, that had made that meal memorable:
Lucy's supple, jazzy, horn-playing angel, with the faraway look on
her face. I had travelled to Martel to reunite her soul with her lime-
stone body.

The latter wasn't hard to find. The houses and walls, the many
towers and turrets of Martel, are almost exclusively built of pale,
nearly white limestone blocks. The sheer abundance easily gives rise
to thoughts of fairy tales. I simply looked for the biggest ones and
that way found the church. It was a Gothic structure of the 1300s,
hidden behind an aggressively fortified tower. As I stood beneath its
massive, arched entryway – so wide that cars can drive between the
arches – looking at the angel on her tympanum, I more than once
felt the hairs on the back of my neck quiver in expectation of a rapidly
falling portcullis.

The Romanesque tympanum is a relic from an earlier church, and its grace set it at odds with the hulking porch tower. It was protected and in good shape, although a shiny brown patina that had developed on the raised parts of the relief, plus remnants of paint (green, red, ochre) and the angle of the sun, made it hard to see very clearly. Lucy's black-and-white photograph, taken at a different time of day – delicate greys fading to definitive blacks – told my eyes far more than the stone revealed. The overall sway and grace of the figure was there, the lunge of the angel's right thigh, some swirls of drapery; but the curve of her back and cloak, her fingers gripping the horn (impossibly far down its neck), the gorgeous slope of her jaw line, the flip of her hair, her otherworldly eyes – where were these on the afternoon I was in Martel? Where were the little souls popping out of coffins at her feet, like so many resurrected hedgehogs? That these things lay dormant in the stone I didn't doubt, but at that particular moment they simply weren't accessible to the eye.

Without Lucy's photograph the angel was incomplete. From the viewpoint of a passing observer, wedded to the limitations of my single glance in time, she was as dependent on the photograph in my hand (a marvel of light, water, and photo chemicals) to achieve her fullest expression, to become herself, body and soul, as a kernel is on sunlight and rainwater (and the marvel of photosynthesis) to become a corn stalk. Her very incompleteness seemed to give the angel a sentient quality – she appeared to be a creature capable of growth and change – that contradicted the stasis of immortality, both of angels and stones. Like the figures at Conques, she existed by grace of time, Lucy's and mine, rather than beyond it. I couldn't make her fly, as Lucy had done for Raphael at the church of Perse back in Espalion, but between us we did loan her the dubious mortal sensation of longing.

I watched the shadows deepen, remembering. Twenty years earlier, when I was 20, I had lived in Paris, near the Parc Monceau. Every Thursday afternoon I would take the Métro to Châtelet-Les Halles,

and walk from there through the reawakening streets of the Marais. It was not yet a chic neighbourhood; youth and money were only just beginning to filter in. The wartime generation still occupied the old townhouses on Rue des Francs Bourgeois, living in private, bohemian gentility behind the public grime.

I learned to step through a low door into a cobbled courtyard and up an exterior flight of stairs to the apartment of 'Madame', my art teacher. Madame was in her sixties; she wore her ash-blonde hair like Grace Kelly's and a silk scarf around her neck (always the same one). I wanted to learn techniques of drawing – I had discovered Rembrandt's etchings and was mad to crosshatch – but she was impatient with mere draughtsmanship, and tried in vain to turn me into an abstract colourist. When I balked at this she placed a plaster cast of a classical head on the table and ordered me to 'copy if I must'.

I drew the head over and over, week upon week. It seemed she had no other. Madame would talk on the phone in the other room, occasionally sauntering to my table to look from sketchpad to head, whereupon she would exhale sadly. Sometimes an elderly gentleman friend of hers visited. He would sit with me and chat in Québécois French (another subject of disparagement), which I found far easier to understand than her Parisian accent. It was tomb-cold in the apartment. Lucy had written of going to a luncheon at an old woman's unheated *pension* in the winter of 1919. 'My feet were lumps of ice and the food became chilled before it could reach your mouth,' she'd noted. 'After lunch we went to her icey [*sic*] bed-room where I put on my coat ashamed of my chattering teeth.' I, too, had been embarrassed by my numb toes and bluing fingernails, my soft American dependence on central heating.

Once Madame had invited me to stay for a dinner party, which had of course honoured and terrified me. My job had been to set the table. Never having encountered knife rests before I'd thought they were decorative, and grouped them in artistic clusters. My ensembles were the subject of general hilarity – Madame had waited until we were all

seated to expose the faux pas – but otherwise I had been respectfully treated, asked for opinions, and given whisky to drink.

Whatever else transpired at Madame's, one thing remained the same: she never turned on an electric light while I was working. The head and I both sat beneath an immense north-facing window. When I'd first arrive my ever-present subject would be shadowless in the flat, white Parisian light of autumn. Slowly, very slowly, it would begin to seem as if a drop of Indian ink had been added to the atmosphere, clouding it slightly. I'd try to blink away the encroaching greyness. Maybe an hour later, when I next returned to awareness, the head and I both were merging into silvery smudges like the graphite marks on my page. My eyes would be strained to the utmost.

When I finally complained about this, having looked up 'eyestrain' in advance (*fatigue des yeux*), politely inquiring at the same time if I couldn't please copy something else, Madame replied, 'If I've led you to believe you are copying, I am sorry. You are not "copying". You are recording the voyage of the head as it sails into evening.' (Madame loved colourful language.) 'Your sketch, therefore, is a record of changing moments; it is a history of contradictions. It is a travelogue. What it is not is a copy, because you never saw a *single* head to begin with. You saw all the heads that the light revealed at different times. Turning on an electric lamp and casting shadows would be like causing [I can't recall the exact French verb she used] a shipwreck.'

Clearly it had been a source of vast frustration to Madame that I had been so patient, as her answer seemed to have been rehearsed for some time. I had not thought about her, or the Marais, or knife rests, or the classical head with its straight nose and wound braids, for years, not until I watched the Martel sunset dissolving Lucy's angel. Madame had been right: my drawing had recorded changes in the relationship of sculpture and light (which is why, as a strictly representational exercise, it inevitably became a dark muddle of smudges). Lucy's photograph was different; it plucked just one

moment out of a similar relationship. It was only when that moment was coupled with mine that the sculpted angel became a creature like us, incomplete in her own stony skin. Perhaps the tribesmen who famously refused to be photographed, believing the camera to be a thief of souls, were on to something after all.

In the last of the lilac light I dug out my copy of Lucy's journal, looking for a written record of the angel to supplement the visual one.

> August 22, Sunday
>
> Did not get off at 10. Anfossi not ready, he does not seem well. K and I walked ahead, but for slate or red-tile roofs country seems like New England. A perfect summer day. Went first to Martel – a local festival and service in church but tympanum was outside. Very lovely. A Last Judgement, angels either side blowing horns – long and curved like their own limbs, particularly lovely.

I smiled. Lucy liked to fuss over Anfossi; she even worried that jolting over bad roads tired his arms. Only once in her journal did she mention reprimanding him (or rather, making Kingsely do so), and this only for driving too fast for her to take in the scenery.

Upon the angels Lucy bestowed high praise (recall that she had only found Isaiah a 'high water mark'), although as far as I could make out their horns were straight. As daylight failed I held her photograph up to the church for one last look. Christ's hand, palm up, prominently extends into Lucy's portrait next to the angel's horn. In the picture he has a thumb; on the tympanum he did not. I may have been thinking about the assemblage of points in time, but I must not have been feeling it; in my heart, I knew, it had been 1920. Thanks to Christ's missing thumb, eighty-two years rushed into what remained of the evening, a slim five hours, filling them with the century just passed and sweeping Lucy and Madame far away from me, leaving me on my own in the company of kind strangers.

* * *

'*Est-ce qu'on embrace?*' asked the old man after he had finished filling my car with petrol – 'May I hug you?' Broken blood vessels made messy purple filigree of his nose and cheeks. We had exchanged stories about the airports of Houston, Los Angeles, and New York City; enough said, I warranted, to merit a hug.

'*Oui,*' I replied, carelessly as it turned out, whereupon he drew me towards him not by the arms but the sides of my ribcage, so that my breasts popped up like two honeydew melons which he then squashed dramatically against his chest. After the danger of suffocation passed, I had to give him credit. I was clearly in the presence of a master of the outrageous but unthreatening gesture, a man who had mined every nuance out of the word 'avuncular'. I told him he was a *garçon méchant* – a bad boy – and headed down the N20.

The A20, the modern *auto-route*, and its alter-ego, the older, slower N20, run side by side, north to south, slicing France's mid-section in two from Paris to Toulouse. On road maps these red and yellow lines halve Quercy as well. It's a division I had been unable to dislodge from my mind the entire time I was in France. To the east of the twinned highways lie Quercy's dry, limestone *causses*, which give onto the *rougier* of the central Rouergue, climaxing in the Aubrac highlands. More or less neatly to the west is Quercy Blanc – White Quercy – which takes its name from a layer of bright white chalk that overlays the limestone. Flowing perpendicular to the high-ways are four principal rivers, which corrugate the easterly landscape, especially, into ribbons of gorges and fertile valleys: the Dordogne, the most northerly, followed in southerly order by the Lot, the Aveyron, and the Tarn.

After weeks of exploring eastern Quercy and the Rouergue, the A20 and N20 had become boundaries of known territory, while Quercy Blanc loomed somewhere on the other side, a region of dragons, for all I knew, a different place entirely. Such, sadly, is the perceptual power I surrender to maps. And yet Moissac Abbey lay to the west of the red and yellow lines, so to the west of those lines I at last went.

As it turned out, it *was* different over there. Driving south from Souillac, I crossed under the A20 from the Causse de Limogne into what could have been Tuscany had the people there not insisted on speaking French. It was a soft landscape. The luminosity had a southern quality, a higher intensity that was the visual equivalent of a long, high note on a clarinet. Woods and tilled fields rose and fell in alternate patterns and vineyards plotted the hillsides. Scattered villages of baked white limestone and tiled roofs commanded individual rises, very much in the way of Tuscan hill towns, stamping the countryside with an air of arty self-possession. The land was ripe and beautiful, scented, a place to swoon over, and immensely kind to man. For its produce – small, sweet, striped melons, peaches, apples, cherries, plums, nectarines, and especially the Chasselas de Moissac, tiny, golden dessert grapes so exquisite they have their own AOC designation – it is called the 'fruit basket' of southwestern France. Perversely, I've always preferred severity to fecundity. I found I'd already given my heart to the bleached emptiness of the *causses* and the blood-red stone of the river valleys.

Montpezat-de-Quercy was one of the hill towns where the earth shed chalky white dust; Lauzerte, located on the GR65, the Chemin de St Jacques, about sixty-five miles southwest of Conques, was another. Lauzerte was so still in the early evening, pilgrims resting motionless in the moted shade of the market square, that a bird flew confidently in and out of its nest only inches from their heads. In Montpezat faint shades of grey, cream, and pink played over the face of the white limestone church, inside of which a sixteenth-century Flemish tapestry recounted the life of St Martin. In the background of a scene of Martin furiously praying away the devil was a thatched-roof house of fitted limestone blocks, cornered and lintelled with granite. The corals, creams, and yellows of its cut stones were the same colours as those of the church, the same as those of the *causses*.

Moissac, a town of about 12,000, also on the Chemin de St Jacques, was not as silent, as white, or as promising. Tuscany gave way to

Crédit Agricole banks and buses of school children. To my sad dismay, the abbey's famous cloister was accessible only through the tourist information office – a minor but unpleasant surprise, like finding tarnish on the Queen's silver. Moissac Abbey has many times over been called the most perfect, most important, most beautiful Roman-esque monument in France. It's certainly more convenient to reach than Conques, and its sculpture has had greater influence on the region's art. The carvings of the intact south portal, which like those of Beaulieu and Souillac belong to the School of Cahors, but are just a bit older, sculpted between 1115 and 1130, wear their weathering well. And unlike most other Romanesque abbeys in southern France, Moissac has kept its original cloister, now guarded by a ticket booth and gift shop.

I paid my five euros and entered the place that Meyer Schapiro had committed to photographic memory, that Kingsley had studied, that Lucy had come to admire. A perfectly square green lawn, flecked with wildflowers, dominated by an immense evergreen, was diagon-ally divided in half by a crisp black shadow. Around the perimeter ran four galleries, open to the courtyard but protected overhead by low, red-tile roofs held aloft by slender columns. Each column or twinned pair of columns blossomed at eye-level into a four-sided capital – there were 76 of them – the bases of which sat upon a low stone wall. The white limestone capitals had been sculpted with scenes from the Bible just before the reliefs of the south porch, sometime between 1085 and 1115.

Two middle-aged Frenchwomen sat on one of the walls in the sun. Both wore couture suits, one bright yellow, the other magenta. The woman in magenta also wore a smart black hat and had a silk scarf expertly draped over her shoulder; her friend's hair shone electric-cinnamon. Both had on patent leather pumps, and they were sur-rounded by an aureole of Chanel No. 5. As I surreptitiously took their picture an aggrieved American voice called out from one of the shadowed galleries, 'Hey, where the heck are you guys?' and a young

couple, giggling ferociously, brushed past me – '*Pardon!*' gasped the woman in accented French – in search of a new hiding spot.

Worlds collided with a vengeance, and I belonged to neither. The third world that I had come to see hovered above the women's conversation and the Americans' game like silent, stone static. All 304 capital faces were carved with petite scenes of wonder and distress: visitations, flagellations, flayings, expulsions, martyrdoms, banquets, resurrections, adorations, visions. The columns were like Roman-esque telephone poles with invisible lines running between their capi-tals, crackling with the urgency of salvation and the contagious excitement of art. I willingly entered their alternate dimension, not a different world but a distillation of the one I'm generally familiar with; one in which incidents and figures are drawn from reality but, as Schapiro said, 'it is another logic of space and movement that governs them'.

This other logic took its cue from crescendos in emotion and meaning, and a visual preference for decorative effect over represen-tation. It was unconcerned with ordinary chronology or spatial per-spective. To enter this world – which after all isn't the here-and-now; who knows how cause and effect, or gravity, or geometry work in heaven, or worked in the past? – is to feel the wind blow from all directions at once. It's to stand facing forward with your feet in profile; to be as big as Jerusalem or the same size as the horse you ride. It's where a newborn can be larger than a king and where St Michael can fight a dragon, and Jesus raise Lazarus from the dead. Nebuchadnezzar and Alexander the Great exist there in the same timeless place as Peter, Paul, and Herod. It's spacious enough to fit heaven and hell, earth, and the past, present, and what in the first century of the last millennium, was the future.

This place does not exist alongside our world but within it, subject to our weather and anger and rain. Most of the little white limestone carvings were headless or faceless, not from erosion but by intent. Some had developed a mushroom-coloured patina, others had tithed

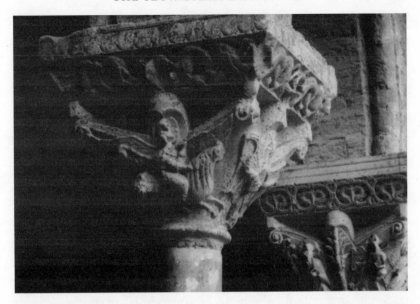

their details to the seasons. I didn't know the rules, didn't know at which point to break into the closed square. In the end I took direction from my own world, and mulled over the capitals that basked in strongest sunshine. A train went by and shook both realms to their core.

The three Magi strode purposely across their capital like members of a chorus line, capes flying, bearing gifts, following their star that had blossomed into a flower. On another capital the Apostles fished atop waves of decorative cornrows, carefully trolling their cross-stitched net. Loveliest of all was John's Rider of the Apocalypse, whose horse and wings and his flying cape stretched out to fill the triangular-shaped space with utter perfection of design. The limestone was pitted and worn – both rider and horse were faceless – yet still the pair thrust forward in a gust of wind that whipped the eye.

Adam stood before the Lord in the east gallery. Schapiro was right: he was less an observed representation than an assemblage of 'separate limbs . . . and masses', a collection of nouns rather than a

co-ordinated body of verbs. Like Madame, my Parisian art teacher, who wanted me to record a comprehensive succession of moments in time, the sculptor had used his mind's eye to rove through space in order to present as comprehensive an image as possible. In a contemporary writing workshop we'd say he 'told' rather than 'showed', but telling was the visual currency of his time, and he didn't just 'tell' Adam, he sang him, thoroughly. We see his legs in full profile and the front of his chest and torso; his hand, reaching toward God, supplicating, is larger than the thigh that merely supports him. His head is missing. Adam is more epic poem than sculpture.

A mobile phone rang inside a rucksack and a woman sitting beneath the Annunciation answered it in German. I had lost the cloister to France's bewitched hours: closed from noon to two. Instead I'd traded its quietude for the more raucous south portal, the steps of which were at the moment a perch for tourists and dogs.

Moissac's southern entrance was the inspiration for that of Beaulieu and the fragments of Souillac. A trumeau dripped with the elongated figure of Jeremiah, who despite his languor was clearly the rather stiff older brother of Souillac's gorgeous Isaiah. Kingsley had been dismissive. While he wrote that the trumeau had 'a certain brutal power', Jeremiah was in fact 'dull', despite the edgy swirls of his gown. Lucy's portrait observes him but does not meet his gaze, as Kingsley's had locked eyes with that of Isaiah. In her photograph he seems self-absorbed, whereas in person he conveys benevolence, his look, cast down upon the humans below him, trapped between love and helplessness.

The tympanum, yet another Last Judgement, is stripped of incidents from both sides of mortality. Humankind's petty problems are relegated to the narrative carvings on the porch below. It is instead a vision of Christ's eternal reign, where an overall impression of power and perfection emerges in a radiance of restless, elegant bodies and draperies. So much has been written about Moissac's tympanum that

I'll simply say it awes but does not engage the merely mortal. I was drawn instead to the humble rows of carved animals that crept around the archways of the entrance. A scrawny dog, ribs prominent, creeping, tail between its legs, moved me more than the impassive King of Heaven. (It is this judgmental Christ against whom thirteenth-century heretics – alternately known as the Cathars or Albigensians – dared protest. One man told the Inquisition of Languedoc that if he could get his hands on the God who 'saved but one out of a thousand of the creatures he created' he would 'tear him to pieces and spit in his face'.)

The German woman had moved into the sun with her mobile, and was now sitting at the feet of Luxuria, who, like her carved sister at Beaulieu, was unhappily suckling snakes and was effectively, though not so gruesomely, weathered. 'A great grotesque,' Kingsley had written, with feeling. This meant that the other side of the porch, the eastern side where I sought refuge, had fallen into deep shadow. I approached its reliefs abetted by Lucy's photographs, which she must have taken much later in the afternoon, when the sun was shining from the west.

She and I both were drawn to an elegant Annunciation in which a long-legged, barefoot angel relates his surprising news to a now-faceless Virgin. The draped cloth of his long, wide sleeve was breathtaking – the stone's expression of velvet uncannily convincing – but the angel's face had been restored. The repair work, with its lack of patina, jarred against the old stone – until, that is, I referred to Lucy's photograph. Astonishingly, its even, grainy greys restored the integrity of the figure and lent it a grace that the sculpture itself now lacked. In Lucy's image the angel's head merely appeared sunlit, rather than awkwardly new.

Above these figures was a horizontal frieze of sculpted narratives that depicted, among other things, the holy family's flight into Egypt and, next to that, the Fall of the Idols in the city of Heliopolis.

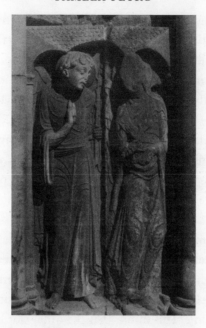

The vital details of the carvings, like those of Lucy's angel at Martel, those ordinary observations that draw the eye's sympathy, had been lost to encroaching shadows. Mary sat side-saddle on a donkey with Jesus on her lap, as Joseph led them on foot. Jesus looked up at his mother but I couldn't see his face, nor could I see the donkey's bridle, Jesus' toes, nor the way Mary's arm curled protectively around her son. The tumbling idol next to Joseph, struck down in such a way that he was facing forward but bent sideways like a horseshoe, his upside-down head next to his knees, was barely visible at all.

And yet these details miraculously rose up, Lazarus-like, out of Lucy's photographs. (A stone Lazarus was carved near the Flight, one hand on his chest and a look of astonishment on his face. I could barely pick him out of the shade.) As I peered into the shadows someone's instamatic camera hoarsely rewound itself behind me. Lucy had stood on this porch before these very carvings eighty-two

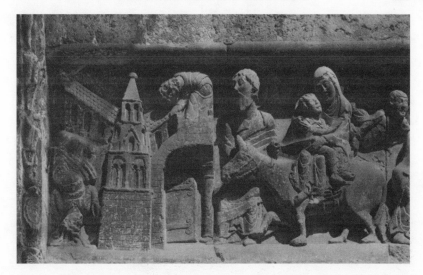

years earlier, the sun beating on her back as it now shone in my face. I wondered if she'd ever become weary of the great hulking camera: the weight of it, the time it took to set up the tripod, to work the dual focusing knobs. Like train cars on a track, the adjustable front and back portions of a view camera slide along a rail when the knobs are turned, literally travelling to produce a still image. This capacity for relational movement between the camera's parts, and between the lens and the subject, constitutes one of the view camera's chief seductions, as it offers far more control over perspective and focus than a 35mm model. 'By adjusting the independent front and back of the camera' – this from *A User's Guide to the View Camera* – 'you can rearrange the position of the vanishing point and the location of sharpest focus'.

My shadow rippled across Moissac's flagstones. It occurred to me just then that time and Lucy had given me the same ability as the view camera, a talent that had come naturally to the sculptors of the cloister capitals. In fact my journey itself, my travels in southern France in the company of Lucy's photographs, was beginning to look like nothing if not a Romanesque performance. I had all along been

living out one of the defining strategies of this marvellous art, the source of so much of its strangeness to a modern eye.

This was not something I had planned or intended, a surprise delivered without a herald angel, unless you count the stone one carved nearby. My pilgrimage hadn't ever been a point on a map but an equation I simply hadn't thought to add up: stone and photography, body and soul. I sought peace inside the church, but instead of finding an empty chalkboard on which to sketch my thoughts, like the pale limestone caverns of Conques and Souillac, so soothingly stripped of colour, Moissac looked like a paint box. The interior had been restored in 1964 to a fifteenth-century Gothic colour scheme ('a rather shocking yellow', huffed *The Blue Guide*, a little prudishly). It was pleasantly buttery, but YELLOW shouted and the storm in my head only whispered, so I abandoned the sanctuary for a café opposite the south portal. The most beautiful pigeon in France shared my table.

Meyer Schapiro had broached the idea of 'completeness' in Romanesque sculpture. Adam's body on the cloister capital was depicted from many vantage points at once. Although he may look confusing or naive to us now, his design was originally a gesture of clarity. The sculptor fashioned his legs from the angle that most readily means 'legs' to most eyes; he sculpted Adam's torso from the angle that most clearly conveys the idea of 'torso'. This impulse is even more apparent in the treatment of architecture. There is a capital along the north gallery that depicts the Crusaders; one face shows an angel with a fine pair of patterned wings and a cross, standing next to a turreted building that represents 'Jerusalem'. Schapiro wrote: 'by an adjustment which is characteristic of this art, with its concept of completeness, the roof is as visible to us as the lower doorway.'

'Jerusalem' looks awkward, even childish. But like the other carvings in the cloister, it's actually a work of immense visual generosity,

a bouquet of observations gathered from multiple fields of vision. In a single, sculpted image we see more than one dimension at more than one moment in time, and in this striving for completeness, in this roomy creativity, lies the chrysalis of twentieth-century cubism and the great, spacious heart of the Romanesque. This is what I'd instinctively loved – craved, even – all along. Company. What I had originally thought of as an unselfconscious urge to inform, even at the expense of clumsiness, turned out to be pre-modern inclusivity – a plural, public way of seeing that hadn't yet been limited to the private perspective of the individual eye.

I had thought Lucy and I were on divergent paths. Through photography she had released the old sculptures from their bondage in space; I was trying to bind them back to their bedrock. But our differences were nothing compared to what we accomplished as a team. Her photographs enabled my modern sight, tethered to linear perspective, to rove through space and time like the mind's eye of a Romanesque sculptor. They offered a different angle, a different hour, a different quality of light and position of shadow than those the present had dealt to me. Together we had stumbled upon a more spacious, more generous, more inclusive, more sympathetic way of looking at the world. We had forged a strange, cubist partnership, Lucy and I, which, like Romanesque sculpture, was built upon a multitude of viewpoints. As we took our places in past and present, we approximated the controls of her view camera, adjusted for focus, and travelled together between a succession of vanishing points.

I felt an urgent need for food and wine. Along with the tomato salad and local rosé that I'd ordered (the wine was a little too sweet, but I liked its VDQS appellation, 'Coteaux du Quercy') the waiter also brought me a pen. When I expressed surprise he pointed at mine. I'd been writing so hard I'd bent the nib of my marker; it was now at a 45-degree angle to its shaft, and I'd been compensating unawares by contorting my wrist backwards. I blushed and took the pen. The Americans from the cloister had assembled below the tympanum.

'You know, it looks Indian,' said one. 'No, it was built by the Romans,' corrected her friend.

Next to them a Frenchwoman in mismatched blouse and skirt left her cocker spaniel and her baguette with a friend and ran into the abbey. The dog went to pieces, howling and crying in distress. Moments later the woman ran out again, squatted down and took the dog's face in her hands. *'Ne t'inquiete pas, mon petit, je reviens'* (Don't worry, little one, I'll be right back). She returned to the church and the dog commenced to sniff, silently.

I wished I smoked; the rhythm of consciously breathing in and blowing out might have harnessed my mind in some practical way. Instead I was left with a mental free-for-all, out of which, to my surprise, stepped Henry Adams, waving his big book. In *Mont Saint Michel and Chartres* Adams tells his niece and readers that to understand the Middle Ages they 'had better become bilingual'. This was precisely Lucy's gift to me: the visual bilingualism of the Romanesque. I may be extrapolating a little, but it's a way of seeing that reduced my own perspective to one amongst many, spanning different points in space and time. It was humbling, a move away from the arrogance of the singular, modern eye (and 'I'). Romanesque vision truly was pre-modern, but it was as necessary and appealing now as it had ever been. Was there buried somewhere deep in its attraction a reassurance of community? An implication in the art, borne out by Lucy and me, that multiplicity and pluralism were as sure a route toward sublimity as individual genius? And isn't seeking evidence of not being alone another way of asking 'Are we saved?' in a secular age?

Travelling with Lucy's images was a warmer, friendlier way, to paraphrase Madame, of watching a single work of art sail into evening, without the smudges, strain, or time lapse. It implied a polytheism of the eye (I remembered with pleasure that Lucy had called polytheism 'a much more rational explanation of the existing universe' than monotheism). Kingsley had also collected moments in time –

moments preserved in photographs of different art works from vary-
ing locations, that he then set one against the other. To stage this
kind of comparison you must retain a modern outlook, you must
remain inside yourself, stand still, and judge differences from your
singular point of view. It is the opposite of looking at the same thing
from different points in time and space, which demands the inclusion,
if not of others, then at least the Romanesque genius for otherness.
Expressed in sedentary stone, Romanesque sculpture is an art of
perceptual travel on its own pilgrimage toward eternity.

Lucy, through her delight in making new art from old, and I
through her photographs, had made sculpted angels feel and fly. By
contrast to our miraculous partnership – in which Lucy would take
pride, I think; she identified herself first and last as a photographer –
Kingsley's vision was set in stone, even as his life split in two. It was
not a balanced dis-co-ordination. Unlike the swooping housemartins
of Conques, the sculpted birds of Souillac did not sing in pleasant
disharmony.

* * *

In 1930 Kingsley and Lucy bought Glenveagh Castle in Donegal, on
the western coast of Ireland. Kingsley had repeated the success of
Romanesque Sculpture of the Pilgrimage Roads with *Spanish Roman-
esque Sculpture*, published five years later, by which time he felt he'd
finished with the field. In her essay on Kingsley and Émile Mâle –
ultimately the more influential of the two – Janice Mann attributed
his dwindling interest in the Romanesque to his need for singularity,
for being a trailblazer. She quotes the draft of a letter he wrote to two
Harvard colleagues in 1929, asking permission to resign. Kingsley
explained, 'With the great development of archaeology in the last few
years the complexion of things has changed. It is no longer a field for
a pioneer, but for co-operative production. The peculiar advantages I
once possessed no longer count.'

A generous man to a fault, Kingsley none the less had no wish to

embrace plurality, at least in his professional life. By 1929 he may have had other reasons to wish to quit Cambridge as well, fear of scandal chief amongst them. However, he either didn't send his letter or his colleagues talked him out of resignation. Instead, Kingsley set about learning Irish Gaelic (he already spoke Spanish, Catalan, and polyglot Scandinavian, 'in addition to the more usual European tongues'). The language would serve his new passion for early Irish stone crosses, as would his second home – far from the eyes and tongues of Cambridge, Massachusetts – on the far-flung coast of Donegal.

7

THE CAUSSES

... but when I try to imagine a faultless love
Or the life to come, what I hear is the murmur
Of underground streams, what I see is a limestone landscape.

'In Praise of Limestone', W. H. Auden

The rarest thing on the *causses* is a puddle. It's no place for Narcissus. If you want to see yourself there, you have to look deeper.

It's not that there is no rain. The rain falls in Quercy, sometimes torrentially, but it sieves through the topsoil – a thin residue of weathered limestone broken into clay, silt, and sand – and seeps down to the bedrock. But that's not the end of it. Limestone is soluble. The rainwater literally eats it away, dissolving the bedrock of Quercy into a porous sponge that sucks moisture from the above-ground landscape, collecting it in a labyrinth of underground lakes, chasms, caverns, and rivers. That leaves the daylit world gasping under the baking sun. When limestone guzzles down the rain, all that's left is arid soil fit only for scrub pine and juniper, a few ashes and stunted oaks, and the pale grasses that feed sheep and goats. Some crops – corn, wheat, walnuts – get by on the fringes. Far underground, wherever men have affixed electric lamps, the algae that clings to stalactites is the brilliant green of Irish fields in spring.

Everywhere the bones of the earth are exposed like compound

fractures. These outcrops, greyed with old sunshine like cedar shingle houses along the New England coast, are joined by mazes of low, dry-stone walls. There are literally thousands and thousands of these, marking out perimeters of phantom fields. A mania for order gripped the Quercynoise farmers of the nineteenth century, and the result was a bourgeoisification of the earth itself. The place was too untidy, rocks everywhere. So farmers picked them up, figured out whose sheep belonged to whom, and outlined everything in stones. It didn't help them grow richer, only more organized. Today half the farms you see are abandoned, their old walls composed of blind stones leading other blind stones nowhere in particular.

One of the problems of farming on scraps of earth – the few spots where there is a greater proportion of soil to exposed bedrock – was that farmers didn't have the luxury of ever letting a field lie fallow. They compensated in a particularly clever, if ultimately unsuccessful, fashion. They kept pigeons (also good for stew) and collected their droppings to spread on tilled earth as fertilizer. The stone dovecotes they built, called *pigeonniers* or *colombiers*, still stand like ornamental follies, rarely now surrounded by crops. Abandoned or not, they are always and everywhere watched over by the merciless stone walls, which also hold crumbling, round-hut *cabanes* and Stone-Age cromlechs prisoner with equal, undiscriminating vigilance

Marion carefully constructed a frontier between the butter pot and basket of baguette slices. Her stones were the same colour as the bread, crusty-brown on two sides where they'd been familiar with iron oxide, and pale, creamy white on the others. She had a handful of them, limestone chips gathered up from the garden, and had been seized by an instinct of her ancestors to partition the breakfast table.

Marion could count to ten in English but was only nine, and her doll was named Marie. For a reason I didn't care to dwell on I had been banished from the hotel dining room to a table at the small adjacent pub, where Marion's mother sullenly served my breakfast.

Marion occupied the only other table. After a shy interval of about three minutes our eyes met.

'You are from where?'

'The United States.'

'Have you been to New York?'

'Yes.'

'My father works in a restaurant in New York! Have you eaten there?' The mother's air of martyrdom explained.

I asked the name but she didn't know. I told her that all French restaurants in New York are good.

'I don't like what my *papa* prepares.'

I asked her what she did like.

'*Les hamburgers.*'

That said, Marion had never heard of McDonald's. I congratulated her on this feat but it only piqued her interest.

Marion lives in Thegra, a village on the northern edge of the Causse de Gramat where the local stones have been gathered into especially stylish architecture. Thegrian roofs point and poke toward heaven in conical *lauze* turrets and red-tile gables, and all the walls have the textured look of grey cat fur stroked backwards. On the morning I spoke to Marion men old enough to remember the Second World War were setting out tricolour flags for Bastille Day and tending pink hydrangeas.

After we'd both finished eating, Marion approached. I was glad to have been sequestered in the pub; the dining room, though encased in two-feet thick stone walls, blinded customers with fluorescent track lights and was decorated with a collection of bright, embroider-by-numbers pictures of children cuddling baby animals. The pub had a no-nonsense bar and better company.

She held out two fists and inclined her head toward each. I picked the left, and she opened her fingers to reveal one of her building stones.

'For me?'

She shook her head affirmatively.

I ransacked my luggage for something to give her in return, but only came up with a pad of neon pink, sticky-backed notes, on which she immediately began to draw pictures of cats and dogs. These would soon, I knew, be stuck all over the hotel. We parted reluctantly.

The morning had a caul over it, a damp white hush. I drove thin farm lanes and filled my windscreen with green-and-tan strata. First, an ashy-golden, dry-stone wall; then a layer of ivy; a fringe of pale weeds; then the tops of young green corn stalks. In the distance, walnut orchards repeated the pattern, the bases of their trunks heaped with stones like Marion's, above which crosshatched leaves swung in the wind as a green fishing net rides waves.

I liked this bi-chromatic place of stone and grudging vegetation, but I wanted to see the water. I knew it collected below ground like a repressed memory of the limestone, some dim, buried recollection of a Jurassic ocean. And so to plumb the psyche of the rock I descended, along with scores of French families, Dutch caravaners, and over a hundred Japanese tourists, into the Gouffre de Padirac.

Gouffre means 'chasm'. It is really, as I overheard someone say in English, a giant, natural well, a perfectly round hole in the ground 246 feet deep and 105 feet wide. It formed when the ceiling of an underground cavern collapsed (thereby undermining the phrase 'terra firma'), revealing the innards of the earth to the sky. Or it was one of the devil's shortcuts to hell. Either way, the *Gouffre* must satisfy some primal curiosity – perhaps our instinct to break things open, from eggs to geodes to the crust of the earth – because it was swarming with people. One big hole in the ground is so far responsible, to my count, for three car parks, two hotels, a collection of *brasseries* and snack bars, several souvenir and *artésenal* shops, not enough WCs, and very long ticket lines.

You can follow the sun down the hole – the trajectory of its rays is marked in algae and long garlands of moss – and then go farther. Three hundred steps followed by three elevators. All day long there's

an unending line of humanity shuffling down into the ground and out of sight, as if Dante and Virgil had decided to open a tour business. The constant ping of thousands of footfalls on metal treads sounds like a perpetual rainstorm. At the bottom a recorded message plays over and over in French and English: 'If the lighting fails, visitors are asked to stand still and wait . . .'

Below ground the *Gouffre* opens onto a series of spacious, dripstone-encrusted galleries. The usual comparisons flood the mind: candle drippings, mushrooms, gills, ears (the last was a little unexpected), in all the shades of brown eggs. It was the *causse*, transformed.

Signs urged my fellows and me to follow passageways until we came to a *quai* on the banks of an underground river – the River Plane, which eventually emerges to flow into the Dordogne – whereupon we were ushered into gondolas. I shared mine with three generations of a Japanese family, all of whom wore baseball caps that read 'Volvo Grand Masters'.

Our boatman poled us into a flooded gallery called the Lake of Rain. Here, more than nine hundred feet underground, was the limestone's secret reservoir, the holy water that consecrates the bedrock of Quercy. It's called sweetwater, tending to alkaline from the infusion of lime. Good for the making of whisky (in Scotland and Kentucky) and for preparing the soil in which grapevines grow best. Anyone who doesn't believe that rock, limestone rock, is soluble in water had better go to the Gouffre de Padirac. Drips fell everywhere, on my face, my head, my notebook, on the visor of the Japanese grandmother's cap. Plop. Plop. Plop. And each one carried the *causse*, the foundation of all that waited above, in solution. The pale, heavy stone I thought I knew – Marion's rock, Isaiah, the nave of Conques – was shape-shifting before my eyes. What was sedentary became portable; what seemed finished revealed itself to be merely in transit. And what a transit! Limy sediment collected in seawater – compressed over aeons into rock – rock pummelled by rain – its sedimentary laces slowly undone – quarried into pieces small enough to be borne by

water – carried in solution – wearied of and set down: Left Luggage cemented (for a time) to the tip of a stone finger hanging from a cave ceiling.

Limestone is not as still as we think, nor is it exclusively the thing we mean when we call it by name. 'Limestone', whether shaped in our likeness or cropping from the ground, is better thought of as a tick on the geological clock than the rock-solid substance of which we sculpt our dreams and build our shelters. If a pilgrimage is a transforming journey, then limestone *is* a pilgrimage.

I liked the *Gouffre*. I liked the fact that, all similarities to the River Styx aside, traffic on the Plane went in two directions. I liked knowing that what was taken from the world above – not just from the weathered stones of the *causse* but the ravaged figures of Beaulieu, and other sculptures too – was redeposited down here in another form. These dripstones could well be Jesus or Luxuria, the Devil, Lazarus, or the Apostles reconstituted, and none the less beautiful for it. Secrets, all of them, whispered on the slow breath of stone, telling us which way the geological wind had been blowing.

I tasted the sweetwater before I climbed back up into the sun. Like all good water it didn't remind me of anything. Across its surface rippled a pleated image of me.

* * *

The inhabitants of Quercy are famously reserved. They are the New Englanders of Southern France, with a reputation for being mannerly but aloof, a people reared on bedrock and accustomed to spareness. They're as likely to communicate through stone – dolmens, tympana, walls – as speech. There's a theory that their landed quietude was abetted by the influx of English blood during the Hundred Years War. South of the Garonne easygoing, Mediterranean ways are said to replace the reticence, though in my experience both manners and geography begin to loosen up a little farther north, in Quercy Blanc, as my warm-blooded friend at the petrol station attested.

What other French people mean when they say that the Quercynois are reserved is that the Quercynois of the *causses* are reserved. (As usual, everything is relative. No one outside the region speaks at all of the Rouergat, folded up quietly in their hills between two major *auto-routes*, on the *causses* they have a reputation for insularity and closed-mouthed poverty.) The *causses*, however, do not begrudge all gifts to those who live on them, as I began to discover in Gramat, the town which lends its name to the central of Quercy's major plateaux (to the north is the Causse de Martel, to the south is the Causse de Limogne).

My intention had been to visit Rocamadour, but I was foiled by my own habitual impatience. The medieval pilgrimage town famously – to my mind, a little pretentiously – defies gravity by clinging to a sheer hillside, and is rumoured to possess a miracle-working, twelfth-century Madonna. Every tourist south of Paris who wasn't at the Gouffre de Padirac was trying to leave a vehicle in one of its outlying car parks. (Lucy called the place 'picturesque, tourist-ridden Rocama-dour'.) Five minutes in an ugly traffic jam was all it took to send me wheeling back out of town onto the bleached emptiness of the Causse de Gramat, a noontime reprise of my earlier escape from Figeac.

Gramat is the quintessential *causse*: empty, arid, undulating like a shaken blanket of limestone. Beautiful, yet all I could think about was food and my lack of it, but for a half-eaten roll of fruit-flavoured Mentos and a bottle of mineral water. My guidebook contained exactly one sentence on the town of Gramat, in the centre of the *causse*: 'The Lion d'Or has an excellent restaurant specialising in local produce.' I drove there without delay.

Unlike Rocamadour, Gramat had not one tourist to its name. It was neither ugly nor pretty; residents moved with the efficiency of those uninterrupted by the glamour of miracles. In the midst of town sat a big, fieldstone hotel veined in wisteria, with café tables and umbrellas set out front. The Lion d'Or, The Golden Lion. The tablecloths were starched and pink and the umbrellas white, the

silverware heavy and pitted with age but gleaming. I hesitated, worried suddenly it might be too expensive, but the delay proved fateful – the hostess was already indicating a table. I sat and selected from the starter and entrée menus the two items with the most words I was able to understand.

The starter, I knew, would feature *fois gras*, about which I had an Augustinian opinion: Lord, please give me the strength to forgo eating goose liver pâté, but not yet.

After leaving the Gouffre de Padirac I had briefly stopped at a farmstand that sold pâté*s* and *confits*. Like nearby Perigord, Quercy is a top producer of *fois gras* and other goose and duck products. Old brochures advertising farm shops and local co-operatives are splashed with photos of rugged elderly women in cheerful aprons performing *le gavage*, the force-feeding of geese. The women sit on something earthy – a stump or a rock, anything to imply that the land itself somehow sanctions this act – with a goose firmly wedged between their knees as they expertly shove a funnel down its throat (over-feeding makes for a plumper and tastier liver). New brochures invariably depict free-range flocks waddling around in front of a handsome stone barn. One even had a cover-shot of baby goslings. There were no animals in sight whatsoever where I'd stopped, except for a friendly dog that jumped in my car. I'd bought a little tin of *rillette de sangliers* – a coarse wild boar pâté – on the likely assumption that no old woman, however brawny, would willingly force-feed a boar.

But now I'd become complicit again. I'd intended to drown my qualms in a glass of Cahors, but recalling that I had to drive after lunch, I waved away the wine list. My young waitress gave me a disapproving look, as if abstinence were a mutual insult. She was slight and dark-haired, and like her one other colleague wore a navy blue suit with matching pumps. The two of them clipped back and forth with exceptional purpose and professionalism, carrying ice buckets and laden trays. Shortly after I'd ordered, a gentleman at a

nearby table, also alone, half-stood, turned, and apologized for sitting with his back to me. 'It is the way they seated us, yes? My apologies.'

'*Madame!*' exclaimed the waitress, setting my starter before me. The menu had described it as a *cassoulet* of escargots with parsley, *fois gras*, and grilled toast. I had expected a little stew, or at least something that could be described by a culinary term. Instead I had been served geography. On the large white plate lay a pool of green – young-toned green, the colour of the tender insides of leeks, of perfect limes and new growth, sprinkled with darker flecks like minced spruce needles. Atop the pool sat a honey-brown wedge of toast tossed with slices of roasted garlic. A dark, earthen mound came next – the *fois gras*, smelling of richness and secrecy, like an overturned garden – capped by a fountain of green onion sprigs. Snails hunkered in the way of fieldstones around the construction.

In the time it takes lightning to strike I saw Neolithic tombs out on the *causse* and the mosses that grows in their shade. I saw Quercy's aimless drystone walls and the algae clinging to the *Gouffre*. And then I ate, hungrily. It was one of the three or four best things I've ever tasted.

'Is Madame pleased?' My young waitress again. I nodded enthusiastically. 'Is Madame tasting the flavours of the calendar? Yes?' Her face looked expectant and keenly hopeful. 'In this,' she pointed to my plate, 'one perhaps tastes the young year and the old?' It was a question I sensed she wasn't sure I'd be able to answer. But I also had the impression that I'd acquired a tutor driven to cultivate the vocation of eating in those who appeared to lack it. She smiled and clipped off in a whirl of competence, having alarmingly upped the ante of what constitutes lunchtime satisfaction. M.F.K. Fisher wrote in the Thirties about having been virtually accosted with food, course upon course, by a provincial French waitress fanatically passionate about her job. I had assumed she'd exaggerated the tale, but was now not so sure.

A Brittany spaniel zigzagged between the tables and I took a few

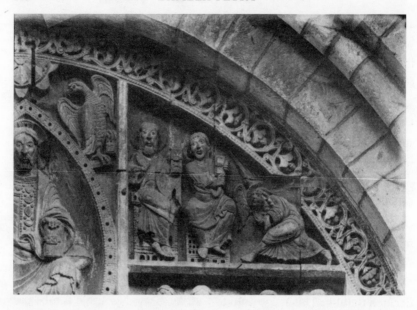

more bites. My waitress was right. It did taste of all the seasons at once, of promise *and* fulfilment, of photosynthesis and darkness. I hadn't noticed. I hadn't the practice. My eyes usually told me everything I thought I needed to know. Even now they were taking over again. One of the waitresses hurried up to a table, bent down, and with long, professional strokes brushed crumbs into her open palm. Without a moment's hesitation I knew where I'd seen the same gesture before: on the tympanum of the Romanesque church at Carrenac, a nearby town on the Dordogne built of baguette-coloured limestone. Lucy and Kingsley had been compelled to wait there over an hour for the tympanum to be free of spotted sunshine before they could photograph it. Lucy had observed in her journal that the two squat angels rushing toward Christ from either side had looked 'almost comic in their attitude of hurrying eagerness'.

How right she was. Bent double to accommodate their corners, the angels had lunged forward, round-shouldered and obsequious, with arms held out in front of them precisely as if they were carrying

steaming tureens to Christ. They may in fact be the only winged waiters ever recorded on a Romanesque tympanum, eternally hurrying, draperies tugged to the utmost between tiptoed back feet and outstretched front ankles.

Unlike other churches I'd seen in Quercy and the Rouergue, Carrenac's had been encroached upon by the town. There was no space for awe, no sense of approach, only surprised discovery. You were on top of it before you knew it, face to face with a menagerie of beasts that prowled the portal. Duck, wolf, mink, bird, boar. Each bristle on the boar's back and haunches had been picked out with a chisel, and as if in contradiction of the 'wild' in front of his English name, he'd worn a tiny collar with a bell.

'*Voilà, Madame!*' My second course had taken me unawares. I decided that I had been too hungry for the first, and that my waitress's quiz about the seasons had therefore been void. This time, primed but no longer ravenous, I was ready to taste the unseen, ready to take art's leap into the intangible from the unaccustomed platform of my tongue. For my entrée I had ordered *gâteau de canard* – literally duck cake (since I'd already eaten goose, I thought I might as well do in a duck, too) – cooked in shallots and pan juices and served in a 'mirror of red wine' (how I liked that!) with wild mushrooms. The cake turned out to be a golden concoction of puréed potatoes; morsels of crispy duck were hidden beneath. A fan of sliced potatoes, each pleat membrane-thin, hovered on top, nesting in a little mound of red cabbage pierced with rosemary and a strip of baked bacon. A tiny wall of mushrooms, fallen under the attack of my fork, tumbled into the dark red, silky lake.

It posed a prodigious challenge. There was a gill-tickling sweetness, but also a richness, an almost overwhelming richness. The dish was the culinary equivalent to Permian sandstone, and well beyond me in maturity. It had outgrown spring. Some hitherto unconsulted intelligence in my gullet whispered it was about vitality in the prime

of life, about embracing complexity and autumn, whereas the starter, like me, hovered between spring and fall.

I wanted to communicate at least a fraction of these thoughts to my waitress, but while I'd been eating, an entire orchestra had arrived at the restaurant unexpectedly. The outdoor tables were filling up with men and women who carried awkward instrument cases mostly shaped like giant pears. The latter had been set down to become a run of rapids in the aisles that the two waitresses navigated with cool, if slightly manic, grace. I decided to keep my gastronomic enlightenments to myself. That I had eaten with appreciation – and probably comic concentration – was more than evident.

No sooner had I concluded this than my young waitress raced past my table, hesitated a millisecond, then turned back. She beamed first at my nearly empty plate and then at me. '*Vous me permettez?*' – Will you allow me? And then so deftly that her fingers never touched my skin, she tucked in the label at the neck of my sleeveless top.

As I was starting my car after lunch I was startled by a tap at the window. It was the man who had sat with his back to me at the Lion d'Or. Was I in a hurry? I said no, not particularly. Why then, he wondered, had I eaten so quickly, and without wine or coffee? I told him I thought it had been a leisurely lunch. He wasn't having it.

'I insist,' he said, 'that you have coffee with me now. The meal needs, what do you call it, a full stop? Yes?'

As at Espalion, where I'd toyed with concluding dinner on the unacceptable note of the cheese board, here again I seemed not to have fully appreciated the role of sequence in the national ritual. We went to a café.

His name was Serge. I first learned that he'd had the Quercy lamb (another AOC product) with garden vegetables, chanterelles, and saffron. Did I know saffron was a product of the *causse*? I looked witless. I knew it grew in Spain, but not France. Serge explained that purple saffron crocuses – the fabled spice is made from their

golden-red pistils – had been a significant product of Quercy in the late Middle Ages up until the eighteenth century. Then it had virtually disappeared until a few years ago, when some local entrepreneurs had again taken saffron in hand. The crocuses thrive in dry, limy soil.

'Are you a horticulturist?' I asked. Our sentences, mermaid-like, began in one language and ended in another.

'*Mais non*. I am a travelling salesman of children's clothes.'

'But you're from Quercy.'

'*Non*. I eat here, simply. I educate myself about the places in which I eat.'

'How did you know I hadn't had coffee or wine when you were facing the other direction?'

'I asked the waitress why you and I finished at the same time, when I had arrived three-quarters of an hour before you.'

'Oh.' I privately marvelled that strangers took my dining and digestion so seriously.

Serge continued. He'd chosen the homemade walnut ice cream for dessert. Had I seen the groves nearby? This time I shook my head yes. Then we approached the subject dearest to his heart; the reason, it seems, I had been taken under wing.

'May I ask, if you don't mind, why you did not take wine?' Serge had a gentle manner and intense eyes. He was middle-aged and courteous, with a slight tremble of the hand that I guessed came from too many solitary meals concluded with cigarettes and brandy. I told him I truly loved wine, but was driving after lunch. He shrugged with contempt.

'Your duck needed a Cahors – *Et bien, Pamela, one glass of Cahors!* – to come alive again.' I made a face at the image but he was too serious for humour. 'We are not far from the vineyards here in Gramat. The *terroirs* of Cahors are just down the road. You must respect locality.'

An excellent wine shop in Gramat called Atrium sold '*Cahors et*

Grands Vins du Sud-Ouest'. It had the hush of a church and was almost morbidly respectful of its product. The salespeople looked like models. Serge took me there for a brief lecture.

'Your duck: now ideally, he would have wanted an older Cahors, not a young one. But for your *fois gras*, ah, well, perhaps you'd have required two glasses after all. For the *fois gras* I would have selected a younger wine.' He assumed I knew he was talking about reds. He explained that Cahors are produced from Malbec grapes – locally called Auxerrois – with some Merlot tossed in for fruitiness. Unlike most other AOC wines, Cahors' grapes are grown in two distinctly different environments. Some vines grow on terraces in the Lot valley; wines from these grapes mature quickly and are ready to be drunk after three years. Other vines grow on the *causse* itself. These wines must develop for at least five years, though the very best vintages are held back for fifteen or more.

'Serve the young wines with *fois gras* or Roquefort, and you won't go wrong,' advised Serge. 'And for the older ones, of the *causse?*' His eyes glowed with eagerness, and we'd only just finished lunch. 'Truffles, fowl, wild mushrooms, and *les cabecous de Rocamadour. Oui? Vous savez les cabecous?*' I explained that I'd tasted the little round pats of goat cheese in the Rouergue – Serge shrugged again – and had visited a car park in Rocamadour. Once again, the importance of the subject precluded humour. Even though *cabecous* are also made in the Rouergue, the town of Rocamadour gets the AOC designation.

Serge helped me pick out a good bottle of mid-priced wine, a 1997 Château de Haute-Serré, and then roared off in his van to sell tiny frocks and overalls. Not far south of Gramat, while contemplating my waitress's expert tuck of my tag – How many times had she passed by without feeling quite familiar enough to slip it back in? Had I somehow earned the favour? – I sadly ran over a foot-long, bright green lizard on the A20. Moments later I came upon the improbable sight of two ancient shepherdesses and their flocks of sheep gathered

together on a traffic island in the midst of an empty new intersection. One of the women jumped up and down, clasped a hand over her mouth and pointed the other at my car. I stared at her in confusion, then turned and looked ahead just in time to see one of the flock, a straggler, sauntering across the road about ten feet in front of my bonnet. I nearly stood the car on end, but missed her by inches. In the slowed-down vacuum of panic I'd seen her eye (she was that close) and it had looked no more nor less terrified than the eyes of sheep usually do.

The women crossed themselves and cheered. I stopped down the road to collect my files, books, Mentos, and water bottles from the floor where they'd been flung. My photocopies of Lucy's journal lay in a heap. Out of curiosity I looked up her entry on Cahors cathedral, where I was headed, and found this as well: 'For luncheon at Lion d'Or – unusually delicious for 7 francs including wine. Hotel clean and attractive.' I'd paid 22 euros.

*　　*　　*

Cahors is two things: a city and a wine. Both have an easy authority. The city pulls the River Lot around it on three sides like a stole. It's been a leading city – capital of the old province of Quercy, and before that of the Cadurcii, a Celtic tribe that bequeathed the French their name and proved a thorn in the side of the Romans – and a captured city, having been taken first by Rome, then the Moors, and later the English. The wine is one of the great wines of France to be grown on Jurassic limestone (others are Sancerre, Chablis, and Burgundy's Côte d'Or). Cahors is nicknamed 'black wine', its depth of colour in the glass similar to the luminous maroon highlights on the coat of a black dog sleeping in the sun.

The city isn't big, only about twenty thousand people, but wine, history, and rows of venerable sycamore trees give it heft and self-esteem. Everyone rushes to see the fourteenth-century Pont Valentre, probably the most photographed medieval bridge in France. I drove

across the bridge and visited the Cathedral of St Stephen instead. The afternoon was quiet and the sun had the clarity of a mathematical equation. People sat in shade or walked slowly, taking small bites of walnut pastries that tasted fresh and sweet, but mildly so, more like a scent on a breeze than a flavour in the mouth.

The southern façade of the cathedral opened onto a large square named for a local member of the Resistance. It was a calm, grey wall of stone. People sat on benches facing the small entrance and looked contemplative, as one is supposed to in the presence of Age and Art. An English couple paced back and forth.

'Excuse me,' the woman stopped me, 'but we can't find the Ascension.'

'I know. I'm looking for some very beautiful figures who are supposed to be whirling around in restlessness,' I said, loosely quoting from Lucy's journal.

'Nothing whirling here,' said the man.

We poked around the corner of the western façade, and found even less decoration. Continuing around the next corner we were all three nearly mowed down by a tiny white-and-gold locomotive pulling four miniature cars of tourists behind it. The cobbled alley on which it ran was so narrow that the little train occupied nearly its entire width; another street, descending from the north, met it in a T-junction not twenty feet from the (locked) doors of the cathedral. A Peruvian quartet in alpaca ponchos was playing folk songs on wooden flutes on a nearby corner.

'There it is!' cried the Englishwoman, jumping out of the way of the train.

Carennac may have taken bites out of its Romanesque church, but Cahors has practically digested the sculpted frenzy of its cathedral's north portal. I had to stand in the street with binoculars to see the tympanum and mad-cap cornice above, pressing up against a shopfront on the minuscule sidewalk whenever a car went past. It was a twelfth-century secret in full view.

Whereas Carennac's Ascension had been carried off with sedate decorum – the Apostles all sat, only the waiter angels rushed – here there was a strong sense of compartmentalized agitation. The tympanum had none of the radiant, integrated energy of Moissac, yet within his or her frame no figure was in repose, either. The standing Apostles along the bottom row looked like people who had been waiting a very long time for a bus. (For reasons known only to himself, the sculptor chose to carve ten Apostles, one with his back to the viewer; hiding behind the rather rude Apostle was his eleventh colleague, peering over his shoulder. Lucy photographed the pair.)

Two campy angels on either side of Christ posed like chorus girls in a 1920s review. Hands on hips, heads on shoulders, arms waving, knees bent, every pose exaggerated, they were Lucy's 'whirling' figures without a doubt, standard-bearers of what Schapiro called 'the dominant restlessness of Romanesque art'. Like Kingsley, these angels would never sit still. The 'repining restlessness' to which man was sentenced by a jealous God in Herbert's poem 'The Pulley' – recited to me by Annie on that long road to Lunel – had here been wished upon the angels by a twelfth-century sculptor who must have had jazz playing in his head.

'They look like a pair of dancing girls, don't they?' muttered the Englishman.

'TTTTTWWWWANNNNNNG – SLIDE – TTTTTTWANNNNNG.' The air throbbed suddenly and almost knocked us down. The three of us looked at each other in terror. 'I SAID IF YOU LOVE ME, YOU BETTER CALL ME BY NAME. I SAID IF YOU LOVE ME, YOU BETTER CALL ME BY NAME . . .'

By now we'd run across the street to peer into the neo-classical courtyard of the Conseil Général du Département du Lot. '. . . 'CAUSE IF YOU DON'T IT'LL BE ONE CRYIN' SHAME . . .' An American blues band had unpacked its electric guitars and plugged in its amps – orange extension chords ran inside through open

windows – and was rocking the sleepy Cahors afternoon for all it was worth. Delta blues on the Lot. I'd seen posters for a jazz festival, but hadn't paid much attention. I never dreamt for a moment that the angels would have live back-up.

'TTTTTWWWWWANNNNG – SLIDE – TTTTWWWANNNNG . . .' The band was practising for an evening performance, and they kept repeating the same phrase over and over again. Whenever they stopped the Peruvians' flutes would fill the void with the divine irony of Simon and Garfunkle's 'Sounds of Silence'.

I went back to the cathedral. There is a very real sense that only after the sculptors finished the tympanum did they really begin to enjoy themselves. A slim necklace of interlocked figures floats around the portal: people and beasts, feet to feet, head to feet, feet to head, holding hands, spearing each other, grasping reins, thrusting swords into one another's backsides. Above them is a cornice cut with elaborate dental work, upheld by figurative corbels. Tiny sculpted figures pop out of the dental moulding, flinging their arms wide as if to say, 'Here I am!' Then they disappear into the stonework, only for their legs to re-emerge through open medallions on the underside of the cornice. It's a fantastically clever idea and a tour de force of craftsmanship.

Below them the corbels seemed more animated than ever by the music. A couple made love; a woman hung upside down in a back bend; a pig snorted; a naked man clung to his block of stone, looking over his shoulder in concern at the ground far below. So much glee in the details, such observation and delight, that Christ's Ascension seemed almost an afterthought. No wonder St Bernard had fussed and fumed at these 'beautiful deformities'. Each glance at the nostril-flaring monster, sticking out its tongue at the crowd below, was a glance away from one of the scenes of St Stephen's martyrdom. Where would the eyes linger? That Bernard himself wasn't looking only at saints and Virgins is clear from his letter:

To what purpose are those unclean apes, those fierce lions, those monstrous centaurs, those half-men, those striped tigers, those fighting knights, those hunters winding their horns? Many bodies are there seen under one head, or again, many heads to a single body. Here is a four-footed beast with a serpent's tail; there, a fish with a beast's head. Here the forepart of a horse trails half a goat behind it, or a horned beast bears the hind-quarters of a horse. In short, so many and so marvellous are the varieties of shapes on every hand, that we are more tempted to read in the marble than our books . . .

Romanesque sculpture looks eternity in the eye, but it also looks away. It's the priest at mass *and* the altar boy making faces behind him. It instructs and it tempts us away from our lessons. It gives us a choice, thank heavens – what art before or since has done that? – because its makers knew we are restless creatures, that even God bores us sometimes, and that the music playing in our heads isn't always that of an angelic choir.

* * *

Few things transform a dingy hotel room faster and more thoroughly than a bottle of good perfume. I have worn 'Ivoire', a venerable scent made by Balmain, since I chose it from the cosmetics counter at Galeries Lafayette in Paris twenty years ago, and have never tired of it. I carried a bottle in my luggage – bound in a plastic bag in the event it leaked – as much for its whisky-golden colour, ivory cap, and Art-Deco lettering as for the hushed richness of its fragrance.

I sat on the bed staring at my treasured bottle of 'Ivoire' as the day began to cool off and the sun deepen, at peace with the knowledge that it was the most elegant item in the room. Through the open window came sounds so familiar I half-listened for them at this hour: glasses plunking on a table, the heavier thud of a bowl being set down, the efficient click-clack of cutlery plucking porcelain. These dinnertime noises, so matter-of-factly French, bit into me and made me acutely aware I was alone and without utensils. Except, of course,

for my corkscrew: I opened the Château de Haute-Serré that Serge
had told me to save – it was the colour of garnets in dim light – and
contemplated my perfume.

After leaving Cahors I had driven onto the Causse de Limogne.
New roadcuts revealed that beneath the ashy monochrome of grey-
baked limestone the bedrock swirled in alternating bands of red and
white that looked just like American-style bacon, though each
striation had the texture of broken bones. The red bands were made
up of clay tinted by iron oxide. As limestone weathers, iron oxide is
often one of the impurities left behind by the dissolving rock as its
constituent compound, calcium carbonate, disperses out into the soil.
A little further on the wild *causse* had given way to the orderly green
waves of a large vineyard. In mid-summer the foliage was luxuriant
but the grapes still immature. The vines were planted amidst raised
rows of limestone chips that looked like long, reddish-brown barrows.
I saw a sign by the roadside: Vignobles de Château de Haute-Serré.

Jurassic limestone can keep its holy water to itself as long as it
leaves the wine to us. The same rock I had just left in Cahors, piled
into a cathedral now blackened by years of coal and automobile soot,
is not only good for carving, wall-making, and the keeping of fossils;
nothing can beat it when it comes to growing grapevines. This is
France's 'national rock', and it bequeathed the ideal soil to the Causse
de Limogne for the making of black wine.

The *terroir* of a vineyard is essentially its environment, the interplay
between its geology and topography, which together account for
critical things like how well the soil drains, exposure to sun and shade,
and the slope of the earth. None of the grapes that go on to become
France's finest wines are grown on flat land; in fact the best place for
vines is the mid-slope of an incline – what in English is called the
'belly', and in French the *rein*, or 'kidney', of the hill – which tends
to trap sunlight and offer decent drainage. The Haute-Serré vines
rode on some low hummocks called *cloups*, rich, red pockets of the
causse where iron oxide collects and helps bind the topsoil together.

Beyond doubt, soil is the linchpin of any *terroir*. Without good soil, and by that vintners mean the quality of its structure and texture, no decent vine will thrive.

Lots of factors influence the composition of what I call 'dirt', too many to name. Suffice it to say that dirt, or soil, is basically weathered bedrock combined with whatever else may have washed into it. Mixed-up, granular soil is best for growing vines: a combination of silt, sand, pebbles, and clay. All of these elements conveniently precipitate out of limestone when its calcium carbonate leaches out. It is the latter that scientists at the University of Bordeaux call 'the one chemical soil constituent generally associated with wine quality'. Calcium carbonate not only neutralizes acids in the earth (alkaline soils tend to hold nutrients longer), but also – and here's the key – eases slowly back out of solution to form a chain of molecules that gives soil added cohesion (think of a microscopic hairnet for the earth). A *terroir* structured by calcium carbonate will retain just enough water and minerals to feed the roots of the vines, and no more.

Although I learned about the heroic role of calcium carbonate after I'd left France, I'd seen plenty of evidence of locals' belief in its winsome properties. All the little limestone-chip barrows I'd noted in vineyards and walnut groves throughout Quercy testified to their respect. Those shard mounds were the great diplomats of the *causse*, negotiating the essential rapport between the earth and its harvest and the old, taciturn farmers who cared for both.

I was roused from my contemplation of wine and perfume by the sound of hooves. Three brown, riderless horses, manes flying wildly, were racing down the Rue du Marché aux Truffes, the main street of what was apparently the three-horse town of Lalbenque, not far from Cahors, where I was staying for the night. It was hard to tell if I were witnessing an escape or a ritual. I hung out my hotel window for a while watching for a posse; as none came, I returned to my wine.

They say the finest Cahors wines are made from grapes grown between loops in the serpentine path of the River Lot, such as the goose-neck occupied by the city of Cahors itself. The few vineyards on the Causse de Gramat are supposed to produce only so-so wines. The ones on the Causse de Limogne, planted in those rich pockets of micro-topography, the *cloups*, and woven throughout with calcium carbonate, can equal the river wines as long as they're properly aged.

I was aware that the Haute-Serré I was drinking took no notice of my hazelnut yoghurt (I'd fashioned a spoon out of the foil lid) and cheese and crackers – in fact it held them in contempt – but I doubted I could place it on a sliding scale amongst its kin. It swam in my glass like a summer storm. Its 'black' colour comes from the grapevines' absorption of iron oxide, which deepens the hue of the grapes and boosts their tannin content. I knew it was not a wine for the faint of heart. It wasn't fruity, nor was it bossy like a Cabernet. The city of Cahors had thrived on this thoroughly sensible wine throughout the Middle Ages – the Chemin de St Jacques wound through town on the way to Moissac, and pilgrims were ever a thirsty lot – but its prominence had waned in modern times. It was never allowed to compete with the wines of Bordeaux, the export of which had been protected by federal law, and after a canal was built along the Garonne in the nineteenth century, shifting the focus of east–west transit south of Cahors city, the wine became parochial (fitful attacks of frost and fungus in the mid twentieth century didn't help matters). Parochial, yes, but parochial in reputation only. In 1971 Cahors finally earned its AOC designation, and I knew why.

Most wines are laced with secret references for the tongue. Raspberries, citrus flavours, nuts, pepper. Good taste buds will find them in the first sip; lesser, maybe, in the first glass. It's what happens when you keep drinking that matters. A poor wine will eventually bore you, turn acidic, make you sick. But a good wine, like my Haute-Serré, will build associations atop associations, tenuously webbing them like calcareous soil, bridging them from tongue to eye, eye to memory,

memory to mind – mind, perhaps, finally, to sleep. As dusk collected in my narrow room, raspberries eventually led to intangibles as the wine undid the stays of the day, then the years, the real and the imagined.

Flashes appeared unbidden, clear yet unaccountable. An old face, female, a stranger to me but not, apparently, to my mind's eye. A Goya print from a hotel hallway. A lizard in green death throes framed in my rearview mirror. A famous *cabane* on the outskirts of Lalbenque, here called a *caselle*, the Caselle de Nouel; a perfect cone of roof weathered like a dripstone beehive. Graphite, metallic-smelling and shiny on the fish-belly heel of my hand. My dog – I missed my dog! – asleep against my thigh like a dark, tangible wine stain, warm and soft. The *fois gras* from lunch (ah, but not the duck, in contradiction to Serge's tutorial). The pattern of knife-cuts atop my notebook. A big hole in the ground called the Gouffre de Padirac.

It occurred to me that I'd written one book about trying to learn another people's language (Welsh). I wrote a second about listening to other people's stories (in the American South). Now I was writing a third about ignoring the footsore tug of the Chemin de St Jacques and staying put in France to burrow into quarries and limestone landscapes. What did that mean? The subject was still literally foreign to me, but its metaphor reached inside and announced it had business there. Sybille Bedford said that the 'daily quarrying' of book writing is 'an anchor rather than a burden'. Just so, my travels here on the porous *causse* were casting a weighted plumb line down into my heart – a place I have long hesitated to excavate.

The evening had stilled. The meal I'd heard but not eaten was long over. The *causse* and its limestone and its underground pools tilted, then slid out of substantiality into emblem. As far as I was concerned there was nothing around for miles and miles but meta-phor lying still and cooling, smelling of chalk under the night sky. Some people must write in order to know what they think. But I am different. I have physically to travel the routes of my thoughts before

I am able to read them on my mind's map. Only then can I get my bearings.

In the night-time quiet of Lalbenque, a town of winter hubbub, complacent in summer emptiness, only the sound of my own glass rising and setting; intermittent swallows of wine. I didn't want this pilgrimage to be about me. Henry Adams warned that I might shatter the whole art by calling into it a single motive of my own. I wanted it to be about Romanesque sculpture and its battered dreams of eternity. But there was no escaping it: my own short history was bound up in the present demands of sculpture. Seeking the quarry sources of carved stone had hinted at a spiritual dimension in the bedrock, and it had been a covert command that I was only now receiving to plunge beneath the surface ripples of my reflection to the sediment beneath.

Adams wrote that the attachment of his contemporary, John Ruskin, to Gothic strangeness, what he called Ruskin's 'love of the savage and grotesque', ultimately 'threw more light on the reflexes of modern sensibility than on the architecture he was trying to see'. And so, likewise, my contemporary soul was bound for good or ill to the Romanesque. It needed my eager imagination to repair its sculpted eternity in ruins, and at one time I'd needed its strangeness to protect myself from my own all-consuming imagination.

I poured out the last of the bottle, drank it down, and slept through the night.

At breakfast I watched the waitress erase the blackboard entry from the previous evening – *Omelette aux truffes* – and write tonight's in its place: *Omelette aux truffes*. A hazy image flared – horses galloping down the main street, a street with a sign, a sign that read . . . Rue du Marché aux Truffes. I stopped the young man who brought my baguette and coffee to ask if there were anything in the least special about Lalbenque.

'*Ah, bien sûr, Madame,*' he replied, 'it is the Truffle Town.'

'The Truffle Town?'

'Yes, yes, everyone knows this. All around Lalbenque, *sur les causses, dans le Parc Naturel Régional des Causses du Quercy* – we are within this park, you know? – the truffles are harvested. Yes, black truffles. Black truffles of Quercy. It is our speciality. Beginning in November they are sold at market here in Lalbenque. We are an official "*Site Remarquable du Goût*". *Oui, vous comprenez?*'

I understood. Lalbenque was the home of the remarkable truffle, that curious fungus that looks like a small, charcoal-coloured brain.

It was not, to belabour a point, truffle season. The town baked under the Quercy sun with dull intensity, and few creatures moved. I went into a butcher's shop where tiny jars of the little black fungi were stacked in the window. They looked like blackberries and were fantastically expensive. I picked one up and quickly put it down. For a second the butcher looked hopeful, then resigned, and then, in the absence of customers and anything else to do, he became talkative. He knew more, I believe, about truffles than Serge did about Cahors wine. He came from a truffle family.

They grew at the bottom of oak trees. You could tell which ones because the grass around the foot of the tree was burnt – something from the truffle, he didn't know what. They began to grow in late spring, they developed over summer, were harvested in winter. They loved the shallow soil of the *cause*. Lime? *Qu'est-ce que c'est*, 'lime'? Ah, *calcaire*! Calcium carbonate. Yes, yes, that was it. Truffles required calcium carbonate. His father cultivated them, was very successful. His father said that red limestone produced the best truffles – the ones with the best nose. Fragrance? The best fragrance. Iron oxide made the soil red, the nicest truffles needed iron.

It took up to fifteen years to prepare a young oak before its roots would yield the truffle fungus. Yes, a long time. His father gathered them with dogs. No, not pigs, dogs. Something about truffle-flies. In his father's day this area of Quercy produced hundreds of tons of truffles, everyone was in the business. But now the farmers have gone,

the English have bought up the old *mas* – the farmsteads – as country homes. Yes, people from Paris too. No one knows how to hunt truffles anymore. Maybe ten tons at most now. That is why they are so expensive. Oh, about 500 euros a kilo. The market here in Lalbenque? It takes place every Tuesday, from November to March. You should see it, much commotion. Hard to believe, eh? No, we don't keep many for ourselves, they are worth too much, as you see, he said, indicating the jar I had carefully set back on the window ledge.

I was appalled that I'd missed the chance to eat a truffle omelette in the Truffle Town. Perhaps there would yet be an opportunity. I had drunk a grey *caselle* and more stone walls than Hermes could ever desire, scores of dolmens and a cavern of stalactites. Now I wanted to try heaven (and hell), and see if I could taste a family resemblance.

8

PILGRIMAGE

Perfect perspective derives from a point of origin as well as a
vanishing point.

Travelling Light, Peter Osborne

On 28 January 1933, Lucy and Kingsley Porter arrived in the United
States aboard the SS *Transylvania*, having set sail from England a
fortnight earlier. The date of entry is stamped in Kingsley's passport
almost directly on top of his photograph, which he has signed 'A.
Kingsley Porter' just beneath the words, 'Photograph of Bearer'. In
the picture Kingsley looks distinguished in an Irish tweed suit, his
mouth falling open on the cusp of a smile. His face is kind, approach-
able, considerate.

There is nothing unusual about Kingsley's passport picture except
that Lucy stands at his side. She would be a full head shorter if he
weren't slightly stooped, and she looks at the camera with unsmiling,
clear-eyed suspicion. Her hair is severely pulled back and greying at
the temples. Age has pruned her face of inessential flesh and emotion,
leaving only severe beauty, like that of chiselled stone.

At the time the US Department of State was of the opinion that
Lucy, like all married women, was herself inessential, an addendum
to Kingsley's passport made note of by two succinct words: 'and
wife'. None the less, she remained staunchly in the picture.

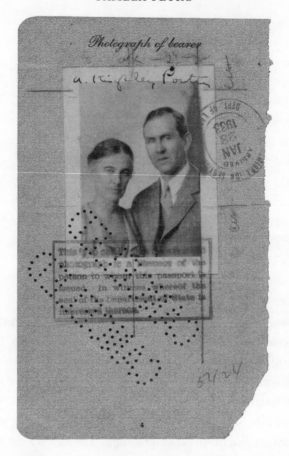

Lucy and Kingsley were returning to Cambridge, Massachusetts, from Glenveagh, their stone fortress in County Donegal on the northwest coast of Ireland, where they had been since the previous June. Kingsley confessed to Bernard Berenson in a shipboard letter that, 'I left rather tearfully, wondering almost if I should see again the lakes and hills.' He pinned his attack of sentimentality to widespread fear that Eamon de Valera – in his second term as head of the recently formed Irish Free State – might make good on a threat to confiscate private property (he did not). In truth, Kingsley was

coming to see the lakes and hills of Ireland, and especially the sea, as allies in his battle for privacy and peace while Harvard, by contrast, became an ever more stressful minefield.

Kingsley and Lucy had bought Glenveagh Castle in 1930: a logical enough purchase given Kingsley's interest in the untapped field of tenth-century Irish sculpture, Celtic crosses in particular. Yet Glenveagh was considered far-flung even in Ireland. It wasn't particularly near any of the stone crosses he was studying – of the 276 illustrations in his 1931 book *Crosses and Culture of Ireland,* only 3 of the crosses depicted are in Donegal – nor was it readily accessible from Dublin. The castle is in northwest Donegal, itself the northwesternmost county in Ireland; in the 1930s it was easily a day's drive from Dublin, over poor roads across poorer countryside.

Glenveagh did have one enormous asset, however, and that was its very inaccessibility. The Porters could count on few visits from friends in London, much less France and Italy. Ireland at the time was more than just isolated and unfashionable, it was politically unstable; the violent battles that had resulted in the creation of the Irish Free State were still fresh in the European imagination. As for the castle, it was not only located near the rim of the most remote county, it was hidden within a 24,000-acre 'park', a desolate, mostly treeless tract encompassing bogland, glacial valleys, and the Derryveagh Mountains. The latter are often described as 'starkly beautiful' – a string of abrupt, barren hills breaking into brutal cones of granite at the tops. Guidebooks like to call what is now Glenveagh National Park one of the bleakest, most isolated places in the country.

These factors made Glenveagh an ideal place for millionaires to hide – not least because Lucy and Kingsley's secret lair had radiant central heating (it had been installed in 1910, making the castle one of the first buildings in the British Isles to be centrally heated). Glenveagh was built of the same granite that crops out on the hilltops, a sea-grey, uncompromising stone that's plentiful but extremely tough to work with. Its plan essentially describes a square with an

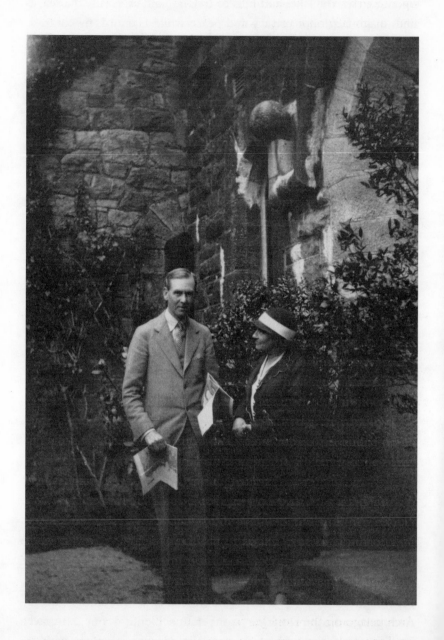

open courtyard in the centre, rising at one corner in a round tower and, diagonally opposite, a rectangular keep with turrets. If it looks self-consciously like a castle of the mind, there's good reason: Glenveagh was constructed in 1873 by the wealthy Irish-American John George Adair, who bought the land and evicted its 254 tenants in order to graze his sheep and build his fantasy home. (Most of those evicted later died of hunger or were sent to workhouses; ironically, Adair later won a seat in Parliament on a tenants' rights platform. When he died his wife tried to bury him in a churchyard on the property; locals couldn't bear the thought of his eternal presence in their midst and protested – in vain – to prevent his interment.)

After Adair's death his wife Cornelia, an American from Texas, designed an intricate garden for which the property is still famous (it was the third owner, John James McIlhenny – grandson of the American inventor of the gas meter – who bequeathed the castle and grounds to the Irish State). Glenveagh park also encompasses a large lake, Lough Veagh, and, according to local legend, the grave of Columcille (also known as Columba), one of Ireland's most active saints, who died in the year 597. Columcille was an aristocrat, warrior, sailor, and prolific founder of churches, including his own monastery on the Scottish isle of Iona. His biographers called him 'a poet and a man of action' – the same dichotomy friends invoked when describing Kingsley. Lucy noted that Irish peasants were forever making pilgrimages across the Glenveagh grounds to the legendary site of his grave.

Despite its magnificent isolation Kingsley wasn't entirely satisfied with his castle – for one thing it wasn't on the sea – and persuaded local workmen to build him a fisherman's cottage on a nearby, hourglass-shaped island called Inishbofin. According to Lucy, it was here that he found '[a] wilderness of beauty and holy solitude' that the cave-like naves and chapels of Romanesque churches could no longer provide. Inishbofin is one of four small islands that make up the Tory Archipelago off the Donegal coast (Columcille founded a monastery on Tory itself, the farthest flung of the group). The Porters found

that even residents of their under-populated, isolated corner of the
county looked upon these islands as 'remote'. Unlike Tory, the main
island, which in the Thirties supported a church and shops and was
serviced by a government launch, Inishbofin, though closer to the
mainland, had scarce human presence. Some twenty-eight families
lived on its more hospitable, leeward side, but Kingsley chose to
have his cottage built on what Lucy called 'the forbidden part', the
northern tip where the land rose in rocky cliffs, connected only by a
narrow sandbar to the 'flat, more friendly part where the fishermen
live'. The locals thought he was crazy. 'Not one of [the] island people
would have spent a night in our cottage,' wrote Lucy. 'It was "too
lonesome," too much a part of the open sea [that] they had so many
reasons to dread.'

Lucy herself was terrified of the water, a fact that made her many
oceanic crossings considerably heroic and her consent to the cottage

on Inishbofin an act of reckless, certainly selfless, bravery. It also under-scored the extremity of Kingsley's craving for solitude, this being one of the times he sacrificed his consideration for his wife to his need for freedom, as he'd also done after Lucy's operation in 1920, when he hurried her back to Europe against the wishes of her doctor.

Inishbofin lay two miles offshore and could only be reached by small, open rowboats called curraghs. The Porters employed a Gaelic-speaking boatman, but he usually accompanied them in a separate vessel as Kingsley preferred to row Lucy and himself in their own little boat, *The Swan*. The sea was rarely, if ever, calm.

In January 1933, the Porters left their Irish holdings well before the SS *Transylvania* sailed for the States in order to spend time in London. The city visit wasn't a holiday; it was a chance for Kingsley to meet with Havelock Ellis, the pioneering physician whose multi-volume work *Studies in the Psychology of Sex*, published between 1897 and 1910, had won him both respect and censure. The most notorious volume of the set – it was actually banned for a time – was a study of homosexuality called *Sexual Inversion*, in which he argued that homosexuality was not an illness and therefore could not be 'cured', but a natural, if minority, state of being, and urged acceptance and tolerance.

Kingsley had first approached Ellis about his 'case' over a year earlier, and the two men had struck up a correspondence. At the time, Ellis had found Lucy sympathetic and her husband suffering from what Kingsley himself called 'extreme nervousness' and spells of depression. Ellis was calming, accepting, and creative in his solution to Kingsley's problem. His prescription was not abstinence but an introduction to a young man.

As it happened, Ellis had recently begun a similar correspondence with a 20-year-old Californian named Alan Campbell. Campbell had heard of Ellis's reputation as a 'sexologist' and had sent him his manuscript of a novel called *Starborn*, a homosexual coming-of-age

tale based on his own experience. Ellis shared Campbell's cover letter with Kingsley who responded, 'I was interested to read C's letter . . . He was perhaps a bit Nietche-an [sic] in his treatment of his family, yet I know it is better and more right to be apparently cold-blooded than to be stifled.'

By December 1931 Kingsley had read *Starborn* himself, 'with emotion', finding it 'on the whole unsaleable' – due, perhaps, to its undisguised homosexual content – yet also 'profound and moving' in passages. While the two older men pondered Campbell's suitability as Kingsley's future lover – presumably Ellis made overtures on his client's behalf – Alan Campbell borrowed money from a wealthy friend in San Francisco and set off on a visit to India. Kingsley, meanwhile, spent the spring of 1932 working up the courage to invite him to Glenveagh the following July, when he and Lucy would commence a six-month stay in Donegal.

Throughout that spring Kingsley's moods rose and fell unpredictably. In April he wrote to Ellis from Elmwood that, 'Hearing from you and writing to you have . . . helped me more than I can ever hope to tell you: if patches of blue sky are now beginning to appear I know that it is fundamentally your doing.' Yet in the same letter he mentioned two suicides at Harvard following 'rumours of the usual indefinite type' – meaning some sort of homosexual scandal. 'And I see around me so many ruined lives,' he continued. 'Yet any effort to help (the fundamental causes . . . I mean) seems fraught with the danger of making a tragic matter more tragic still.'

Kingsley clearly had not made up his mind about the efficaciousness of Ellis's radical prescription, yet he steeled himself to it and at last invited Alan Campbell to join him and Lucy in Donegal.

On 3 July 1932, Lucy scribbled a note in her date-book about their exhilarating arrival at Glenveagh Castle: 'The beauty of the dawn forming out of moonlit night as we drove home.' Two days later she added: 'Alan came for luncheon.'

Campbell was supposed to have stayed a week but cut his visit slightly short, agreeing to return in September or October. Kingsley immediately sent a favourable report to Ellis. 'We both like him. Lucy feels that through fine-grained intuition he often arrives at a rightness that usually is attained only through intellectual striving. As the untying of this (if it be untied) and other knots in my life are due primarily to her, her judgement, re-enforcing my own (which I am quite aware is liable to be unbalanced) means a great deal to me.'

Lucy did not record her impressions of Alan Campbell in writing. Her opinion as cited by Kingsley loops around itself like one of his knots – slippery enough to accommodate a charge of immaturity, at the very least, within the compliment. Although she did not keep a journal that summer Lucy did record Alan's comings and goings in one of her intermittently detailed date-books. Her summer and fall entries for 1932 are unusually discursive in this respect and, perhaps as she intended, cryptically revealing of her state of mind.

Shortly after 'A.C. leaves' she made note of her and Kingsley's first excursion of the year to Inishbofin: 'Most beautiful night of Ireland. K rowed curragh with bed et cetera to island.' The next day she added, 'K had swim while . . . I got breakfast. So good, all such a liberation.'

Following their stay on the island, towards the end of July, Lucy recorded 'Kingsley worried', then 'Kingsley more worried. Sent wire to England.' Shortly after these days of tension Alan returned to Glenveagh two months ahead of schedule, prompting a pattern of visits that were to continue throughout September. When Alan was in residence, Lucy's date-book concentrated on his and Kingsley's activities and a round of endless luncheon parties with the local gentry, with a few incisive asides. On 25 July she wrote, 'Alan arrived. (I read in bed).' And on the same day in the margin, seemingly gathered from Kingsley, 'Himself after 20 yrs. – may[be] after 30 yrs.' She didn't mention that a month before they had celebrated their twentieth wedding anniversary.

When Alan left Glenveagh a few days later he promised to return in several weeks; Kingsley's spirits soared. 'Our opinion of him continues to be in every way favourable,' he reported to Ellis. 'On the whole the experiment seems to me to be working exceedingly well – better than I should have dared to hope. I feel a deep sense of gratitude to you, deeper than I know how to express, for having put me in touch with Alan.'

Kingsley went on to chronicle his progress almost clinically. His nervousness had disappeared, and although spells of depression persisted, he had 'an inner conviction that they are things of the past'. He wrote that he was as yet unable to recoup his old energy, but that was perhaps due to age. And he bragged that to his 'triumphant delight' he had been able to sleep on the noisy steamer to Ireland that had kept Lucy awake.

This careful recording of physical improvements suggests that both doctor and patient put enormous faith in the restorative powers of the sexual act, almost as if Alan were a human medication that if taken regularly would have Kingsley right as rain in no time. 'The experiment', as they conceived it, was brokered on the belief that Alan was for sex and Lucy for keeps – a bed partner and a life partner, to be taken simultaneously – with no apparent regard to Lucy's (empty) bed, nor to Alan's own desires, sexual or otherwise. In a later letter Kingsley remarked to Ellis about the 'withering effects of abstinence', citing as evidence Catholic priests and elderly spinsters. As it seems he was sleeping only with Alan at the time of his writing, how he squared this observation with the effects of its consequences on Lucy was a matter for his own heart.

Alan returned to Glenveagh Castle on 27 August 1932 and stayed for nearly a month. The day after his arrival Lucy wrote the frankest words she ever committed to her diary: 'again the feeling solitude brings – perhaps for the 5th or 6th time in my life. This connected back to childhood, girlhood "alones".'

At times her entries from this month have the tone of someone willing herself to be a good sport – 'We are reading Plato aloud in the evenings.' She even dispassionately noted that she'd finished Thomas Mann's *Death in Venice*, about a middle-aged man's obsession with a young boy. 'I enjoyed [it] even more,' she wrote, her pen cutting like a scalpel between emotion and intellect, 'as I thought it over in the night.' In other entries she dropped her guard and admitted to now familiar feelings of frustration and anger. 'I very much out of hand. K and I walked together.' On 23 September: 'I perhaps too [in]different to groupings.' Then on the 24th, 'Not so indifferent. Sleep allusive. K & Alan to Churchill . . .'

Even social gatherings, once briefly noted, were now shaded by two or three words of critique. A rowing party on Lough Veagh was described as 'A night without a wrinkle on the lake . . . A night of youth – (long for age!) . . .'

At about the same time Lucy was longing for age, Kingsley confided his euphoria to Ellis.

> Alan Campbell has been with us now nearly a month, which has been one of intense happiness to me, and what is more marvellous and important, I do not think Lucy has been entirely unhappy. Alan's character is one of extraordinary beauty – sweet, unselfish, straight-from-the-shoulder, unclouded by dark moods. I believe in his genius and should be not in the least surprised if he turned out to be your spiritual successor. We both of us (Lucy and I) envy the parents who have such a boy.

If Ellis worried that Kingsley had fatherly thoughts for Alan – a sure indication that part of him, at least, was uncomfortable with their relationship as lovers – he did not record it.

Alan left Glenveagh for the last time that year at the end of September. The following day Lucy wrote, 'I read . . . as K dressed; thought to slip back for a moment to old routine but found K at letters.' That Kingsley chose to busy himself with correspondence, possibly to avoid a confessional discussion, must have dashed Lucy's

hopes of returning to a pre-Alan existence. Shortly after this incident, however, her mood brightened – 'Alone, wrote and read, a heavenly day' – and they embarked on a round of activities and short trips to stave off a recurrence of Kingsley's depression.

In a rare short narrative she recorded a hunting trip in the castle grounds and the painfully slow death of a stag shot by Kingsley.

> K and I stalking. He got a nine pointer who scratched his ear so humanly while dying. He rolled over and over. K couldn't get a good shot. From the wet, windswept scallop where we clung, K could only see the tips of his antlers and occasionally his back. Shot that twice, and yet he died slowly. A lovely hind (light coloured as a fawn) slowly walk[ed] about after the shot. Saw him, evidently, and then slowly down through the woods across the road and with increasing acceleration through the stream (a streak of sliver and up the other side[)].

Lucy's dispassionate tone makes it hard to say if she were appalled or fascinated by the event. That the scene lodged like a presentiment in her mind – the image of her husband, the dying deer, and its fleeing mate – is certainly suggestive. No other event in her 1932 date-book merited even half as long a notation.

Around this time, early October, Kingsley wrote to Ellis to report that, 'You have made over my life. You know it. I do not need to tell you', and enclosed a cheque by way of gratitude. By the time they were due to sail back to the States in January, however, Kingsley's mood had begun to fray. He'd had 'long and warm' letters from Alan who had, however, returned to his parents' home in California and settled on the idea of becoming a nurse.

'He is apparently still set on nursing,' Kingsley wrote to Ellis, 'but has not so far been able to find a hospital willing to take him. I imagine the unemployed are lining up for this as for all other means of livelihood.'

This is Kingsley's only reference to the Depression in his correspondence with Ellis, distracted as he was by the return of his own. With this

letter, like a kind of unspoken threat or plea, he included a clipping from the Paris edition of the *New York Herald* about the suicide pact of two Englishmen, implicitly lovers, who had been found dead in Paris. Kingsley's repeated references to suicides amongst homosexual men seem to have been his way of indicating to Ellis that he was in desperate trouble; third-party references were as frank as he became.

His final letter before they sailed, written on 12 January, was slightly more explicit. 'I fear I am hardly turning out to be the prize exhibit of the results of your kindness and sympathy, as I had so confidently hoped.' On the subject of Alan's nursing he wrote, 'I feel of course selfish regret, for it means the unsolving of my own life, but it is really his choice . . . And if my dream hadn't gone to shipwreck on this rock it would have on another.' He concluded dramatically, predicting that 'unless the vapours pass we may be back almost by return steamer'. In his present condition he thought that teaching at Harvard was out of the question.

The Porters arrived in the United States on 28 January; one week later they were entertaining Alan at Elmwood. Just a month after Kingsley's desperate missives to Ellis, he, Lucy, and Alan – who had led Kingsley to believe that coming back East was not possible until springtime at the earliest – were back under one roof, the panic of January all but forgotten. Soon Kingsley would write that he was doing the best teaching of his life; he even noted, touchingly, that 'people seem to like me as they never have before'. Their ménage took shape as it had the previous summer, with Lucy's date-book (ever the centre of archival activity) full of Kingsley's and Alan's dental appointments and (separate) social events. They made plans to sail back to Europe in July 1933.

* * *

I had been to Limogne before. The little town lies due south of Gramat and occupies the centre of its own *causse*, an arid landscape

of Neolithic tombs, stone crosses, and, wherever iron-rich *cloups* are found, vineyards. Limogne is a pretty Quercynois town, brimming with incident and colour (it also has one of the best gourmet shops in the area). Towns of this size in the Rouergue, just the far side of villagedom, tend to be monochromatic; all the visual interest – and it's considerable – comes from the texture and silhouette of toast-coloured building stone. In Quercy, closer to Toulouse and the *auto-route*, where there is greater familiarity with tourism and English, awareness of the value of potted plants and painted shutters is more acute.

On my previous visit to Limogne I'd been hunting dolmens and the Chemin de St Jacques, the pilgrims' long road to Compostela. A man in the tourist office had given me directions; another man in the gourmet shop had done much with hand signals and even made me a map. I begged the Milky Way to cast a shadow. But I found neither route nor tombs. This was about to change.

The difference this time was that I had company. My friend Marguerite had flown in from the States and we had rented a *gîte* in the hamlet of Racannières near Caylus, a medieval town on Quercy's southern marches, not far from Limogne. Unlike Annie, Marguerite is not hardy. She can walk great distances but because she is slight and pretty, and frequently vocal about not wanting to, people rarely make her. This, too, was about to change.

The day began on an uncertain foot. We drove through the rolling vineyards of Puylaroque on a road that didn't exist on our map (neither, come to think of it, did the town). It felt good, like a higher order of digestion, to pare vision with the wonderfully dry rosé of the previous evening, a VDQS Côteaux du Quercy 1999, a wine that carried no baggage whatsoever, which is just what we'd hoped for on a hot summer night. Yet despite the pleasure, it was disconcerting that the map suggested a reality different from the one on the ground. This continued to be our problem in Limogne.

We parked the car and pored over a guidebook I'd bought to the

Sentier de Saint-Jacques-de-Compostelle. The map implied that we would pick up the path off the D24, just south of town. Marguerite and I prowled up and down a hundred feet of roadway.

'We should probably be looking for some sort of trail marker,' she suggested.

'I told you, I've been through this book a hundred times and you'd think there'd be some kind of legend, or key, but there isn't. Come on, we must not have gone far enough.'

We retraced our steps; a cow was mildly interested. 'If you didn't find it before, maybe they've re-routed it.'

'They cannot re-route it! My God, that would be sacrilege. No one can *move* the pilgrimage road.'

Marguerite seized the book and it occurred to me that in a sense this was true. The route itself may shift gradually atop the earth like the course of a river, tributaries may break out from time to time, but this path was necessarily a beaten one. Its location was a function of tradition rather than design. The difference between pilgrimage and exploration is that while both are undertaken on behalf of future well-being, the pilgrim doesn't envision a new world as he or she moves ahead, but imaginatively reconstructs an old one. The pilgrim is a follower, not an innovator. Nicholas Howe said, 'Pilgrimage is an act of following', and its public dimension, in this case the path, in my own case Lucy's photographs, demands validation from the individual imagination (in this way a pilgrimage is both public and private, expansive and introspective). For the path to exist as a pilgrimage way we must imagine we hear the sounds of footfalls that came before ours, and those of footfalls to come. These echoes fall silent a little to the south, or a little to the north, of the Chemin de St Jacques.

'Here it is, page 7.' Marguerite managed to pitch her voice perfectly between triumph and nonchalance.

'I don't believe it.'

'Look, here's a key to the trail markers. A white band on top of a

red band means *Bonne Direction*. A white and red X means *Mauvaise Direction.*' Marguerite had been a French major at university; we'd met in Paris while I was studying with Madame, my high-strung art teacher (it was to Marguerite that I first poured out my woeful tale of the napkin rests). Her accent is wonderful.

I grabbed the book back and stared. 'I thought that page was an advertisement.'

Literally within moments of Marguerite's discovery we'd found a white and red band on the back of a road sign, and a narrow trail we'd not noticed before disappearing down a rent in a hedgerow. It was as if a camera lens had resolved into focus, or a secret world had suddenly become known to us. It was certainly known only to those on foot. A gathering of tiny stone cairns surrounded the base of an iron cross that someone had placed next to the path.

Once we were on our way markings appeared everywhere. The earthen trail was rocky underfoot, with grassy lees bordered in dry-stone walls. Thin forests of scrub oak straggled on either side, their branches meeting overhead in loose green ribs that vaulted the nave of the Causse de Limogne.

In sunlight the walls were grey; in shadow they were lavender. Substantial patches were upholstered in the living velvet of bright green mosses. Marguerite noticed that wherever there was a new stone-spill – a place where a wall had recently tumbled or been knocked down – its innards were the colour of fresh cream, or the pale tan of *café au lait*. She picked up a chip and put it to her nose. I told her to close her eyes.

'It smells of ocean – of very, very dry ocean.'

We walked on in silence, westward, the path of stars invisible over our heads. There were older echoes on the *causse* than the distant ringing of footsteps. Farther back, before time was measured in hours or strata, waves had crashed where the soles of our feet now fell. It would have been pointless then to walk hundreds of miles to Finisterre – the end of the earth, the end of the road, St James's

home in Compostela, countless horizons away – because the earth would have already ended. Even now our destination, saintless but holy, was here where we already were, here on the *causse*. No need to walk so far; the limestone's fossils were our precedent pilgrims, as these walls were now our reliquaries, their pale bones gaping through wherever the framework had fallen down. It was from those tiny landslides – once the source of penance stones – that the scent of sanctity seeped out.

We hadn't travelled far, perhaps a mile or so, when we came to a sign for the Dolmen du Joncas lettered on an arrow that pointed down a track off the *Chemin*. This was one of the prehistoric tombs I had been searching for.

'Shall we?' I asked Marguerite, who nodded in the kind, weary way that good sports always nod. Marguerite and I have visited dolmens together in England, Wales, Scotland, and also Portugal, where they're called *antas* – she knew I was determined.

A few minutes on a pink trail and we were there. It was a little dolmen on top of a tumulus, surrounded by a copse of crooked, mossy trees. The capstone, about the size and shape of a two-foot thick door, was mottled with lichen and supported by a pair of dwarf megaliths, each only a few feet high. The whole construction bore a striking resemblance to the caves children make by draping a blanket over the backs of two chairs. I have no doubt Annie would have called it a pet rock, but if nothing else, the setting retained an atmosphere of choice. This place had been chosen by someone, and it still felt that way. Perhaps it was a trick of the man-made hill, blending architecture into nature (the megalith builders had concentrated their efforts on the *causses* because the land had allowed them to; the topsoil was soft and shallow, and the sedimentary bedrock broke regularly so that big slabs could be easily quarried). Whatever the reason, embers from the 5,000-year-old combustion of imagination and raw material still smouldered here. The little dolmen embodied an ancient shock of

recognition that the environment can be shaped into an expression of the spirit.

Wild orchids, tiny and magenta-coloured, grew around the tomb. Marguerite and I sat on the edge of its hummock and ate cherry yoghurt, cheese-and-avocado sandwiches, and Bonne Maman biscuits. I quoted Lucy: 'Hot day and plenty of flies, but impressed with the delight of travelling.' We both smiled at the good fit of her words.

The air was heavy and smelled of pine. I got up and pressed my hands hard against the dolmen's rough capstone, filling its crevices with my flesh. I thought again as I had on the road to Lunel that it's not such a bad thing that dolmens have fallen out of our collective memory. Forgetting gives rise to marvellous invention. Here on the Causse de Limogne the big stones were once thought to have been homes to fairies or tombs of giants. They were rumoured to have medicinal powers: cover a capstone in flowers and be cured. If you made the sign of the cross over a particular dolmen and tossed a coin inside, then walked your bull three times around it, he would be tamed.

Had their ancestors not forgotten the tombs' original functions, the farmers of Quercy, those stony-faced, bourgeois wall-builders, would never have become so creative. I was different. I learned to invent because I was afraid of forgetting. I feared I would forget myself, become lost in such a wide world, and so like Kingsley I created one of my own instead. Since I cannot guide you along the paths of his daydreams, I will take you down a brief aside along those of mine.

* * *

Appropriately, it all began in a cavern. I was 11 or so. I had been a perfectly ordinary child until my parents took me underground, and then everything changed. I don't know what happened; perhaps I was instinctively seduced by the idea of an alternate world of weird splendour, underground and unknown, which we walked on top of

everyday unawares. I loved the stalactites and stalagmites; I loved the fall-vegetable colours and the drip-drip-drip of the sculpting water; I loved the privacy of it. Something there tugged at me very hard, and I found I could no more leave Luray Caverns behind then than I can stop reinventing Lucy and Kingsley's lives now.

The Luray Caverns are in Virginia. By the time my father had driven us home to New Jersey, an eight-hour trip, a large extended family had taken possession of the caves in my mind. They lived during the American Revolution; when the British Army burned down their farmstead they literally went underground to dwell amongst the limestone formations and secret pools, emerging from time to time to make guerrilla raids or sell mushrooms at market. I had no role in their adventures; I never confused their world with mine. My daydreams – in which I could indulge my tastes for history, adventure, and eighteenth-century fashion – were simply more fun than anything I found on television.

My colonial troglodytes lived in my mind for years. I suppose the strangest thing about these 'daydream characters', as I called them, is that they didn't fade away as I grew into adolescence and, later still, maturity; they merely evolved.

By the time I was 16 I'd begun to realize my stories had an addictive edge. One day before I set out to write a school essay I decided to allow myself ten minutes for daydreaming; four hours later I'd yet to pick up my pen. I was shocked when I looked at the clock (and a little thrilled at the magnitude of my misbehaviour). I hadn't intended to keep at it so long, but I'd been unable to stop. Fortunately – dangerously – there was no book to end, no programme to finish. My stories just went on and on; there was no reason for my 'inner teller' ever to stop.

And she never did. By the time I reached university daydreaming was a reflexive habit. By my mid twenties a fiction had taken shape that now, today, has historical roots in my life – where and when I've authored it, to what degree, at what age – and deep fictional roots of

its own. In her memoir *Sunbathing in the Rain*, the poet Gwyneth Lewis refers to what she calls 'my need for a reality away from ordinary life'. For Lewis, alcohol and poetry (in that order) provided the alternative, though she's careful to differentiate between them. 'I see alcohol as a journey away from reality, into fantasy,' writes the poet, 'and poetry as an indirect route deeper into reality's hinterland.' For me, equally dependent on the need to reconstitute the found world, daydreaming has filled a role, an intriguing grey area, somewhere between the two.

Only once, while recovering from a serious accident, did I lose my balance between internal and external worlds. I didn't confuse them, I simply lost interest in the one that leaves visible traces. It wasn't exactly a retreat from 'life' or activity (daydreaming is rigorous, it demands enormous creative energy, which is why it's impossible, as I discovered, to drink and dream at the same time). But it was a retreat from active living. At times whole days passed without my noticing.

Eventually life came and claimed me, and I gratefully went with it. I fully expected as I grew older that my daydreams would disappear; instead they've only diminished. Wielded carefully, I've found they can serve as alchemical tools for converting observation into empathy. Often I spend whole years without them, yet they never vanish entirely. Rather my daydreams are contained now, like a river canalized, flowing on often into darker, more disturbing channels than I have ever ventured myself, filtering the world's soot out of my system.

Call daydreaming a twilight art: most often it leads neither to enlightenment nor darkness, though on occasion its practitioners find themselves in one or the other. There are scholars who would have it that Henry Adams' straight-faced fantasy in *Mont Saint Michel and Chartres* – conjuring the Virgin Mary as the cathedral's architect – was actually a daydream borne of psychological desperation. They

argue that in Adams' alternate world the Virgin embodied a perfect woman, all-giving, all-forgiving, deathless – someone to compensate for Marion's suicide and his companion's refusal of marriage. Never mind that this trivializes Adams' very real quest for the Other – the architecture of the twelfth century – and that it needlessly undermines the work. The imaginative impulse to leap beyond ordinary life is at the heart of his book. The past was Adams' cavern: a place of inaccessible splendour that couldn't be seen, but of which we are all cognisant. He knew that imagination (buttressed by solid research) was the only way to break through the crust of the present, down to where the reservoirs of the previous world lay, waiting to be reconstructed in his mind. He was both pilgrim and spelunker, charting the darkness but arriving, finally, into bright light.

Kingsley's young lover, Alan Campbell, was neither of those things, but he was also a world-class daydreamer. In a letter to Havelock Ellis, Alan freely discussed his habit of conjuring alternate realities.

> About daydreaming – my first recollection of daydreaming in which sex definitely entered, began with the various romances that impressed me in book form, or more often and perhaps more vividly, through the medium of motion pictures – but it was the sad stories of the heroines that moved me . . . I was too young to know I was identifying myself with them . . . I would take a beautiful woman and her attractive lover into my mind and make up situations for them – for 2 or 3 years remaining entirely on the outside . . . just watching my dreams of the 2 lovers as one does on a motion picture screen.

Alan Campbell had the ill luck to enter posterity as a 21-year-old: it is unfair to contrast his mind's eye movies with the mature explorations of Henry Adams. And yet they were both travellers away from quotidian life, though Adams' work led him to that lovely place of Lewis's – reality's hinterland – while Alan's led him into fantasy.

That the daydreams of a homosexual teenager offered an outlet from repression is an almost tawdry cliché – something that Alan

recognized himself. More importantly, it was this reflex of his, a way of creating a flexible, private space in a hostile environment, that in fact made Alan Campbell the perfect choice to become Kingsley's lover. A capacity that Havelock Ellis perhaps discerned in him before he spelled it out himself. (Ellis's enthusiastic role in the Porter–Campbell ménage, on shaky ethical ground from the outset, appears even more so given the fact that Ellis himself was impotent until he was 60. He wryly noted, 'I am regarded as an authority on sex, a fact which sometimes amused one or two (though not all) of my intimate women friends.')

Kingsley, of course, shared Alan's talent for daydreaming. Like me, he was a dreamer who covered his tracks in travel. Like Adams, and while his homosexuality was still undisclosed (and unpractised), he sought shelter in the past. It was probably no coincidence that just about the same time Kingsley acknowledged his homosexual fantasies – in the late 1920s – his interest in the Romanesque faltered, and he turned his attention instead to the stone crosses of Ireland. He may have recognized that, while the past is a welcome haven, a man can't live in a dream any more than a stone can inhabit a photograph. We have bodies as well as souls, and his inevitably got in the way.

Donegal was a refuge that offered the kind of real privacy that his daydream of medieval history could no longer support. By 1933 Kingsley had effectively exchanged sanctuary in time for sanctuary in space, seeking distance here on earth rather than comfort in time gone by.

Although he had found a refuge that could temporarily absorb the growing dis-co-ordination of his life, Kingsley was not yet prepared to give up his daytime reality in the person of Lucy. And for a time he didn't have to, thanks to Alan Campbell and his youthful imagination. Between them, in Donegal and later in Cambridge, with their vast capacities for fantasy, Kingsley and Alan were able to create a space in which their sexual 'experiment' could unfold. It was a twilit space between perception and truth, love and cruelty, courage and fear, in

which all three had to grope their way. The dusk lasted for a time, but eventually they found their way to darkness.

I sat alone in the twilight. I didn't dare daydream on my travels, it had become too fraught a pastime. Instead I wondered: if I wrote my daydreams down, would the spell of fascination be broken – would they be of no more interest than daily soap operas – or were these dreams really my life's sediment in flux, fact being reconstituted, importantly, as fiction? I wondered why I'd begun to carry fictional people around in my head in the first place, and did other people do it too?

I pulled no ready answers out of the French air, but I kept going back to that first time I'd indulged in wanton daydreaming instead of writing an essay. It smacked of everything I wasn't as a teen-ager: unambitious, lazy, carefree. It also smacked of fear. I made a note in my journal: 'Initially daydreaming had to do with dread rather than procrastination, with an unwillingness to depart from myself. I was genuinely afraid that if I spent time considering things external to me, generated by others, I would lose myself and never return.'

These words had an unmistakeable ring of truth. So this was what lay beneath my own porous skin, where the truth had sieved away and collected. I realized I was only now articulating what at the time had been a wordless feeling akin to vertigo – to the dizzy panic Kingsley felt when he went mountain climbing. 'When I was a student,' I continued writing,

> I'd believed that knowledge was something you picked up like groceries: you could get it anywhere, anytime. The only 'real work' was that forged within oneself. So I took studio art and writing courses. I saw no connection or continuity between what others did or had done, and what I might do . . . It never occurred to me – as I doubt it did to Kingsley – that creative expression might be a community effort of humankind.

I had always been more afraid than arrogant. Afraid of discovering
that others had the same thoughts before me; afraid of being over-
whelmed by debate. No wonder my daydreams were so essential:
they *were* the thing forged inside. They offered satisfaction without
challenge. They came from *me*.

I began to find it odd that these memories were rising up in France,
of all places, where my days were crammed with something as alien
to my misspent youth as Romanesque sculpture. Then a suspicion
dawned: what if, twenty years ago, the very attraction had lain in this
unfamiliarity? When I'd first studied Romanesque art at university it
was utterly new to me: no happy memories of holidays in France
clung to its column capitals, no friend had recommended the course.
Not of my time or hemisphere, even, Romanesque sculpture had
nothing to do with me. Learning about it meant acquiring the type
of 'knowledge' I'd so undervalued, and that was a relief.

A keystone fell into place. The Romanesque had been a relief from
me. In my heart its strangeness – its beautiful deformity – had less to
do with monsters than the simple marvel of its externality. Of course,
Oceanic art and Pre-Columbian sculptures were new to me too.
Either of these subjects could well have provided the otherness I
craved. But Romanesque sculpture, with its wrecked and weathered
eternities – the Apostles without faces, the wingless angels – had
offered more than difference. It had needed my restorative imagina-
tion for its message to be viable in the twentieth century. I couldn't
get lost in this art, succumb to a gravity greater than mine, because
I was a part of it from the outset, responding to its needs as much as
my own insecurity. It was safe. External yet inviting, bracingly differ-
ent yet romantically dependent on my sympathy – it was the right
balance at last. I'd let go of myself and fallen in love with stone.

* * *

Marguerite and I took a self-timed photo before leaving the little
dolmen and returning to the *Chemin*. The sun had begun to light

up the pale day and we tied our jackets around our waists. After a
few minutes she broke the green silence.

'There's just one thing I don't believe.'

'What?'

'That you were a normal child until you went to Luray Caverns.
You were never a normal child.'

'Yes I was.'

'Weren't you convinced you floated to the ceiling at night? And
what about the monsters that lived in the closet and under the bed –
and in the dresser drawers?'

I'd forgotten about that. Marguerite, of course, had heard it all
before, probably as long ago as our student days in Paris. On week-
ends, joined by our friend Annette, we used to gather in the grand
bedroom Annette and I shared – a high-ceilinged room with a marble
fireplace and prominent crystal chandelier, probably last painted
before the war – and transport each other back to the Americas. We'd
drink wine and eat Annette's improbable stash of summer sausages
from Wisconsin, hidden in her armoire, and tell stories about our
childhoods. Marguerite had the best ones because she'd grown up in
Brazil. I'd assumed mine were dull because my family, loving and
happy though we were, had lived in suburban New Jersey. But come
to think of it, I would have inhabited an inner Romanesque place
filled with St Bernard's seductive monsters wherever we'd lived. My
world just came that way.

By now the path under our feet had grown firm and grassy, the
green barrel vault given way to sky; wherever the branches grew
together again the ground became soft and earthen. In those places
the trees and walls would be thick with mosses and lichen. Occasion-
ally we'd be startled by a cow looming over one of the stone walls.
One of these creatures looked me in the eye then turned and ripped
a leaf from a diminutive oak tree and shook it in her mouth, as if
giving me slow and deliberate instructions: this is how we enjoy
ourselves in these parts.

Marguerite and I talked as people of long acquaintance do on walks, in comfortable fits and spurts with long gaps of silence, following conversational cues from a minute, an hour, a year, a decade ago.

'The yoghurt here is better than at home, don't you think?'

'Remember Madame Peneau's yoghurt?' Madame Peneau was the ancient woman from whom we had rented rooms in Paris. She had made her own yoghurt daily in white porcelain cups and served it plain, with a little sugar on the side. 'That was the best thing about dinner.' I was still bitter that she'd watered the wine.

Marguerite was silent for a moment, then asked, 'Tell me one thing. Do you like Lucy and Kingsley?'

'Yes.' I'd intended to elaborate, but my answer fell off abruptly into silence. It was too big a question.

'Well, I can't forgive Kingsley for making Lucy go out in a little boat to that island, when she was terrified of the sea.' Marguerite gets deathly seasick and is not at all keen on boats. There've been times on ferries when I've actually feared she'd pitch herself overboard rather than endure another second of nausea.

'Perhaps he thought he was protecting her, too, by hiding them both away. The crossing would be short, then they would be safe.'

Marguerite looked sceptical. Now that it was warmer the breeze smelled of juniper; yet another gin-scented summer on the *causse*. I only half-believed my defence of Kingsley. His needs and terrors – his passions, too, and his dreams – were the rudders in their lives. Lucy was his crew, and I'd begun to think he hadn't provided her with a life vest.

We decided to change direction. Our hiking of the pilgrimage road was symbolic rather than extensive, of a day's duration rather than a season's. Because most of the sights of interest – several *gariottes* and a *fontaine* – lay in the opposite direction, after a time we opted to retrace our steps and then carry on eastward. Soon we met a group of four pilgrims with hats and staffs who greeted us cordially. Shortly

afterwards we passed through a rural hamlet dominated by a rabbit hutch and a *gariotte* (an alternative name for a *cabane*) filled with hay. One of the cottages, built of rough-cut, yellow limestone, had a triangular tympanum set above the lintel, a very grand gesture for a cottage, I thought. It was of fine white stone, similar to the masons' capital at Conques, and into it was etched a line drawing of the little settlement with the date 1811. It could have been carved last year, so little had it worn or weathered, or the village changed.

With the hamlet well behind us the *causse* opened up, the trees thinned, and only the moors stretched beside us. At a desolate cross-roads we bumped into a group of eight pilgrims striding purposefully toward Compostela.

'*Vous avez trompé le sens!*' one of them called after us, 'You're going the wrong way!'

'How did they know we've lost our senses?' Marguerite got to the double entendre before I did. I think her feet were beginning to hurt.

'It's OK. If Lucy and Kingsley could do the pilgrimage backwards, so can we.'

In fact, I thought, the Porters had yet to steer me wrong. It was their presence on my travels that had led me beyond my instinctive love of the Romanesque. Twenty years ago, as a young woman, I'd followed the lure of its funny looking sculpture out into the open sea of ideas, far beyond the shallows of myself. And now . . . I thought back months, not years, earlier, to Moissac. Standing there at the south portal, sweating in the sun in the company of Meyer Schapiro's ideas and Lucy's photographs, hadn't I stumbled onto the essential reason Romanesque generosity was so vital to me? If ever anyone had needed to absorb the virtues of plurality, to envision the shared, manifold way of seeing and knowing that was at the crux of the Romanesque – this communal, anonymous art – it was I.

Why *had* I fallen so hard for the Romanesque? It was clear now – clearer than the French sky over the Chemin de St Jacques, milky by

this time with afternoon heat. The lessons of Moissac proved that I'd been craving precisely what I hadn't allowed myself: mental space and company, permission to embrace multiple points of view. I'd needed a good stiff wind of otherness to blow into my life. I'd needed a humbling, and I'd found it in a darkened room where lectures were accompanied by the soft, slip-click percussion of a slide projector. The strange, sculpted figures I saw in that class, their heads facing forward and feet in profile, bodies united by an archaic aesthetic of 'completeness', set me on the long pilgrimage of kicking myself off my pedestal and abandoning singularity for the embrace of community.

When I'd returned from lectures in the spring of 1982, determined to convince my friends of the glories of limestone carvings and radiating chapels (much to their distress), I didn't comprehend any of this any more than I'd stopped to consider the impact of oxygen on my internal organs. I was just excited about Romanesque sculpture, and that's as it should have been. People rarely grasp the reason something is good for them, but sometimes they do instinctively reach for it. To pursue that instinctive spark into a deeper understanding of the mind or spirit, commencing without a ready explanation, grapples, I think, with the essence of pilgrimage.

There can be no pilgrimage without that elemental leap out of the self. All true pilgrimages start internally, but they can't stay there; one of the chief characteristics of pilgrimage – what differentiates it from meditation or daydreaming – is that it is not a strictly private endeavour. A road with only one walker yields only one perspective. That road can't be a pilgrimage way, it's a blazed trail. The Chemin de St Jacques, by contrast, is crowded with hikers, history, allusions. If she's inquisitive and dedicated, the pilgrim, like the Romanesque sculptor, will assemble a legion of viewpoints about herself, the world, even why the road was taken in the first place. It is these turns of the kaleidoscope that will help her reach her destination. If I hadn't carried Lucy's photographs to France with me I would not have

expanded my perspective; I would only have seen the angel Raphael from my own point of view, and that would not have been enough to witness his freedom and flight. Pilgrimage is always a deft dance between public participation, relativity, and fortuitousness.

And it's a circle dance. Henry Adams said the road to Chartres was a pilgrimage way, and that to understand the Middle Ages we had to become pilgrims again. How right he was; yet his admonition that one could shatter the 'whole art' – the glittering illusion of the Virgin's achievement at Chartres Cathedral – by 'calling into it a single motive of one's own' only sketches half the cyclical accomplishment of pilgrimage. It never occurred to me that I would learn anything about myself from Romanesque art, I just loved it. Following that love to France and pressing the old sculptures for truths led me beyond the great churches and into the landscape, then under the landscape and into prehistory. That process – my way of walking the road – made the art come alive, and its spark caught fire in my life as the contemplation of Chartres doubtless did in Adams', whether he acknowledged it or not.

A few miles east of Limogne, Marguerite and I reached the Fontaine de Malecargue. The 'fountain', as we'd been calling it, turned out to be a big, open well: the pinnacle of nineteenth-century Quercynois industriousness. A rectangle of water, about twenty feet below ground level, had been marked off from the pasture above by, naturally, an enclosure of stone walls. A flight of steps led down to the khaki-coloured water, and an immense iron wheel, pretty enough, had it been smaller, to have turned an elegant coffee-grinder, stood in place to pump the water up a labyrinth of pipes into a concrete drinking trough. The trough was lined with feathery green algae and it was full.

'I suppose it's still in use,' said Marguerite, dipping in a finger suspiciously.

'Probably. There seem to be plenty of candidates around that could

use a drink.' The gong and jangle of sheep and cow bells sounded from behind a clump of trees.

'Shall we head back?'

'Absolutely,' I replied, remembering how my hips had ached in Conques. Before we left the well to turn back for home I dropped in a handful of blue cornflowers that I'd been carrying. They didn't make a sound as they hit the water.

<p style="text-align:center">* * *</p>

> These last few days I feel a truly extraordinary harmony between the three of us in this delightful old house – I guess it will be many years before I realize the value of this friendship. Kingsley would enjoy thinking it is perfect. Perhaps it is in ways . . . There is no pain – no jealousy – nothing has been lost . . . The only imperfection is in myself – I want to be alone . . .

Kingsley apologized to Havelock Ellis in nearly every letter he sent for burdening the doctor with yet more correspondence; Alan Campbell seems to have had no qualms of this sort. His above summation of life with Kingsley and Lucy is from one of four long letters written to Ellis during the spring of 1933 from his comfortable attic room at Elmwood in Cambridge, Massachusetts. Under the circumstances, Alan's reams of correspondence weren't so surprising: Ellis was his only confidant, the only person other than Lucy aware of the nature of his and Kingsley's relationship.

Alan was still very young, and in hindsight his letters appear self-involved to the point of being wilfully myopic. Eighty years later it is easy to see him as a minor character in a much larger drama, which makes his self-involvement seem out of key with events, childish, even, given the noose that was slipping around the Porters' lives. And yet he was, of course, entitled to dwell on his own, disruptive story – that of a lonely young man who wanted to be a writer, who longed to be helpful and important in the world, and was homesick for the boyfriend he'd left in California.

Despite his youth and preoccupations, Alan was not unperceptive: his view of the Porter household and his place in it was far more accurate than Kingsley's. Of Lucy's thoughts during this period nothing is known, though much may be guessed; she either distanced herself from her emotions or chose not to leave traces of them in her date-book.

The Cambridge phase of 'the experiment' was an outwardly successful one. Alan had not been getting along with his father in California, and so after initially indicating that he would remain on the West Coast until spring, he suddenly accepted Kingsley's renewed invitation to join him and Lucy at Elmwood. He explained to Ellis,

What the Porters offer me is a blessing, after the situation at my own home . . . My parents are overawed with the idea of a Harvard professor and his wife – I left home without any money from Father (Mr Porter sent me my fare) – and I work 3 hours a day for Lucy and Kingsley, and they give me $30 a month, so that I am independent financially. Consequently I receive affectionate, friendly letters from my father quite regularly.

Between the lines of Alan's letter are traces of a shift in filial allegiance from father, now distant correspondent, to lover – as if it made him more comfortable to think of the Porters as surrogate parents, paying him a monthly allowance – that correspond to the near parental pride of Kingsley's earlier letter from Glenveagh. This awkward double-think in their relationship seems to have suited both partners. In whatever light he chose to regard them, Alan had a high opinion of both Porters. He told Ellis: 'They are both such wonderful people – here at Cambridge I admire them even more than in Ireland. They treat everyone with whom they come into contact so beautifully – I almost envy their stability, their culture – and their aptitude for work.'

This last trait was not idly mentioned. Lucy and Kingsley had taken Alan on as their secretary after his high-minded dream of becoming a nurse met a quick end. As he confessed to Ellis in his feminine, backhand writing, the Porters 'went to a great deal of trouble to find an opening in a hospital for me, and . . . I remained exactly 3 days'. The hospital had depressed Alan to the point of tears. He complained that the job was too wearying and that he had so little energy, and feared that Lucy and Kingsley were disappointed in him.

Kingsley indeed fretted over what was to become of him. Despite Alan's constant, oft-repeated theme of publishing *Starborn* and using his imagined windfall to finance another book, Kingsley had scant hopes for him in that line, and seems to have discussed setting him up in a 'routine vocation' as the owner of a bookshop. Such worries aside, Kingsley flourished in the *ménage à trois* that he and Ellis had

created. He felt that Alan was content and wrote of his own 'unquali-
fied happiness', then assessed that of his wife:

> Lucy is wonderful. She has always been selfless – now has come a
> sort of heroic quality that gives her a new power and dignity. She
> appears to have grown and developed in every way under the
> experience of the last months. She seems too very happy, perhaps
> happier than ever; and I am sure that in that she couldn't deceive
> me. As far as the three of us are concerned, the situation is as
> perfect as anything in this world is likely to be.

This is a breathtaking claim. Its validity aside, Kingsley's letter reveals
that dangerous extremity of one kind or another held sway in the
Porter ménage. Whether it sprang from his own stunning refusal
to recognize the essential instability of their medically sanctioned
'experiment' or, if we take his words at face value, from Lucy's alarm-
ing emotional martyrdom, it is impossible to say. Most probably it
stemmed from a combination of the two. Either way, the situation
was abetted by Alan's own extreme charm, essential kindness, and his
eagerness to please the people who were really his employers.

 With Lucy and Kingsley, Alan was always cheerful and accommoda-
ting – and why not? He himself enumerated the reasons he had to
be happy: kindness, friendship, liberty (financial and otherwise), the
luxury of beautiful surroundings, access to books and lectures. He
was even encouraged by Kingsley – 'poor innocent darling' – to take
on a young lover if he wished, an idea that his own youthful sense of
propriety deemed both discourteous and inadvisable. (In reporting
this proposition to Ellis he specified that 'Kingsley of course, can
stand anything except my having a relation with an older man – he
draws the line at thirty-five.' In the spring of 1933 Kingsley was
50 years old.)

 And yet Alan, disproving Kingsley's stamp of perfection on their
lives, was unhappy. It was a constant theme in his letters to Ellis,
who must have been distressed by the disjunction between his two
correspondents. Alan wrote anxiously,

> It is difficult, isn't it, to be as fond of anyone as I am of Kingsley
> and at the same time not feel for that person what they feel
> towards you? Everytime we are together, Kingsley is so much
> refreshed and I am so afraid my presence is becoming a habit with
> him. I am once in awhile nervous that if the opportunity offers
> itself for me to be alone and write, Kingsley will not be cured.

Alan longed to be alone. He stated again and again that he wanted
to 'touch' people, by which he meant be of service to society; as he
had failed at this in the literal sense, bungling his mission to be a
nurse, he felt he might serve people through his writing. In order to
be a serious author, however, he believed he needed total privacy.
'The unfortunate thing is, Lucy and Kingsley do practically every-
thing possible to give me time to myself. But I cannot write, because
inside of myself I do not feel alone, living in the same house with
them.'

Company distracted Alan's muse; in the presence of others he felt
'undressed', as if the Porters and others could read his subversive
mind. At times he fretted to Ellis that this overwhelming need for
solitude was an 'imaginary difficulty', especially compared to the very
real worries then pressing the Porters, whose fortune had finally
begun to be eroded by the Depression. 'Kingsley looks awfully well,'
Alan reported, 'but all this financial havoc must be upsetting him
considerably. Mrs Porter is, of course, marvelous about it.' (Alan then
wrote of Lucy's 'marvelous buoyancy' – a phrase so close in spirit to
Kingsley's hagiographic description of her happiness that it seems
likely they discussed Lucy in private, each reassuring the other of her
selfless regard for their welfare.)

Although he was meant to return to Ireland with the Porters in
July, over the course of the spring Alan privately – and to Ellis –
talked himself out of the plan. 'In my heart, I want to get the Atlantic
Ocean between us again, when I settle down to writing.' He chastised
himself for his selfishness, but none the less stuck to his guns. Mean-
while he wrote:

It is consoling to know my presence here is of such value to
Kingsley. Only I know it is an unequal exchange, since I physically
give him what he seems unable to do without, and he physically
is only a sympathetic release to me . . . Mr Ellis, I do not believe
I could endure it if our experiment ever became tragic or
disagreeable . . .

What Alan could not have known when he posted his letter in Febru-
ary 1933, was that in two months' time his presence at Elmwood
would set in motion the very tragedy he feared. It was in April that
Kingsley wrote to Ellis with the good news of Lucy's selfless happi-
ness, of his improved teaching and likeability, of the perfection of
their ménage. But he added that a shadow had arisen:

> It has been reported to me that people are talking about Alan –
> not for anything he has done, but the boy of course always wears
> his nature on his sleeve, which is one of the most valuable things
> about him. I have forseen that he must arouse comment, and
> rather intended that he should. Yet now the situation is here I
> find myself assailed by anxiety. But Lucy is so splendid, nothing
> matters.

An interesting choice of words: 'rather intended that he should'.
Kingsley was well aware that, although Harvard had enjoyed a repu-
tation as something of a haven for Ivy League homosexuals – and
would do so again – it was anything but during the 1909–33 tenure of
President A. Lawrence Lowell. Lowell was more of a liberal, academic
reformer than a reactionary conservative, but his distaste for homo-
sexuality was such that he secretly authorized investigations of homo-
sexual undergraduates, resulting in 'kangaroo' trials, expulsions, and
two suicides. This was the atmosphere into which Kingsley intro-
duced Alan Campbell.

The matter of Alan's presence grew grave. Instead of sailing for
Ireland in July, Lucy and Kingsley upped the date to the end of May,
leaving Cambridge under an, albeit discreet, cloud of scandal. Alan

agreed to be on the same side of the ocean, but made separate plans to stay in England.

The incident that caused their flight was so discreet, in fact, that none of the principals involved mentioned it in writing, save for two of Kingsley's letters to Havelock Ellis. In the first he thanked Ellis for seeing him in London, and for his sympathy. In the second, written on 17 June from Glenveagh, he made reference to a Harvard administrator's assumption that he would be back teaching in the fall, from which he extrapolated that, 'at least some of the higher authorities are back of me'. Kingsley added that he 'should know in the next few weeks. I dread victory almost as much as defeat, for it would entail the moral obligation of sticking out another year, which I doubt whether my nerves could possibly stand.'

Seemingly there were those at Harvard who wanted him out, and others who supported him. Without records, it is impossible to know whether the pressure being brought to bear on Kingsley was official or clandestine; in either case, it was effective. In fact, Kingsley seemed almost relieved that the thing he had so long dreaded had finally come to pass. By the time he'd written to Ellis from Glenveagh, however, where he and Lucy were hidden away from the world, the horror of it was already beginning to fade. Everything would be fine. The strain 'which so troubled me', he wrote, putting inordinate faith in distance, 'is relieved'.

* * *

Lucy and Kingsley did not open Glenveagh when they arrived in June 1933, as they had done in previous years. On the 19th of that month, sitting beside a turf fire as a storm beat against the granite outside, Kingsley wrote to his old friend Bernard Berenson to say that they were 'camping out in one or two rooms – a measure partly of economy but also actuated by desire, almost need, to be a bit by ourselves'. According to Lucy's date-book, they visited Inishbofin ten days later.

Despite their desire to be alone – an ironic echo of Alan and his

literary aspirations – Lucy and Kingsley invited their friend, the poet George Russell, to visit them at the castle on 8 July. Russell had been to see them before, and they'd taken him to their cottage on Inishbofin. Lucy recalled that he had enjoyed neither island nor islanders. 'His mind,' she wrote, 'was too used to dwell on "things invisible to mortal sight" to differentiate people who had no intimate connection with his own life nor with his inner thought.'

One of the Glenveagh maids thought that Kingsley and Russell were two of a kind: 'Mr Russell, like Mr Porter . . . don't think of the things of this world.' None the less, Russell enjoyed the couple's corporeal hospitality. He and Kingsley would linger over dinner until one a.m., or take long walks by night, following the stars in and out of fences, wading through streams. ('Never have I heard such heartening talk,' recalled Kingsley, 'and never have I had a harder time trying to find the way.') Russell readily agreed to a visit.

Lucy and Kingsley spent the day before his arrival alone together on Inishbofin, having left behind a note for the poet saying they'd return from the island about the same time he was due to arrive. They had instructed their chauffeur – Anfossi, who had been with them since their Romanesque jaunts on the Continent – to pick him up at the station and bring him to the dock. 'I can't tell you how glad we are you are coming,' wrote Kingsley. 'You and Donegal are, we feel, the best the world has to offer.'

Once on the island the Porters caught some pollack for dinner, and arranged for their boatman to meet them at the cottage the following morning. That night there was a full moon, because of which tides were running unusually high. Although the boatman showed up the next morning as planned, all three of them decided the sea was too rough for fishing, so Kingsley helped him pull the boat higher onto the beach above the tideline, and then set out for a walk.

When Lucy met Russell later that day – he and Anfossi had been waiting hours for their curragh to dock on the mainland – she was

grave. 'Kingsley will not return tonight,' she told him. 'Kingsley will never return.'

He had not come back from his walk. The weather had turned suddenly stormy and she had become anxious. When thunder and lightning set in she'd roused Owen the boatman and his dog and they'd begun a search; other fishing families of Inishbofin had joined in, but Kingsley had vanished. The next day the Donegal sea patrol went out looking for his body, and returned with no better result. Lucy never set foot on Inishbofin again.

'Think A. K. Porter Fell Into Sea' was the headline of a *New York Times* story that ran on 15 July 1933, correcting an initial report of the 10th that he had been lost in the capsizing of a boat. No one had seen Kingsley die, although Lucy sketched a scenario for Russell as soon as he'd helped her ashore. He later wrote to a friend that he'd found her 'in agony', but Lucy had been composed enough to observe as she steered the boat toward the mainland that the storm had passed and the sky was light, although 'waters passed in great mountains beneath the little craft'. Of her conversation with Russell she recalled:

> I told him that in the morning [Kingsley] had gone out before me and it must have been to the cliffs above the sea and he must have drowned. And the springtide ebbing (it was the time of the summer moon) and the strong offshore wind blowing, must have swept his body out to sea . . .

The next day Russell repeated Lucy's story in a letter. 'The body has not yet been discovered and it may be washed into the Atlantic, as Porter fell on the far side of the island with an outgoing tide.' The *New York Times* carried the same news in its 15 July report. 'The fact that the cliffs over which he passed were wet and slippery, and that a swift out going tide was running, convinced the family that he had missed his footing and fallen into the sea.'

There was an inquest into Kingsley's death two months later, at

which Lucy was the first and chief witness. On 14 September the *New York Times* reported the outcome – 'Porter Death a "Mishap" ' – and noted that Lucy had told the coroner of her 'six hour search with two fishermen in a thunderstorm . . . over the lonely island'. She was quoted as saying, 'I think my husband must have slipped off the cliffs, fallen into the sea and been carried away. Our married life was very happy and we had no financial or other worries.'

Three days after Kingsley's death, Alan Campbell wrote to Havelock Ellis; it was to be the last letter of Alan's that Ellis preserved amongst his papers. Russell had mentioned in one of his own notes from Glenveagh, written immediately after the tragedy, that Lucy had cabled 'some American friend of Kingsley's' in England, who was on his way to the castle. Russell added in a subsequent note that he was now able to leave Lucy's side as the friend – 'one of her husband's secretaries . . . a nice fellow' – had arrived. This was Alan, who had been holed up (alone) in Stratford-upon-Avon, working on a new novel.

Alan reiterated that Kingsley 'must have slipped from a high cliff in the wind', adding that on the day of his death he and Lucy had planned to write letters *en plein air* after breakfast, and that Kingsley had gone on a few minutes' ahead to find a sheltered spot. That was the last she had seen of him. Alan concluded by saying that he and Lucy had made plans to return to Elmwood, and that they had walked together on the Glenveagh estate the previous evening, 'both able to feel K has found release and liberation'. It was the closest anyone had come in writing to a suggestion of suicide.

In her 1993 article 'The Fate of Kingsley Porter', printed in the *Donegal Annual*, Hilary Richardson pondered why, when Kingsley did not return from his walk, 'did Lucy accept that it was the end with such ease?' One might as well wonder why she misled the Donegal coroner about their having 'no financial or other worries', when in fact Kingsley had been seriously depressed for some time

and they had been deeply troubled over their investments. 'There can be little doubt that she accepted his death so quickly,' wrote Richardson, 'because she was half-prepared for it.'

Kingsley had said to Ellis in his letter of 17 June that he expected a verdict from Harvard in 'the next few weeks'. His death on 8 July came exactly three weeks to the day after that letter. If, however, Kingsley had received a reply from the university before rowing to Inishbofin with Lucy, then she kept the matter – and its contents – entirely to herself.

In truth Lucy's actions raise no questions; she was simply protecting Kingsley in death just as she had over the twenty-one years of their marriage. After news of his 'accident' reached the world at large she was flooded with expressions of grief. Berenson had 'wept so he could hardly read'. Richardson added that, 'Letters came from Spanish abbots, from Coptic monasteries in Egypt, from the most exalted of French academics and from Donegal fisherfolk.' There was no reason to temper their sorrow with the probability that the still youthful, well-respected professor had jumped rather than fallen from the cliffs.

Years earlier, contentedly marooned in Carcassonne – the medieval city on the watershed between Atlantic and Mediterranean, where Kingsley had felt that the wind nearly blew him from the cliffs – Lucy's happiness had been tempered by the death of a relative at home, James Waller. She had written to her sisiter Ruth to say that 'Although he was young and with wealth and health and should have had everything to live for, I feel that death comes as a solution to him.' Waller's wife had recently died, and he'd been unable to envision a future without her. Lucy had a good memory; her own words must have echoed as she hunted along the Inishbofin cliffs alone, searching for Kingsley's body.

Those borrowed words from an earlier time, written on behalf of another person, are amongst the few we have from Lucy on the subject of her husband's death. Her date-books remained empty

for weeks following Kingsley's disappearance; she kept no journal. Whereas friends recorded Henry Adams' unconventional responses to Marion's suicide – he'd worn red instead of black; he'd ripped off the armband that was meant to show his grief – Lucy's sadness drained away inside her.

At first she did all the things expected of a wealthy widow. She published Kingsley's remaining papers; she continued to expand his archive of photographs; she appeared at a conference in Stockholm in September 1933 in his stead; she organized memorials to him (Meyer Schapiro's paper on the sculptures of Souillac was printed in the journal *Mediaeval Studies* in memory of A. Kingsley Porter). Then she did something extraordinary. Lucy secretly contacted Havelock Ellis and said that she wanted to establish a fund to pay 'a first class scientist, doctor or professor of – what? sociology? to devote his time to the study of homosexuality'.

Ellis responded warmly to the idea, but steered Lucy away from the constraints of academe toward funding private research overseen by a foundation. Lucy agreed; at first she'd hoped to charge Kingsley's brother Louis with presiding over this mission, but quickly took control herself. She wrote to Ellis that she wanted the recipient of her grant not only to collect statistics but come 'into contact with . . . homosexual people so as to give and take information'. Her goal was to help homosexuals understand themselves and society to understand them, 'with the hope that they may lead happy and useful lives'.

Lucy's mission statement was as close as she would come in writing to admitting she believed her husband had deliberately taken his life. In another letter to Ellis, whom she revered, Lucy expressed relief that Kingsley's will had been accepted for probation without her having to appear before a judge. 'So I am pleased I have not had to talk – and have kept my peace – about so much concerning Kingsley.'

Unlike Kingsley and Alan – who were, to be fair, patients (or perhaps subjects) of Ellis's – Lucy was not the focus of her own

letters. She discussed her plans ('I am stumbling towards my goal');
she took note of winter: 'Today . . . 10 below zero, pipes frozen in
the bathroom and even kitchen but outside the trees stretched in
long purple lines on the snow. I love it and K did too.' She also took
note of Alan: 'I think he is happier and seems to have grown in
self-control.' After this comment from the autumn of 1933 all refer-
ences to Alan Campbell cease. But above all, Lucy kept her sights set
on her 'ultimate goal'. As she wrote to Ellis:

> This is really to produce another H[avelock] E[llis]. Only, as this
> can't be done we shall try to create out of the young doctor (or
> rather he will do so, himself) someone who will work – ever
> swinging toward a wide embracing sweep of culture and sympathy
> – directly with patients. My own restricted goal for him is that he
> may help and save a life of value before the breaking point . . .

She did not need say to Ellis that it had been too late to save Kingsley.

By this time Ellis had contacted a young American doctor at
Bellevue Psychiatric Hospital in New York named Joseph Wortis and
proposed the plan. Wortis accepted the offer in 1934, and immedi-
ately announced his desire to go to Vienna to be psychoanalysed by
Freud. Lucy balked at the money required – she wrote to Ellis inquir-
ing, 'could we have the daughter at half price?' – noting that it was
precisely because she looked rich that she really wasn't.

'If I could get rid of beautiful Glenveagh,' she wrote, 'I should be
so much freer financially.' Eventually Lucy did sell their Donegal
castle (in 1937), but not before Wortis had indeed met with Freud.
He continued to receive Lucy's fellowship, administered by the
Rockefeller Foundation, for the greater part of a decade.

In 1937, perhaps as a gesture of farewell to Ireland, Lucy collected
the letters that George Russell had sent to Kingsley during the brief
years of their friendship in a volume called *Æ's Letters to Minánlabáin*
(the latter is Irish Gaelic for 'Churchill', the town closest to Glen-
veagh in possession of a post office). At the end of her introduction

she stood on her own cliff, as it were, in her widow's black, and took a long look at the far-distant horizon. The arc of flight that had propelled Kingsley beyond the frame of their life together had led, inevitably, to the sea, and Lucy found that she was able to make peace with it at last. His death had transformed them both.

'And now,' she wrote, 'that the sea had become his sepulchre I was released from the dread of it which had haunted me . . . This fear which had always hung upon me suddenly dropped and let me free.'

When John James McIlhenny bought Glenveagh Castle he inherited a house full of rumours that Kingsley had never actually died. The servants told him that Mr Porter used to return to visit his wife late at night. These rumours took root in a world unsatisfied with sudden death, especially of the rich and successful, and there is little reason to believe them; all indications lead to the conclusion that Kingsley purposely ended his life on the headlands of Inishbofin.

It was a curious death. His great friend Bernard Berenson moved in urbane, aesthete circles; he and his crowd would have been accepting of Kingsley's sexual preference. Furthermore, in his heart, Kingsley had always longed to remain in Europe, and had the money and connections to live well there, and carry on his own research as an independent scholar. Glenveagh and Inishbofin were far from prying eyes. Lucy was the most obliging of mates. And yet Kingsley renounced solace from any of these quarters. It is easy to suppose that the puritan in him could not morally tolerate his 'deviancy', but that misses the point. He accepted his homosexuality, but the costs of living in a repressive environment proved fatally distracting to his work. (Ironically, Lawrence Lowell retired from Harvard shortly after Kingsley killed himself.) In his own eyes, Kingsley was first and foremost a scholar and an intellectual, yet the personal turmoil of his last years undermined this image by diverting his attention. It wasn't that he was a *homo*sexual being that was unacceptable, it was that something once taken for granted, such as sexuality of any kind, had pushed its

way to the forefront of his life. For someone who had defined himself through his work, this turn of events left him rudderless, without a *raison d'être*. His confusion was like that of a profoundly healthy person who suddenly finds himself permanently ill.

Kingsley had written to Ellis that, 'The future is still obscure for me. I feel I can never again be what I have been, yet I am determined from burning bridges by a doubt whether I shall be able to justify my existence by any other means than those by which I have been attempting to do so in the past. I feel that no solution postulated on idleness can be right or satisfying.'

The puritan in Kingsley was not a prude: he was a tyrant of productivity. Any response from Harvard, either positive or negative, would have fanned the flames of unrest in his life, making the once serene world of scholarly output a thing of the past, and an impossibility in the future. Inishbofin was a lovely place to escape to, but there were no libraries there. Perhaps Harvard's response had been his breaking point, and he had been driven from the cliffs by the wild dogs of self-loss, confusion, and despair. Or maybe he hadn't yet finished running. Maybe he realized that the only way to extend the shelter of his far-flung island from geography to infinity was to keep walking when the cliffs ended. Here at this other Finisterre, Europe's northern complement to Compostela in the south, time and space would be united, for by joining it he would enter the eternal safety of the past.

The lone refuge in which Kingsley's soul could stand, unlike that of Henry Adams' sturdy cathedrals, had no structural support. The nave floor fell away beneath him as he began yet another phase of his pilgrimage, on his way to becoming art himself, in the soft, limy bed at the bottom of the sea.

9

RACANNIÈRES

Ideally you should eat your truffle omelette with a serviette draped over your head, to capture the full truffle aroma.

Lonely Planet, *Southwest France*

Chickens: live, cooked, or plucked. Sunflowers. Fresh herbs in bundles; dried herbs in plastic bags. Apricots, plums, nectarines, strawberries. Tomatoes, courgettes, lettuces; beans, green and yellow; carrots, garlic, shallots.

Cooked paella. Wide-eyed trout. Jams made from currants, plums, and cherries. Olive oils from Spain, fabric from Provence. Cooked pigeons. Cheeses made from the milk of cows, goats, and sheep. Cheeses the size of a sleeping terrier, cheeses that fit my palm. Walnut liqueurs and sweets. Homemade cakes braided like wreaths. Pastries. *Aligot* in a pot the size of a bathtub, stirred by a man with a wooden paddle. English language. Tins of wild boar pâté; *confits* of all sorts. Puppies for sale; dogs in baskets, on leashes, stuffed in blouses, not for sale.

Sausages every shade of sandstone. Honey. Truffle apéritif in big bottles, truffle essence in small ones. Potatoes, honest and dirty. Used English mysteries and Brazilian authors in translation: five euros. Straw baskets. African drums. Tibetan mortars and pestles. Advice from old women on how to make delicate summer soups (dip in a

sprig of wild fennel for the last two minutes before serving; even babies will eat it). Bird call whistles.

Marguerite and I. We were there too, at the St Antonin-Noble-Val Sunday market, according to Ed the very best in southern Quercy. As always it was Lucy who caught the morning's mood. 'A day of many little things which passes as quickly as one of big impressions,' I quoted to Marguerite, recalling a comment in her journal.

'She's been a good companion, hasn't she?' I nodded.

Variety is not what makes the head spin at morning markets in southwest France – replication is. Given time I will be able to choose between a wedge of Roquefort and pats of Cabecous, or perhaps a slice of Laguiole at the cheese stall. The problem is there is never just one cheese stall. There are several, and suddenly easygoing people who are perfectly content to buy a car without reading consumer report guides, who sleep peacefully without seeing the end of a film, are obliged to the very core of their beings to seek out the *best* cheese stall at the market. If this involves miles' worth of retraced steps for comparison's sake, so be it. This is southern France; it's summer. We live an ocean away in a cold, northern place. We have to get this just right.

And we did. We bought Laguiole and several discs of Cabecous, bags of vegetables and round Quercy melons, potatoes, shallots, saucissons. The moment I would remember next winter came at the truffle stall. There were no thimble-size jars of truffles for sale as there were at Lalbenque, but the woman sold me some essence and told me to mix it with raw eggs an hour before I prepared a simple omelette. It will not taste like a truffle omelette, but it will taste like an acute memory of one. I liked this idea of memory before experience; it left something to look forward to. Before I wandered off she offered me a sip of her aperitif. It had the flavour of deep, earthen well-being, sweetened.

While Marguerite napped upstairs under generous swags of mosquito netting and a woollen blanket – it was cold as a church in our *gîte* –

I sat outside in a chaise longue in the shade, sharing the garden with a black chicken and Ed and Bianca's two dogs, Astra and Comet. I had intended to write in my journal, but productivity of any sort would have been an affront to the afternoon. Even flies couldn't be bothered to buzz. New aluminium gutters creaked in the searing heat and the beaded curtain in our open doorway gave a quiet voice to the breeze.

Our *gîte* was part of a farming hamlet called Racannières that concealed itself in deep countryside on the Causse de Caylus. A limestone escarpment rose above the farmhouses, its flank gouged here and there with bone-white gashes, like an abstract version of the White Horse of Uffington. It was from the top of this bluff, standing next to a stone cross, that we had first looked down on the red tiled roofs, neat green-and-blond fields, swimming pool ('Unexpected but not unwelcome,' said Marguerite), and *pigeonnier* of the tiny community.

'Look!' I'd cried excitedly. 'We have a *pigeonnier*!'

'Where?'

'That little tree house-like thing down there. You know, it could be *the pigeonnier*!'

'What *pigeonnier*?'

I explained that I'd been enamoured of Quercy's old dovecotes for months, and had amassed a collection of photos and local postcards. One in particular had caught my eye, a large, handsome, half-timbered *pigeonnier* with a peaked roof and flared cap at its pinnacle (a roof type called a 'mule's foot'). It sat grandly aloft, a good ten feet off the ground, atop four limestone columns. A combination of brick and stone filled the spaces between its ancient beams, giving the whole structure an unexpected prettiness. I'd had no real hope of actually seeing it, as I'd been told that most of the original *pigeonniers* were located in isolated countryside and were exceptionally hard to find.

We descended the hill and approached the settlement, and hope

became amazement: indeed, we were going to live across the lane from the '*pigeonnier ancien de Racannières*', as my postcard called it. As we discovered, most of the hamlet turned on another sense of this word *ancien*, meaning not 'old' but 'former'. Two outlying farms still worked the land (you could tell these by the smell), though the two complexes that formed the hamlet itself had been converted to holiday homes. One was quite grand; the owners had put in the pool we'd seen from the hilltop. (Pools seemed to be the rage in the Quercynois countryside; several restored farmhouses in the area had them, and they gave me whiplash whenever we drove past, the bright blue of them out of whack with the earth's colour scheme, as if they were bits of fallen sky.)

Racannières' other farm was like a teenager; it was in the midst of metamorphosing from one thing to another. The couple who owned it, Ed and Bianca, weren't much older than teenagers themselves. Ed was from Lincolnshire. He'd vacationed in Quercy one summer, loved it, and stayed on to work for a local farmer. When this house came on the market – ten years' vacant, a Swiss cheese of a roof – he'd bought it and he and his girlfriend Bianca had moved permanently to France. They lived in the crumbling farmhouse year-round, and had fixed up part of the attached barn as a holiday *gîte* to help pay their mortgage. They advertised it on the Internet. I'd found the picture they'd posted while sitting at my desk in Massachusetts and had rented it on the spot.

In my mind Ed had looked like Peter Mayle. I was certain he'd be holding a Campari and soda when we arrived, suavely rising from his lounge chair at the sound of our car on the cobbled yard. As it happened there *was* a cobbled yard; as we approached both Marguerite and I took the young man standing in it, his royal blue overalls – the *de rigueur* uniform of all French workmen – thoroughly caked in limestone dust, to be Ed's teenage son. It was, of course, Ed. Shy and slight, dark-haired, deeply kind.

He'd led us through the working portion of the ancient barn to

the front of the *gîte*. Had I closed my eyes, smell would have said we were moving from crypt to nave – from the spicy scent of damp rock without sun nor warmth to a more domestic smell, that of stone tempered with humans. The *gîte* had 2½-foot thick limestone walls, exposed beams, and a red tiled roof. I walked in and stood quivering with instinctual delight, all senses on high alert, like an animal finally at home after having been long deprived of its lair.

My eyes took in a massive stone hearth, black with the soot of centuries, then, set into the back wall, an even larger *lavoir*, a recessed basin beneath an arched lintel, large enough to accommodate several people intent on the communal washing of clothes. Ed had plastered the interior walls but left the stonework inside the *lavoir* exposed; one single stone, laid horizontally, was about the size of Marguerite. The whole thing was filled with a towering construction of carefully placed paperback books. Someone, I guessed, knew how to build dry stone walls.

Upstairs both bedroom and bath crouched beneath eaves angled like a pair of hands folded in prayer. With power tools and the fearlessness of youth – a photo album in the *gîte* documented their gritty restoration – Ed and Bianca had worked a miracle. They hadn't 'converted' an old barn, forcing twenty-first-century amenities down the gullet of an ancient shell; they'd painstakingly made the past comfortable. How Kingsley (patrician that he was) would have appreciated it! Here at Racannières there was no need to conjure an otherworld; history, normally so frustratingly inaccessible, was present and available for convenient use. The bathtub, sink, and toilet were thoroughly modern but simple, co-existing easily with exposed stone, wood, and plaster in the skylit bathroom. Not one of the kitchen's modern conveniences seemed out of place with the rough walls, wooden floor, or candlelit chandelier.

'This is where I found the date.' Ed showed us a former window next to the hearth that had been walled over from the outside. '1661.'

I stuck my head in the oven-like cavity and took in the shard ends

of the façade's smooth stones. It was like looking at the entrance to an undiscovered cave from the inside out.

A storm was coming. My nose caught it first, a peppery smell on the rising breeze, before I looked up to see an alarming bank of dark clouds piled above the farmhouse. A slice of melon-coloured sky lay wedged beneath it along the horizon. The afternoon's heat was about to break.

I went inside and opened the wild boar pâté I'd bought in Haute Quercy and cut slices of baguette. (We'd arrived around 5 p.m. on a Saturday afternoon. Bianca had assumed we'd not had time to shop, and had left us bread, milk, butter, jam, orange juice, fruit, wine, and chilled champagne – all the essentials of a good kitchen.)

Marguerite was stirring upstairs, making noises as if she were trying to find her way out of the mosquito netting. I opened a bottle of Marcillac just as rain began to fall, and stuck my head upstairs to call her down to watch the storm. Bianca was growing lemon-scented geraniums along the stairwell ledge, and for a moment it seemed as if the sky were shedding lemon drops. The anticipatory scent – that peppery odour of baked summer bedrock readying itself for rain, the groundwater far below expectant, thirsty – the racy scent of the geraniums – the wetness of the Marcillac in my mouth, sending up its own peppery aroma: all tangled together in the sensory onrush and dimming light of the storm. Marguerite came down in a sweater and we watched the branches of the great tree across the way bending and thrashing like angry dancers. Soon lateral sheets of rain were slapping the house and we turned on the lights.

We took out our courgettes, tomatoes, and *haricots verts*, olive and walnut oils, potatoes and *saucissons*, and a wedge of Laguiole cheese from the Aubrac. Hail began to fall, pounding and bouncing, and the spiciness of the air gave way to the earthy aromas of the market, all blended, accompanied, tumbled together in our noses and on our palates, by the genius of the Marcillac.

'Look!' cried Marguerite, running for the broom. Rainwater was flowing liberally under our front door, making its way in a great wave toward the wrought-iron sofa bed. As she tried to beat back the tide I prepared dinner, both of our efforts accompanied by thunderclaps and flashes of lightning. Under flickering lights I sliced the potatoes and cooked them in olive oil and garlic, and arranged them in an alternating pinwheel with thin wedges of sausage. Tomatoes, cooked beans, and raw, diced courgette went into a salad seasoned with salt, pepper, and walnut oil. The cheese came last. After dinner, when the rain had stopped, we felt refreshed but not full, as if we'd eaten a season, a good, light one. We felt as if we'd eaten summer.

* * *

The *gîte* was bilingual: French on the outside and English on the inside. All the notes, written recommendations of where to eat, what towns to visit, all the paperbacks in the *lavoir*, were in English. Marguerite carefully eased out *The Girl with the Pearl Earring* by Tracy Chevalier and replaced it with *The Hours* by Michael Cunning-ham, which she'd just finished. But step through the beaded curtain and outside were wide French shutters and the unmistakable lime-stone *pierres de tailles* of Quercy, and beyond our farm enclosure, the roll of the *causse* and the smell of juniper.

Bianca, however, was thoroughly English. Blonde and fair, mother to young Tom, young herself – very young – friendliness came to her as involuntarily as breathing. She was not the kind of person whose happiness hinged on convenience. A different country, a different language, a house without a roof, a baby on her hip: these things didn't bother her. Whether or not Tom's bawling and the dogs' barks woke us in the morning seemed the extent of her cares. We assured her they did not, and she was satisfied. Bianca didn't fuss. We were free to come and go as we pleased.

Not that coming and going was easy. A jumble of farm tracks led from Racannières to the secondary road into Caylus. It took about

fifteen minutes just to reach the secondary turning, an often fraught
trip thanks to speeding farmers and a mongrel car-chaser who lay in
wait for us at about the halfway mark, choosing to let us pass unmol-
ested just often enough to lull me into a false sense of security. None
the less, we persevered on our outings. Caylus was for errands and
essentials: bank, *pâtisserie*, post office. To my delight the town was
plastered in yellow posters advertising a band called 'Marguerite
N'Aime Pas Le Rock N' Roll'.

'But I do,' she protested, 'as long as there's not too much
screaming.'

Caylus is technically within the *département* of Tarn-et-Garonne,
though that status is an administrative footnote; a better description
is that it lies in the Bonnette river valley, long the historical and
geographical boundary between Quercy and the Rouergue.

The town was torched in 1211 by Simon de Montfort, and today
proudly promotes a house in the medieval quarter, built shortly after
Montfort's conflagration, that is decorated by sculptures of wolves.
We went to Caylus' annual *Marché Nocturne*, the Night Market, to
watch local youth dress up in medieval velvets and brocades – in
which they smoked and drank beer – and a farmer direct his border
collie to herd five terrified sheep through a maze in the car park. At
'*Stop!*' the collie would slow. At '*Tout stop!*' she would crouch low
and freeze. The sheep merely trembled and defecated. Over the loud-
speaker a man pleaded with the crowd to listen out for the owners of
an English car parked in front of the church and tell them 'in their
language' to move it immediately.

This part of Quercy is something of an English second-home
owners' outpost; in St Antonin there is even an English-language
bookstore. There are scores of jokes about Agincourt, but the void
into which outsiders are rushing has little to do with England. Sub-
sistence farming failed in this remote part of France when comparative
lifestyles arrived on the wings of telegraph wires. Unlike Provence,
roots of the only remaining industry – tourism – here and in neigh-

bouring Rouergue are shallow at best, and there is nothing left to hold people to the land. Of the fourteen thousand holiday homes in Quercy ten years ago – the number has probably doubled by now – most were renovated from abandoned properties.

Marguerite and I roamed both sides of the Quercy–Rouergue border. Najac, on the Rouergue side, was for views and shopping. Caussade was for the Intermarché supermarket. Septfonds for calling home from a sweltering phone box and visiting a little dolmen in the woods. Villefranche was for a busy Thursday market. Varen for an unsung Romanesque church called St Serge (my kind saint of black wine): for its echoing barrel vault, dripping *la maladie blanche*; its one showy limestone capital of a monkey and a ram grinning thousand-year-old, sly, toothy grins; for its unabashed cave smell of rock and water.

The tiny village of Parisot was for the memorably named restaurant Les Vieilles Pierres, the Old Stones. Its façade was a patchwork of cream and Conques-yellow stonework; its menu was simple and inexpensive. *Potage. Salad aux Gésiers* (more chicken gizzards; 'How many chickens,' asked Marguerite, 'does it take to make a salad?'). *Confit* of duck and roast potatoes. Cheese board. *Tarte aux prunes.* It occurred to our fellow diners that they did not have to consume each of these courses, but this knowledge did not dawn on us and we gamely persevered through all of them.

'What a ceremony a meal is in Europe,' Lucy had cried in her journal. 'An hour to serve it and 30 hours . . . necessary to digest it.' We toasted her with groans.

When the bill came it turned out that the *vin* was not *compris*, as advertised.

'It's an outrage!' cried Marguerite, who is famous for her ability to guess the precise amount of the bill before it arrives. The wine had thrown her off.

'Travelling with you is like travelling with Lucy,' I told her, recalling that Lucy had made daily notations in her journal as to whether or not wine had been included in their *prix-fixe* meals.

St Antonin was for paying my final respects to Lucy's art. The town lies beside the Aveyron beneath limestone cliffs, violet-hued in the afternoon's shadow, capped by the kind of jagged peaks once beloved by medieval painters. On a Monday, France's infuriating day of rest when most provincial shops are closed, it was as if there had never been a market there. Marguerite and I wandered a ghost town, searching for the Ancien Hôtel de Ville, which Lucy had photographed in 1920 when it was already 795 years old and France's most ancient civic structure. We were amazed to find its fairly unmistakable square tower and arcade of round, Romanesque archways right on the market square.

'A man was selling tomatoes here yesterday,' recalled Marguerite. 'Remember? You thought they were exceptionally red and took a picture.'

It was hard to reconcile the grey stone antiquity before us with yesterday's vibrant tomatoes. I had stood on this spot beneath the fury, wit, and the tragedy of Romanesque art and it had been invisible to me; I'd been far too concerned with food. And that probably spoke well of me. No one lives by art alone.

We would have missed the traces of twelfth-century sculpture today too had we not carried Lucy's photographs. It was they that directed our eyes up a storey to a second-floor gallery of carved column capitals and two large reliefs. The images weren't the best Lucy had ever made, but again they served us as a third pair of eyes, pointing out what we otherwise would have overlooked. Adam, Eve, the snake, and the Tree of Life crowded onto one of the oblong relief panels. The snake seemed to have been the most fun to carve; he had lovely, decorative scales and a graceful curl to his tail. The tree was a column that had sprouted. The fallen Adam and Eve conveyed their plight through enormous, bereft eyes, hands clasping at their throats, and positively elephantine leaves covering their private parts. The rest of their bodies had no role in the narrative and therefore had been dealt with cursorily. Why they both had the toes of a tree sloth, I can't say.

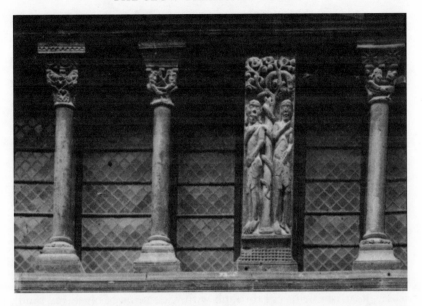

More fun than the First Couple were two creatures on a neighbour-ing capital, small but boldly sunlit in Lucy's photograph. A man with long, curly hair grappled with a monster. He grasped its arm – or perhaps its tentacle – and the monster vigorously fought back. Their mouths were open, teeth bared, eyes wide and rolling, and yet their zest to snap one another's necks seemed to be the pinnacle of sheer good fun. They were like cartoon enemies, elaborately plotting each other's demise but never dying because, oddly, that's what makes people laugh. And why should we, inhabitants of the twentieth and twenty-first centuries, have a monopoly on the cartoon Zeitgeist? Here it was in St Antonin, whacked out of stone rather than drawn on animation cells, but the impulse was precisely the same. Romanesque sculpture was the only public medium of the eleventh and twelfth centuries. Now we have so many media we differentiate: sculpture is for Serious Art. Cartoons are for silliness. Newspapers are for world events. But a thousand years ago there was only sculpture, and we're mistaken if we expect it to have had a singular purpose. It served every role, because people then needed to laugh and cry and fret and

congratulate themselves and fear death precisely as we do now. Only then, all of those needs were served by stone.

Our most ambitious excursion was to Rodez, in the Rouergue. Marguerite had seen what I privately called 'the white side' of south-west France. She'd seen the weathered and bleached limestone rocks of Quercy's walls and farmhouses, cousins to Beaulieu's weirdly eroded sculptures, all worn into what looked like the vertebrae of great but unknown animals. Now I wanted her to see 'the red side', the older sandstone landscape of the Rouergue that had produced the church of Perse and the chapel of Ste Foy at Conques, that had fostered our Marcillac.

As we drove east we quickly left the scrubby undulations of the *causse* and entered the expansive dimensions of the Aveyron river valley, its green fields cut through with wide veins of blush-red sandstone. Marguerite declared it pretty and restful but familiar – 'It looks like Wales with make-up' was her comment – and that if forced to choose, she would have to opt for the dry, secretive *causse*. For me, entering the Rouergue was like a trip home. For weeks all roads had led to Rodez. If I'd seen the silhouette of its oxblood cathedral once from the city's hellish tangle of roundabouts, I'd seen it a hundred times, or so it seemed. Twice I'd tried to breech the defences of the place, its one-way systems and nest of hilly lanes, and twice been defeated by lack of parking. Today we'd arrived determined to conquer.

It was ridiculously easy. We left the car near the immense sandstone pile of the cathedral, a precise, Gothic construction that despite the warmth of its pink stone spoke to me coolly of man and mathematics. I preferred Conques, where I'd caught murmurs of a dialogue between abbey and earth. Marguerite and I window shopped; we turned green, pink, and blue in the unaccustomed light of neon; we got lost; we bought soap at a diminutive Monoprix, where a man claimed a large bag of summer squash from the lost-and-found. What

had brought us to Rodez were not the shops, however, but the Musée Fenaille, the archaeological museum of the Rouergue that had just reopened after several years of renovations.

I had been waiting for this moment for months. The Musée Fenaille has the largest and best collection of statue-menhirs in France. At the outset of my journey, in a hesitant frame of mind hard now to recollect, I had found a statue-menhir at the Musée Joseph Vaylet in Espalion. That stone had seemed to represent something fundamental and basic – mere animation, signified by eyes and a mouth. A homunculus of granite. These stones in Rodez were individuals with carefully delineated characteristics. My eyes ran over them and I saw that the difference between the Joseph Vaylet menhir and these was the difference between the beginning of my pilgrimage, when Lucy and Kingsley were all strangers to me, and the end.

They were not at all what I'd expected. There was a roomful of these strange, flat standing stones, all dating from between 3300 to 2200 BC. They had more in common with churchyard headstones than with Stonehenge. The waist-high menhirs were humble and tablet-shaped, and most were carved in low relief from red or grey sandstone. Vertical lines on the lower half meant legs; horizontal lines at midpoint represented a waist or belt; faces were indicated by eyes and a nose and often decorated with simple lines denoting tattoos. Fingers and toes were schematically, but meticulously, etched. Some of the male menhirs carried incised weapons; the female ones wore carved necklaces. Labels noted that these stones of the Rouergue were unique not just for their profusion, but because they were carved on both front and back.

'Make a note,' whispered Marguerite, 'that they're sitting in little enclosures of dirt – I mean earth.'

I did what she said. Another sign in English announced that the menhirs were hard to date because 'all of them were found on their own out in the wild'. The little boxes of soil were their last contact with the environment they had known for thousands of

years, before they were deemed too valuable to remain feral stones.

I went up to one of the squat, red carvings and looked her in the eye. Her necklace was her most prominent feature, followed by the tattoos on her cheeks. The mermaid at Perse had clearly inherited her little round button breasts. I could see I was face to face with that mermaid's many-times great-grandmother, an elder child of the Permian Extinction, a stone Venus.

Years ago, just a few weeks after my course on the Romanesque had ended, I had spent the summer on an island with my friend Mary on the opposite side of the Atlantic from Inishbofin. We had been summer chambermaids: we cleaned hotel rooms by morning, swam by afternoon, made beach fires by night. We were the only chambermaids ever, I think, to obtain library cards. One foggy day I checked out a book while Mary and her boyfriend Tom walked the periphery of the nine-by-three-mile island. It was called *The Thorny Paradise*, a treatise on children's literature by Edward Blisten. I'd borrowed the library's typewriter to pound out the following excerpt that Blisten had addressed to a Neolithic statue he called the Stone Venus. I've had it in a file ever since.

> If seeing became this art, then speech must have become words. The words are in her . . . but if so they are embedded as prisoners in the granite. They seeped into the cold stone until they became conspirators in its muteness. Perhaps it is to this Venus that the French poet Gaston Bachelard addresses the question, 'What is the source of our first suffering?' and translates her unspoken reply, 'It lies in the fact that we hesitated to (could not) speak. It was born in the moment when we accumulated silent things within us.'

I stepped back to get a better look at the little menhir. Her arms were awkwardly stretched across her chest, as if she were reaching for something. Again I looked in her eyes but they were only two dark hollows in the sandstone. She wasn't human. Unlike the Venus de Milo she didn't even look human. She kept her distance from us;

she remained true to her nature, stone, sprung from the bedrock. That was the appeal of this stone Venus, mother to my beloved Romanesque sculptures. For all her muteness she seemed to rebuke Blisten and Bachelard. Was it possible that the poet had got it wrong? Perhaps the truly important thing about these ancient stones *is* their silence. There are many kinds of bilingualism, and maybe the most basic one of all is silence and speech. It's not a stretch to see art, or invention, as the attempted translation between them. Two languages: the noise of the present, the hush of the past. The silence of eternity, the roar of passing time. Not a source of suffering, simply the nature of things.

The menhir seemed to confirm it. Her quietude – a silence that had swallowed the noise of generations one after the other as surely as the *causse* absorbs rainwater – was a reminder of this bilingual way of the world. There has always been speech and silence, as there will always be holes and objects to fill them. The past is one such cavity, tugging at us with the insistence of the tide to fill it with invention; the weathered sculpture bequeathed to us by Romanesque artists is another. We have these quiet hollows inside us as well, and the languages we invent to fill those inner places make us all bilingual creatures. Some speak pidgin to themselves; others, like me, invent grammars and syntaxes and create a cast to give them voice. Just as the little female menhir is testimony that five thousand years ago someone tried to translate between the inarticulate bedrock – the earthen silence of prehistory – and the noise of humans, so my own daydreams are evidence of my lifelong attempted translation between the great racket of the world and my owner inner quietude.

* * *

We were famished by the time we got back to Racannières, so much so I forgot to watch out for the car-chaser (he didn't appear; he was probably having dinner). Marguerite had been reduced to hunting for stray Mentos that weeks earlier had fallen under the passenger's

seat when she realized it was Tuesday. She popped her head up.

'Today's the day Bianca said the bakery was open! Head for Lasalle.'

Instead of taking a turning at one of the tiny crossroads that led to our *gîte* I drove straight ahead, up a hill signposted 'Lasalle'. Bianca had told us that there was a *boulangerie* in the tiny village, open only from 4–8 p.m. from Tuesday to Thursday, where bread was baked the old-fashioned way inside a stone oven fuelled by a wood fire. Just as we'd had to find the perfect cheese stall at the St Antonin market, so we now had to have a baguette from this bakery and none other.

The village was no bigger than our hamlet, the bakery no more spacious than a hall closet. All its shelves were empty. An old man soon responded to my ring.

'You are the foreign woman from the car!' he said.

'Yes. I am here to buy your bread,' I replied.

We seemed to be speaking in some kind of staccato code, and I half expected him to ask me for a password, but he only inquired if I wanted a *pain*. As *pain* means bread in French, I readily agreed. Yes, that's what I wanted.

He looked apologetic, said something I didn't catch, and disappeared. Moments later he returned with a rock-hard substance the colour of blackened chestnuts, the shape of a submarine, and the size of a human thigh.

'That's not a baguette.' Marguerite stated the obvious. We tried to break off an end to eat in the car but that proved impossible. It later took two of us – one to hold it down, the other wielding a giant serrated knife – to hack the thing into edible bits.

Back at Racannières we found Ed and Bianca outside playing with little Tom and the dogs. I commented on the chalky state of Ed's blue overalls and he said with pride that he'd been at the stone-breaking machine again. At this Marguerite sighed deeply and disappeared into the *gîte*, knowing she'd have to wait for dinner.

'You have a stone-breaking machine?'

'Yeah, I'll show it to you.' Ed took me to a pile of rocks over by the horse barn, and said he'd bought the limestone from a place in Lalbenque. The stones were pale and hard-edged from their recent fissures, still delicate in colour like seashells. He told me that many of the older houses in the area had been built dry-stone fashion, like Quercy's old walls.

'But that's out of poverty,' he added, 'not choice. If there's one thing people around here aren't poor in, anyway, it's stone.'

Ed said that he was able to do dry-stone work himself. 'I thought so!' I interrupted. 'I could tell from the paperback construction in the *lavoir*.' He smiled and indicated the far wall of the farmhouse that I hadn't seen before, the way its shaped stones, the *pierres de tailles*, contrasted to the rougher ones used for the barn.

'I'm using mortar on the house, though.'

The chief feature of Ed's wall was that it was only half standing. A shiny blue tarp protected the space where the upper portion should have been. I pointed this out as an inconvenience and Ed laughed.

'Well, you see, it was like this,' he began, and told me a story that started with the significant fact that his father is an architect. Before he'd bought the house he'd asked his dad to come to Quercy and take a look. His dad had located a huge foundation crack and told Ed and Bianca by all means not to buy the place. 'Oh, what does he know?' said the local farmers. 'That crack has always been there. It was there when my grandfather was this big.' They indicated a point around their knees. 'Boof! It's fine.' Ed listened to those who knew the place, knew the tendencies of its stone.

'And then one day,' he said, 'I was here by the barn and Bianca was over in the garden when there was this incredible roar. I took cover – Bianca thought a plane had hit the house or something. The wall had fallen down. Just like that. It fell down.'

Ed smiled, cheerily adding that he'd never done any home renovation work before. Some days later Bianca took us on a tour of the

inside of the house. Everything was bathed in blue light, like a blue-print come to life, lit up by sunshine beating on the outside of the tarp. It was like a camp – a makeshift camp set up by squatters who know they'll have to flee at a moment's notice. The tarp billowed into the bedroom and living area. I tripped over their hot plate.

'Look at this,' cried Bianca gleefully, waving toward an absence. The house had no back. She indicated an open chasm at the rear of the space – their living quarters occupied the upper level of the structure – beyond which gaped the cavernous emptiness of a two-storey barn. If you kept walking you'd fall about twenty feet down to crash onto the barn floor below. Ed had propped up a narrow wooden ladder to help negotiate the distance.

'See, way down there at the bottom?' I squinted over the edge of the floorboards into the murky light. 'That's our toilet. We only show people this place when they're getting ready to leave, because otherwise the guilt would ruin their holiday.'

We were suitably horrified. On the other side of the common wall Marguerite and I had been living in comfortable splendour. Thankfully, I had not yet seen their digs when I set out after my talk with Ed to prepare our truffle omelette, our designated treat at the end of the long Rodez excursion. The very first thing I did was insert a corkscrew into a bottle of Cahors, a Château La Gravette 2000; the very next thing I did was break it. The corkscrew had consisted of a handsome, shellacked tree root fitted with a screw-pull, its effective-ness dependent on brute strength. When I used mine the steel screw snapped boldly in half.

'Guess we won't have wine tonight,' said Marguerite matter-of-factly.

I must have looked as if I were about to cry.

'I'm just kidding. Go see if Ed can help you.'

I marched over to apologize for breaking the corkscrew and found Bianca at her front gate, talking with the driver of a blue van who as I approached shut off the engine, hopped out, and opened the doors

at the back. An enchanting smell of fresh-baked bread nearly knocked me down. He reached in and handed Bianca two perfectly baked baguettes. She asked me if we needed any bread.

'Remember I told you the Lasalle bakery truck comes around every Tuesday evening?'

I'd forgotten that part. Now I understood what the old man had said, and why the shelves were all empty: all he'd had left to give me in the shop was an over-baked *pain*. Everything else was on its way to Racannières. I sighed, and told Bianca about the corkscrew.

She didn't give a fig about it, but being a sensitive soul instantly grasped the sad implications of a permanently corked bottle. She gave the wine to Ed, who put it in a vice in his workshop and eventually yanked out both cork and broken screw together with a pair of pliers. He said he felt like a hero. I assured him he was.

The wine's back label encouraged us to drink it with *toute la cuisine du Quercy.*

'All at once?' asked Marguerite.

'I think not. But it puts a lot of pressure on the omelette, doesn't it?'

I'd found a recipe for an Omelette aux Truffes that suggested I put one to two small truffles in an airtight bag with eight eggs for several hours; the eggs, I was assured, would be infused with the truffles' subtle flavour. Here I substituted the market lady's advice, and beat five eggs with three or so ounces of truffle essence, salt, and pepper and then let the bowl sit in the refrigerator for an hour. There wasn't much I could do about the next step, which wanted me to sauté the chopped truffles in goose fat and Monbazillac wine (a sweet, golden white from Haute Quercy). As a kind of culinary penance I sautéd some mushrooms in Coteaux du Quercy rosé and butter instead – reserving them to garnish a green salad – in order to prepare the pan. Then I added more butter, got the pan hot as the recipe instructed, and poured in the eggs, letting them cook until they were set.

It was a good omelette. Were I to write a recipe I'd include 'imagin-
ation' as one of the essential ingredients. My tongue kept catching
the promise of something magnificent, maybe the flavour of satisfac-
tion itself, but it was more a hint than an actual sensory experience.
Which wasn't a bad thing: everyone who tastes an Omelette à l'Ess-
ence des Truffes fills in the taste gap with their own imagined
magnificence. I experienced truffles the same way I'd experienced
Romanesque sculpture and Lucy and Kingsley: people and art
'othered' from me by time, as Coleridge had written of old age's
distance from youth. It was the same way I had experienced France,
a place 'othered' from me by space, as the poet had said of his
neighbour. All were complete on their own terms but on mine they
were fragments, the space between us akin to the difference between
Lucy's photographs and carved stones, between daydreams and life.

* * *

Elmwood; Cambridge, Massachusetts
1962

Lucy awkwardly pulled the red volume from its slipcase. They had
never thought when they'd chosen not to bind the volumes of photo-
graphs – could it have been almost forty years ago? – that one day
their fingers (her fingers) would be too arthritic to keep track of all
the loose plates. She grasped at them but the top batch of images
slipped through her hands and fell to the floor.

She managed to catch Number 376 and pin it to her lap. It was
the Annunciation from the Moissac porch. Lucy smiled at the tall,
slim-hipped angel and the slightly shorter Virgin next to him. The
Virgin's face was missing as if it had been sheered off, so that the
shock of the angel's message registered only in her upturned hands.
The day she'd taken that picture had been a good day. Sunny. Warm.
There'd been that nice artist they'd met at the abbey with whom
they'd had a long and delicious lunch. She'd forgotten his name.
How could she ever have imagined she'd been tired then? Moissac

faded, and Lucy's inward gaze fell upon a slightly more recent horizon, that awful day of Kingsley's own annunciation . . .

No, no, she wouldn't see it. She shook the image from her mind and refocused on the photograph, squinting to read the caption. 'Moissac, (Tarn-et-Garonne). Relief of eastern side of porch. Annunciation. L.W.P. phot.'

Her initials: Lucy Wallace Porter. Another woman, thought Lucy, inhabiting another life. She called herself Lucy Kingsley Porter now, bearing the burden in name as well as deed of living for them both these nearly thirty long years – a task that was finally nearing its end. What was it Coleridge had said about old age? Ah yes, he'd called it 'youth *othered* by time'. But Lucy no longer felt young even in her heart. The images in Kingsley's book alone held her youth now: the way the sunlight had fallen on her and on the sculptures she had loved because he had loved them; the angles through which she had looked at France and Spain that long summer of 1920; the initials of a married woman, not a widow.

She slammed the volume shut as best she could, her hands trembling. Let it all stay in there for someone else to find. Soon – she smiled with weary satisfaction – it would be the only place she would remain. She had donated all the original photographs from *Romanesque Sculpture of the Pilgrimage Roads* to the visual archive of Harvard's Fine Arts Library. The photographer in her couldn't help noticing that the originals were far superior to these printed copies. Well, all for the better, then, that Harvard had them for safe keeping. Harvard would endure, and so would Kingsley's legacy. She had instructed the archivist how to attribute the photographs, carefully noting when an image had been taken by one of Kingsley's assistants, or when he'd got it from a photographic service like Lasalle or Baylac. All the rest were to be labelled exclusively A.K.P. She herself was to be acknowledged only for her generosity: 'Gift of Mrs A.K. Porter'.

Lucy took a deep breath and looked up at the ceiling; she'd have to make a note to tell Harvard they'd have to re-plaster after her

death (Kingsley had been so right to leave the house to the university when her days in it were done). She exhaled loudly and then smiled. She hadn't expected this feeling of freedom. It reminded her of her change of heart towards the sea after Kingsley had died. It was a kind of permission to stop caring now. Lucy closed her eyes and saw herself wading into the water. It was a familiar image. Yes. In a second's beat she knew she'd borrowed it from that picture she'd taken of Kingsley – the last one – with his trouser legs hiked up, coat over his arm, stepping into the cold Atlantic toward their curragh on the way to Inishbofin.

In giving away her life – it *was* her life she'd given, or her eye at least; so much of her time spent seeing the world through a camera lens! – she'd found company at last. These years had been busy, but lonely. Maybe now, in her photographs (the old possessive pronoun still came to her against her will), she and Kingsley would be together for ever in the long eternity of the Harvard archive. In their beautiful pictures of beautiful old sculptures – she never ceased to marvel at how those carvings could be so awkward yet so lovely – within those pictures, behind the grainy grey stone, in the shadows, she would marry Kingsley again within an art big-hearted enough to support them both.

EPILOGUE

Inishbofin on a Sunday morning.
Sunlight, turfsmoke, seagulls, boatslip, diesel.
One by one we were being handed down
Into a boat that slipped and shilly-shallied
Scaresomely every time.

'Seeing Things', Seamus Heaney

Annie and I had reached a crossroads. To the east lay Gortahork; to the west, Meenlaragh and the Bloody Foreland. We were looking for a B&B.

'Oh, the Bloody Foreland, I think,' said Annie decisively. She spun the wheel and we began to navigate a knob of land protruding into the Atlantic. A scattering of recent houses jumbled between seaside pastures and outcrops of granite. It was hard to reconcile the vulgar starkness of the man-made structures with the natural, dishevelled beauty of the promontory; the only thing they had in common was the engulfing sea. The air, coming through the windows in chilling, day's-end gusts, smelled like island whiskey, of turf-smoke and iodine.

'It's gloriously surreal through these sunglasses,' said Annie, handing me her bright pink lenses.

I waved them away. 'Take them off. It's real.'

Here at the western edge of Europe the setting sun was unobstructed in its brilliance. It coloured the grasses of the leeward hills vivid

burgundy and made beaten copper of the waves. But for a dredger trawling in and out of the tiny, utilitarian harbour at Magheraroarty pier, we were alone with the sunset and our intentions. After I had finished my manuscript I'd read it over and been unsatisfied. What had crossing to Inishbofin in a curragh cost Lucy? How isolated was Glenveagh Castle, even today? Did anyone in Donegal remember the Porters? So many questions remained. I could not write of Ireland, as I had Quercy and the Rouergue, that I was the Porters' fellow traveller, in the same place but a different time. I decided I could not finish my book until I'd been to Donegal. It wouldn't be a pilgrimage, the way my travels in France had been. Nor would it be research in a strict sense, but rather an exercise in imaginative recreation – in daydreaming. A perilous mission perhaps, but a necessary one. Annie, my high-spirited companion from Conques – she of the over-hearty legs and keen insight – had volunteered to go with me.

Two young boys appeared kicking a football. According to them, there were no B&Bs in Ireland. Inquires in a desultory pub produced much the same answer. The light had turned from pink to mauve and the temperature fallen in degrees by the handful when we met a windsurfer on the barren concrete pier. Shouting over the gusts, he gave us directions to various forms of lodging (had we turned toward Gortahork rather than the Bloody Foreland, these choices would have been instantly ours), and told us that if we'd our hearts set on reaching Inishbofin, as it seemed, to get ourselves back to the pier around 9 a.m. the following morning. Perhaps an outgoing fisherman could drop us off.

'No use trying to make arrangements tonight, though,' he advised. 'You can't count on anything here.'

The windsurfer had uncannily echoed directions to Inishbofin that I'd found on the Internet. Under 'Access' the site had read, simply, 'Fishing boat from Magheraroarty Pier'. In summer the year-round ferry to Tory Island also made sporadic stops at Inishbofin, where

there was a seasonal hostel. Now, in late September, the man who ran it was the last member of the tiny summer community left on the island; soon he, too, would return to winter on the mainland.

Annie and I indeed discovered an ideal B&B about a mile from the pier, with bedside lamps that could be turned on and off by a tap of the shade. After a five-hour drive from Dublin and a few glasses of wine we'd found this inexhaustibly fascinating. Our landlady, Geraldine, told us that the Bloody Foreland was named not for a battle, as we'd guessed – 'For once, something Irish that's got nothing to do with gore nor tragedy,' she'd said – but for its spectacular sunsets. 'The sun goes down red and takes the land with it. And the stars . . .' Geraldine indicated the heavens. 'It's like a sugar bowl. You can't lose your way on a clear night.'

Assuming she'd lived here all her life I began to pepper her with questions, but Geraldine waved me off. It turned out she was from Belfast, and had been, in the not too distant past, the first female executive for General Motors Corporation in Europe.

'You can't count on anything here,' echoed Annie, maddeningly.

We were now standing at the end of the empty pier. It was an unusually warm autumn day. To the east rose the Derryveagh Mountains, solitary and sharp-peaked; from the map I knew that Glenveagh Castle would lie in their afternoon shadow. Ahead of us the green bump of Inishbofin stretched on top of the sea, nearly meeting a low, dune-slung finger of the mainland. The narrow channel between them churned with riptides. Several small, open boats were tied up to the pier, but no one came to claim them. The dredger, back at its monotonous task, was the only sign of life.

'Imagine,' mused Annie. 'I mean just imagine: do you feel out of place here?' I nodded affirmatively. 'So do I. Can you think what it must have been like for Kingsley and Lucy to suddenly drive up to the pier, chauffeured by Anfossi in their fancy car? What must people have thought? What must Lucy have thought?'

I was considering these questions when a red truck turned onto the pier and headed toward us. An old man got out and peered at the sea. We descended on him and asked if he had a boat – could he take us to Inishbofin?

No, he said, with genuine regret: he'd already taken his boat out of the water for the winter. But glancing at those that remained and mentally matching them with their owners, he started ticking off candidates who might give us a ride, and how we could find them. Suddenly he stopped, mid sentence.

'Why do yus want to go to Inishbofin, then?'

I said I was doing some research for a book.

'I was born there,' he volunteered. 'Now I live on the mainland – no one's out there fulltime any more. The Government wanted us to leave.'

Annie was staring at him as he spoke as if she saw something interesting through the back of his head. I guessed that she, too, was taking in his white stubble and greying ginger chest hair, the lines around his pale blue eyes, and calculating.

'She's researching an American couple,' she said, indicating me. 'You might have heard of them. Kingsley and Lucy Porter.'

John Coll – we had made our introductions – squinted at nothing, and then his eyes grew large. 'Aye!' he gasped. 'Why, I haven't thought of Mr and Mrs Porter in years.'

'Did you know them?' My voice shook with hope.

'Oh, aye. I was a lad of about six when they were here. Over six foot he was, and she was little.' John Coll indicated his waist. 'He was a handsome man, and a gentleman. We kids used to follow him around and he'd give us apples. He always kept apples in his pockets for us. And we'd help him pull his curragh up on the beach – for that he'd give us two shillings apiece.'

It was nice to think of Kingsley as a pilgrim who carried apples instead of stones.

John Coll exlained that Kingsley had paid two pounds to every

household on the island for permission to walk across common land ('A fortune back then,' whispered Annie), and the exorbitant sum of seven pounds each to three families, including Coll's, for the right to build his cottage.

'Aye, like I said, Mr Porter was a gentleman. I remember there was an old woman lived out there – she only spoke Gaelic, of course, so I'm translating – well, she said to him, "You're a little bloke – meaning a regular lad – for a big millionaire".'

I asked about Lucy. 'She was a nice woman,' he said, a little doubtfully. 'She had a voice on her, she did.'

Annie and I exchanged surprised glances. 'What do you think happened to him?' she asked.

John Coll shook his head, as if nagged by an old worry. 'Now how could he have drowned, then? Mr Porter knew that island well; he was in and out of there all the time. They say he lost his footing?' He snorted in disgust. 'No, it was something deliberate. We all knew that.'

'Did he kill himself, then?' Annie suggested, almost whispering. For a moment it seemed as if our little triad could still get to the bottom of Kingsley's disappearance if we tried hard enough. Everyone leaned closer.

Coll shook his head and frowned – that wasn't it at all. Why would he do that? He explained that the night before Kingsley disappeared was the only time his boatman had ever stayed on the island. 'Now that was strange, wasn't it?' His eyebrows shot up and lingered. At this point we heard voices behind us and saw that two middle-aged men and a boy had walked out onto the pier. Annie excused herself and ran over to them.

John Coll continued. It seemed his parents and the other adults of Inishbofin had formed two theories. 'Everyone suspected foul play,' he said, but there was another option. The Porters' cottage was built far from the village alongside the island's solitary beach – the only place other than the village pier where you could launch a curragh.

The beach faced north toward the other islands of the Tory Archi-pelago. Why had the boatman remained that night? To row Kingsley away to Inishdooey, Inishbeg or Tory, so he could disappear and start his life over somewhere new. After all, the only people who had claimed to see him the following day were Lucy and the boatman . . .

Peals of laughter from down the pier. I heard, 'You're Annie, and I'm Danny!' Then more laughter followed by, 'There's one man out there now, and two of you – how's that going to work?'

'What do you believe happened?' I asked Mr Coll, but he only smiled, too smart to be pinned down. 'Did people like the Porters?'

'Oh aye, everyone liked them. They were nice people.' He talked about them driving down to the pier in Mr Kingsley's sports car. 'There were only eight houses in the village then,' he said, pointing eight times with his finger in the direction I was looking, but seeing a different village to the one before my eyes. I overheard Danny say, significantly, 'Well, whoever took you out would be wanting some sort of compensation, now . . .'

Before he got back in his red truck John Coll told me he'd been all over the world; he'd even worked as a bricky in Australia for twelve years. 'To be truthful with ya,' he said wistfully, 'I'd have stayed there, but my wife didn't like it. So here we are again, back in Donegal.'

The sea was smooth. Danny's 10-year-old son Mark steered us in the open curragh (now fitted with outboard motor) from Magheraroarty pier to Inishbofin in less than twenty minutes – Danny had agreed to take us and, critically, pick us up, for 15 euros each – but I could feel a restive power in the waves beneath the little boat.

'You're lucky to get such a calm sea. Not many days like this,' commented the father. We arrived to find the island's pier strewn with lobster traps and discarded floats. 'Can't make a living fishing any more,' he said matter-of-factly. 'Used to be good for lobster and crab, but it's been over-fished now.' Danny jerked his head toward

the emerald Atlantic in the way of someone on familiar terms with a large, dangerous animal, adding, 'You can catch yer supper here by the harbour, but there's a wee swell of a whirlpool on the other side of the island.' He also had been born on Inishbofin, into a community of about two hundred people. Now the village was crumbling and deserted; windows were boarded up, roofs swaybacked and missing shingles.

There was, however, a newly whitewashed shrine at the top of the pier: a square box that could have been a bus shelter had we not seen a statue of Christ through a window. A matching shrine on the mainland held a statue of the Virgin Mary.

'Now that says something about the weather,' I commented.

Annie stood in front of it and waved toward the mainland. 'Hi ya, mum,' she yelled. I jabbed her in the ribs, and we agreed to meet Danny and Mark in five hours' time. Before we hiked away around a bend I asked Danny if he'd grown up on any stories about the Porters.

He squinted, his freckles folding into the sun wrinkles around his eyes. 'Aye. People reckoned that he was taken away by a boat in the night. That he'd arranged it.'

'Why?'

'Because his wife was very old. She had money, see, but . . .' He raised his eyebrows and let his voice trail off, leaving us to our conclusions.

Our plan was to hike the circumference of the 2½- by 1-kilometre island and find the ruins of Lucy and Kingsley's cottage, which both John Coll and Danny had assured us were hard to miss. In my mind's eye the sky over Inishbofin had always been grey, the turf deep green from near constant rains, the cliffs high and charcoal coloured. But this was not the island that lay before us now. The ground was soft and peaty underfoot, its hue the cheerful green of bell peppers. Without sheep to keep them in check, golden grasses grew tall and luxuriant, peppered with late-season wildflowers. There was not a

tree on the island. In the distance we could see that the granite cliffs of the northwest coast were not nearly as high as I'd imagined, and that they were tongue-pink. Inishbofin, it seemed, shared a palette with the Rouergue.

But for occasional herons, rabbits were our only company, thousands of them. With no more natural predators, humans included, they had seized the island as their personal refuge. We saw live ones, dead ones in every state of decomposition, bones, droppings. The turf was thick with rabbit waste.

After about an hour of northwesterly walking, just after Annie revealed she'd left our lunch back on the mainland in the car, we came to the island's sandy, cinched waist, marked by a natural cairn of bleached white stones. Fifteen minutes later we were peering over a clifftop into a narrow chasm of seawater, reminiscent of the well Marguerite and I had seen alongside the Chemin de St Jacques, near Limogne. Dark fault lines ran through the tall piles of salmon-pink bedrock; where these seams had given way, the cliffs were fractured and broken, like teeth in an ancient skull. But the stone itself – Ordovician granite older than time immemorial, some of the oldest rock in Europe, laid down 345 million years before the limestone of the *causses* – had been sea-worn smooth. All in all, it was a pretty place to die.

'Does it make any more sense here?' asked Annie.

'No.' Geology doesn't lie, but it can't answer for human behaviour. I wasn't sure what I felt, but I certainly agreed with John Coll: it was extremely hard to believe Kingsley had lost his footing. It hadn't been wet the morning he disappeared – the storm had come later. The cliff tops were level and secure. If he had indeed died here, he had done so deliberately.

I wanted to believe the islanders' theories about his being spirited away by a boat in the night, but they, of course, had not been aware of his personal problems. From the viewpoint of a community whose own, endemic worry is securing sufficient food and shelter, a million-

aire has solved the troubles of this world. It occurred to me that in dying, Kingsley had become the raw material of art – of imaginative invention – far faster than I'd thought. Flesh, especially in seawater, will decompose quickly, but it will take millions of years for bones to wear down and then solidify again into limestone; a memory, however, can become a romantic legend overnight.

However difficult life had been for the fishermen of Inishbofin and their families in the 1930s (how luxurious it must have seemed to them that Kingsley used the ocean as a swimming pool), it only became worse over the course of the twentieth century. The peat – their only affordable source of fuel – had been depleted; the sea over-fished; the beautiful remoteness of the land traded for tourism. To John Coll the past wasn't tragic, it was a source of hope and daydreams. Kingsley, at least, had escaped. He'd rowed away by night to begin new adventures in foreign lands – perhaps even Australia. Coll himself, thanks to his wife, was going to end his days in Donegal, watching his family's empty home crumble away.

We spotted the beach before the ruin. In the distance the Tory Island Light winked like a drowsy star. The beach was just a slim curl of sand, creamy coloured and smooth, an anomaly along the otherwise dark, pebbly strand. It was exquisite. Empty but for the footprints of oyster-catchers, blue-veined like fine Roquefort.

Annie and I had crested the island heading east, and were bounding seaward across the high-pile turf craning our heads this way and that, seeking some sign of human construction. Once or twice we were fooled by outcrops covered in golden lichen – it wasn't hard here to conceptualize the leap from bedrock to dolmen – until Annie had cried, 'There it is!'

The ruined cottage wasn't fifty feet from the beach. Lucy was right: it was so open and unprotected, so solitary, that it had more in common with the empty ocean than it did the shelter of dry land. It was almost painfully small. The pinkish dry-stone foundations stood

waist-high; there was a gap where the entryway had been, and a recessed hearth set into the south wall. The enclosure was carpeted with grasses and nettles and dead stalks of Queen Anne's Lace. I paced off the footage: 12 x 24. Crumbled outbuildings, now more cairns than structures, straggled away from the cottage.

'So good, all such a liberation.' I quoted Lucy.

'I rather think this was the whirlpool on the other side of the island,' said Annie.

I opened my notebook and read aloud, 'What the future may hold we foresee only dimly and uncertainly. But we look forward to it with confidence that the foundations laid are right and solid. And those foundations we owe to you.'

'Kingsley wrote that to Havelock Ellis in the fall of 1932.'

We stopped talking and listened to the oyster-catchers' cries. Months earlier I had written of the noose tightening around the Porters' lives; here was that noose in stone – a tight, 72-foot perimeter of granite. I had expected to enjoy finding the cottage. I thought it might bring me closer to Lucy and Kingsley, if only imaginatively. And I was right about that, but sorry it had. The knowledge I brought to the little ruin overwhelmed its dimensions. There was no roof – only the soaring emptiness of the sky and windswept beach, the dark mountains of the mainland beyond – yet I felt claustrophobic, as if I couldn't get enough air.

'They ran all the way here,' said Annie, her voice mystified, 'to this immense solitude, and then penned themselves up together with all they knew and feared, in this little stone box . . .'

How revealing, I thought, that they'd found a granite island – the hardest and most unforgiving of all rock. How far they'd come from the life-saving limestone of Quercy, the stone of travel, ever-mutating, ever-becoming, the porous partner of earth's brethren elements, water and air. By contrast, granite was indeed the stone of standing still, the sea's stationary adversary. It was the stone of few options, of having nowhere else to go.

'What do you make of John Coll's and Danny's impressions of Lucy?' I asked.

'Well, it's pretty clear, isn't it? She was afraid of the sea. We had a calm ride but can you imagine what it's like even with a slight breeze? This cottage wasn't her idea; she didn't speak Gaelic; she was stuck out here while he tramped all over the island. The lack of communication and her innate distrust of this idea from the start . . .' I eyed her and she said, 'I know, I'm guessing, but even to Lucy this must surely have seemed like strange behaviour – you have to admit, it's a long way from I Tatti and Elmwood to a hut – it all probably played into the myth that she was some kind of harridan.'

I shook my head in agreement. 'Remember at breakfast? Geraldine told us with absolute certainty that a son of Glenveagh's third owner, McIlhenny, had drowned off Inishbofin in 1967, and his body had never been found.'

'She'd been pretty sure of that.'

'Well, McIlhenny had no children.' Like the bog we'd seen earlier, gouged black where it had been recently cut and harvested (locals have a limited dispensation to harvest peat for fuel; each property, in fact, comes with an allotment of bogland), the mind preserves and conflates artefacts from different eras. Distance and forgetfulness – and the reminders of ruins or the wounds of landscapes – always give rise to invention.

I ran my hands over a pile of cool granite pebbles someone had left on one of the stones framing the doorway. They felt smooth and dense. Impenetrable.

'They'd always worked as a team,' I mused. 'Even Alan's entering their lives had been a joint decision.'

'But they ceased to work as a team when he killed himself,' said Annie. 'Surely that was a decision he took alone.'

Had it been? I thought of Lucy on her own in the cottage suffo-cated by the weight of all she knew about her husband: the response from Harvard that may or may not have just arrived; Alan's desire to

be apart from them; Kingsley's morbid interest in the suicides of other homosexual men; his recurrent depression. Had his offering to go on first, alone, been a kind of code that she'd been able to decipher – an intention she'd dreaded but had not the heart to prevent? How had she endured the ten minutes or so it would have taken Kingsley to cross the island to the cliffs? Had she used her imagination like a view camera to reconcile different points in space – one final, Roman-esque gesture of unfathomable love – to be there beside him in her mind's eye?

The ruined cottage drew me in and tempted me with these ques-tions that it was not in my daydreamer's nature to avoid. Its own nature was to seek completeness, just as mine was to give substance to these shadows. This time, however, a taste of tragedy lingered in my reinvention, and it gave me no pleasure.

* * *

On the return trip from Inishbofin to the mainland Danny's son Mark had given Annie a prize: a whale vertebra he'd found on the island over the summer.

'What a treasure!' she'd exclaimed when he'd shown it to us. It was the size and shape of a coffee mug, with its own smooth topography of tiny craters and crevices where seawater had exploited the bone's porous crust. When we were climbing out of the curragh onto the pier's slippery stone steps, he'd held it out to her.

'Go on, take it, it's yours.'

She'd demurred, but he'd insisted. 'Go on, da, make the lady take it!' he'd cried to Danny in desperation. Danny had given Annie a look and she'd conceded, scooping the vertebra from Mark's outstretched hands as she stepped gingerly out of the boat. 'The sea won't have this one,' she'd announced to me.

'It's just a hiatus,' I replied.

That night we'd eaten at the Big Bear as we had the night before – it was the only restaurant open in Gortahork post season. Repeat-

ing the pattern of the previous evening, we'd ordered a bottle of Bordeaux and had been served Beaujolais. Only on a third try – we thought we'd take another bottle back to the B&B – did the mysterious Bordeaux finally make an appearance.

'You know what they say,' said Annie, who'd successfully bummed a corkscrew off Geraldine, 'two Beaujolais's do a Bordeaux make.'

'No one says that.'

'Now they do.'

It was raining. A thin, soaking rain that threw a wet shadow over the granite of Glenveagh Castle. The castle is so ingrown within its lair in the gorse-bald Derryveagh Mountains that visitors must park in an outlying car park and take a bus along the one-track lane to the residence. Annie and I puttered for a bit amongst the dripping ornamental gardens and then joined a tour group led by a fastidious woman named Maureen.

Room after room unfolded, all decorated with hearty elegance by John James McIlhenny. I prowled around unsettled and edgy, like a dog hunting a scent that's gone cold. Then Maureen ushered us into the library, and I came to attention with a jolt; Annie described it later as the human equivalent of being on point.

'This is their room,' I whispered urgently. 'I know it. This is where they spent their time.' It was decorated in a minor key compared to the rest of the house: faded, floral stuffed chairs and sofa around the fireplace, books lining the walls. The windows held a spectacular view of Lough Veagh, the dark waters of which nearly broke against the castle walls.

Maureen spoke up. 'The furnishings in this room date back to the early 1930s, when Arthur Kingsley Porter and his wife Lucy owned Glenveagh Castle.' She pointed out that George Russell's paintings – dreamy landscapes and fairies in the moonlight – hung on the walls and dictated the colour scheme. A medieval wood carving of Christ on the cross hung above a corner writing desk. My mind's canvas

cleared and this time I welcomed the vision. This was where they had entertained Alan on his first visit; this was where Lucy had waited for him after Kingsley's death. I'd tried to imagine Alan yesterday out on the pink cliffs, but had failed. He may have visited Inishbofin, but the island was Kingsley and Lucy's inner sanctum, their private chapel – there was no room for him there, neither in the cottage nor my imagination. Alan's was an indoor personality; it was easy to conjure him here.

'I thought this might be an unspeakable ordeal,' he had written to Ellis, shortly after arriving at Glenveagh in July 1933, '[but] Lucy's courage and understanding are limitless. I can only hope to learn from her.'

Perhaps he had written those words here in the library, beneath the mounted wooden crucifix (or perhaps like Greta Garbo, a later guest of McIlhenny's, he preferred to remain alone in his room). It was a succinct summation of his experience with the Porters: courteous and complimentary, the events whirling around him bent self-ward by his own inner magnetic pole. To Alan, Kingsley's death had become an opportunity to learn good form; he was too young to know that everyone's understanding has its limits.

'He went out walking and disappeared,' Maureen was saying. The group perked up.

'Was he murdered?' asked one woman eagerly.

'No one knows,' she replied to interested murmurs. Kingsley's disappearance quickly became the highlight of the tour. According to a book for sale in the ticket office, he'd either been drowned by a freak wave or smuggled off Inishbofin to start a new life in Paris. Maureen had been loath to offer a view. Annie had pleaded. 'Well,' she said in a small voice, 'he was devoted to his wife Lucy. But perhaps he had a dear friend . . .'

After the tour we hiked high into the treeless hills above Glenveagh. Rain squalls were blowing in off the sea in purplish pleats, bruising

alternate peaks to the north. Maureen had said that Kingsley 'adored the climate here. He considered the rain to be his pet.' I shivered in wonder. Closer to hand, heather and gorse grew amongst the amber grasses; Annie swore that gorse, at its peak, smells exactly like coconut.

'Isn't it odd,' I said, 'that of all people on earth, Kingsley should have bought a folly. He'd been offended by the restoration work at Carcassonne.'

'Perhaps Lucy finally put her foot down about something and said, "Okay, mister, buy a castle in Ireland if you must, but it better damned well have central heating."'

I laughed. 'Maybe that was it. Let's sit here awhile.' I was slightly footsore after yesterday, but was determined not to bring this up to Annie – not yet, anyway. The squalls were coming closer now, curtaining off the far distance. I concentrated on the view at our feet. The land was beautiful in small doses as well as large. A foot-square patch held the intricate patterns of an oriental rug woven from heather blossoms, ochre-tipped grasses, inch-long flowers shaped like burnt-orange wheat stalks, tiny pink sedges, jade-coloured mosses, and the tip of a granite outcrop, pale with lichen ringed round it like sea foam.

Kingsley had written that Donegal was the loveliest landscape he had seen. To love a place like this is to yearn for freedom beyond human grasp. Out in the elemental openness you are exposed to the endless, enormous sky, and yet – converse consequence of the hills' barrenness – you're also inescapably conscious of the geography beneath your feet: the geology of the earth and the way the rock bucks and falls and peaks. This landscape tempts you with infinity and breaks your heart by reminding you that your mind will never experience it. To love that, as Kingsley did and I do now, is to love mortality itself.

He had once implied that if ever the knots of his life were to be untied it was Lucy who had the unique power to untie them. By July

1933, however, the Porters were done with untying human knots. As with every other step he took throughout his married life, Kingsley stepped off the pink cliffs of Inishbofin with his wife's tacit acceptance. Rather than splintering their teamwork, this final secret, shared on either side of death, tugged the knot of their marriage into the Irish interlaced symbol of infinity – a knot well known to Romanesque stone carvers, with neither beginning nor end.

A Note on Sources

I am my own
geology, strata on strata
of the imagination, tufa
dreams, the limestone mind
honeycombed by the running away
of too much thought . . .

'Inside', R.S. Thomas

Kingsley Porter began his book *Crosses and Culture of Ireland* with an epigram: 'Who Excludes Error Also Shuts the Door on Truth'. He is right, and I imagine I've kept the door to truth well open in these pages. On the other hand I've no wish to court wanton inaccuracy, and as I am neither archivist, art historian, nor geologist, I'd like to acknowledge some of the sources and specialists whose works buttress this book.

Unpublished material relating to the Porters – specifically, Lucy's journals and date-books, Lucy and Kingsley's letters, Kingsley's manuscripts, and their personal photographs – is open to public access at the Harvard University Archives. Letters from both Porters and Alan Campbell to Havelock Ellis are preserved amongst Ellis's papers at the British Library. Original photographs from *Romanesque Sculpture of the Pilgrimage Roads* are stored at Harvard's Fine Arts Library in the Porter Archive. Ironically, the 'long eternity' at the library proved more tenuous than Lucy had imagined; the Porters' negatives began to break down and had to be re-shot on 35-mm film in the 1980s. Most, however, were rescued and preserved with little damage.

It was at Harvard that I learned what little I yet know of Lucy Porter's later life. She continued to live at Elmwood in Cambridge, Massachusetts until her death on 20 September 1962, at the age of 86. Lucy lived long enough to see her nephew, Adlai Stevenson, run for President in 1956 – and lose to Dwight Eisenhower. An interview in a 1944 newspaper column entitled 'Our Gracious Ladies' indicated that she was Chairman of the Women's Division of the Cambridge War Finance Committee; that she endeavoured to be a scholar but felt she didn't succeed; spoke Italian fluently; acted as a photographer for her husband; and was 'petite, with grey hair, blue eyes, and a . . . point of view as modern as the current hit song, "Mairsey Dotes".' She was buried in Stamford, Connecticut.

To avoid confusion on the subject of Alan Campbell: note that the Alan Campbell who lived with Lucy and Kingsley Porter in 1932–3 is *not* the same Alan Campbell (also a young homosexual American with literary aspirations, active in the 1930s) who married humorist Dorothy Parker and later became a successful screenwriter in Hollywood.

Uncovering information about the Porters and their contemporaries was much less an event than a process. At the time of my first trip to southwest France in spring 2002, I was aware of Lucy's journals and photographs and *Romanesque Sculpture of the Pilgrimage Roads*; only later did I learn of Kingsley's secret, and later still the Ellis letters in London. In this sense my manuscript was an organic undertaking from start to finish, growing and adapting as my understanding of the Porters, and my relation to them and to Romanesque sculpture, evolved over time.

My readings in Romanesque art centre around the works of Meyer Schapiro, whose major essays were collected by George Braziller in 1977 in the comprehensive volume, *Romanesque Art*. In 1985 Braziller separately published an illustrated edition of one of these essays, 'The Romanesque Sculptures of Moissac', which I highly recommend as a visual companion to any perusal of the subject. It is

highly enhanced by David Finn's insightful black-and-white photographs of the cloister capitals and sculptures of the south portal and tympanum, and makes a terrific guide to the abbey.

Sumptuously illustrated and exhaustively detailed works on Romanesque art abound; for a brief and quirky introduction from the perspective of its strangest sculptures I suggest Anthony Weir and James Jerman's *Images of Lust: Sexual Carvings on Medieval Churches*. The authors succinctly catch the spirit of Romanesque sculpture in their capsule preface, and go on to discuss many structures in southwest France, including the abbeys of Beaulieu and Souillac.

Jonathan Sumption gives a highly readable account of the Compostela pilgrimage in *Pilgrimage: An Image of Medieval Religion*. For a contemporary translation of the 'guidebook' portion of the Codex of Calixtinus, turn to William Melczer's *The Pilgrim's Guide*, which also includes a detailed introduction to the medieval pilgrimage. Anyone wishing to burrow deeper into Conques – the abbey and its village, its natural environment, and especially the cult and spiritual attraction of its patron, Ste Foy – is advised to read Hannah Green's 2000 memoir, *Little Saint*. Green was an American who became a secular (yet highly spiritual) devotee of Ste Foy, to the extent that she and her husband moved permanently to Conques. The book is a posthumously published collection of her journals. Also interesting for its exploration of the art of southwest France is Frederick Turner's *In the Land of Temple Caves: Notes on Art and the Human Spirit*, of 2003. Like one of his (and my) heroes, Henry David Thoreau, Turner is attuned to the cyclical nature of life on earth, which he sees as best expressed in France's prehistoric cave paintings.

I found James Wilson's *Terroir*, published by the University of California Press in 1998, to be an in-depth yet jargon-free introduction to the intersection of geology and wine-making. As a useful accompaniment, I recommend the comprehensive series of geological maps of France published by Éditions du BRGM in Orléans, France

(available from GeoPubs in Minehead, Somerset). In terms of general geology, while there are textbooks by the score, I found John McPhee's Pulitzer Prize-winning quintet of essays, *Annals of the Former World*, essential to my understanding. Although the book ostensibly concerns the geology of the United States – the author pursues a dizzying range of geological causes and effects along the 40th parallel (also, conveniently, Interstate 80) – the enormity of its reach in space and time renders it of universal importance and application. McPhee's presentation of geological time is meant to assault the human worldview and it does, memorably. It is an important and poetic book.

Finally, I urge anyone interested in the art and thought of the Middle Ages to read or revisit Henry Adams' *Mont Saint Michel and Chartres*, which is available in paperback from Penguin Classics. Learning about the past is one thing; loving it emotionally and intellectually is another; conveying the spark of that love is yet another, still rarer achievement, and it is Adams'. Read his book.

Acknowledgements

Often it's difficult to decide where to begin to thank all of the people who have contributed to a book. But in this case it is simple. I owe an extraordinary debt to Dolores Gillerman, a woman I barely know. Professor Gillerman taught Romanesque Art second semester at Brown University, in 1982. It was the finest, most exhilarating course I have ever attended.

'Look at this capital. It's a piece of stone. It's just a goddamn stone. But what a magnificent stone it is!' That's how she began her first lecture, and I was enthralled. She radiated the spirit of the Romanesque in her down-to-earth teaching style, and she hooked me for life. Since that class, Romanesque sculpture has provided me with solace, sanctuary, humour, challenge, and great happiness, and for that I will always be thankful to her.

Once I began to research in earnest I was lucky to find a friend and tireless librarian in Julia Ettingbow at the Art Storage Facility at Smith College, where I first saw the 1923 edition of *Romanesque Sculpture of the Pilgrimage Roads*; Paula and Casey Knynenburg were later invaluable in helping me find my own copy of Volume Four. I owe a further debt of gratitude to the remarkable staff at Harvard's University Archives. Michelle Gachette and Brian Sullivan, in particular, were not only friendly, professional, and insightful, but truly shared my excitement and on their own initiative discovered materials I would never have known to look for. My thanks also extend to Martha Mahard and Joanne Toplyn of Harvard's Fine Arts Library's Historical Photograph Collection, whose good nature and knowledge made the monumental task of tracking down images both easy and pleasurable. Finally, I applaud the matchless efficiency, good humour, and patience of the Readers' Admissions crew at the British Library (Nigel in particular).

Georgia Wright, former Co-Director of the Limestone Sculpture Provenance Project, has been a wonderfully generous mentor from the outset,

sharing with me much material generated by the Limestone Project as well as her own video work on the medieval abbey of Vézelay. Lore Holmes, a chemist at Brookhaven National Laboratory, and Annie Blanc, a geologist at the Laboratoire de Recherche des Monuments Historiques in France, both of whom are associated with the Project, have likewise been exceptionally free with their time, knowledge, and advice. I would also like to thank sculptor Laura Travis of Providence, Rhode Island, for initiating me into the techniques of stone carving.

I owe a further debt to David Finn, who photographed the sculptures of Moissac Abbey for the 1985 edition of Meyer Schapiro's monumental study. Over the course of our correspondence, Mr Finn offered insights both personal and professional as to Dr Schapiro's working method and his own, and I am thankful to him for his comments as well as his beautiful black-and-white images.

My friend Nina Mercat offered not only welcome hospitality – along with that of Bernard, Audrey, Alison, and Pascal – but cheerfully stepped up to the telephone whenever my French failed. I am deeply grateful for her help. Kathleen Hadfield was a tireless suggester of research materials. So was my dear, late friend Dick Newman, whose knowledge of Harvard University and sheer interest and good humour filled me with pleasure whenever he called to check on my progress. ('*What*? You're still on Chapter Three? What have you been doing?') Sue Simon came along with unbridled enthusiasm for Kingsley and Lucy's story during the dark days of 2003 and early 2004, and I will always be grateful for her support. And without Gwyneth Lewis' assurance that 'everyone is bilingual', as she once told me, this book wouldn't exist.

I have to credit Ed and Bianca Sunderland for our delightful experience at Racannières. Their local knowledge, suggestions, and excellent spirits turned a research trip into a holiday. As for the unsung, often unnamed, characters who march through these pages – Serge, the owners and staff at the Hôtel Moderne in Espalion, a butcher in Lalbenque, Geraldine, Danny, and John Coll in Ireland – I can only say that their presence made my journeys a pleasure and the book brim with their good will. I thank them all.

To my readers, who found time and energy in the midst of busy lives to distil their (often contradictory, always insightful) reactions for me, I offer respect and sincerest gratitude. Theirs are gifts of the highest order, and I am thankful to my friends Tom Ferguson, Kathy Miles, Annie Garthwaite,

Marguerite Harrison, Heidi Dix (before her own travels took her away), Nicholas Howe, and Michael Gorra for their close readings. The significance of their encouragement and advice on everything from medieval theology to structure and style is beyond stating. I can say the same of my longtime friend and editor at the late Flamingo imprint, Philip Gwyn Jones, who commissioned the book and knew better than I that I needed time to develop my ideas, and never once doubted that I would. His belief in the power of inchoate enthusiasm is wondrous and rare. After Flamingo's demise, Jon Butler briefly oversaw the project – my thanks for his consideration during a difficult period – before it landed in the supremely capable hands of Nicholas Pearson at Fourth Estate. It was my, and my book's, great fortune to have found such a caring and perceptive editor. My thanks to him and to Michael Cox, whose fine taste and acute eye for detail proved sound rudders throughout the copy-editing process, and made it a pleasure. I am in awe of the miracle-working Catherine Heaney, who shepherded this book through the rigours of publication. Lastly, thanks to Holley Miles, Vera Brice and Rose Cooper, whose visual sensitivity brought Lucy's photos to life and made the book beautiful.

While my parents didn't participate in this book in a literal sense – though they may have liked to – they surely helped create it, for they instilled in me a love of travel and adventure as it is pursued either on foot or in books. Their lifelong belief in me has given me confidence to go exploring in both directions. I further applaud my father's deep knowledge of geology and mineralogy. Thanks to his collection of rocks and minerals, I not only remain the only child in Verona, New Jersey ever to lug a dinosaur footprint to school for show-and-tell, I am now, after forty-three years, genuinely able to share his interest and pride in his specimens.

Finally there are the travellers. I celebrate Annie Garthwaite's extraordinary generosity of spirit, imagination, good humour, and finances: without her I may not have walked so far, but I'd never have had so much fun. She is truly indomitable. Marguerite Harrison receives my deepest thanks, not only for her gift of companionship on the road, but at home as well. She watched the book develop day by day, prodded and encouraged, endured and cajoled, tolerated my absences, walked the dog, and got on a plane and flew to Toulouse because I wanted her to join me in the gin-scented summer of 2002. She is tireless in friendship, acute in perception, and extraordinarily thoughtful. And for these qualities I am grateful.

Index

Figures in italics indicate illustrations.